W9-ARH-632

Fear and the Muse Kept Watch

ALSO BY ANDY McSMITH

The Iraq Report: A Special Investigation
No Such Thing as Society: A History of Britain in the 1980s
Innocent in the House
Faces of Labour: The Inside Story
Kenneth Clarke: A Political Biography
John Smith: A Life, 1938–1994

Fear and the Muse Kept Watch

The Russian Masters—from Akhmatova and Pasternak
to Shostakovich and Eisenstein—Under Stalin

Andy McSmith

THE NEW PRESS

NEW YORK
LONDON

GLEN COVE PUBLIC LIBRARY
4 GLEN COVE AVENUE
GLEN COVE, NEW YORK 11542-2885

© 2015 by Andy McSmith
All rights reserved.

No part of this book may be reproduced, in any form,
without written permission from the publisher.

Anna Akhmatova, excerpts from *Complete Poems of Anna Akhmatova*,
translated by Judith Hemschemeyer, edited and introduced by Roberta Reeder.
Copyright © 1989, 1992, 1997 by Judith Hemschemeyer. Reprinted with the permission of
The Permissions Company, Inc., on behalf of Zephyr Press, www.zephyrpress.org.

Requests for permission to reproduce selections from this book should be mailed to:
Permissions Department, The New Press, 120 Wall Street, 31st floor, New York, NY 10005.

Published in the United States by The New Press, New York, 2015
Distributed by Perseus Distribution

LIBRARY OF CONGRESS CATALOGING-IN-PUBLICATION DATA

McSmith, Andy.
 Fear and the muse kept watch : the Russian masters—from Akhmatova and Pasternak
to Shostakovich and Eisenstein—under Stalin / Andy McSmith.
 pages cm
 Includes bibliographical references and index.
 ISBN 978-1-59558-056-6 (hardcover : alkaline paper) — ISBN 978-1-62097-079-9
(e-book) 1. Soviet Union—Intellectual life—1917-1970. 2. Arts—Political
aspects—Soviet Union—History. 3. Artists—Soviet Union—Biography. 4. Authors,
Russian—20th century—Biography. 5. Composers—Soviet Union—Biography.
6. Motion picture producers and directors—Soviet Union—Biography. 7. Stalin,
Joseph, 1879-1953—Influence. 8. Politics and culture—Soviet Union—History.
9. Soviet Union—Politics and government—1936-1953. I. Title.
 DK268.3.M35 2015
 700.92'247—dc23

 2015008415

The New Press publishes books that promote and enrich public discussion and understanding
of the issues vital to our democracy and to a more equitable world. These books are made
possible by the enthusiasm of our readers; the support of a committed group of donors,
large and small; the collaboration of our many partners in the independent media
and the not-for-profit sector; booksellers, who often hand-sell
New Press books; librarians; and above all by our authors.

www.thenewpress.com

Composition by Westchester Book Composition
This book was set in Adobe Caslon

Printed in the United States of America

2 4 6 8 10 9 7 5 3 1

To Imogen,
who is living under communism as I write

Contents

Introduction

Anna Akhmatova spent the morning of February 25, 1917, by the old-style Russian calendar, at her dressmaker's in Petrograd. After the visit, the poet hailed a horse-drawn carriage and asked to be taken across the Liteiny Bridge to the Vyborg district, where she was staying with friends. The cabbie refused her fare. There was trouble in the Vyborg, shooting in the streets—it was too dangerous. Unable to get home, Akhmatova spent the day wandering through the city. Everywhere there were disturbances. Fires had started. The tsar had ordered troops sent out to calm the crowds, but the mood was turning defiant and even the ferocious Cossacks were reluctant to attack their fellow citizens. Revolutionary manifestos had been pasted here and there. There had not been scenes like this in the Russian capital since the suppression of the 1905 revolt.

That evening, Akhmatova visited the Alexandrinsky Theatre in the company of a poetry-loving army officer who, like others before and after, was besotted with her. They were there to see a dress rehearsal of a new production of Mikhail Lermontov's *Masquerade* directed by Vsevolod Meyerhold. It has been described as "the last act of a tragedy of the old regime, when the Petersburg elite went to enjoy themselves at this splendidly luxurious production in the midst of all the chaos and confusion."[1] Even during a revolution and a never-ending war in Europe that had cost a million Russian lives, some people were still keen to see what was showing at the theater. One of the keenest was a nineteen-year-old who did not have the social connections to be invited to a dress rehearsal—he lived with his father, a civil engineer—but who had heard that the ever-experimental Meyerhold had introduced

clowns to this new production. Young Sergei Eisenstein loved theater and loved clowns, so as soon as he heard that the production was open to the public, he risked the gunfire, the disruption of public transport, and all the other hazards to be at the theater doors. It was a wasted journey: the Alexandrinsky was closed and the production had been called off.

Another memorable cultural event marked the evening of February 25: a literary and musical soiree in an artists' studio run by Nadezhda Dobychina, who wanted to attract visitors to her latest art exhibition. Her most famous guest was the writer Maxim Gorky, whom she introduced that evening to the young composer Sergei Prokofiev, who gave a performance of a few of his short pieces, including a new work for voice and piano based on the Hans Christian Andersen tale "The Ugly Duckling." After that night Gorky and Prokofiev became firm friends, and when Prokofiev was called up to fight in the war with Germany later that year, Gorky made such a fuss that the summons was canceled. That week in February, curiosity almost killed Prokofiev: he ventured out to see what was happening in the streets and had to dodge behind a house when the shooting came too close.

The revolution brought an explosion of freedom to a country that had never known anything but autocracy or chaos. Within barely a decade, that freedom was gone. Instead of liberating the human spirit, the upheaval had given rise to one of the most repressive and invasive dictatorships in human history. Why that happened is one of the great questions of recent human history—which I will not attempt to answer in full; however, a contributory cause can be inferred from the behavior of Akhmatova, Prokofiev, Eisenstein, and others on the day the monarchy collapsed: they were interested enough to ask questions and perhaps venture into the streets to take a look, but it does not seem to have crossed their minds that this was a crisis in which they might usefully get involved. There is justice in the charge laid by Prokofiev's first, Soviet biographer: "In these groups the very possibility of a relationship between art and politics was considered unthinkable . . . a betrayal of the principles of pure art"—though, to be fair, he might have added that if they had wanted to take up political activity, there was no obvious way to begin.[2]

The middle class, or bourgeoisie, had a vital role in the scheme of history laid out by Karl Marx. He forecast that where there was feudalism, economic progress would give rise to a bourgeoisie who would overthrow the old order and create a capitalist democracy, as they had in England. The workers' revolution would follow when class conflict made capitalism's continued existence untenable. But in 1917 Russia's middle class was tiny. It had no collective

political experience. Nineteenth-century Russian literature is replete with characters who agonize over the great questions of human existence but do nothing. The old regime was too repressive and too inefficient to adapt to changing times, so those who were interested in politics generally either gave up or became revolutionaries. The tsar was brought down not by an assertive bourgeoisie but by street riots of the urban poor and by the refusal of war-weary troops to enforce his authority.

During 1917, Russia's provisional government struggled to create a democracy based on the Western model in highly volatile conditions, while still waging a war with Germany that was as good as lost. A right-wing military coup, in August, was poorly planned and easily shut down, but there was no certainty that the next would not succeed. Instead the moment was seized by the one group on the revolutionary left that was sufficiently disciplined to take power and hold it. While other political parties were mostly shapeless collections of more or less like-minded individuals without a leader able to exercise authority, the Bolsheviks had a command structure centered on Vladimir Lenin, who had dominated the organization from its founding. They also might have floundered in the chaos of 1917 had the Germans not obligingly put Lenin on a "sealed" train sent across enemy territory to return him to Russia from exile in Switzerland. The Bolsheviks had almost no support in the countryside, which gave them no chance of winning a free election, but they were well organized in every important urban center, and once in power they secured the temporary loyalty of millions of peasants by inciting them to seize ownership of the land from the aristocracy. The two revolutions swept through every institution in the Russian Empire, bringing down the tsar and all his ministers, destroying the police force, causing the army to disintegrate, and tearing apart the official standing of the Russian Orthodox Church. The aristocracy lost their land; the factory owners lost their factories, seized by the state in the name of the workers. The Bolsheviks disbanded Russia's first properly elected parliament, the Constituent Assembly, before it ever had a chance to meet.

Through this chaos, one aspect of the old way of life survived: the educated Russian's love of high culture. Russia's political system was primitive, but its fiction, music, opera, drama, and poetry were renowned worldwide, and all of it was comparatively new. The secular culture that took the world by storm began with Alexander Pushkin, soon after the defeat of Napoléon's army, and continued to produce great waves of creativity, interrupted by the occasional trough. The last trough followed the defeat of the 1905 revolution

and lasted until 1912, when Russian poetry, music, and art burst into life once more.

Russian art was never far removed from political dissent. Pushkin and Mikhail Lermontov were exiled to south Russia for being politically suspect. Leo Tolstoy and Gorky became living symbols of resistance. The principal work from which the wave of revolutionaries in the 1870s drew inspiration was not a political essay but Nikolai Chernyshevsky's novel *What Is to Be Done?* It was a mediocre novel, especially compared to the enduring masterpieces produced during the same period, but its revolutionary message was uncompromising, and its author was revered for the twenty years he spent either in prison or in exile.

Russia's outpouring of great works during the nineteenth century was produced by the same "bourgeoisie" who so signally failed to fulfill the task set them by Karl Marx. Though Tolstoy was an aristocrat and Gorky was an itinerant laborer, the great Russian artists and the audiences who sustained them were principally from the small, emerging urban middle class, most of whom settled down passively under the new Bolshevik regime to carry on the work they had done under the old regime.

The Bolsheviks extinguished all political life outside their newly founded Communist Party. The soviets, the government ministries (now designated people's commissariats), the unions, and the nationalized industries were all under party control. They had built the Red Army from the rubble of the collapsing imperial army and had created a new police force, the Cheka, from scratch, but they did not possess the numbers or the managerial and technical expertise to manage the factories and run the state apparatus on their own. They needed their "bourgeois specialists": the army officers, managers, engineers, bureaucrats, teachers, and lecturers left over from the old regime, although Bolshevik theory said that such people now belonged in history's dustbin.

It cannot have been very fulfilling to be a "bourgeois specialist" in the new communist state. It meant holding a responsible job without the matching social status. The specialists were answerable for failures in their sections, but they had no political rights. They could not hold meetings or air their opinions in the state-controlled media. They had no unions, guilds, or staff associations and were not greatly respected by the new class of commissars. Still, those who loved literature—of whom there were many—could in the early days go to a poetry recital by one of the stars of the class of 1912, such as Akhmatova or Boris Pasternak, or go to the theater to see the latest play

by Mikhail Bulgakov. There they would be in congenial company, away from the monotonous clamor of Bolshevik propaganda. Even after censorship had tightened, there were still concert halls where they could listen to the latest work by the young Dmitri Shostakovich. An artist whose name could fill an auditorium was therefore a person of consequence in a land where almost nobody other than party leaders mattered.

In the 1920s, the Bolsheviks were too busy with other pressing issues to form a coherent policy toward the cultural activity taking place on their watch. With rare exceptions, those who loomed large in the debates over literature and art in that decade were not major figures in the party structure. At first, the leading Bolsheviks were engrossed in winning the civil war, which ended when the Red Army overtook the Whites' last territorial base, in Crimea, in November 1920 and massacred the officers who had made the mistake of surrendering instead of fleeing into exile. Afterward there were other sporadic episodes of violent resistance to Bolshevik rule; the revolt by sailors at the Kronstadt naval base in March 1921 is the best-known example. Civil war had dislocated the economy: almost the only "trade" between city and countryside consisted of armed detachments entering five hundred thousand villages to requisition grain by force, in order to prevent the cities from starving. In March 1921, Lenin addressed that problem by ordering an economic retreat, the New Economic Policy (NEP), which allowed private trading and some private enterprise in an economy that had been wholly under state control. As the economy recovered toward its prewar level, the party was confronted by the massive task of increasing industrial output after seizing power in the name of the industrial working class in an empire where factory workers made up barely one-fiftieth of the total population.

The Bolsheviks had absolute faith in Marx's prediction that the workers of the world would arise and overthrow capitalism. They expected the war to ignite world revolution, enabling them to look to the developed nations of Western Europe for assistance in generating Russia's industrial revolution. By 1923, however, there had been three failed revolutions in Germany, a Red Army invasion of Poland had been repulsed, and the Bolsheviks knew that they were on their own. By malignant coincidence, that also was the year that Lenin became fatally ill. The argument over how to proceed with industrialization became subsumed in a vicious struggle for the succession.

The Left, led by Trotsky, wanted rapid industrialization and refused to give up on world revolution; they did not accept Stalin's formula for "Socialism in One Country." But even if they had the stronger case, which is arguable, the

Left was hobbled from the start by the regime within the Communist Party that Lenin had bequeathed. During the civil war, the party had become a heaving morass of factions and alliances, with its annual congresses the venue for fierce arguments, but in the crisis of March 1921 Lenin ruled that all factional activity must end. He may have intended the ruling to be temporary, but it was still in force when communism collapsed seventy years later. In April 1922, Lenin appointed Josif Stalin general secretary of the Communist Party, a modest-sounding title that made him master of the party machine—and it was the machine that decided what did or did not constitute factional activity. By the time Lenin realized the appointment was a terrible mistake, he was too ill to reverse it. Stalin was in an inviolable position. He could organize his supporters and place them in key positions as part of his job, but anyone else who tried to organize support for a political position was guilty of factional activity and a breach of party rules. Before the decade was over, the Left had been outlawed and Trotsky sent into exile.

After he had crushed the Left, Stalin suddenly changed course and decided after all to industrialize at breakneck speed, with the imposition of the First Five-Year Plan in 1928. Economic life in the countryside in what was now the Union of Soviet Socialist Republics had recovered well under the New Economic Policy, and the more successful peasant farmers, known as the kulaks, had accumulated livestock, might soon become employers of hired labor, and were learning to play the market to get the maximum price for their produce. This did not alarm communists on the right of the party—of whom the most important was Nikolai Bukharin—for whom the kulaks were an asset because of their contribution to the general economic revival. For Stalin, it was a question of *kto kogo*, "who whom": who ruled and who was ruled. When the peasants failed to supply sufficient grain to feed the towns after the 1928 harvest because they were waiting for the price to rise, Stalin chose to detect a criminal conspiracy against communist rule. He sent detachments to seize grain, as they had in the civil war, and forced through the inhumanly cruel policy of driving the entire rural population onto collective farms—except for a million or more who resisted and were either killed or sent to labor camps. Agricultural output fell catastrophically, but Stalin enforced a rule that the towns must be supplied first and seed laid aside for planting. Only after those conditions were met could the peasants feed their families. The result was one of the worst famines ever to arise from a deliberate govern-

ment policy. Even hardened communists were sickened by the suffering, but, having collaborated in imposing the ban on factional activity on the Trotskyite left, Bukharin and his allies felt honor bound to abide by the same rules and so were easily isolated and crushed.

The elimination of the Left and the Right gave Stalin the political authority and spare time to turn his attention to the arts. Until then, writers had been watched over by middle-ranking commissars and chekists who might harass, bully, and censor them but who were not book burners like the Nazis; they retained a wary respect for acclaimed artists, particularly those whose reputations had spread beyond the Soviet Union, and did not, as a rule, presume to tell them how to write.

Stalin was not so modest. He did not merely hunt for political deviation: he was the ultimate arbiter of literary taste. He was the foremost literary critic, historian, and philosopher in the land. He decided whether a novel, play, or opera was well written. His micromanagement of the most politically sensitive medium, the cinema, was such that no film could go into general release until he had had a chance to see it at a private screening in the Kremlin. Directors learned that it was wise to send the script to Stalin to read before shooting even began. Around the dictator was a small army of minor dictators interpreting his wishes. Their effect on the creative process was well described by Alexander Solzhenitsyn in *The First Circle*, a novel written in the 1960s but set in the latter years of Stalin's rule.

> Every time he started a new book, he felt hopeful, he swore to himself and to his friends that this time nothing and no one would prevent him, he would write a genuine book. He set about it with enthusiasm. But very soon he noticed that he was not alone. Swimming in front of him was the ever clearer image of the one he was writing for, one particular famous reviewer. . . . He could just imagine Zhabov reading his latest book and thundering at him (it had had happened before), spreading himself over half a page in *Literaturnaya gazeta*. He would head the article "Who Is Behind this New Trend?" or "More About Some Fashionable Trends in our Literature." . . . Very soon, he would show . . . that Galakhov's new book showed his vicious, anti-social character and revealed the shaky foundations of his philosophy. As in paragraph after paragraph Galakhov tried to guess the form Zhabov's attack would take and ensure against it, he soon found himself watering the book down until it was as bland and insipid as all the rest.[3]

Under this stultifying regime in which, to quote Pasternak, independent thought was "a form of meningitis," it beggars belief that anything of any lasting value could be created. And yet Russia under communist rule produced works of extraordinary power and beauty that continue to delight long after the passing of those who created them. Some of the finest poetry in the Russian language was written in the oppressive chaos of the 1920s or under Stalin's malignant eyes. Shostakovich wrote his Fourth, Fifth, and Seventh Symphonies and other lasting compositions under Stalin; Prokofiev composed the most popular piece for children in the world's classical repertoire, *Peter and the Wolf*, and the wonderful ballet *Romeo and Juliet* and collaborated with Eisenstein on *Alexander Nevsky*, one of the most popular films of the 1930s; Bulgakov secretly wrote Russia's favorite twentieth-century novel, *The Master and Margarita*; Pasternak wrote *Doctor Zhivago*; and that other magnificent and now underrated novel *Quiet Flows the Don* appeared under the name of Mikhail Sholokhov.

On the whole—again surprisingly—Stalin recognized the great artists within his domain and treated them with more respect than he showed communist officials who crossed him. Trotsky's biography of his rival begins with the remark that Stalin was "Asiatic," as if he were a twentieth-century Genghis Khan from the bandit country beyond the Caucasus Mountains. Stalin was indeed as ruthless and suspicious as any barbarian despot, but he was not ignorant. He had been educated at the Tiflis Seminary in Georgia, one of the best schools in the empire outside the major Russian cities. The young Josif Vissarionovich Dzhugashvili, son of a violent, drunken cobbler, may have been a playground bully and gang leader, but he was an intelligent pupil. His singing voice was "good enough for him to go professional," according to Simon Sebag Montefiore, while "as a poet he showed a certain talent in another craft which might have provided an alternative to politics and bloodletting."[4] Once in power, he was shrewd enough to understand that his regime gained in prestige from artists producing work that was genuinely admired at home and abroad. He was also clever enough to differentiate between real artists and hacks turning out rubbish to please the authorities. He would, when it suited him, arbitrarily raise a mediocrity like the now-forgotten composer Ivan Dzerzhinsky to sudden prominence while having his officials bully and harass Shostakovich, but his subsequent behavior makes it obvious that he knew which of those two composers was a great artist and which was the mediocrity. Despite the dreadful ordeals the dictator put him through, Shostakovich remained a privileged Soviet citizen. He, Prokofiev,

and other successful artists became very wealthy by the standards of the place and time.

Bulgakov's background and manner almost invited the designation "enemy of the people": he was the brother of two army officers who had fought the Bolsheviks and fled abroad with the defeated White Army. His first stage play survived censorship because of the personal intervention of the first powerful communist to acknowledge Bulgakov's great talent: Stalin. It is sometimes suggested that Bulgakov was Stalin's favorite writer, which is not true. That accolade belongs to Sholokhov, if anyone, but Bulgakov was conscious of the ambiguity of his position, which he neatly captured in his play *A Cabal of Hypocrites*, usually known by the shorter title *Molière*. The play ostensibly describes the travails of a writer during the reign of Louis XIV, but the parallel with Bulgakov's life was so transparent that Stalin's chief censor saw through it straightaway. In act two, scene one, Louis XIV makes the extraordinary gesture of inviting Molière to sit at his table. The writer blanches and protests, "Your Majesty, I cannot accept this honor. It is too great." The Sun King insists, and a trembling Molière takes his place as ordered.

LOUIS. Would you care for some chicken?

MOLIÈRE. My favorite dish, your majesty. (*Pleading*) Allow me to stand.

LOUIS. Eat your dinner. How is my godson getting on?

MOLIÈRE. To my great sorrow the child has died, your majesty.

LOUIS. What, the second child as well?

MOLIÈRE. My children do not live long, your majesty.

LOUIS. You should not grieve over it.

MOLIÈRE. No one in France, sire, has had dinner with you before. I am overwhelmed, and therefore somewhat nervous.

LOUIS. France, Monsieur de Molière, is sitting before you. France is eating chicken, and is not nervous.

MOLIÈRE. Sire, you are the only person in the world who can say that![5]

To an audience used to free speech, this reads as a black comedy about a writer of great talent forced to debase himself before an absolute ruler—but imagine what would have gone through the mind of an aristocratic courtier in Versailles, brought up to believe that title and pedigree were all that mattered and whose life has been spent straining to be acknowledged by the king,

on seeing a commoner being honored in this extraordinary way for no better reason than that he wrote amusing plays. Bulgakov endured endless harassment from the authorities, until everything he wrote was banned except the one play that had received Stalin's personal endorsement. To us, that makes him a persecuted writer. To his contemporaries, he was someone who had enjoyed the exceptional privilege of speaking directly to Stalin on the telephone and could therefore go to bed without fearing an ominous knock on the door in the night. There must have been petty officials longing to be recognized by Stalin who envied Bulgakov.

The rise and fall of the Bolsheviks and the great and terrible impact of their vast experiment is one of the epics of the twentieth century, and it has intrigued me ever since I discovered that *Animal Farm* by George Orwell shadowed real events. The memoirs of Nadezhda Mandelstam first introduced me to the thought that the most interesting figures in the drama were not the main players; they were the people swept up in these swirling events who nonetheless held on to their humanity, maintained friendships, and were true to themselves, particularly if they were creative artists, a dangerously public vocation. It also intrigued me that there were so many great artists at work in such dangerous conditions.

Orwell's celebrated novel *1984* imagined a society in which people have had all the creative life crushed out of them by the state, making them like robots, incapable of free thought. Orwell acknowledged that he took the idea for *1984* from a novel written in 1920 by a Russian, Yevgeny Zamyatin. The word "robot" is Russian in origin: it reflects what English-speaking people imagined Russians living under communism were like.

But, rather like 1960s hippies who thought they could expand their consciousness by taking hallucinogenic drugs, I am in no doubt that absorbing great music, poetry, drama, and literature is mind expanding. In an age when we treat recreation in any form as nothing more than a consumer choice, we undervalue the impact of art and culture on human civilization. A dictatorship can force people who have experienced the impact of great art into an outward show of obedience but cannot make them inwardly believe that government propaganda is the final truth. A Russian who had absorbed Akhmatova's poetry or Shostakovich's music could not be turned into a robot, even by Stalin's terrifyingly efficient machinery of repression. Despite their apparent helplessness, these artists were not minor characters in the history of their times: they were part of the story.

The revolution, by the way, was not altogether bad for the arts. Its immense drama was also a source of inspiration. The young Sergei Eisenstein, for example, as an artist, owed everything to the revolution.

In the text, I have tried to keep unfamiliar names and acronyms to a minimum, but certain complications were unavoidable. The political police created by the communists went through several name changes before it became the KGB. Originally, it was Cheka. For a very short period (which I have ignored), it was the GPU, and then it was the OGPU until 1934, when it became the NKVD. After 1941, it was the MGB. I have used the terms Cheka, OGPU, and NKVD according to the period. Saint Petersburg underwent three name changes in the previous century: from 1914 to 1924, it was Petrograd; and then, for the remainder of the communist period, it was Leningrad. Again, I have used whichever name is correct for the time.

1

Eisenstein in the Jazz Age

Our cinema is a weapon, first and foremost, to be used to combat hostile ideology.

—SERGEI EISENSTEIN

In the wild Russian summer of 1917, an odd-looking teenager with a huge head, a barrel-shaped torso, small limbs, delicate hands, a huge forehead, a high quiff, and inquisitive eyes was to be found lurking on the streets of Petrograd, looking for trouble. He did not want to be involved in the trouble, however: he wanted to make a mental record of it and everything else he saw. He was living in a private fantasy in which he was a twentieth-century Leonardo da Vinci, soaking up experiences from which he would extract artistic inspiration.

There was scarcely a Russian alive anywhere whose life was not overturned in February 1917, when the Romanov dynasty, which had ruled the empire for three hundred years, was brought down. For this particular teenager, it was a bewildering, exuberant year. He did not mind the noise, the crackle of gunfire, the thud of running feet, or the sight of armed men patrolling the streets; such disturbances were linked to a cherished childhood memory. The tsar had almost been overthrown in 1905, around the time of his seventh birthday, when his parents decided that it was unsafe in Riga, where he had spent his infancy, and he and his mother moved to Saint Petersburg. Having his mother all to himself, in a flat furnished to her artistic tastes, with his father three hundred miles away, was the happiest time of his life. The worst time came during the oppressive quiet after the revolutionary disturbances

had been suppressed, when his mother ran off with a new lover and left him alone with his detested father.

He did not mix with others of his age. Girls did not attract him. He believed that he was a freak. He found solace in the arts, especially the theater—a pleasure to which his mother had introduced him. Initially the revolution was a shock because the theaters closed and he was denied his favorite escape from the dreariness of life under the thumb of his dull, reactionary, and aggrieved father. At home, Sergei Eisenstein had to listen respectfully while the older man complained about the collapse of authority and the lack of respect and deference, and, as his father was complaining, an exciting, subversive thought gained currency in the adolescent's mind: if Russians no longer owed their tsar unquestioning obedience, then he did not have to obey his father. Mikhail Eisenstein wanted his son to follow in his footsteps as an engineer. He must have been shocked rigid when the previously obedient boy refused the offer of a place at the Petrograd Institute of Civil Engineering so that instead he could try to sell his drawings to the numerous newspapers that had sprung up in the excitement of revolution. "Well behaved child that I was, it amazes me to think that I sent the whole production line to blazes," he reflected in his memoirs.[1]

That was his first step in a journey of self-discovery. The second was when he stumbled upon a German essay, which he could read easily because he had been raised in a multilingual household. Its title, "Leonardo da Vinci: A Psychosexual Study of Infallible Reminiscence," roused his curiosity because he had been intrigued by da Vinci's *Benois Madonna* in the Hermitage Museum. Written by Sigmund Freud in 1910, the essay postulated that da Vinci's creativity was heightened by his sublimated homosexuality, which originated in a vividly recalled childhood trauma. Homosexuality had been a criminal offense in Russia for centuries. Eisenstein apparently had never heard of such a phenomenon, any more than he had heard of Freud. As he read the essay, the "memory of childhood," the distress he had experienced on being abandoned by his mother, exploded into his consciousness, and "a new sun was on the horizon. All swollen with love; it was a revelation."[2] Suddenly he had an explanation for why he felt so different from other adolescents. Better still, he had found that there had once been someone else like him: the great Leonardo da Vinci.

Da Vinci had walked the streets of Florence after the overthrow of its Medici rulers, observing the riots; so Eisenstein also went out into the streets. In Petrograd in 1917, there was no shortage of historic events to witness, but

young Eisenstein was not very good at being in the right place even when it was the right time. If he had been at the Finland Station on April 3, he would have seen the cheering crowds greet Vladimir Lenin on his return from exile. In May, the provisional government was shaken by riots, and the socialist lawyer Alexander Kerensky took over as prime minister. Kerensky exhorted Russia to rise from exhaustion for one last offensive against Germany, but the combination of war weariness, hunger, and revolutionary excitement instead set off more riots during the heat of July. This time our young witness was in the middle of the action, standing on the corner of Sadovaya Street and Nevsky Prospekt when troops fired warning shots at the crowd. From the shelter of a storefront, young Eisenstein watched and noted:

> The street emptied immediately. The pavement, the road—it was as if a jeweller's had been turned out on the streets; watches, watches, watches—fob watches on a chain, watches with pendants, with bracelets; cigarette cases, cigarette cases, cigarette cases—tortoise shell and silver, monogrammed, with dates, plain ones even. I saw people quite unfit, even poorly built for running, in headlong flight. Watches on chains were jolted out of waistcoat pockets. Cigarette cases flew out of side pockets—and canes, canes, canes—Panama hats. My legs carried me out of the range of the machine-guns. But it was not at all frightening. These days went down in history—history, for which I so thirsted, which I so wanted to lay my hands on![3]

More exciting events tumbled over one another. Lenin went into hiding while other Bolsheviks were arrested. Kerensky fell out with the army command, who attempted a coup that failed, playing into the Bolsheviks' hands—but our witness missed all this because he had been distracted by the discovery of a superb collection of engravings left to his aunt by her late husband. "I would run my hands over the engraving with all the rapture of a true collector caressing a genuine treasure," he recalled. "I spent about an hour ordering the articles on the eighteenth century engraves. Then I went to bed. There seemed to be more shooting than usual coming from one part of the town, but it was quiet in our house in Tauride Street. Before going to bed, I pedantically wrote the date on the cuttings to show they were put into order—25 October 1917."[4] On the modern calendar, it was November 7, 1917, and across town the Bolsheviks had seized power.

Eisenstein's father reacted by enlisting in the White Army to help destroy the Bolshevik pestilence, a brave decision for a middle-aged man of German

descent with a Jewish-sounding name. His son decided to do the very thing his father had wanted but that he had previously refused to do: he offered his services as a civil engineer—to the Red Army. Father and son never saw each other again.

If the younger Eisenstein had any potential as a military engineer, it was not put to use; instead the Red Army wisely deployed his artistic talents, first in Smolensk, where he decorated an agitprop train, and then in Minsk, where he built a mobile stage. After the civil war, he drifted to Moscow, once again the capital of Russia, as one of thousands of young, unemployed ex-servicemen living in poverty. The only work that interested Eisenstein was in the theater, but the difficulties of finding any paid job were made all the greater by a Bolshevik policy of giving preference to applicants from working-class families. No work meant no ration card, but he did not let that worry him. "The young don't bother their heads about anything," one of his contemporaries, Nadezhda Mandelstam, remarked about this period. "Our grim-faced parents went to their doom while we enjoyed life hugely."[5] Eisenstein slept on a trunk in someone's apartment until an old school friend, Maxim Straukh, and Maxim's actress girlfriend, Yudif Glizer, found him a room adjoining theirs. And then he fell in love. It happened when he put a piece of bread down for a moment on a theater lighting board and it was stolen by a "slim, strong, handsome, fair-haired and golden-skinned" seventeen-year-old named Grigori "Grisha" Alexandrov, a scene painter recently arrived from the Urals.[6] A fierce argument erupted, ending when Eisenstein learned that the thief had not eaten for two days and let him have the precious bread. Whether or not their relationship was ever physical, there is no doubt that Eisenstein, a virginal twenty-two-year-old, was smitten.

In January 1921, the Proletkult Theatre took Eisenstein on as a set designer. He threw himself into the work with such commitment that he was soon also the costume designer and a co-producer of a dramatization of Jack London's short story "The Mexican" and caught the attention of Vsevolod Meyerhold, a man he had idolized from afar and who was to be his first surrogate father. Eisenstein was thrilled to see this monumental figure in Russian culture in the audience one evening. As an actor, Meyerhold had played the male lead in the first Moscow production of Chekhov's first play, *The Seagull*, before making a break with realism and becoming one of the century's greatest exponents of avant-garde theater. He had also been one of the first artists of any significance to support the Bolsheviks, which very nearly cost him his life when he was discovered on the wrong side of the battle lines during the

civil war. To mark his Red Army service, he dressed in boots, puttees, a soldier's greatcoat thrown on with affected carelessness, a dark woolen scarf, and a cap adorned with a badge bearing Lenin's profile, all assembled with the contrived simplicity of a trained actor. After the performance, Meyerhold invited Eisenstein to a coffeehouse to meet the people's commissar for enlightenment, Anatoli Lunacharsky, where he sat listening in awe as these two famous men talked. "The God-like, incomparable Meyerhold, I beheld him then for the first time and I was to worship him all my life,"[7] Eisenstein wrote.

In autumn 1921, Meyerhold was appointed head of the newly launched State Higher Theater Workshops, in which Eisenstein was among the first students enrolled. It was located in the mezzanine, at 23 Novinsky Boulevard, in "an empty but chaotic" kitchen. Meyerhold and his first wife lived in the attic. Here Eisenstein sat almost literally at the master's feet: "His lectures were mirages and dreams. . . . I cannot remember what Meyerhold talked about—flavours, colours, sounds, a gold haze over everything. His lectures were like the songs of snakes—'whoever hears the songs forgets everything.'"[8] He received lessons on stage direction and biomechanics, acrobatics and puppetry. He watched in dumb amazement as Meyerhold used a Javanese puppet to perform part of an opera, followed by a scene from *The Government Inspector*. He was Meyerhold's keenest, most talented pupil, but therein lay the seed of unforeseen disaster: Meyerhold liked the company of people he could dominate but did not like to be challenged or addressed as an equal. At one session, Eisenstein spotted a concealed problem in the master's lecture and questioned him, only to be shocked when Meyerhold reacted with "an air of official politeness, a slightly derisive sympathy." Eisenstein was about to suffer the most painful rejection of his adult life—or, as he put it, he was "expelled from the Gates of Heaven!" by the "creative genius and treacherous personality" whom he had idolized.[9] It was a foretaste of what he would experience later in his relations with that political genius and treacherous personality Josif Stalin, who had recently been assigned the task of sorting out the chaotic Communist Party apparatus, under the unimpressive-sounding title of general secretary.

In March 1923, Eisenstein was appointed artistic director of Proletkult's touring company. His directorial debut was a production of *Enough Folly in Every Wise Man*, by the nineteenth-century playwright Alexander Ostrovsky, and with it he showed what he had learned from Meyerhold. He staged it in a circus arena, where clowns juggled, performed acrobatics, threw water at

one another, and put explosives under their seats. One actress had lamps for breasts, and they lit up when her character became excited. There were bad clowns, representing the counterrevolutionaries Lord Curzon and General Joffre, and good clowns. The cast of novices included Grisha Alexandrov and Yudif Glizer, who went on to a long career as one of the Soviet Union's leading actresses. The wild spectacle was compounded by a band playing a type of music unfamiliar to Russian ears, which Eisenstein had picked up in one of the new cafés that had sprung up during these relatively carefree years. It was jazz, imported from America. To perform it in a theater was "quite a daring thing in revolutionary Moscow," Eisenstein's young collaborator Sergei Yutkevich observed decades later.[10]

The critic Viktor Shklovsky watched bemused as "happy confusion reigned on the stage. Glizer climbed up a pole. Why? I guess because she was acting out the expression 'to kick against the pricks.' Then young Alexandrov walked the wire. In addition, a certain General Joffre took part in the performance. His name was announced in bold letters—twice!—on the actor's rear end, i.e. on his coloured trousers."[11] Lunacharsky, the people's commissar, watched with unconcealed alarm. This was not theater as he knew and approved it; yet these wild young players were committed supporters of the revolution, which the older performers were not. Also, unexpectedly, the audience loved it, principally because of an innovation that not even Meyerhold had ever thought of. The sequence opened with the lead character, Glumov (played by Alexandrov), coming onstage in a top hat and with a white face to complain that his diary had been stolen. Then curtains parted at the back of the stage, and the astonished audience was shown something most would never have seen before: a film. It was a surreal display of the contents of Glumov's diary, with Glumov wandering over rooftops, waving at passing airplanes, and flattering his patrons by turning into whatever they expected him to be: for General Joffre, he became a machine gun; for his doting aunt, he became a baby. Film being in short supply, exactly 120 meters had been used to shoot a sequence 120 meters long. The job was completed in a day. "Thus the theatre took a leap into the cinema, expanding metaphors to degrees of literalness unattainable in the theatre itself," Eisenstein claimed. "And this culminated in the final stroke: when the audience called for me, I did not come on stage to take my curtain-calls—instead I appeared on screen bowing like a peculiar version of the Pathé cockerel, with the shock of hair I affected in those days that was worthy of the Metro-Goldwyn-Mayer lion!"[12]

During 1921, the Bolsheviks had loosened their control of the economy and allowed a degree of private trading under what was termed the New Economic Policy (NEP). The main objective was to restore the ruptured economic links between town and country and to end the famine that followed the civil war, by allowing traders, or nepmen, to buy and sell farm produce. A side effect was that Russia's embryonic film industry returned to life. Old projectors and prints of foreign films were retrieved from their wartime hiding places, and tickets went on sale in the markets. Though the screenings were usually in old, often very dilapidated theaters, the audiences ignored the discomfort to escape from hardship into the world of Western silent movies. Hollywood stars such as Charlie Chaplin were becoming as popular in the big Russian cities as they were at home. It was a very profitable new industry and potentially a very powerful political tool. Film taken by an amateur Scandinavian cameraman in the famine-stricken Volga region in the winter of 1921 had been seen around the world, bringing in large sums of foreign aid. Lenin was quick to spot the political potential. He dictated a memo in January 1922 instructing that there was to be a register of all available films and that the cinemas should strike a balance between films shown purely for entertainment, which had to be free of pornography and counterrevolutionary content, and films with a political message, which "must be checked by old Marxists and writers" to avoid the all-too-common error of turning out propaganda that was so dire that it defeated its own purpose.[13] The following month, Lunacharsky was summoned to give a progress report. "You are reported to be a protector of art, so you must remember that of all the arts for us the most important is cinema," Lenin told him.[14]

By 1925, there were more than two thousand cinemas in the cities and nearly five hundred in villages, augmented by about five thousand traveling projectors. In the Arbat district of Moscow, Douglas Fairbanks had his name in electric letters three feet high; Mary Pickford was equally celebrated. Proceeds from ticket sales were used to finance an indigenous film industry.[15] Now it had money, audiences, and grandiose plans; it lacked only talented film directors committed to the Bolshevik cause. Goskino, the state cinema company, was planning a sequence of seven films that would tell the story of the revolution, from the beginning of the century up to the Bolshevik revolution. The only one that was ever shot was the fifth, which told the story of a strike. Initially, it was a script, written by the head of Proletkult, without a director.

Eisenstein had fallen out with Proletkult, as he fell out with every source of authority he ever encountered, but he now had three successful stage productions on his CV, two of which showed political commitment. He had marked the sixth anniversary of the Bolshevik revolution with a production of the emerging playwright Sergei Tretyakov's *Can You Hear Me, Moscow?*, which dealt with the recent revolutionary upheaval in Germany, and followed it with Tretyakov's *Gas Masks*, which was staged in the Moscow Gas Works for maximum realism. Goskino noted that Eisenstein was interested in cinema and risked hiring him to direct *Strike*. The cameraman was Eduard Tisse, who coincidentally had been in the audience on the night when Eisenstein's production of Ostrovsky almost ended in tragedy: Alexandrov fell off the high wire, knocking the metal support into the audience near where Tisse was sitting. Tisse combined superb technical ability with a gift for seemingly reading Eisenstein's mind. People who watched them collaborate—which they did on every film Eisenstein made—said that they scarcely exchanged a word, as if each knew what the other expected without having to speak.

Eisenstein put hours of research into *Strike*, interviewing former strikers and factory agitators and reading many texts, including Émile Zola's *Germinal*. During the shooting, he behaved exactly as Meyerhold would have done: making impossible demands on everybody, bringing his conception to life without the least thought for the expense or inconvenience involved. For one scene, he demanded a thousand extras, supplementing an already sizable troupe of professional actors, including Alexandrov, Glizer, and Maxim Straukh. In Eisenstein's words, *Strike* "brought collective and mass action onto the screen, in contrast to the individualism and the 'triangle' drama of the bourgeois cinema. . . . No screen had ever before reflected an image of collective action." The result was an uneasy contrast of styles: the workers were handsome, healthy young men with firm jaws married to handsome, strong-looking women. There are three identical fat capitalists, slow, clumsy, and greedy, led by a fourth who is clever and tall but has bad teeth. The police spies are identified by close-ups of eyes that are never still. In one surreal shot, the king of the underworld, who has been hired to help break the strike, whistles, and his dozens of shady associates emerge from rows of barrels sunk into the ground. The ending is a tragedy, a massacre of the workers and their families, intercut with graphic close-up shots of a bull having its throat cut.

While the film, first shown on February 1, 1925, was technically brilliant, its political message—to put it kindly—was a symptom of Eisenstein's blindness to reality. Russian factory workers had undeniably suffered harsh,

repressive conditions in 1912, the year in which the film was set, but any inference that their lot had improved by 1925 simply was not true. There was a dispute tearing the Communist Party apart in the wake of Lenin's death the previous year over whether to proceed rapidly with the industrialization of the Soviet Union or move slowly and allow living standards to recover from the destruction of war and civil war. The people's commissar for finance, Grigori Sokolnikov—then one of the leading voices for moderation—observed that wages in the metal industries, mines, and railways were still below their prewar level.[16] Any factory worker who saw Eisenstein's film in the year it came out therefore is likely to have been paid less in that year than when the film was set. Very soon real strikes coincidentally broke out again in real factories, and the head of the Moscow Communist Party issued a threat that any party member caught collaborating with the strikers would be expelled.

None of this affected the reception for Eisenstein's film, which was immediately recognized as the first masterpiece produced by the new industry, a film with a revolutionary message that could not have been made anywhere but in the USSR. *Pravda* correspondent Mikhail Koltsov hailed *Strike* as "the first revolutionary creation of our cinema." But success did not bring Eisenstein contentment. He had fallen into a petty dispute over the authorship of the *Strike* screenplay and was knocked back by a rejection in his personal life. He was probably not capable of entering a sexual relationship with a woman, but there was an actress whom he thought might be a suitable partner, if only he could muster the nerve to make an approach—and he was most upset when Grisha Alexandrov moved in first. Heaping one disaster upon another, his mother, Yulia Eisenstein, suddenly turned up in Moscow after fourteen years abroad, because her inherited wealth had dried up. He installed her in an apartment in Leningrad to keep her away from Moscow, but she would remain a tiresome presence in his life until her death in August 1946.

At least he was not short of work. Another project awaited a director, a script with the working title *The Year 1905*, written by an Old Bolshevik named N.F. Agadzhanova to mark the twentieth anniversary of the 1905 revolution, in which she had taken part. Eisenstein wrote, "Nune"—as he called her—"instilled in me a true sense of the historical revolutionary past. In conversations with her any typical episode of the past struggle became a 'reality' pulsing with life. . . . Nune was the first Bolshevik civilian I had met—all the others sat on military committees or were 'senior staff.' She was quite simply a human being."[17] Together they sketched out a scheme for an epic project in eight episodes, starting from Bloody Sunday, when tsarist troops fired on a

hunger march in Saint Petersburg, and ending with the workers' rising in Moscow being crushed. They began filming in Leningrad but were overtaken by two setbacks, both of which turned out to be disguised good luck. The cameraman objected to using cranes, wharves, and other innovations to get the angles Eisenstein wanted and so resigned. To Eisenstein's delight, Tisse took over. Then bad weather forced them to break off shooting, and an official from the industry suggested a move to Odessa, where they could work on an episode that included a short sequence depicting a naval mutiny aboard the battleship *Potemkin*. That short sequence would grow until it became the whole film, rupturing Eisenstein's relationship with Nune, who objected to his cavalier treatment of her script, but creating what in the view of many critics is the greatest silent movie ever made.

First, Eisenstein needed a boat, but almost all of imperial Russia's Black Sea Fleet was at the bottom of the sea, scuttled by the retreating White Army. He was offered the cruiser *Comintern*, but its quarterdeck and bridgehead were too narrow to be passed off convincingly as sections of a warship. Then his assistant director came upon an old battleship called *The Twelve Apostles*, anchored to the seabed in a remote inlet within the Sebastopol naval base. It was a wreck whose gun turrets, masts, flagstaffs, and captain's bridge had been lost to the waves, and its lower decks were being used to store live mines. The high surrounding cliffs would intrude on any camera shot, but then Eisenstein's resourceful assistant worked out a way to turn the wreck ninety degrees, with live mines rattling down below, so that its hull pointed toward the open sea. They used old admiralty blueprints to re-create the external features of the *Potemkin* with laths, girders, and sheets of plywood. With time running out, they could not delay long enough to unload the lower decks and had to work at speed, at perpetual risk of being blown to pieces by the live mines rolling around in the hold, beneath the disapproving eye of a supervisor named Glazastikov, whose name was derived from the adjective *glazastyi*, meaning "pop-eyed" or "sharp-eyed," and who, in Eisenstein's opinion, was "more terrible than the mines."[18]

Next, Eisenstein needed a cast. Five professional actors had accompanied him to Odessa. The many other parts were filled by whomever they could find. An old gardener with a white beard was pulled in to play a priest. The boilermaker from the Sebastopol hotel where they were staying was a small, skinny type; Eisenstein was looking at him idly, thinking how unappealing he was, and suddenly saw him in the role of the ship's medical orderly, in a

famous scene in which he examines the infested meat that the sailors are required to eat and sees no maggots.

As Eisenstein scoured Odessa for interesting locations, he had a lucky find in the gardens of the Alupka Palace. He saw six stone lions on the palace steps, all in different poses, and decided to film them. The shots were taken, Eisenstein recalled, over the protests of a park keeper "in down-at-heel boots and baggy trousers. . . . We ran from lion to lion with our camera and so confused this severe and abiding guardian of the peace that he finally shook his fist at us and left us to take close-ups of three of the marble beasts."[19] From this came the famous montage in which a stone lion seems to rear up in outrage at the brutality of the tsar's troops.

Finally, there were the Odessa steps, which Eisenstein elevated into one of the most famous flights of stairs in the world. He implied in his memoirs that the entire scene of mass panic, with a crowd fleeing down the stone steps as troops fired on them, came to him spontaneously, though this conflicts with the recollections of Maxim Straukh:

> I remember very well the night he came back in enormous excitement from the Lenin Library in Moscow to the flat we shared at that time. He carried a copy of a magazine published in Paris, called *L'Illustration*, which contained an article about the mutiny, and included a drawing of the famous scene on the steps of Odessa. What happened on those steps—or rather what did *not* happen, for historically the scene is extremely dubious—seemed to Eisenstein to have all the potentialities of a sequence that on a single location could summarize so much of what he wanted to say in his film. So as soon as we were all established in Odessa, his very first professional act was to go out and see the steps for himself.[20]

Others who have visited those steps have been mystified by what Eisenstein saw there. There are only 120, though the editing gives the impression that there are hundreds—an effect achieved by using several cameras simultaneously, with techniques devised by Tisse that had never been used in cinema before. One camera was on a specially built trolley covering the length of the steps; another was strapped to the waist of a circus acrobat, who ran, tumbled, and jumped down the steps with the rest of the crowd. That crowd consisted of hundreds of extras, commanded by the five professionals, including Straukh and Alexandrov, known by then as the Iron Five.

The Battleship Potemkin was every bit as brilliant technically as *Strike* and equally blind to the reality of Soviet life. A recent naval revolt had cost many more lives than the *Potemkin* mutiny. Early in 1921, the crew of the battleship *Petropavlovsk* on the Kronstadt naval base called a mass meeting and passed a resolution calling for new elections to the soviets, free speech, independent trade unions, the release of all political prisoners, and the dissolution of the armed detachments that were confiscating grain to feed the towns. Other ships in Kronstadt joined the action. The Bolsheviks treated this as counterrevolution and sent in the Red Army. The official death toll was over five hundred, with more than four thousand injured, but the real figures have been put at ten thousand killed in the fighting, plus two thousand rebels executed after they had surrendered and hundreds more sent to Solovki Prison, where most died.[21] Another eight thousand fled to Finland. By contrast, the death toll from the *Potemkin* mutiny was perhaps ten officers killed during the revolt, seven mutineers executed afterward, and fifty-four imprisoned, while about six hundred took refuge in Romania.[22] But, because Kronstadt had been a revolt against Bolshevik rule, there could be no question of it being commemorated in Soviet cinemas.

Working at a phenomenal rate, Eisenstein had *Potemkin* ready for a private showing at the Bolshoi Theatre on December 21, 1925. A public premiere in Arbat Square followed four weeks later. The initial reaction was a letdown. In Russia, the film played to half-empty theaters; a war-weary public preferred escapist dreams from Hollywood. The Soviet government was keen to export its movies and had created a new company, Sovkino, for that purpose, but Sovkino's president, an Old Bolshevik named Konstantin Shvedshikov, assumed that capitalist distributors would not buy propaganda films. He put *Potemkin* in the "morgue." Fortunately one person who did see it was the poet Vladimir Mayakovsky, who marched straight from the auditorium to Shvedshikov's office. Waclaw Solski, a Polish communist working for Sovkino, witnessed what followed:

> Shvedshikov was a Soviet bureaucrat with pronounced bourgeois habits. He didn't know anything about the movies, but he liked the products Hollywood sent to Moscow in the hope of finding a Russian market. Sovkino bought very few American films, but Shvedshikov used to spend hours enjoying them in his private projection room, and the more banal the movie, the better he liked it. He was also slightly anti-Semitic, and he didn't like Eisenstein, whom, in private conversation, he used to call "The Nobleman of Jerusalem."

Mayakovsky took the floor first. He talked, as usual, in a thunderous voice, pounding the table with his fists and rapping on the floor with the heavy cane he always carried at that time. He demanded that Shvedshikov immediately export *Potemkin* and told him he would go down in history as a villain if he did not. Several times, Shvedshikov tried to get a word in, but in vain. Nobody ever could say anything when Mayakovsky spoke. The climax of his speech was rather dramatic. Having finished, he turned to go.

"Are you through?" Shvedshikov asked. "If you are, I would like to say a few words myself."

Mayakovsky paused in the doorway and replied with great dignity: "I'm not through yet and I won't be for at least five hundred years. Shvedshikovs come and go, but art remains. Remember that!"

With that, he left.[23]

Potemkin was sent to Berlin, where it was a sensation. Soon it was showing at seven cinemas in that one city. It provoked a debate in the Reichstag after an anxious deputy, taken in by Eisenstein and Tisse's clever editing, believed that the Soviet navy really had as many warships as there appeared to be on-screen. The Berlin audience included Douglas Fairbanks and Mary Pickford, who were touring Europe. Fairbanks was captivated, and the couple traveled to Moscow to shake the hand of the film's twenty-seven-year-old creator. In Britain and France, the film was banned from cinemas but caused a sensation in the private clubs that screened it. It crossed to the United States, where it was banned in Pennsylvania for fear that it might inspire American sailors to mutiny but was eventually shown in New York; afterward it traveled south to Mexico and Buenos Aires. A copy was smuggled illegally into Madrid. Charlie Chaplin judged it to be the "best film in the world." David O. Selznick, an associate producer at MGM, wrote to a colleague recommending that the company consider finding projects for Eisenstein. He wrote, "The film has no characters in an individual sense; it has not one studio set; yet it is gripping beyond words—its vivid and realistic reproduction of a bit of history being far more interesting than any film of fiction; and this is simply because of the genius of its production and direction."[24] It made a deep impression even on people who disliked it. "The motion pictures of the twenties— like the theater—remain the chief symbol of a flourishing cultural life in those days," Nadezhda Mandelstam recalled in old age. "The cinema means the famous Odessa steps with the child's baby carriage . . . [and] maggots wriggling in a piece of rotten meat. Future generations will marvel at the

wealth of detail and the poverty of ideas in these films. Perhaps ideas are not needed in films, but these, as propaganda productions, had pretensions to them—which only brings out even more their underlying cruelty. I particularly remember that sadistic baby carriage teetering down the steps."[25]

Eisenstein's next project was to have been a film on China, with a screenplay by Tretyakov, but a dispute about the party line on China remained unresolved. Instead he was assigned to make a film about agriculture, provisionally titled *The General Line*; preparations were interrupted, however, when the party decided that commemorating the tenth anniversary of the Bolshevik revolution took precedence. Eisenstein assembled 2,800 extras to re-create the storming of the Winter Palace. Afterward, an elderly porter grumbled that they had done more damage than during the original attack. For one of the crowd scenes, Eisenstein dipped into his own recollections of 1917 and instructed actors to drop umbrellas and other items as they fled. Unfortunately, the cast included some tidy-minded steelworkers, who helpfully picked up the dropped items as they ran. The shot could not be repeated because it had involved closing one of Leningrad's busiest streets for the day, but it looked so realistic that a still from the film was reproduced in numerous books in the belief that it was a genuine photograph taken in 1917.

The finished film, titled *October 1917*, did not repeat the critical success of *Potemkin*. Viktor Shklovsky attended a private viewing with Vsevolod Pudovkin, one of the few cinema directors Eisenstein respected as a rival, and wrote, "The cinematographers gathered in the room gasped in amazement. Yet, disappointment showed on their faces, too. They went away happy, all right, but still they found fault with Eisenstein. I was walking arm in arm with the young Pudovkin when I heard him say enviously: 'I would give an arm or a leg for such a magnificent failure.'"[26] Shklovsky agreed that, for all its stunning effects, the film did not hang together as well as *Potemkin*. Lunacharsky praised it, but Mayakovsky was "disgusted" by the depiction of Lenin, who "resembled not Lenin, but a statue of Lenin."[27] Mayakovsky's friend Osip Brik complained that Eisenstein "forced someone who looked like Lenin to play the role of Lenin" with "disgracefully false" results.[28] Later, Eisenstein conceded that the film had not worked but was an object lesson in "how one's *idées fixes* should, or should not, be treated."[29]

It also hit a problem more ominous than any of its artistic failings. It was one of several films scheduled for release on November 7, 1927, the tenth anniversary of the revolution. One rival production had Stalin, Nikolai Bukharin, and other luminaries in its cast, playing themselves. Eisenstein had sensibly

used actors but, with startling naïveté, had the various historic characters faithfully replicate the roles they actually played in 1917. Just as the film was due for release, the factional warfare within the Communist Party was coming to a head. Fights broke out during the anniversary celebrations, and a shot was fired at Trotsky's car by a drunken policeman. The Fifteenth Party Congress duly blamed the troubles on the Trotskyites and expelled several dozen from the party along with Trotsky himself, who was exiled to Kazakhstan. He had been chairman of the Petrograd Soviet and the man who actually had directed operations on the night the Bolsheviks seized power—facts that had not yet been removed from the records when Eisenstein began filming. Rival directors scented that history needed to be revised in line with where the power lay, but Eisenstein apparently did not. Three films were released in November, but not his. This caused some wild rumors in Moscow, including one that Eisenstein and Alexandrov had joined the opposition. Eisenstein published a disclaimer in the newspaper *Kino* at the end of the month, blaming the delay on the work involved in producing what he said was to be a two-part film totaling four thousand meters in length. When *October* had its belated premiere, in March 1928, it was a one-part film, measuring a little over two thousand seven hundred meters.[30]

The truth was more dramatic. One evening, in Eisenstein's absence, his studio was visited by a man no more than five foot six, with one arm shorter than the other, pigeon-toed, modestly dressed in a party tunic and baggy trousers, and whose face, beneath thick black hair and marked by a childhood bout of smallpox, "radiated the graceful strength of the mountain-men of the Caucasus."[31] It was Stalin. He was not yet the terrifying dictator that he would be within a decade—he did not yet have the power to have anyone he chose taken away to be tortured and killed without explanation—but he already was in the process of assuming the mantle of infallibility. A vital part of this process involved revisiting and falsifying the history of the Bolshevik Party. In the revised version, Lenin became the first infallible leader, all of whose struggles had been a contest between truth and falsehood. Anyone who had ever opposed Lenin, with very rare exceptions, was now marked as being either malicious or steeped irredeemably in error. The most important carrier of ideological error was Leon Trotsky, who had opposed Lenin for fourteen years, until 1917, and had clashed with him again in 1920. The difficult period for the new Stalin school of history was in between, when Trotsky had been Lenin's greatest ally; hence the visit from the general secretary.

There is no record of the conversation, but it is likely that in this, his first direct intervention in the arts, Stalin deployed the rough charm and patience that he could display with great self-control when it suited him. One observer who saw Stalin close-up—and lived to tell of it—remembered watching him being accosted at a meeting by an excitable, voluble minor functionary: "What held my attention and made me remember the scene was Stalin's amazing patience. He struck me as an ideal listener. He was on the verge of departing, had one foot on the edge of the stairs, yet he stood there for almost an hour, calm, unhurried, attentive, as though he had all the time in the world to give up to this agitated little clerk."[32]

Even if Stalin was at his most genial, it was fortunate for Eisenstein that he was not present when Stalin dropped by, for the occasion might have been too heavy a test of his acceptance of a rule that he once recorded in his diary: "Our cinema is a weapon, first and foremost, to be used to combat hostile ideology."[33] He might have made the fatal mistake of arguing in defense of his creation. Instead he reputedly confided his frustrated reaction to his diary, a section later destroyed by his widow. It can be deduced that Stalin demanded changes in the film, claiming that it was historically inaccurate. In the final version, Trotsky's name is mentioned just once, in a context implying that he was obstructing the Bolsheviks' preparations to seize power. And it was presumably upon seeing the original rushes that Stalin formed the suspicion that Eisenstein was a covert Trotskyite, although he kept that opinion to himself for the time being.

But it should not be thought that the young Eisenstein was a persecuted artist. He was by any standards a very privileged young man, one whom the Soviet system presented with opportunities that he would not have found anywhere else. He was, to quote Shklovsky, "completely a product of Soviet collectivist reality [who] sprang up on the general front of Left art."[34]

Life in Russia improved slowly but measurably between 1921 and the end of the decade. Tram cars ran on time. Food and other consumer goods were on sale again. About a quarter of Moscow's shops were run by private owners. Goods sold privately were more expensive than those sold by state competitors because of high taxes, but everybody with money, including high-ranking communists, shopped in the private stores, consulted private doctors and private dentists, hired private photographers, and ate in private restaurants. A new casino opened on Moscow's Tverskaya Street, near where prostitutes plied their trade outside the public baths.

Moscow's greatest social problem was overcrowding. The city's population had increased by hundreds of thousands without any corresponding rise in available housing, but Eisenstein was cushioned even against this. The success of *Potemkin* allowed him to move out of his single room into a two-room apartment and decorate it according to his own taste. Shklovsky was vividly impressed by the furniture and decor, which included a "flat, very broad bed with armour netting . . . a seven-branched silver candelabra the size of a man, [and] life-size wooden statues of the apostles stared at you from a corner." There were Mexican rugs, bookshelves painted in white oil, and walls covered with prints of photographs of ancient churches, while "in the niches beneath the ceiling of a baroque, church angels pressed their carved wings against the cornice. With their many eyes, they looked down from a variety of angles on the ten-eyed telephone dial . . . [and] from a carved gilded frame on the wall jutted out half a globe in relief like a portrait of our hemisphere. Another globe circled by the moon hung on the ceiling next to the chandelier."[35]

Eisenstein's interrupted film about rural life still had to be completed. After a long search for a peasant woman to be its star, they finally came upon an illiterate young woman named Marfa Lapkina whose striking face was exactly right and who was persuaded with some difficulty to be filmed. A film crew was an alien presence in a village. One day, twenty young girls who had acted as extras in a wedding scene were ordered by their mothers not to return to work—someone had started a rumor that the camera could photograph them naked through their clothes.

While Eisenstein and Alexandrov were on location, one of the most terrible crises of the twentieth century was just beginning. In January 1928, the Politburo was informed that there was a grain shortage once again. A good harvest in 1926 had lulled the leadership into believing that the wartime food shortages were a thing of the past, but the factories were not producing enough goods that peasants felt they needed, and the peasants had learned from experience that if they hoarded grain, they got a better price when scarcity took hold. Having completed his defeat of Trotsky, Stalin was now pushing for rapid industrialization, which would be severely set back if grain became more expensive.[36] He gave orders for thirty thousand activists recruited from the towns to go out and seize the grain by force. The delicate trading relationship between town and city that had taken more than six years to build was ruptured. So was the uneasy alliance between Stalin and the party's lead

ideologist, Nikolai Bukharin, who was horrified by his discovery that Stalin was "a Genghis Khan" who would "ruin the whole revolution."[37] These sentiments were shared at all levels of the party, but unlike the Left opposition, the Right never openly organized itself to challenge Stalin, thinking they could work within the system instead.

None of these events cast a shadow over the idyllic picture of rural life in Eisenstein's last silent movie, *The General Line*. The crew was back in Moscow in spring 1929, the montages completed, and Eisenstein and Alexandrov were lecturing to film students when they were told that Stalin was on the telephone. To their surprise and delight, the general secretary was calling, with apologies for interrupting their work, to ask whether it would be "convenient" for them to drop by his office at two o'clock the following afternoon.

An American journalist who secured an interview with Stalin some months after Eisenstein and Alexandrov's visit recalled the awe-inspiring experience of finding the normally impenetrable entrance to the six-story Central Committee building just inside the ancient Kremlin wall suddenly open and welcoming. After being led by a guard to the "quiet, orderly, unhurried but efficient" anteroom of the reclusive dictator's office, where half a dozen others were waiting, and being told by an "amiable" woman secretary to go on through to the enormous office, Stalin met him at the door with a pleasant handshake.[38] The two excited young Russians would have gone through a similar experience before being admitted on the stroke of two. As usual when he was meeting an outsider, Stalin took the precaution of having two of his coterie with him, in this case his deputy Vyacheslav Molotov and Kliment Voroshilov, the people's commissar for war. Alexandrov later wrote an account of this meeting that was published while Stalin was alive, so we should not be surprised that its tone is one of breathless reverence. "We were greeted warmly and kindly," he wrote. "An unconstrained discussion followed. With great sensitivity Josif Vissarionovich gave us his critical comments on *The General Line*. Then he went on to the general question of film art."

Stalin lectured them on the importance of Soviet cinema at home and abroad. People who did not know a word of Russian, nor had ever read a book published in the Soviet Union, were crowding into cinemas to watch *Potemkin*. He exhorted, "You film-makers can't imagine what responsible work is in your hands. Take serious note of every act, every word of your heroes. Remember that your work will be judged by millions of people. You should not invent images and events while sitting in your office. You must take them from life—learn from life. Let life teach you!"[39]

That advice did not inspire the pair to soar to new artistic heights. Released at the end of 1929 as *Old and New* after Stalin objected that the title *The General Line* made it sound too authoritative, it was the least successful of all Eisenstein's completed films. Its most celebrated scene showed peasants watching a demonstration of a machine that separated cream from milk; though it was intended as a celebration of industrial progress's power to enrich the lives of the rural poor, its homoerotic climax, in which "the milk hovers for a moment in the spout of the cream-separator before it gushes out, producing fountains of thick, white substance," resembles a scene from *The Naked Gun*.[40]

But if Alexandrov's account is accurate, Stalin prophesized with impressive accuracy that the influence of film would "increase enormously" when sound was added. At the time that he made these remarks (if he made them), Hollywood's first sound movie was less than two years old, and leading directors were resisting an innovation they felt might cheapen their art. Back in August 1928, Eisenstein, Pudovkin, and Alexandrov had issued a joint statement warning that "sound is a double-edged invention and its most probable application will be along the line of least resistance, i.e., in the field of the satisfaction of simple curiosity."[41]

Sound was on the way, whatever they thought, and the film industry was slowing down to reequip itself. While that was happening, Eisenstein was given permission to go abroad. He, Alexandrov, and Tisse set off in August 1929 to see Europe's capitals and then to seek their fortune in Hollywood. The three young Russians must have felt that the world lay at their feet, when actually Eisenstein's troubles were about to begin.

2

The Hooligan Poet and the Proletarians

This is a most interesting piece of work. A peculiar brand of communism. It's hooligan communism.

—VLADIMIR LENIN

While Eisenstein was wandering about lost in the upheaval of 1917, the poet Vladimir Mayakovsky was having the time of his life. This "mighty and big-striding animal—physically more like a trained-down prize fighter than a poet—and with a bold shout and dominating wit and nerves of leather" was soaking up the excitement and letting Petrograd know that a true artist does not hide: he goes out and is disruptive, defiant, and fearless.[1] On the street, he spotted the editor of an anti-Semitic journal and slapped him. He turned up at a banquet hosted by Russia's leading liberal politician, Pavel Milyukov, the minister for foreign affairs, at which the French ambassador was the guest of honor. Mayakovsky strutted through the hall, taking food off other guests' plates, and when the minister rose to propose a toast he, according to future Nobel laureate Ivan Bunin, "jumped up on a chair and began to yell something so obscene that the minister froze to the spot. [Milyukov] immediately got hold of himself and again proclaimed 'Ladies and Gentlemen!' But Mayakovsky yelled something even fouler than before."[2] The minister made one more failed attempt to speak, and then the French ambassador rose to his feet, but Mayakovsky only became rowdier. To the disgusted Bunin, this was the exhibitionist behavior of an overgrown hooligan. To Mayakovsky, it was a fusion of revolutionary politics and performance art.

Mayakovsky has become a Moscow landmark. The metro's Mayakovsky Station opens onto Triumphal Square, in which stands an immense statue of the poet. It was not commissioned by lovers of good literature but put there in obedience to a diktat from Stalin, who never showed any interest in Mayakovsky while he was alive but, in December 1935, five years after he was dead, suddenly pronounced, "Mayakovsky was and remains the best and most talented poet of our epoch. Indifference to his memory is a crime." After that, every Soviet schoolchild had to memorize the agitprop stanzas that Mayakovsky wrote in praise of Lenin, or on the joy of holding a Soviet passport, or generally on why a poet should be a propagandist.

There was nothing remarkable in Stalin anointing himself the nation's number one poetry critic, since by 1935 he was on the way to becoming the Soviet Union's final authority in every field of human knowledge, but his choice of Mayakovsky as the poet laureate of the revolution was not without irony. Mayakovsky was not only a radical in politics but also a leader of a movement that proposed to destroy all outdated art forms and find a new artistic language for revolutionary times. His tragedy was that almost all the Bolsheviks, with whom he identified, were conservative in their artistic tastes: they wanted art that was revolutionary in content but traditional in form. Eisenstein was able to experiment in his early films because the Bolsheviks had no preconceived idea of how films should be made. This was not true of poetry, drama, or art. By struggling to get the Bolsheviks to acknowledge the avant-garde as the art form of the revolution, Mayakovsky was doomed to endless frustration—a contributory cause of the despair that led to his suicide.

He joined the Bolsheviks in Moscow in 1908, during the stagnant period after the suppression of the 1905 revolution. Aged only fifteen, he was arrested for possessing illegal literature, freed on probation, caught a second time, and interned in Moscow's Butyrki Prison, where the harassed governor was soon complaining of the difficulty of controlling this giant schoolboy. "Mayakovsky incites other prisoners to disobedience," he said in a memo to his superiors. "He insistently demands of the guard free access to all cells, purporting to be the prisoners' spokesman; whenever he is let out of his cell to go to the lavatory or washroom, he stays out of his cell for half an hour, parading up and down the corridor. Mayakovsky does not pay attention to any of my requests concerning order."[3] This wild behavior earned him a long period of solitary confinement in cell 103, which he remembered as a time of peace spent immersed in books from the prison library. "Love is something I learnt in Butyrki. I fell in love with the keyhole to cell 103,"[4] he recalled.

In the 1920s, Mayakovsky was criticized for abandoning revolutionary politics after his release. His answer was that he would never have found his true creative voice if he had had "to spend all my life writing leaflets, interpreting thoughts taken from books that were right but not composed by me."[5] Viktor Shklovsky, a sympathetic observer, thought that there was another explanation: "People remember Mayakovsky as a conqueror. They talk about how he resisted in prison, and that is true. Vladimir Mayakovsky was an exceedingly strong man. He was, however, sixteen years old. The boy was kept in solitary for five months. He came out of prison shattered."[6]

Mayakovsky was manifestly unfit for work in the revolutionary underground, which required the skill to agitate without being noticed. His massive physique would have made it almost impossible for him to pass unnoticed by police spies even if he had behaved with more discretion. That also would have been difficult for him, because his extroverted behavior was a cover for shyness. He was profoundly alone. His first poetry collection, published at his own expense in 1913, ended with the lines:

I'm as lonely as the eye
Of the one-eyed man in the valley of the blind.[7]

Alexander Pasternak, Boris's younger brother, was a classmate of Mayakovsky's and attributed this loneliness to the trauma of his father's sudden death when he was twelve years old and to his widowed mother's decision to move to Moscow, plunging the grieving young boy from rural Georgia into a school full of sophisticated young Muscovites. On one notable occasion, though, he momentarily came out of his shell when a child was being bullied in the playground. "At the top of his deep bass voice, Mayakovsky ordered this victimization to stop at once. The bully ignored him, and Mayakovsky immediately attacked him with such cold-blooded decisiveness that the coward bolted," Pasternak recalled.[8]

After prison, he enrolled in the Moscow School of Painting, Sculpture and Architecture, where his talent was spotted by David Burliuk, an abstract painter from a wealthy Cossack family who was drawn into a ferocious argument with "a tall, uncombed and unwashed young man with a face of an Apache" during a visit to the school.[9] Mayakovsky, who was then eighteen, and Burliuk, who was twenty-nine, met for a second time at a concert, where they discovered that they both despised Sergei Rachmaninov, Russia's foremost living composer. Mayakovsky later claimed that during this conversa-

tion he thought up a few lines of poetry, which he wrote down and showed to the older man. "You wrote it yourself? You're a genius!" Burliuk exclaimed. "That evening, quite unexpectedly, I became a poet," wrote Mayakovsky. "The very next morning Burliuk, introducing me to someone, said in his characteristic bass, 'You don't know him? My friend, a genius, the noted poet, Mayakovsky.' I motioned him to stop, but Burliuk went relentlessly on."[10]

The story may have improved with the telling, but there is no doubt that this encounter was effectively the start of the artistic movement known later as Russian Futurism. Its adherents announced themselves in December 1912 with a manifesto titled *A Slap in the Face of Public Taste*, in which they proclaimed, "We alone are the image of our time. . . . Pushkin, Dostoyevsky, Tolstoy etc., etc. must be thrown overboard. . . . All those Maxim Gorkys, Bloks . . . etc. etc. need only villas on a river bank. . . . From the height of skyscrapers we look down on their littleness."[11]

These young iconoclasts then made it their mission to take art into the streets. Outrageously dressed, they assembled on Moscow's Kamensky Bridge and walked slowly up and down, reciting poetry. They invaded restaurants, cafés, theaters, railway stations—anywhere they could provoke a reaction. The star of these performances was the teenage Mayakovsky, with his huge physique, powerful voice, compelling verse, and a shocking new yellow tunic made by his indulgent mother and sisters. The police judged that the yellow tunic was a threat to public order and tried unsuccessfully to ban him from wearing it in public.

It was all a pose. Mayakovsky revered Tolstoy and was reading *Anna Karenina* on the day he was released from prison. In August 1921, Mayakovsky was shocked to learn of the premature death of Alexander Blok, the greatest of the turn-of-the-century Russian poets. "Some still cannot free themselves from the spell of his poetry . . . but all remember Blok with equal affection," he wrote.[12] His first meeting with Gorky, in 1915, was a study in mutual respect. "There really is no Futurism, there's just Mayakovsky—a poet of great caliber," Gorky proclaimed, though later they fell out and stayed on bad terms for the rest of Mayakovsky's life.[13] The reason, reputedly, was that Gorky was shocked by Mayakovsky's views on sex, though the younger man's proclaimed promiscuity was yet another pose: he was actually shy and not very successful with women.

Similarly, Mayakovsky's friend and mentor Burliuk claimed to despise all visual art except what was then the most modern form of abstract painting, and yet Burliuk's tutor at the Moscow School of Painting, Leonid Pasternak (father of Boris and Alexander), noted contemptuously how his pupil would hurry

back from delivering a philippic against artists of previous generations to resume learning how to draw from life. "Some people mistook what was happening for something of a revolutionary nature, whereas these 'currents' in art were of a purely bourgeois and snobbish character," Pasternak senior reckoned.[14]

Mayakovsky's dirty appearance was another pose, and Burliuk was not the only one to note it. Ivan Bunin described Mayakovsky in 1917 as being dressed "just like those poorly shaven people who live in wretched hotel rooms and use public latrines in the morning."[15] In fact, he was morbidly careful about personal hygiene because his father, who had been a woodcutter, had died from blood poisoning. He was afraid of the slightest scratch; he was constantly washing his hands; he would never drink from someone else's glass or eat from someone else's plate; outside his home he would try not to touch door handles; and he would walk long distances rather than take public transport, where he might touch another person's hands.[16]

That was not his only pose. Boris Pasternak, who emerged in 1913 as Mayakovsky's main rival on the Moscow poetry circuit, observed, "If he was handsome, witty, talented, perhaps supertalented, that was not the main thing about him. The main thing was his innate iron self-control, a kind of inherited principle of nobility, a feeling of duty which did not permit him to be less handsome, less witty, less talented."[17] In a separate recollection, Pasternak explained, "He chose the pose of external integrity—the hardest of all for an artist. He kept up this pose so completely that it is hardly possible to give the characteristics of its inmost secret."[18]

When the Bolsheviks took power in November 1917, Anatoli Lunacharsky, the people's commissar for enlightenment, booked a hall and sent out 120 invitations to writers and other cultural figures to gather and show support for the new regime. The hall turned out to be more than the event required—a large sofa would have sufficed. Five invitees put themselves at risk by showing support for a regime that might collapse any day, though what they lacked in numbers they made up in quality, because they included Mayakovsky, Vsevolod Meyerhold, and Blok. Mayakovsky expected Lunacharsky to respond by recognizing avant-garde art as the art of the revolution and to heed his advice on such matters as the future of Russia's museums. But an expert on antiques named A. Benoit hesitated for only a few days before offering his services, which Lunacharsky gratefully accepted, whereupon Mayakovsky took umbrage and left Petrograd for Moscow.

There he rejoined the old crowd to launch the Poets Café, where artists and young Bolsheviks mingled in congenial company on a sawdust floor while

poets and other performers, including the young composer Sergei Prokofiev, took to the stage. The scene was crowded and often rowdy. One evening it was invaded by anarchists led by a handsome ruffian called Guido, bedecked in jewels and rings, with two pistols in his belt and accompanied by a cabaret singer they shoved onstage, though he was too drunk to perform. When Mayakovsky ejected him from the stage and began a poetry recital, Guido brandished a gun. Violence was averted by the fortuitous presence of a company of Red Guards.[19]

As a sideline, Mayakovsky took up filmmaking. Seven years before Eisenstein's first film, he had directed three in quick succession. The third, a fantasy about a ballerina, was written especially for a woman named Lili Brik, who traveled to Moscow in May 1918 to appear in it. Before the revolution, Mayakovsky had had a brief affair with Lili's sister, Ella Kagan (later well known in France as the writer and communist Elsa Triolet), but then fell madly, obsessively in love with Lili—"a very beautiful woman with large hazel brown eyes," according to one male contemporary.[20]

Osip Brik, a successful businessman turned communist, was strangely tolerant as Mayakovsky bombarded Lili with love poetry, which Pasternak thought was some of his finest work but the recipient found quite tiresome. "Volodya didn't simply fall in love with me. He attacked me, I was under attack. For two and a half years I didn't have a single minute's peace," she complained.[21] Superficially, they were a mismatched pair: the educated, married woman and her wild suitor from Georgia. Bengt Jangfeldt, a Swedish scholar who knew Lili Brik, observed that their correspondence "gives ample evidence of the difference in their educations: Lil Brik's letters are orthographically correct, whereas Mayakovsky's are full of spelling and other mistakes."[22] Under her influence, he had his hair cut and discarded that yellow jacket, while under his influence she broke off sexual relations with her husband, who may have been a repressed homosexual. According to Lili's account, however, it was not until she joined Mayakovksy for the filmmaking venture that they became lovers.

They returned to Petrograd together in June, and Mayakovsky moved into a flat in the Briks' house on Zhukovsky Street. Later, all three moved into three rooms in Levashovo, outside Petrograd. They settled permanently in Moscow in March 1919, reestablishing their unusual three-person household, which became a literary salon and the headquarters of the movement for avantgarde art. A friend also arranged for Mayakovsky to have a study in Lubyansky Passage, which he retained for the rest of his life. The study is where he

kept a gun that he had acquired during his brief period as a filmmaker and that he would one day use on himself.

His hyperactive mind had moved meanwhile to another new medium. Lunacharsky and Meyerhold (who was now a Communist Party member) wanted to mark the first anniversary of the Bolshevik revolution with a new stage production but were lost for a suitable script until Mayakovsky turned up with *Mystery Bouffe*, a retelling in verse of the story of the ark in which seven "pure" couples—including a Russian merchant, a Chinese emperor, and a priest—escaped to the only land left dry by the deluge of revolution, built an ark, raved about finding Ararat, and received a sermon from a simple man who walks on water, who promises a paradise on earth in which "you don't tire your hands in vain toil—work blossoms like a rose in your hand." Meyerhold loved it. Lunacharsky came to the Briks' apartment to hear it read by the author and put aside any reservations he may have had about its departure from the realism of Anton Chekhov to order that it be produced. Finding professional actors and theater hands to work on an avant-garde communist drama proved so difficult that the project was nearly aborted, but it was eventually performed for three nights, to mixed reactions, at the Petrograd Conservatoire, with settings and costumes designed by the Suprematist painter Kazimir Malevich and with Mayakovsky playing the lead role.

Next, he threw himself into work at the Russian Telegraphic Agency, Rosta, where a little group of artists turned out colorful propaganda posters with rhyming captions, sometimes at a rate of fifty posters in a night. Between October 1920 and February 1922, Mayakovsky made two thousand drawings and 280 posters. He also persisted in his lonely struggle to try to produce poetry that suited the times. Early in the civil war, he wrote "Order No. 1 to the Army of the Arts," followed in 1921 by "Order No. 2," poems that instructed poets to stop writing and artists to stop painting because the times demanded action:

I,
a genius—or non-genius,
having given up trifles,
and working in Rosta,
say to you
before they drive you away with rifle butts
give it up![23]

He did not, of course, do as he exhorted others to do. During most of 1919 and 1920, in addition to the hours he put into Rosta, he labored on an epic poem titled *150,000,000*, a parable of the revolution in which the symbolic figure of Ivan arose to combat the grotesque Woodrow Wilson. Mayakovsky intended to publish it anonymously, using the conceit that Russia's 150 million–strong population had spoken through him. In fact, not only was he recognized as the poem's author, but also its publication proved to be a turning point in his life. On the downside, it severely tested his friendship with Boris Pasternak, who judged it to be crude propaganda: "For the first time, I had nothing to say to him. Many years went by . . . we tried to work together and I found myself understanding him less and less."[24] But the work won an early endorsement from the poet and critic Valeri Bryusov, who had been an important figure on the literary circuit before the revolution and had since joined the Communist Party, becoming the deputy director of the literary department of the People's Commissariat for Enlightenment. Despite the shortage of paper, Bryusov wrote to Gosizdat, the state publishing house, insisting that *150,000,000* be published with a large print run.

Even in its infancy and before the rise of Stalin, the Soviet state was micromanaged from the Kremlin. A report reached Lenin's desk that precious paper that could have been used for political propaganda was being wasted on a poem. The chairman of the Council of People's Commissars took a stern, ascetic view of modern culture not because he lacked the education and intellect to appreciate great art—when he went into exile in Siberia, he had taken a copy of Goethe's *Faust* in the original German—but because he disapproved of its effect on the will. "I can't listen to music very often," he once told Maxim Gorky after listening to a Beethoven sonata. "It affects your nerves, makes you want to say stupid, nice things, and stroke the heads of these beings who could create such beauty while living in this filthy hell. But today you mustn't stroke anyone's head. . . . You have to hit them on the head."[25] And even when he permitted himself to enjoy art, his tastes were rooted in the previous century. Lenin admired Pushkin and Tolstoy but suffered an excruciating experience as Russia's new ruler when seated in the front row of a benefit performance for the Red Army. According to his wife, Nadezhda Krupskaya, an actress "declaiming something by Mayakovsky—*Speed is our body and the drum is our heart*—was gesturing right in front of Ilych, who was taken aback by the suddenness of it all. He grasped very little of the recitation and heaved a sigh of relief when [she] was replaced by another

actor who began to read Chekhov."[26] He vented his opinion of Maya-
kovsky later, when talking to Maxim Gorky: "He shouts, invents some
sort of distorted words, and doesn't get anywhere in my opinion—and be-
sides is incomprehensible. It is all disconnected, difficult to read."[27] Gorky,
who had completely broken with Mayakovsky by then, is unlikely to have
disagreed. When Lenin discovered that Gosizdat was proposing a print run
of five thousand for Mayakovsky's latest work, he sent Lunacharsky a memo
telling him that he deserved to be whipped. Lunacharsky's weak reply was
that he did not like the poem either, but Bryusov had wanted to print twenty
thousand copies. Lenin fired off another note to Lunacharsky's deputy
Mikhail Pokrovsky, demanding that the run be reduced to fifteen hundred.

It was fortunate for Mayakovsky that in the early days of Soviet rule there
were some rudimentary checks on arbitrary power—all of which would be
extinguished under Stalin—because, once the word was out that Lenin dis-
approved of Mayakovsky, others decided to harass him. When officials at Go-
sizdat discovered in September 1921 that the entire script of *Mystery Bouffe*
had been published in a magazine called *Vestnik Teatra* (Theater herald), they
ordered its editor not to pay Mayakovsky any fee. He complained to the Mos-
cow Trade Union Council, which ordered that Mayakovsky be paid and
suspended the union membership of the three officials involved for six months.
Scandalously, one of the three was a venerable Old Bolshevik named Ivan
Skvortsov-Stepanov, who had joined the revolutionary movement before
Mayakovsky was born and had been a member of the original Council of
People's Commissars formed on the day of the Bolshevik revolution. The out-
come so outraged *Pravda*'s correspondent Lev Sosnovsky that he called for a
ban on all Mayakovsky's writings and all the propaganda posters he and other
Futurists had produced for Rosta.[28]

Then Mayakovsky's roller-coaster career had another sudden change. Lenin
and Krupskaya visited a students' hostel and were taken aback to discover that
these fanatical young communists, who were ready to die for the revolution,
were also avid fans of Mayakovsky. Lenin promised to think again. He read
150,000,000 and told an astonished official from Gosizdat: "You know, this
is a most interesting piece of work . . . a peculiar brand of communism.
It's hooligan communism."[29] The editor in chief of *Izvestya*, Yuri Steklov,
was another Old Bolshevik whose mind was closed to Mayakovsky's work,
but during one of his days off, in March 1922, a younger editor ran a Maya-
kovsky poem that poked fun at communists who had become addicted to
meetings and debates. Lenin read it as he was preparing a speech to the an-

nual Metal Workers' Congress and told the union representatives, "I am not an admirer of his poetical talent, although I admit that I am not a competent judge. But I have not for a long time read anything on politics and administration with so much pleasure as I read this."[30] With those words, Mayakovsky's troubles with publishers were over. For the remainder of his turbulent life, nothing that he wrote for publication was ever banned. Though he was loath to acknowledge it, his place as a member of the new postrevolutionary elite was secure.

The end of the civil war brought a period of relative calm and optimism. The French-born anarchist Victor Serge, who had left Russia in disgust at the massacre of the Kronstadt sailors in 1921, came back and noted that the country "was returning to life . . . people were no longer hungry and a brisk pace of living was in evidence everywhere. The terror had ceased, without being formally abolished, and everyone tried hard to forget the nightmare of arrests and executions. A new literature was bursting out. . . . It was miraculous!"[31]

Miraculous perhaps, but for Mayakovsky it was also deeply frustrating. The new literature was different from the old in content but not in form. The new writers who celebrated the revolution used a realistic style copied from Tolstoy, Chekhov, and Gorky. Some were actually not new but prerevolutionary writers such as Alexei Tolstoy, an aristocrat's son, and the peripatetic novelist and journalist Ilya Ehrenburg, who had sat out the civil war in Berlin, who were now coming back and adapting to the times. Meanwhile, the avant-garde, which Mayakovsky stubbornly believed to be the true artistic voice of the revolution, was in rapid decline. Victor Khlebnikov, the only Futurist poet with a reputation to rival Mayakovsky's, died in June 1922. David Burliuk emigrated permanently in 1920. Russia's greatest abstract painters, Vasili Kandinsky and Marc Chagall, soon followed. Chagall had welcomed the revolution and marked its first anniversary by decorating the public buildings in his native Vitebsk with gloriously colored murals, which did not impress the local Bolshevik authorities at all. "Why is the cow green and why is the horse flying in the sky? What has it got to do with Marx and Lenin?" he was asked.[32]

Of those who remained in Russia, Kazimir Malevich, who believed in "pure painting" that abandoned all links with given reality, and the constructivist Vladimir Tatlin, who called for artworks constructed from "real materials in real space," loathed one another so intensely that they had a fistfight during the first Futurist exhibition in Petrograd in 1915. Tatlin designed one of the world's most famous unbuilt buildings. It was commissioned to mark the

anniversary of the founding of the Communist International and was to have been the Comintern's world headquarters in Petrograd. Tatlin planned an edifice twice the height of the Empire State Building, made of glass and supported by an iron framework, consisting of a cylinder, a cone, and a cube. The cylinder, in which all lectures, conferences, and Comintern congresses were to be held, would revolve on its axis once a year; the cone, which would accommodate the executive offices, would revolve once a month; and the cube, containing the information center, once a day. The world will never know whether Tatlin's tower would have been robust enough to support its own immense weight, had there been enough steel and other materials to build it in war-ravaged Russia. It exists only as a model in the Tretyakov Gallery in Moscow.

Undiscouraged, Mayakovsky decided to reassemble the old Futurist crowd, along with some new allies, in a movement that he hoped would achieve due recognition for avant-garde poetry, drama, and visual art. The first edition of the magazine *LEF* came out in March 1923 with Mayakovsky as "responsible editor." Osip Brik, who had taken the precaution of becoming a dues-paying communist, lent his apartment for use as an editorial office. Other contributors included the poet Nikolai Aseyev, who survived the Stalin years and tirelessly defended Mayakosky's reputation long after he was dead; the poet Semyon Kirsanov, who lived largely in Mayakovsky's shadow; the playwright Sergei Tretyakov, whose play *Can You Hear Me, Moscow?* was about to go into production under Eisenstein's direction; and the critic Viktor Shklovsky, recently returned from Berlin. *LEF* boasted that avant-garde artists had created "the first art objects in the October era (Tatlin—the monument to the Third International, *Mystery-Bouffe* in Meyerhold's production)," while the old artistic establishment had "set the dogs on avant-garde art." The magazine also pronounced what Ilya Ehrenburg described as a "death sentence on art": "painters were advised to deal with the aesthetics of machines, textiles, and objects of domestic use in place of easel painting; theatrical producers were told to arrange popular fetes and demonstrations and to say goodbye to footlights; poets were told to abandon lyric poetry and to compose inscriptions on posters and slogans instead."[33] Mayakovsky was, as usual, gloriously inconsistent about applying his own rules to himself. His main contribution to the first issue was a lyrical love poem, "About These," written for Lili Brik when they were reunited after a three-month trial separation.

Mayakovsky's real tragedy was that almost nobody cared. There was a fierce debate raging about the future of art in the USSR, but it had nothing to do

with the questions of form that preoccupied *LEF*. It was the conflict between "proletarian" and "bourgeois" art, which dominated the literary scene until Stalin put a stop to it in 1932.

The proletarian art movement, which inflicted so much grief on the Soviet Union's finest writers during the 1920s, was not a product of the Communist Party machine but grew from the explosion of hope brought on by the collapse of the old order. Thousands of young workers who aspired to something better than the factory floor's monotonous routine invested their hopes in Proletkult, an independent organization founded by a talented ex-Bolshevik named Alexander Bogdanov that ran workshops in literature, music, and art. By August 1920, its membership had swelled to four hundred thousand, but it was an organization of producers with too few consumers and whose members would rather sneak off to a recital by Mayakovsky than stay to listen to their comrades. Lenin knew Bogdanov and was wary of him, and he dispatched a high-powered team to take control of Proletkult. The Proletkult that hired the young Eisenstein in 1921 had become an arm of the state.

There was, however, a political logic to what Bogdanov had set out to do, which was picked up by less intelligent and less talented individuals inside the party. Early capitalism had inspired a revolution in the arts at the time of the Renaissance; therefore, the end of capitalism—which is what the Bolsheviks believed their revolution heralded—ought to be the occasion for another cultural explosion, in which "bourgeois" art would be swept away by the art of the proletariat. After Proletkult came a succession of groups dedicated to promoting proletarian culture, none of which made the mistake of trying to work outside the Communist Party. The first was VAPP, the All-Russian Association of Proletarian Writers, which by 1923 had about three thousand members and ran its own publication, *Na postu* (At your post). Unlike Mayakovsky and the tiny group around *LEF*, the petty officials who ran VAPP were not interested in experimenting with new forms of art—all that mattered to them was the class origins of published writers. "The *Na Postu* group abused everybody—Alexei Tolstoy and Mayakovsky, Akhmatova," Ilya Ehrenburg observed.[34]

Though VAPP was founded and led by middle-ranking communists, it never had the authority of the Communist Party behind it. Most of the Bolshevik high command were too busy to care about what form the art of the revolution should take, but there was one outstanding exception. Once the civil war was over, the people's commissar for war, Leon Trotsky—seemingly the second most powerful figure in the communist hierarchy after Lenin—took

time out to write an entire book about postrevolutionary Russian literature. He noted, as a matter of hard fact, that not a single writer of note had yet emerged from the industrial proletariat, with the arguable exception of VAPP's prize exhibit, a communist poet named Demyan Bedny. He concluded that proletarian art was no more than a "promissory note."

Another Old Bolshevik, Alexander Voronsky, had none of Trotsky's political authority but did have a profound love of literature, and he took the same line. He had embarked on an ambitious attempt to revive the thick literary journals through which Russian literature had flourished in the nineteenth century. He founded and edited a magazine with an attractive Russian title, *Krasnaya nov* (it translates awkwardly as "Red virgin soil"), each edition running around three hundred pages, packed with stories and articles by contributors selected for their ability to write. Many of those writers made lasting contributions to Russian literature, but none, to the fury of VAPP, was a factory worker.

In January 1924, when Lenin died, even small-time communists like the leaders of VAPP could see that Trotsky was losing the Kremlin power struggle to the new triumvirate of Stalin, Lev Kamenev, and Grigori Zinoviev. Though the reasons for Trotsky's eclipse had nothing to do with his ideas on literature, his literary opponents seized the moment to try to get the party to intervene in their favor. They succeeded to the extent that the Central Committee convened a two-day seminar on literature but then, to VAPP's dismay, allowed Trotsky to be the main speaker. It was a rowdy meeting, during which Trotsky was heckled. "You won't deny that Shakespeare and Byron somehow speak to your soul and mine," he argued, whereupon a young novelist named Yuri Libedinsky retorted that they would not do so for much longer.[35]

There was only one writer of any real stature who sided with the "proletarians" in this dispute, and that was the ever-contrary Mayakovsky. He did so despite being attacked by VAPP—in whose eyes he did not count as a "proletarian" writer though he was a laborer's son and despite the support he received from Trotsky and Voronsky. An entire chapter of Trotsky's book, published separately in *Pravda* in September 1923, was devoted to Futurism. In it he praised Mayakovsky's talent, energy, and courage, though he considered him too bohemian and ultraleft to be a true communist. Voronsky singled out Mayakovsky's poem "About These" as "a wonderfully sincere, talented poem" and campaigned for his collected works to be published when the poet was still having trouble with Gosizdat.[36] Yet Mayakovsky's obsession

with the idea that the art of the revolution had to be revolutionary in form led him to the bizarre conclusion that he and his friends in *LEF* were natural allies of the ideologues who ran VAPP. He invited their leaders to a meeting at the Briks' apartment early in 1923. They were represented by Libedinsky, a critic named Semyon Rodov who had recently converted from Zionism to communism, and a youth named Leopold Averbakh, who was only twenty years old but very soon would loom large in the field of literary politics. Rodov demanded that *LEF* cease to publish anything by Pasternak or Shklovsky but capitulated in the face of a flat refusal from Mayakovsky, because the visitors needed Mayakovsky's prestige and popularity more than he needed them. The five participants drafted an agreement, published in August 1923, to work together to "steadfastly unmask the bourgeois-gentry and pseudo-sympathetic literary groups and promulgate their own principles of class artistry."[37]

Mayakovsky left Russia in May 1925 and was gone for six months, traveling across Europe, then by boat to Mexico, Chicago, and New York, where, despite his devotion to Lili Brik, he had an affair with a Russian expatriate named Ellie Jones that resulted in the birth of his only known child, a girl who grew up to be a professor of women's studies named Patricia Thompson.

During the four-week journey back by boat, in November 1925, he wrote "Back Home," which includes the lines:

> I wish
> > that Gosplan was in a sweat
> > > debating
> how to give me
> > a year's assignments.
> I wish
> > that standing over tomorrow's thoughts
> > > was a commissar
> bearing a decree.

He had not been back long before the entire literary world was talking about Sergei Yesenin, a wild character who remains one of Russia's favorite poets. Yesenin had written a poem in his own blood titled "Goodbye, Dear Friend" and the following morning, on December 27, 1925, hanged himself in his hotel room in Leningrad. Though Mayakovsky recognized the dead poet's talent, he had not approved of Yesenin while he was alive and did not approve

of the manner of his death. "Why increase the number of suicides?" he asked in his 1926 poem "Sergei Yesenin." "Better to increase the output of ink. . . . In this life, dying is not hard. To make life is truly difficult."[38]

By now, his stated wish to have commissars standing over tomorrow's thoughts was perilously close to fulfillment. Trotsky had been stripped of his office, and Stalin—of whom Mayakovsky knew nothing—had emerged as the sole master of the Communist Party. There had also been an upheaval in VAPP: some leaders had made the error of siding with Zinoviev when he fell out with Stalin. VAPP was disbanded and replaced by what would prove to be a more formidable substitute, RAPP, headed by Leopold Averbakh, who was so young that his generation would be running the Soviet Union until the second half of the 1980s. Averbakh, who possessed the "hairless head of the young senior official, the verbal fluency of a Congress demagogue, and the dominating false-sincere eyes of a manipulator of meetings," compensated for his youth by having exceptionally good family connections, including a brother-in-law, Genrikh Yagoda, who was effectively the head of the secret police.[39]

If Mayakovsky felt any kind of bond with the disgraced ex-leaders of VAPP or gratitude to Trotsky, who had praised him so generously, he put such feelings aside. He dutifully amended "Back Home" to include the lines:

> I want
> the pen and the bayonet
> to be treated the same.
> As with pig iron
> and steel smelting
> so with the manufacturing of verse
> The Politburo
> should receive
> Stalin's report.[40]

LEF had folded while he was abroad, but in January 1927 the first issue of its successor, *New LEF*, went on sale, with the same mission: to advance avant-garde art by identifying it with Bolshevism. In February, the *New LEF* group applied to be admitted to the Federation of Associations of Soviet Writers, a shell organization founded and dominated by RAPP.

Mayakovsky also revived his mission to bring poetry to the people by appearing in a series of public recitals. During one he was given a salutary

insight into the people he thought were his natural allies. Two representatives of RAPP turned up at a meeting organized by *New LEF* where Mayakovsky read aloud a new poem he had written to celebrate the tenth anniversary of the Bolshevik revolution. Most of the audience, including Lunacharsky, loved it. Averbakh, sly and wary, kept his comments to a minimum, leaving his comrade, a young writer named Alexander Fadeyev, to speak out against it, only to be shouted down.

Soon a pattern developed that at each of Mayakovsky's public performances, someone would attack him for alleged political failings. "The gangsters from Averbakh's lot loved it when someone insulted Mayakovsky," his friend Vasili Katanyan claimed. "They were a little afraid of him, did not risk open combat with him, but could not of course resist an opportunity to kick him with somebody else's boot."[41]

Harassed as a poet, he returned to his other trade as a playwright and wrote what became his best-known work for the stage, *The Bedbug*, which premiered on February 13, 1929. The first half was a grotesque satire of the new post-revolutionary bourgeoisie, which was politically acceptable when the New Economic Policy that had created this new merchant class was about to be violently destroyed by Stalin. To emphasize its political relevance, the characters were dressed in ugly contemporary clothes bought in local markets. The second half was set in 1979, the communist future in which everyone's life belongs to the collective and all excesses such as vodka, tobacco, dancing, and sex have been eliminated. Into this world is projected the most vulgar character from the play's first half, who wanders about in this paradise, loveless and lost, recognizing nothing except a bedbug that has survived with him. In this character, Mayakovsky parodied himself, even tutoring the actor in his mannerisms. Despite a lukewarm reception from critics, the play was popular enough to remain in production until a month after Mayakovsky's suicide. It was revived in the Soviet Union to great acclaim two years after Stalin's death.

This play, like his previous one, was directed by Meyerhold, who decided that it required incidental music and turned to a young piano player who worked for his theater. The youth was only twenty-two, shy and studious behind large spectacles, and took his calling seriously, having already written a symphony, an opera, and a ballet. Unfortunately, there was something about him that brought out the worst in Mayakovsky, who would not even shake his hand and ordered him to write something that sounded like the music played by a firemen's band. If the critics were ambiguous about the play,

they were unanimous in their view that the music was awful, and the humiliated composer, whose name was Dmitri Shostakovich, resolved never to work with Mayakovsky again.

When the play appeared, Mayakovsky's mind was elsewhere. During a visit to Paris, he had fallen desperately in love with an eighteen-year-old White Russian émigré named Tatyana Yakovleva. She inspired at least two poems that he wrote in the latter part of 1928. He rushed back to Paris, hoping to persuade her to come to Moscow with him, but she refused. Later in 1929, she married a Frenchman. That he had fallen in love with someone so hostile to the revolution can be read as evidence that Mayakovsky was beginning to feel the regime closing in on him, but he fought back in style with another play, *The Bathhouse*, again directed by Meyerhold, which was even more savage in its attack on the new bureaucrats than *The Bedbug*. The censors ordered cuts even before rehearsals were under way, and after the opening night in January 1930 Mayakovsky was attacked with a savagery he had never experienced before.

This was a time when every writer in the Soviet Union lived in fear of the young Averbakh and his associates, who spoke with clear and confident authority and exercised real power in a way that their predecessor organizations had not. While Stalin was engrossed in defeating one rival after another inside the Kremlin, it was as if the Stalinist faction had granted RAPP the franchise to represent their interests on the artistic front. Reviewing a short story by Andrei Platonov, in 1929, Averbakh declared, "There is ambiguity in it. . . . Our era does not tolerate any ambiguity."[42] They had destroyed their principal rival, Voronsky, who had treated them with disdain, apparently assuming that his years of exile and hardship in the Bolshevik underground would protect him from young upstarts who had joined the party only for self-advancement after the revolution. But RAPP cleverly targeted his most vulnerable point, his friendship with Trotsky, moving in for the kill after Trotsky was banished to Kazakhstan in 1928. Voronsky had published a book, known in English as *Art as the Cognition of Life*, setting out his belief that the "imaginative" part of literature existed independently of party thought. RAPP denounced him on the ground that "he did not so much pursue 'his own' line as write cowardly commentaries on somebody else's."[43] The implication was clear: Voronsky was not a literary scholar but a covert Trotskyite, smuggling Trotskyite ideology into cultural policy. This put the onus on Voronsky to protect himself by denouncing Trotsky, which he honorably refused to do, perhaps hoping that Stalin would agree that competing theories about art were

separate from the issues that had torn apart the Communist Party. But Stalin did not recognize neutrality in his feud with Trotsky, and Voronsky was expelled from the party in February 1928 and subsequently arrested.

In February 1930, Mayakovsky meekly turned up at a conference of RAPP, asking to be allowed to join. The RAPPists scarcely knew how to react. They knew that Mayakovsky would be trouble for them, but they did not want to turn away the most famous writer ever to apply for membership in their organization. "Mayakovsky is suitable material for RAPP," Fadeyev announced to the conference. "As regards his political views, he has proved his affinity with the proletariat. This does not mean, however, that we are admitting Mayakovsky with all his theoretical background. We will admit him to the degree to which he gets rid of that background. We will help him in this."[44]

"Mayakovsky sought friends, but there were no friends for him in RAPP," Viktor Shklovsky observed.[45] Mayakovsky seems to have imagined that he had a friend in a young critic and RAPP member named Vladimir Yermilov, whom he had met some years earlier. In summer 1927, when Mayakovsky was on vacation in Yalta, Lili Brik wrote from Moscow and mentioned that "Yermilov sends his regards."[46] This man would cast his poisonous influence on Soviet literature for forty years; Solzhenitsyn used his name in *The Gulag Archipelago* as a collective noun for the neo-Stalinists who continued to deny that innocent people were arrested in Stalin's time.

Instead of siding with Mayakovsky, Yermilov led RAPP's attack on *The Bathhouse* with all the authority of a twenty-three-year-old who had not seen the play but had read part of the script. "There is no doubt that we hear a false 'leftist' note in Mayakovsky, a note which we know not only from literature,"[47] he declared in an article that originally appeared in RAPP's in-house journal but was given wider importance in March 1930, when it was republished in *Pravda*. Readers would have understood what was being hinted: to accuse Mayakovsky of being "leftist" in a way "we know not only from literature" was to imply that he was a quasi-Trotskyite, in a year when Trotskyites were being rounded up and sent into exile or prison. Mayakovsky retaliated by creating a huge poster with a four-line slogan declaring that there were not enough bathhouses to wash out all the bureaucrats who were aided by the pen of critics like Yermilov and displayed it in the Meyerhold theater. Yermilov protested, and RAPP ordered that the poster be taken down. One of Mayakovsky's last thoughts, set out in his suicide note, was his regret that he gave in.

Though it was humiliating that a poet of his stature should have to defer to an upstart, the incident did not affect Mayakovsky's formal status as a

highly privileged citizen. He now owned an imported Renault, an extra-ordinary luxury for the times. Some people who knew but did not like him thought him well suited to adapt to the Stalinist era; his friend Nikolai Aseyev also prospered. Shostakovich was quoted as saying, "Mayakovsky epitomized all the traits of character I detest—phoneyness, love of self-advertisement, lust for the good life, and most important, contempt for the weak and servil-ity before the strong. Mayakovsky was not a citizen, he was a lackey."[48] Ivan Bunin had reached a similar conclusion as early as 1917: "Lenin and Maya-kovsky were both gluttonous and extremely powerful in their political narrow-mindedness. At one time everyone looked upon them as little more than street clowns. Not for nothing was Mayakovsky called a Futurist, that is, a man of the future."[49]

But neither Bunin nor Shostakovich was as close to Mayakovsky as Boris Pasternak, who terminated their friendship out of disgust at Mayakovsky's political behavior. Yet in 1936, when Pasternak was visited by the French writer André Gide, who had deduced from Soviet propaganda that Stalin and Mayakovsky were political soul mates, he argued on his ex-friend's behalf. "What do you think Mayakovsky died from—the flu? Come on!" Pasternak exclaimed, despite the risk that his remarks would be overheard and reported to the police (as indeed they were, which is why we can now be grateful to the police spy for recording his thoughts). "We can't know how Mayakovsky and Stalin would have got on with one another if Mayakovsky were still alive," Pasternak added. "Perhaps he would be in exile by now. Times have changed. His battle against mediocrity and hypocrisy would get nowhere now."[50]

Mayakovsky gave his last public recital on April 9 and was heckled again. He was finding hostile reactions increasingly difficult to take. He feared for his powerful voice. He had had no voice training when young, and so many public appearances had strained his vocal cords. He must also have had a fore-boding that he had made a terrible mistake about the regime in which he had invested such loyalty. A recent recruit to *New LEF* was a twenty-eight-year-old writer named Vladimir Sillov, whom Boris Pasternak considered to be the only "honest, vital and honourable" member of the group.[51] In March 1930, the OGPU raided Sillov's apartment, uncovered a diary con-taining derogatory remarks about Stalin, took him away, and had him shot.

Mayakovsky spent April 11, 1930, on the telephone repairing relations with his acolyte Aseyev, who was so angry with him for joining RAPP that they had not spoken for two months. That evening, he failed to turn up to a po-

etry reading. When challenged, he claimed not to have been told about it. In fact, he had begun a new affair with a young actress named Nora Polonskaya and had spent the evening with her, her husband, and Aseyev. Lili and Osip Brik were absent because they were on a trip to Europe. On April 14, they sailed from London to Amsterdam, where Lili sent Mayakovsky a cheery postcard bearing a picture of a field of hyacinths in bloom and the message "Volosik! It's absolutely great the way the flowers grow here! Real carpets—tulips, hyacinths and narcissi. We kiss your little muzzles. Lilya Osya. Whatever you turn to, everything Dutch is terribly indecent!"[52] As Lili was writing this amiable nonsense, Moscow's telephones reverberated with the news that Russia's most famous poet was dead.

Mayakovsky had been behaving strangely the night before, when he and Nora visited the writer Valentin Katayev. The lovers were writing notes to each other all evening on torn shreds of paper. At three a.m., as they were leaving, Mayakovsky spoke briefly to Katayev, addressing him in the second-person singular, which he had never done before, and admonishing him not to be sad. In the morning, Mayakovsky took a telephone call from another acolyte, the poet Semyon Kirsanov, who had also taken offense when Mayakovsky joined RAPP. Mayakovsky suggested that they meet at his tailor's the following day. But his mood turned strange again when it was time for Nora to go to work. He demanded that she stay, which was unfair of him; her employers at the Moscow Art Theatre were not going to be impressed with an actress who missed rehearsals because of boyfriend trouble, even if the boyfriend was the legendary Mayakovsky. She left the apartment around ten fifteen a.m. and had taken only a few steps when she heard the sound of a gunshot. Her legs gave way, and she began shouting and raving in the corridor, unable to face going back to see the horror within.

In Mayakovsky's papers there was a suicide note written two days earlier and a twelve-line poem titled "Uzhe vtoroi" (Past one o'clock). "Do not charge anyone with responsibility for my death and, please, do not gossip. The deceased very much disliked gossip," he pleaded. In addition to a short statement of his financial affairs, there was also a footnote asking, "Comrade RAPPists, do not charge me with lack of character. Seriously, there is nothing to be done. Goodbye. Tell Yermilov . . . we should have completed the argument."[53]

The flat where the dead man lay was soon crowded with friends and mourners, including Boris Pasternak, who, with typical understated courage, arrived arm in arm with Vladimir Sillov's young widow, venturing out for the

first time since her husband's execution. Mayakovsky "lay on his side, his face turned towards the wall, somber, tall, a sheet covering him to the chin, his mouth half open as in sleep," Pasternak recalled. "Turning proudly away from us all, even when he was lying down, even in his sleep, he was going away from us in a stubborn endeavor to reach something."[54] Another witness, Emma Gerstein, recalled, "He lay on a table, straight and light, with a face bathed by death, and—despite the arresting sight of his heavy, iron-heeled boots—he appeared to be flying."[55]

This cross section of Moscow's literary community paying its final respects included none of Mayakovsky's new comrades from RAPP. "They stayed at home, conferring and preparing a resolution," Shklovsky wrote.[56] RAPP's first public comment was made through the one person in its coterie with any stature as a writer, the poet Demyan Bedny. "Monstrous—incomprehensible," Bedny wrote in RAPP's journal *Literaturnaya gazeta* a few days later. "The tragedy of his so unexpected end is heightened by its triviality, which is completely out of tune with the questing and original nature of Mayakovsky. And this ghastly letter before his death which is so ghastly in its triviality—what sort of justification is this? . . . I cannot explain this except as a sudden mental collapse, a loss of inner orientation, a morbid crisis of personal experience, and acute psychosis."[57]

To their relief the line held. The official verdict was that Mayakovsky's suicide was a private act unconnected with his public position. Stalin, ever patient, would find a way to deal with RAPP later. For a long time, middle-ranking officials assumed that Mayakovsky was to be forgotten. Though the popularity of his poetry increased after his death, and Lili Brik stayed stalwartly loyal to her former lover's memory, building a collection of his papers and battling to save his last apartment from being torn down, she met nothing but obstruction until, in desperation, she wrote to Stalin on November 29, 1935, complaining that officialdom was blind to Mayakovsky's "immense significance, propaganda role [and] revolutionary relevance."[58] It suddenly transpired that Mayakovsky had an appreciative reader in the Kremlin after all. Stalin passed Brik's note down the line with instructions that the bureaucratic obstacles in her way were to be removed, adding the comment—which appeared in *Literaturnaya gazeta* a few days later—that "Mayakovsky was and is the best and most talented poet of our Soviet era. Indifference to his memory and works is a crime."

That was Stalin's only known pronouncement on the subject of Mayakovsky's poetry, but once was enough. From thereon, Boris Pasternak ob-

served, Mayakovsky was "propagated compulsorily, like potatoes in the reign of Catherine the Great."[59] Pasternak feared that such enforced acclaim would ultimately destroy Mayakovksy as a poet—he called it his "second death." Actually, after he ceased to be force-fed to every Soviet schoolchild, he was rediscovered as a voice of rebellion. On July 19, 2013, there was a ceremonial poetry reading under Mayakovsky's statue in Moscow's Triumphal Square, where dissidents had risked arrest in the early 1960s by holding unauthorized poetry readings. The event opened with a speech by the seventy-seven-year-old poet Yevgeny Rein, who startled his audience by declaring, "I agree with Comrade Stalin! Mayakovsky was and will remain the greatest, most talented poet of our era, and indifference to his memory is a crime!"[60]

3

The Master

Anyone who writes satire in the USSR is questioning the Soviet system.

—MIKHAIL BULGAKOV

Four days after Mayakovsky's suicide, Mikhail Bulgakov was roused from an afternoon nap by a telephone caller claiming to be from the Central Committee. Bulgakov suspected a prank and was not amused. He had no contacts at any level of the Communist Party, let alone the Central Committee; he was so isolated that ten months earlier, in July 1929, he had addressed a despairing letter to Stalin: "I am turning to you to request you to intercede with the Government of the USSR to ask them to EXPEL ME FROM THE USSR TOGETHER WITH MY WIFE L.Ye.BULGAKOVA, who joins me in this request."[1] When that was ignored, he repeated the demand in a much longer letter, dated March 28, 1930. Disheveled and annoyed, he dragged himself to the phone.

"Mikhail Afanasevich Bulgakov?"

"Yes, yes."

"Comrade Stalin will speak to you now."

"What Stalin, Stalin?"

But the first voice did not reply; in its place there was another, with a Georgian accent. If this was a joke, it was becoming dangerous. The second voice said, "Yes. This is Stalin speaking. Greetings, Comrade Bulgakov—or Mikhail Afanasevich, if I remember correctly."

"Greetings, Josif Vissarionovich."

"We received your letter. I have read it, with the comrades. You will receive a favorable reply. And perhaps it's true: there is nothing for you here. Have we treated you that badly?"

Bewildered, Bulgakov took his time before replying. "I have been thinking about that a lot," he eventually said, "whether a Russian writer can really live outside his own country, and it seems to me that he can't."

"You're right. I think so too. Where do you want to work? In the Art Theatre?"

Not many years ago Bulgakov's plays had filled the seats of the Moscow Art Theatre (MAT), but now his work was suppressed and he was unemployed.

"Yes, that's what I wanted, but I spoke to them and they turned me down."

"But send them a job application. I have a feeling they will agree. We must meet and have a talk."

"Yes, yes, Josif Vissarionovich. I really need to talk to you."

"Yes, we must definitely find time to meet. And now, I wish you all the best."[2]

The call was over. Bulgakov immediately dialed the Kremlin to check that the conversation had been genuine. It was. Further confirmation came in the form of a summons to meet Felix Kon, an elderly Pole who had survived twenty years in Siberia under the tsars to become head of the arts section at the People's Commissariat for Enlightenment, who assured Bulgakov that the regime would not want him to emigrate. Asked what he would like to be doing, Bulgakov repeated that he wanted to work in the MAT. Stalin had said that he had a "feeling" that the theater would be willing to employ him and, hey—Stalin was right. Bulgakov was taken on as a director.

The 1920s were a decade of comparative freedom that Russia would not experience again until near the end of the century, and Mikhail Bulgakov was one of the most unlikely beneficiaries. As early as September 1924, Leopold Averbakh denounced him in *Izvestya* as a writer "who doesn't pretend to disguise himself as a fellow traveler," which was accurate enough. Bulgakov came from monarchist stock: his two brothers had emigrated after fighting in the White Army. The novel and play that made him famous depicted the family lives of White officers; his other writings included scathing satires of Soviet life. Even the way he dressed resembled an open challenge, as E. Mindlin, who worked with him on the newspaper *On the Eve*, recalled:

Things we couldn't get, like the dazzlingly fresh collars, hard as plaster-of-Paris, and the carefully knotted tie, a suit that was not modish but finely tailored, the pressed crease in the trousers, the special forms of address to his interlocutors and the appending of old-fashioned particles like the ending "sir," as in "if you please, sir," the kissing of women's hands, and the almost regal ceremony of his bows—absolutely everything made him stand out in our society and environment; and also, of course, the long, fur coat, in which he came, full of dignity, to the editorial office, invariably holding his hands inside the sleeves![3]

That did not slow Bulgakov's sudden rise to fame and wealth during the mid-1920s, but by 1929 Anatoli Lunacharsky, the people's commissar who had kept a benevolent watch over Russian culture, had been sacked and replaced by a minor functionary with no known interest in the arts. Mayakovsky's death was a terrible warning to any writer who thought it was possible to manage without political protection, and Bulgakov had none. All four of his stage plays and all his prose works were suppressed. He could not even earn a living, until suddenly one telephone call changed his life. It can be assumed that when he arrived to begin his new job at the MAT, he was followed everywhere by the envious stares of his new colleagues, all wondering what it was like to hear Stalin's voice over the telephone.

Bulgakov would never have achieved success as a writer in his home country if the Bolsheviks had been in a stronger position at the end of the civil war. He was a product of the New Economic Policy (NEP), the great retreat that enabled small businesses to start up independently of the state. It was also Bulgakov's good fortune that the MAT, one of the greatest theaters in the world, was going through an identity crisis. The MAT was the joint creation of two strange personalities: Konstantin Stanislavsky, who devised the system known as method acting—introduced to Hollywood by James Dean and Marlon Brando half a century later—and Vladimir Nemirovich-Danchenko, who in 1898 took the daring step of putting on a production of *The Seagull* by Anton Chekhov, which had had only a short, disastrous run in Saint Petersburg. The leading roles went to Olga Knipper, Chekhov's future wife, and Meyerhold, who became the MAT's most famous prodigal son. The production brought Russian drama into a new century.

A quarter of a century later, the MAT, still under its renowned dual leadership, continued to thrive, despite having lost its original aristocratic and upper-middle-class audiences. An American journalist posted to Moscow by United Press skeptically observed that "those citadels of snobbery in all lands,

ballet and opera, had fallen to the masses. High admission prices, even with reductions to trade-union members, still barred the lowest categories of labor. Nevertheless, the greater part of these audiences would have gone through life without seeing a first-rate play, let alone a ballet or opera, had it not been for the revolution."[4] Stanislavsky fretted that these new audiences had to be taught "how to sit quietly, how not to talk, how to come into the theatre at the proper time, not to smoke, not to eat nuts in public, not to bring food into the theatre and eat it there, to dress in his best so as to fit more into the atmosphere of beauty."[5] He was so enraged by their behavior during one performance that he stepped out in front of the curtain and delivered a stentorian lecture, after which the stalls went quiet. But Stanislavsky had no cause to complain about the numbers: a thousand people a night crammed in to watch a revival of *The Cherry Orchard*. Consequently, with the arrival of the NEP, the theater had no difficulty reprivatizing itself and living off box office receipts. Because the audiences were new, they did not know that the theater had developed a kind of artistic sclerosis, with the same aging actors and actresses performing the same parts in the same repertoire that had been on offer since the turn of the century. But the management knew and was casting about for new writers.

The NEP also allowed small, privately owned magazines to compete with the state-controlled press. There is a vivid picture of a little enterprise of this kind in Bulgakov's autobiographical novel, published in English as *Black Snow*, in which Ilya Rudolfi, editor of a fictional magazine, *The Motherland*, bursts uninvited into the narrator's room, dressed in a beret "planted jauntily over one ear," an overcoat, and shiny blue galoshes, and with an "imperious nose," "beetling eyebrows," and a black beard that gives him a resemblance to Mephistopheles. Later, the narrator discovers that "Rudolfi had everything: intelligence, flair, even a certain erudition, but he lacked just one thing—money" but would do "anything, at no matter what cost, to publish his famous magazine."[6]

The person being lampooned—unfairly, no doubt—was an enterprising character named Isai Lezhnev, who had launched a publication in 1922 called *Novaya Rossiya* (New Russia), which professed to be politically neutral and was an outlet for writers who had avoided taking sides during the civil war. When it folded, Lezhnev started it up again under the title *Rossiya*. In summer 1923, Bulgakov offered him his first story, "Diaboliada," which Lezhnev turned down. It appeared in a rival journal in February 1924. If we take Bulgakov's fictional account as being approximately true, it would appear that Lezhnev suddenly realized that he had missed out and, having heard gossip

that Bulgakov was working on a full-length novel, turned up in the cold little room that served as the writer's place of residence to read the manuscript.

This was the novel known to English-language readers as *The White Guard*, a realistic and tightly written tale set in Kiev in the winter of 1918. At that time, civil war literature was all the rage, but the stories published in the USSR described only the exploits of Red Army soldiers, in which the Whites were distant enemies, seen through gunsights. In Bulgakov's novel (as the title implies), the heroes were White officers fighting for the restoration of the tsar. If Bulgakov's fictional account accurately depicts what happened, then after reading it Lezhnev announced confidently that there was no chance of it appearing in any publication owned by the state but offered to serialize it in *Rossiya* "for an incredibly small sum." The first installment appeared in December 1924 and must have been quickly spotted by the OGPU, because Bulgakov recorded in his diary in January 1925 that he was being shadowed by "a grey figure carrying a briefcase."[7]

Bulgakov scholars have since tramped around Kiev finding the places where the novel is set. The action is centered at the fictitious address of 13 St. Alexeyevsky Hill, home of the Turbin family, two brothers and a sister, all monarchists. The older brother is a doctor, the younger one a cadet in the Constantine Military Academy. Their home, which is described in great detail, is unusual in that it is one level above the street in the front, with another tenant living in the flat below, but the hill behind the building is so steep that the Turbins' back door opens out directly onto a sloping yard. In 1906, Bulgakov's recently widowed mother had moved with her seven children—of whom Mikhail, then fifteen, was the oldest—into a first-floor apartment at 13 St. Andreyevsky Hill, which rose steeply behind the building so that their back door opened directly onto a sloping yard.

Kiev is not, of course, in Russia, and its Russian-speaking inhabitants were in a position analogous to the Anglo-Irish, looking to the distant monarch for protection against the indigenous peasants and the chaos that threatened if the colonial power weakened. The fictional Turbins despised all the factions that fought for supremacy in Ukraine—the nationalists, the anarchists, and those who collaborated with the German invaders—and when they were forced to accept that the tsar was never returning to the throne, they accepted the Bolsheviks as the least worst alternative. These are likely to have been the sentiments of the Bulgakov family as well.

Bulgakov's teenage brothers were military cadets who joined the White Army, fled with their defeated comrades to Yugoslavia, and lived out their

long lives in Paris. But Mikhail was not a soldier; he was a doctor with a degree in medicine from Kiev University. He was sent to Saratov, in Russia, with his first wife, Tatyana, during the war with Germany and returned to Kiev in February 1918, horrified both by the violence he had witnessed on the way through Moscow and by the chaos at home. "The inhabitants of Kiev reckon that there were eighteen changes of power," he recalled. "Some stay-at-home memoirists counted up to twelve of them. I can tell you there were precisely fourteen; and what's more, I personally lived through ten of them."

He set up a clinic for venereal diseases in the family home, but that enterprise closed when Kiev was occupied by a peasant army led by a nationalist guerrilla named Simon Petlyura. Bulgakov was drafted into Petlyura's army, though he despised them even more than he despised the Bolsheviks. He slipped away to attach himself to the White Army, with whom he traveled to Vladikavkaz, on the northern slopes of the Caucasus.

He appeared in print for the first time as the author of a newspaper article, which lay forgotten for the remainder of the century until it was uncovered by his Russian biographer Marietta Chudakova. That was lucky for Bulgakov, because it was a lyrical piece describing how "everyone is passionately awaiting the country's liberation" from the Bolsheviks.[8] It was also possibly fortuitous that this first venture into journalism was cut short when he contracted typhus, which rendered him unconscious and might have killed him had he not been married to a nurse able to care for him properly. By the time he recovered, in March 1920, Vladikavkaz was under Bolshevik rule, and the civil war was over. With his thirtieth birthday rapidly approaching, Bulgakov reevaluated his life and made the bold decision to try to live as a professional writer, under a hostile regime. He never practiced medicine again but instead turned out stories and satirical sketches for newspapers and completed five stage plays in a year and a half; three of the plays were staged, including a four-act drama called *The Turbin Brothers*—whose title implies an early draft of *The White Guard*—which drew wild cheers from its provincial audience. In September 1921, he moved to Moscow, where he and his wife had a desperate time finding somewhere to live and money for food. His main source of income was writing humorously absurd letters for *Gudok* (the whistle), the official newspaper of the railworkers' union, supposedly coming from simpleminded readers grappling with the arrival of the NEP. He seemed to give up on drama and spent his spare time working on prose fiction. When he reread his old playscripts, he thought them so awful that he destroyed them.

But the novel that Lezhnev began serializing in *Rossiya* was the work of an accomplished writer. It appeared at a moment when some of the younger directors of the MAT were questioning how long they could go on serving up a diet of prerevolutionary plays that had earned Trotsky's scathing verdict that the theater was a refuge for "internal émigrés." Desperate for a new play, Boris Vershilov, the head of the MAT's Second Studio, read the early sections of *The White Guard*, and on April 3, 1925, he sent Bulgakov a penciled note asking him to drop by to be invited to turn his novel into a stage play.[9] It was a gamble for the theater's management, who could not know whether Bulgakov was capable of producing a script good enough for the company that had introduced theater audiences to Anton Chekhov and Maxim Gorky, let alone under the tight deadline they set him. Yet with exemplary self-discipline, he had a play ready to read to the assembled company only four months later, on August 15. Just over two weeks after that reading, Bulgakov received a note instructing him, "At three o'clock tomorrow (Sunday) you must read the play to K.S. Stanislavsky at his flat at 6 Leontyevsky Lane."[10] *Black Snow* includes a farcical description of just such a reading at the home of a revered and tyrannical director whom Bulgakov mischievously named Ivan Vasilievich, the name and patronymic of Ivan the Terrible. The reading is brought to an abrupt end by the sudden intervention of a fat, "satanic" tabby cat that flies into the room, up the curtain, and back down, ripping it from top to bottom. It is to be doubted whether Bulgakov's first encounter with Stanislavsky was really that bad, because they worked together for years before falling out when the theater, under pressure from the government, terminated the production of Bulgakov's last play. And, however awkward their first meeting, the important thing was that Stanislavsky approved the play.

Bulgakov now had so much work that he gave up his day job writing sketches for *Gudok*. Three-quarters of his novel had been serialized. One of his minor stories was published in *Krasnaya nov* in January 1925, which was the nearest he had come to recognition from any arm of the Communist Party. A publishing house was preparing to publish his collection of stories *Diaboliada*, which included his exuberant futuristic satire *The Red Ray*, published in English in 2003 as *The Fatal Eggs*, in which a Moscow professor discovers a ray that can cause living organisms to grow to enormous size and reproduce at a demonic rate; incompetently applied, it causes giant ostriches and snakes to break loose from a state farm, lay waste to the countryside, and march on Moscow before being wiped out by frost. An alert reader might have noticed how the mad professor's first name and patronymic, Vladimir

Ipatyevich, were suspiciously similar to Lenin's, yet at first the story was well received. During 1925, a publishing house was pestering Bulgakov to hurry the completion of his next science fantasy satire, his long story *The Heart of a Dog*, which he handed over in May.

Suddenly, it all began to go wrong. In the autumn, there came an abrupt note from his publishers: "It's a very important and unpleasant matter: some sort of scandal has arisen in the upper regions concerning *Diaboliada*— some sort of attack, as yet unclear, on us. Right now they're confiscating the book from us."[11] It emerged that Lev Kamenev, the third member of the Stalin-Zinoviev-Kamenev triumvirate that had taken charge during Lenin's terminal illness, had read *The Heart of a Dog* and was scandalized. "It's an acerbic broadside about the present age, and there can be absolutely no question of publishing it," he told the publishers.

It is not difficult to see why. The story was another extravagant satire, in which a mangy stray, an injured mongrel dog, is taken off the streets into the home of the eminent scientist Philip Philipovich, who implants a human brain in it. As it learns to speak, it evolves into an ignorant, demanding sub-human who expresses himself like a member of the emerging class of brutish commissars—until the scientist puts him out of his misery by turning him back into a dog. The least sympathetic characters in this tale are those who have adapted quickest to the new Soviet order, particularly the bossy members of the House Committee; the most sympathetic are the scientists, clinging to their bourgeois ways. Here is Philipovich, reacting to the proposition that the revolution had changed things for the better:

I have been living in this house since 1903. And from then until March 1917 there was not one case—let me underline in red pencil *not one case*—of a single pair of galoshes disappearing from that rack even when the front door was open. There are, kindly note, twelve flats in this house and a constant stream of people coming to my consulting-rooms. One fine day in March 1917 all the galoshes disappeared, including two pairs of mine, three walking sticks, an overcoat and the porter's samovar. And since then the rack has ceased to exist. And I won't mention the boiler. The rule apparently is—once a social revolution takes place there's no need to stoke the boiler.[12]

The next blow was the abrupt closure of the magazine *Rossiya* before serialization of *The White Guard* was complete. In *Black Snow*, the hapless narrator turns up at the magazine's office only to be told that the proprietor has

fled abroad. Actually, although Lezhnev was under virulent attack in the communist press, he stayed in Moscow until he was ordered out of the country. His life story has an unexpectedly happy sequel: after four years in exile, he announced that he had repented, and he was allowed back into the USSR. He wrote an autobiographical story that no one dared publish about a Jewish boy from the ghetto who discovers Marxism. Someone passed Lezhnev's manuscript to Stalin, who read it, approved, and rang to say so. Tragically, Lezhnev was out when the call came; after discovering that he had missed a chance to speak to Stalin, he sat by the telephone for a week, not daring to move even to shave, until at last he received word that there would be no second telephone call, but Stalin was recommending him for the post of literary editor of *Pravda*. Almost demented with joy, Lezhnev rushed to the barber to have his seven-day beard removed and scurried around Moscow spreading the news. He lived for twenty more prosperous years. "As regards the fact that Lezhnev didn't shave for a whole week while waiting for Stalin to call back—there is nothing surprising about it: any Soviet citizen would have done the same," Nadezhda Mandelstam observed drily.[13]

Bulgakov's problems multiplied. In October, a letter from the MAT informed him that he would be working with two directors instead of one—Vershilov and Ilya Sudakov, an actor and director recruited to the MAT by Stanislavsky—and summoned him to another meeting. Until now, no one involved appears to have picked up on the most obvious fact about *The White Guard*—that, in Soviet terms, it was deeply subversive. The script had belatedly been submitted to Lunacharsky, who admitted that Bulgakov had talent but tore the script apart for allegedly lacking a single interesting character or situation. The theater management decided that the play would be consigned to a studio rather than the main stage and that Bulgakov would have to revise it. At this point, Bulgakov's patience deserted him, and he sent off a perilously bold letter demanding that the play be produced on the main stage in March or dropped altogether. Fortunately for him, the management gave way. He in turn made changes, notably making the main character, Alexei Turbin, a colonel and a combatant. In the novel, he was a doctor, like the author. On March 26, Stanislavsky came to watch the cast perform the first two acts of the play and was so moved that tears welled in his eyes. Then, in April, nervously aware that left-wing critics were circling, the theater insisted that the play lose its provocative title. After a few weeks of indecision, *The White Guard* was renamed *The Day of the Turbins*.

One week later, Bulgakov returned from work to find OGPU officers waiting in his apartment with a search warrant. He had to watch his armchairs being overturned and poked with needles. The detectives confiscated two copies of the manuscript of *The Heart of a Dog* and a private diary, which Bulgakov had filled with incriminating comments about "foul and unnatural politics" and how "there's no escaping the boors." After reading about Trotsky's dismissal from his post as people's commissar for defense in January 1924, Bulgakov wrote, "God alone knows what will happen to Russia. May He come to her aid!" A few days later, he noted in his diary that Lenin had died but did not consider the event worth any further comment.

His contrasting reactions are odd, because Lenin's death was certainly the bigger and more portentous of those two events. The probable explanation is that Russians of Bulgakov's background were prone to interpreting the rise of Bolshevism as a Jewish conspiracy, personified by Leon Trotsky. Bulgakov appears to have spent the civil war under the impression that Trotsky, not Lenin, was Russia's supreme ruler. During his brief foray into wartime journalism, Bulgakov had proclaimed that "inch by inch the heroic volunteers will tear the Russian land from Trotsky's hands."[14] Alexei Turbin, who of all the characters in *The White Guard* is the one who most closely resembled Bulgakov, warns his friends, "We have something worse on our hands, much worse than the war, worse than the Germans, worse than anything on earth—and that is Trotsky." Toward the end of the novel, Alexei Turbin receives a demented patient who warns him that the Antichrist, "a man with the eyes of a snake," has arrived on earth to lead men into sin and women into debauchery using the name Trotsky, though "his Hebrew name is Abadonna."[15]

While Bulgakov's comments on contemporary political events were few, there was plenty said in the diary about censorship and the crudity of official antireligious propaganda: "it is not just the blasphemy, although that is, of course, unprecedented. . . . The gist of it is that Jesus Christ, no less, was a good-for-nothing and a fraud,"[16] he wrote. Bulgakov would battle with the authorities for years to get his diary back.

He had meanwhile completed a play commissioned by the Vakhtangov Theatre, a breakaway from the MAT founded in the early 1920s that specialized in contemporary drama. Bulgakov presented them with *Zoya's Apartment*. In contrast to *The Day of the Turbins*, this was a romping comedy, a satire on the new class of entrepreneurs who were taking advantage of the

NEP. It does not take long for the audience to find out that the seemingly respectable apartment in question is a brothel and Zoya its madam. There are no redeeming characters anywhere in the drama. Unsurprisingly, progress from script to staging was littered with problems.

While the MAT returned from its summer break, literary Moscow came alive with rumors that a major cultural event was imminent, and Bulgakov discovered what it meant to be famous. The upside was, as he wrote in a letter, "I shall be rich in the autumn!!"[17] On the downside, he was a sitting target for every critic and commentator who believed that the theater should be an instrument for raising political consciousness. A couple of critics named Alexander Orlinsky and Vladimir Blyum objected to the "idiotic" plays of William Shakespeare and were ready to be even more offended by Bulgakov. In his subsequent biography of Molière, Bulgakov mentioned two individuals who made their names by vindictively pursuing the playwright and "had dreamed of fame and had won it thanks to Molière."[18] This was probably a deliberate dig at Orlinsky and Blyum, who are remembered only for the campaign they waged against Bulgakov.

Political pressure from such individuals could not be ignored altogether, however. A mention of Trotsky's name was removed from the script of *The Day of the Turbins* in July 1926, three months ahead of his expulsion from the Politburo. The ending was also adapted to make it more upbeat. In the final version, the family hears the guns of the approaching Red Army, and eighteen-year-old Nikolai Turbin remarks, "This evening is a prologue to a great new historical play." Bulgakov accepted these restraints philosophically now that he was sure that the play would be staged. In the Molière biography, he wrote that a writer will mutilate his work if he has to, just as "a lizard, caught by its tail, breaks off the tail and escapes; for every lizard realizes that it is better to live without a tail than to lose its life."[19]

Stanislavsky sought Lunacharsky's advice on whether there were any other precautions they ought to take. Lunacharsky suggested a private performance for people who mattered. Stanislavsky did not know who the important people were, though, and had to turn for advice to his old rival Meyerhold, who had severed his link with the MAT twenty years earlier but could at least draw up an appropriate guest list. The private performance was held on September 23. Two days later, after Lunacharsky had conferred with the Politburo, the theater announced that the play had been passed for production.

It was a sensational decision by the USSR's new rulers to permit a play that treated sympathetically the losers in a civil war that had ended less than six

years earlier. In the run-up to the opening night, on October 5, 1926, long queues formed outside MAT's ticket office. One of the theater's younger directors observed, "These were not playgoers but palmers, and their pilgrimage was to see a stirring miracle in a land of terror and class hatred. For many years the stained misanthropy of Bolshevik propaganda had covered the 'White bandits'; now, they suddenly turned up—alive and wonderful, erring and terrible, but yet fine Russian people. One could make a pilgrimage to this presentation, for it was filled with the miracle of Christian forgiveness."[20] The audience reaction was so intense that some fainted and had to be revived by ushers in the snowy courtyard. One man stood up as the play ended, tears rolling down his face, and shouted, "Thank you!" A woman was moved to jump up and cry, "All men are brothers!"[21]

Demonstrations like those were bound to antagonize communist critics such as Orlinsky and Blyum, and communist critics were the only ones published in the state-controlled press. Bulgakov kept a scrapbook of everything written about him and reckoned that by March 1930 he had received 301 reviews—a total of two hundred thousand words—298 of which were hostile. *Zoya's Apartment*, which also opened in October, had a similar reception.

Just once, in February 1927, Bulgakov let himself be provoked into debating with the critics. In 1923, Eisenstein's old mentor Meyerhold had been allowed to open his own Moscow theater, to perform radical, experimental works very different from Bulgakov's first play. He turned up to a public meeting in the Meyerhold Theatre in a starched shirt to listen to Lunacharsky struggling to defend *The Day of the Turbins*. Bulgakov decided to engage in an argument that had been raging in the press about whether the character of Alexei Turbin should have employed a servant, a topic that allowed him to ridicule his tormentor Orlinsky. "At the time when the events of my play take place, you couldn't have got a batman for his weight in gold," he remarked. "I can well imagine two scenes with a batman: the first one as I would have written it, the other as Orlinsky would have written it. In mine, it would have gone like this: 'Vasily, put on the samovar,' says Alexei Turbin. 'Yes sir,' replies the batman, and then he would disappear for the rest of the play. Orlinsky wants a different batman, but let me assure you that a good man such as Alexei Turbin would not have dreamt of thrashing his batman."[22]

The contemporaneous record mentions "laughter and applause," but it can be assumed that some people in the audience did not find these comments remotely funny, and his listeners were not limited just to relative nonentities like Orlinsky and Blyum. Leopold Averbakh from the RAPP was in the

audience; so was the official who was to play a large part in Bulgakov's life story, Platon Kerzhentsev, deputy head of the Communist Party's agitprop department. Kerzhentsev was not a hard-nosed careerist like Averbakh but an Old Bolshevik who had spent thirteen years in the party before the revolution, "an old man with a small gray beard and old-fashioned gold-rimmed nose glasses on a black ribbon."[23] He had been involved in Proletkult in the 1920s and firmly believed that theaters should be the preserve of proletarian writers creating plays on proletarian themes, and thus should not be putting on work by someone like Bulgakov. The press ominously reported that "Bulgakov tried to fob off his critics with jokes, but failed dismally."[24]

There was, however, no denying the box office success of *The Day of the Turbins* and therefore no shortage of theaters willing to put on any play they could commission from Bulgakov. His third play, *The Crimson Island*, completed in March 1927, was produced by the Kamerny Theatre in Moscow. It was a play within a play: most of the action was an allegory, in which the inhabitants of the mythical Crimson Island had a revolution and forced out colonial exploiters, enclosed within the farcical story of the writer and director of this allegory coping with a visit from the censor. The allegory was politically acceptable—though it could be criticized for frivolity—but the outer play was a blatant protest against censorship. Bulgakov had good reason to fear that the people it targeted would prevent it from reaching the stage.

He also produced a new script, *Flight*, for the MAT, his fourth in four years. The scene was the Crimea, where the last of the defeated White Armies prepared to flee via Constantinople to Paris. In this play, in order to placate the critics outraged by his sympathetic portrayal of Alexei Turbin and his comrades, there were no military heroes: all of the characters were desperate, cruel, selfish, and defeated except for two noncombatants, a confused young intellectual and a general's wife with whom he falls desperately in love. Her story was drawn from life. Bulgakov had rather cruelly divorced Tatanya Lappa, who had stuck by him through his worst years, for a new love named Lyubov Belozerskaya, who was back in Moscow after fleeing from the Bolsheviks to Paris, via Crimea and Turkey.

In September, Bulgakov was surprised to receive a letter of congratulations from his fellow writer Yevgeny Zamyatin in Leningrad, who was under the impression that *The Crimson Island* had slipped past the censors. Two weeks later, he sent a delighted reply: "You congratulated me two weeks before *The Crimson Island* was permitted, which means you're a prophet. As for the per-

mission, well, I don't know what to say. I wrote *Flight* and handed it in. But it's *The Crimson Island* that's been passed. It's mystical. Who? What? Why?"[25]

With the MAT putting up a spirited fight on behalf of *Flight*, it was now a possibility that Bulgakov could have four plays in production simultaneously. The MAT's sixty-year-old co-founder Nemirovich-Danchenko, who had been abroad throughout the production of *The Day of the Turbins* and was lampooned in *Black Snow* as the absent and unbelievably aged "Aristarkh Platonovich," nonetheless had been shocked by the virulence of the campaign against Bulgakov and was throwing his considerable authority behind its production. Even the zealots campaigning for political correctness in the theater were wary of attacking the director who had discovered Chekhov, someone believed to be more amenable to Bolshevism than Stanislavsky. And he was not the only village elder to rally to Bulgakov's defense. Maxim Gorky, who kept a close eye on new Russian literature from his home in Sorrento, had read some of Bulgakov's stories, and on a visit to Moscow in October 1928, as *Flight* went into rehearsal, he threw his weight into a campaign to ensure that it was passed by the censors. During one of his visits to Russia, he even read the script aloud to the prime minister, Alexei Rykov, who appears to have agreed that it ought to be produced.

Meanwhile, the Proletarian Theatre Association, the theater counterpart of RAPP, was on maneuvers. Its leading figure was a playwright named Vladimir Bill-Belotserkovsky, who had some political authority because he was a member of the Communist Party—albeit joining quite late in life, at the age of thirty-three, but just before the Bolshevik revolution. He organized a collective letter to Stalin, bearing eleven signatures, that described Bulgakov's four plays, but *Flight* in particular, as "reactionary" and only of "average" quality and implied that all his work should be banned.[26]

On January 11, 1929, a youth knocked on the door of a Moscow apartment and, when its middle-aged occupant answered, shot him dead. The victim was Yakov Slashchov, a notoriously cruel former White officer who had fled abroad after the war but had come back. His assassin's brother had been executed by Slashchov's men. A wave of sympathy for the killer went through Moscow, which directly affected Bulgakov because he had read Slashchov's memoirs and had made him the model for the character of the White officer Khludov in *Flight*. To stage *Flight* now might be taken as a pointless provocation.

On January 14, the people's commissar for war, an old Stalin crony named Kliment Voroshilov, was delegated the task of deciding whether *Flight* was suitable for the Soviet stage. He turned for advice to Platon Kerzhentsev, who

was allowed to use Voroshilov's headed notepaper to compose a memo to Stalin bluntly arguing that all work on *Flight* should stop forthwith, because allowing it to go into production would "give comfort to a group within the Art Theatre opposed to the revolutionary repertoire . . . a backward step for our entire theatre policy."[27] On January 30, the Politburo banned *Flight*.

A few days later, a delegation of Ukrainian writers arrived in Moscow to lobby Stalin to extend the ban to include *The Day of the Turbins*. Their visit was marked by a February 9 article in *Pravda* by Kerzhentsev complaining that "our foremost theater continues to stage a play which perversely misrepresents the Ukrainian revolutionary movement and insults Ukrainians." There was no confusion about which play he had in mind: the civilized characters in *The Day of the Turbins* are Russian; the Ukrainians are wild men out of bandit country. While he was at it, Kerzhentsev aimed higher and attacked Lunacharsky for allowing the play to be put on in the first place, prompting a long, self-justifying memo to Stalin from the people's commissar for enlightenment, the content of which was not greatly to Lunacharsky's credit. Worn down by the relentless exponents of proletarian art and knowing that his position was precarious, he did not try to answer Kerzhentsev's question about what constituted art but rehashed the decision to stage *The Day of the Turbins*, pointing out that Politburo members had been consulted at every stage and accusing Kerzhentsev of second-guessing their judgment. He reminded Stalin that he had in fact banned the play a few months earlier, "but you personally telephoned me, Josif Vissarionovich, to suggest that I lift the ban, and even reproached me (albeit mildly), saying the PCE should first have referred the matter to the Politburo."[28]

This revealing comment, in a letter that was to be tucked away in an archive for sixty-four years, is the first piece of evidence that Bulgakov had unknowingly acquired a protector far more powerful than Lunacharsky or any of the people attacking him. The decision to allow *The Day of the Turbins* to continue its run was Stalin's alone. The general secretary had seen the play and was intrigued. He had never met the real-life commanders of the White Army; seeing them brought to life onstage brought home to him the magnitude of the Red Army's achievement in defeating them. He was so fascinated that he kept returning, year after year: the record shows that he went to fifteen separate performances in all.

On February 2, Stalin published an open reply to Bill-Belotserkovsky and the Proletarian Theatre Association. He began sensibly by declaring that the terms "right" and "left," used to describe factions in the Communist Party,

had no meaning when applied to literature: there were no "Trotskyite" or "Bukharinite" schools of literature, but there was anti-Soviet literature, of which *Flight* was an example because it was "an attempt to evoke pity, if not sympathy, for certain sections of the anti-Soviet émigrés." Yet even after delivering that judgment, Stalin was prepared to be conciliatory, saying that *Flight* could be staged if it were suitably amended. Then, turning to *The Day of the Turbins*, he wrote:

> It is not such a bad play, because it does more good than harm. Don't forget that the chief impression it leaves with the spectator is one that is favorable to the Bolsheviks: "If even such people as the Turbins are compelled to lay down their arms and submit to the will of the people . . . then the Bolsheviks must be invincible." . . . *The Day of the Turbins* is a demonstration of the all-conquering power of Bolshevism.[29]

A week later, Stalin met the Ukrainian delegation and tried out the same arguments on them. They were not impressed: Bulgakov had insulted the Ukrainian nation, they told the general secretary firmly. Ukrainian communists had a tendency to be independently minded, and Stalin would crush them with singular ruthlessness in the next decade. For now, he abruptly decided that Bulgakov was causing him more trouble than he was worth. *Crimson Island* premiered on December 11, only to close a few nights later. In February, the run of *Zoya's Apartment* ended after two hundred performances. In March, *The Day of the Turbins* was removed from the MAT's repertoire—though it was revived in the 1930s, unlike the rest of Bulgakov's work. One short month after Stalin had come out publicly in Bulgakov's defense, every word he had written—all four plays, his short stories, his novel, everything—was banned.

Bulgakov must have felt desperately alone, but at least he had a friend and fellow sufferer in the writer Yevgeny Zamyatin. Nearly every literate person in the English-speaking world has felt Zamyatin's influence, whether they have heard of him or not. In his novel *We*, written in 1920 amid the deprivations of civil war, Zamyatin imagined a future in which people were known by serial numbers instead of names and lived in apartments with glass walls so that they could be watched all the time, except during the specified "sex hour," when it was permitted to lower blinds; independent thought was treated as a contagion to be averted by mercifully killing its carriers. He even imagined elections with only one candidate, held on Unanimity Day. This half-forgotten

novel stimulated George Orwell's curiosity when he read about it in a review of Russian literature, and he bought a rare French translation. He acknowledged it as the inspiration for *1984* and surmised that Aldous Huxley must have known about it, too, because of its similarity to *Brave New World*.[30]

Zamyatin shared with Mayakovsky the rare distinction of being both an outstanding artist and an ex-Bolshevik. He had joined during the 1905 revolution when he was a young naval engineer, for which he endured a period in solitary confinement and was banned from Saint Petersburg. He was living in Jesmond, a suburb of Newcastle upon Tyne, supervising the construction of Russian icebreakers, during the 1917 revolution, and instead of rejoining the Bolsheviks he concentrated on writing, trying to find a literary form that would capture the horror of social breakdown and the psychological impact on young men of being given the power to kill with impunity. In Zamyatin's stories, the men in uniform are described as if they were from another world, "the delirium-born, misty world," as he called it in his 1918 short story "Dragon."[31] The world described in *We* was the apotheosis of this chaos, in which the uncontrolled passions of civil war had given way to placid conformity. Zamyatin also provocatively assumed the Bolshevik revolution was only an episode in history, rather than its finale. "Revolution," he wrote, "is everywhere, in everything. It is infinite. There is no final revolution, no final number."[32] The phrase "internal émigré"—a taunt thrown at "former people" who still lived in the Soviet Union but belonged abroad—made one of its first appearances when Trotsky applied it to Zamyatin in his 1924 survey of current Russian literature. It could as well have been applied to Bulgakov. These two gifted writers kept up each other's spirits by exchanging cheery correspondence.

Zamyatin left for his summer break in 1929 in good humor, only to return to an ordeal that would have driven a less robust man to a nervous breakdown. With Lunacharsky finally removed from the picture, Averbakh and his colleagues in RAPP were making a bid for absolute control over literature and had selected Zamyatin as an easy target. Two years earlier, fragments of *We* (not from the original but from a Czech translation retranslated into Russian) had been published in a Russian émigré publication in Prague without Zamyatin's consent—sufficient evidence for RAPP to accuse Zamyatin of being in league with White Russian émigrés. Abandoned by his fellow writers, Zamyatin proudly refused to capitulate, responding instead with a detailed letter demolishing the case against him. RAPP then made it impossible for him to find work, and eighteen months later, in June 1931, he followed

Bulgakov's example and wrote to Stalin seeking permission to emigrate.[33] Unusually, his request was granted, and he died alone in Paris in 1937.

At the very time when Bulgakov and Zamyatin were exchanging good-humored letters about who was the better billiards player, Bulgakov was sinking into despair about his own prospects. With courageous panache, he wrote directly to Stalin in July 1929, with copies to two other Soviet officials and to Maxim Gorky, pointing out that he could not find paid work in the USSR and had been denied permission to go abroad, and he concluded with the startling demand that he be expelled from the Soviet Union.

This letter produced one unexpected result: the police turned up at Bulgakov's door to return the manuscripts they had confiscated three years earlier, including his diary, which he immediately burned. Fortunately for future scholars, the police had copied all the incriminating passages, which were uncovered in the KGB's archives by the journalist Vitaly Shentalinsky more than sixty years later.[34] Why they returned the documents can only be surmised, but it is likely that they were nervous about the reaction from Sorrento if Bulgakov were forced into exile. Gorky was making inquiries from afar about Bulgakov's fate.

The letter failed to elicit any immediate response from the higher authorities or a lifting of the ban on Bulgakov's work. In September, he fired off another letter, this time to Abel Yenukidze, a Georgian who had known Stalin from prerevolutionary days and was chief executive officer of the soviets, again asking that he and his wife, Lyubov, be allowed to leave. On the same day, he wrote to Gorky again to ask, rhetorically, "Why force a writer whose works cannot exist in the Soviet Union to stay in the country? To ensure his death?"

In these incredibly difficult circumstances, unable to earn money and with the MAT after him to return the advance he had been paid for *Flight*, Bulgakov produced some of his finest work. He had begun *The Master and Margarita*, whose existence remained a secret until long after his death. He also completed his play *Molière*, or *A Cabal of Hypocrites*. In January 1930, he wrote to his brother in Paris, saying that the play had been "recognized as the most powerful of my five plays by the best specialists in Moscow"—but not, sadly, by the committee tasked with deciding whether it was fit to be shown to Soviet audiences.[35] In March, he was curtly informed that it was banned. That was the final blow. Bulgakov composed a letter that stretched to eleven pages, addressed to "the Soviet government," and sent it to Stalin and several other leading figures, including the chief of police Genrikh Yagoda. The letter was a masterpiece of pent-up fury that began by revealing that friends were

advising him to renounce all his previous work, write a "communist play," and write a groveling letter to the authorities—all of which he refused to do. He declared defiantly that a writer's duty was to defend freedom of expression. He also summarized the relentless campaign that had been waged against him, naming several of his persecutors, including Averbakh. He daringly described himself as a satirist, then quoted his tormentor Vladimir Blyum: "Anyone who writes satire in the USSR is questioning the Soviet system." This had become true, Bulgakov admitted, making it impossible for him to continue. He pleaded to be allowed to work as a producer/technician in the MAT, under Stanislavsky and Nemirovich-Danchenko, or as a full-time actor, or even as a stagehand. Failing that, he demanded anew that he and Lyubov be allowed out of the country.

Bulgakov's future would have been precarious indeed if the Soviet authorities had let him leave. It would have been very difficult for him to make any impact as a novelist, and even harder to get his plays produced, while living in exile. And though Lyubov was apparently willing to go with him, their relationship was on the point of dissolution. His letter to Stalin had been typed out for him by the wife of a Red Army officer, Yelena Shilovskaya, whose sister worked at the MAT as Nemirovich-Danchenko's secretary. Yelena's husband was fiercely opposed to her involvement with Bulgakov. Both marriages were disintegrating, and Yelena was already in effect the third Mrs. Bulgakov. But instead of finding life among the exiles, Bulgakov discovered that one telephone call meant that he was soon back in paid employment. His sudden good fortune was the talk of literary Moscow, and word soon spread abroad, with an account of the conversation with Stalin appearing in the émigré press.

It obviously was significant that Stalin rang Bulgakov on April 18, 1930, just four days after Mayakovsky had committed suicide. It was well known that Mayakovsky had been hounded by the young thugs from RAPP, who claimed to be acting in Stalin's name. It was a shrewd move by Stalin to make a display of friendship toward a writer who embodied everything that RAPP had set out to destroy. In the files kept by the OGPU is an informer's report on the gossip going around Moscow's theaters that Vitaly Shentalinsky found decades later. The anonymous writer recorded:

> They say that Stalin has nothing to do with the chaos. He was following the right policies but is surrounded by swine. It was they who hounded Bulgakov, one of the most gifted Soviet writers. Various literary good-for-nothings

made their career by persecuting Bulgakov and now Stalin has slapped them down.

It should be said that the popularity of Stalin has developed a simply extraordinary form. He is spoken of with warmth and affection, and the legendary story of Bulgakov's letter is being retold in various forms.[36]

Moreover, Bulgakov still had the invitation from Stalin to meet face-to-face and have a conversation. It is likely that he spent many hours going over in his mind what he would say to the general secretary, but there was no follow-up invitation, and it was made clear to him that he had mattered to the man in the Kremlin just for a day, after which Stalin lost interest.

4

Corrupting Gorky

His whole being expressed hunger for knowledge and human understanding . . .
the supreme, the righteous, the relentless witness of the Revolution.

—VICTOR SERGE

On Bolshoi Solovetsky, the main island in the Solovetsky archipelago, in
Onega Bay on the White Sea beyond Arkhangelsk, there is an ancient mon-
astery the Bolsheviks converted to a prison. One of the people held there was
a graduate of Leningrad University named Dmitri Likhachev, who had been
arrested for discussing philosophy and other dangerous topics with his fel-
low students. He survived five years in the gulag and lived such a long and
successful life that he would be a significant player in the events that brought
the Soviet Union to an end in 1991. While a prisoner, he witnessed the ar-
rival of the steamer *Gleb Boky* on June 20, 1929, and saw a distinguished visi-
tor disembark: a tall, lean, elderly man, bony, stooping, and hollow chested,
with an anguished, pitted face, jutting cheekbones, and a heavy mustache.
His flat workman's cap and plain coat suggested that he had tried to dress
like a policeman but succeeded only in looking odd. It was the writer Maxim
Gorky. At his side was his daughter-in-law Nadezhda Peshkova, known as
Timosha, dressed all in leather.

The prisoners were already fired up by the rumor that the "Stormy Petrel"
was coming. There was no one like Maxim Gorky. Before the revolution, the
tsar's regime arbitrarily arrested thousands of its political opponents, but
whenever they arrested Gorky, they had to let him go, out of deference to pop-
ular opinion. He presented the Bolsheviks with a similar problem during the

civil war years: he had not supported their revolution, he was constantly intervening of behalf of people who were suffering at the hands of the new regime, but his great prestige prevented the regime from taking action against him.

The prison guards on Solovetsky were nervous about his visit: huts were repainted, trees were planted, and husbands and wives were reunited. The prisoners were sure Gorky would see through this facade. "He's been around, you can't fool him—about the logging and the torture on the tree-stumps, the hunger, the disease, the three-tier bunks, those without clothes, the sentences without conviction," they thought.[1]

Gorky and his young companion strode through the camps and along corridors, rarely sparing a sideward glance at the opened cells or the staff lined up to greet them. They were shown the punishment block, where thieves sat meekly on benches. Gorky had a forty-minute conversation with a boy that left him visibly moved. According to Likhachev, the boy was never seen alive again. On a smaller island, a group of convicts who had been loading a ship dressed only in underwear and sacks were ordered to get themselves out of sight, hiding under a tarpaulin as Gorky's steamer chugged by.[2]

His reflections on the visit were published soon afterward. It was necessary, he accepted, for the young Soviet regime to have somewhere like the Solovetsky Islands where "counterrevolutionaries, emotional types, monarchists" could be isolated; but he added, "There is no impression of life being overregulated. No, there is no resemblance to a prison; instead it seems as if these rooms are inhabited by passengers rescued from a drowned ship. . . . If any so-called cultured European society dared to conduct an experiment such as this colony, and if this experiment yielded fruits as ours had, that country would blow all its trumpets and boast about its accomplishments."[3]

Once he was gone, the authorities on Solovetsky held the next round of executions. The executioners were drunk and for economy's sake used one bullet per victim, with varying accuracy. Likhachev remembered passing the mass grave the following morning and seeing where the ground had been disturbed by the final agonies of those carelessly buried alive.

Maxim Gorky, who was born Alexei Peshkov, the son of a laborer from Nizhny Novgorod, could have been one of the great moral figures of his generation. He was the last of the great nineteenth-century Russian writers and the first to bring to life characters from the "lower depths" of Russian society. Not all were realistically drawn—the young revolutionaries he portrayed were impossibly high-minded, and only the employers, police, and spies were despicable. Here, for example, is how a minor character from his long novel

Mother, completed in 1905, responded after discovering that poor working conditions have made him terminally ill: "I can still be of use to the common people—serving as living testimony to a great crime. Here, look at me, dying at the age of twenty-eight!"[4]

This and earlier works made Gorky a sensation. Suddenly, "out of the darkest depths of life, where vice and crime and misery abound, comes the Byron of the twentieth century, the poet of the vagabond and the proletariat, Maxim Gorky," his first English translator, Herman Bernstein, proclaimed in 1901.[5] Leo Tolstoy considered him "a genius but lacking education."[6] Leon Trotsky saluted him as the "poet tramp . . . [who] carried to the Russian intelligentsia the spirit of daring, the romantic bravery of people who had nothing to lose."[7]

To the government of Tsar Nicholas II, he was a nuisance and a threat. He was arrested in 1901, in Nizhny Novgorod, on the grounds that his poem "The Song of the Stormy Petrel" was an incitement to revolution. This allegation did not lack substance: in 1917, Gorky wrote that he had "considered himself" to be a social democrat for seventeen years, implying that he was in contact with revolutionaries before his arrest.[8] However, the outcry whipped up by Leo Tolstoy and many others secured his quick release. Banned from his hometown, Gorky went to the Crimea to recuperate from a lung damaged by a bullet from a suicide attempt he had made in his teens. Anton Chekhov and members of the Moscow Art Theatre (MAT) were also in the Crimea, and Chekhov talked Gorky into trying his hand as a dramatist. His initial offering, *The Petty Bourgeois*, in which the workers were portrayed as intelligent humans and their employer as an oaf, was banned until the MAT appealed directly to the tsar's chief minister, who authorized a private showing. Even so, the censors imposed substantial changes, and on opening night the theater was ringed by a cordon of police and mounted Cossacks.

Undeterred, the MAT put on Gorky's next and most celebrated play, *The Lower Depths*, in which the types of characters who usually only ever appeared on stage as minor and usually comic figures assumed center stage. Stanislavsky, the director, realized to his alarm that no Russian actor knew how to act like a tramp, and he made Gorky take leading members of the company into the unexplored quarters of Saint Petersburg where actual tramps could be found. The play was a wild success, and a bashful Maxim Gorky had to bow to an auditorium full of his social superiors. "It was very funny to see him appear for the first time on the stage, and stand on the boards with a cigarette in his teeth, smiling and lost," Stanislavsky recalled.[9] A century

after his dramatic debut, Gorky ranked above even Chekhov as Russia's favorite native playwright.[10]

In 1902, the Russian Academy of Sciences voted to admit Gorky to the literature department, an extraordinary honor for someone who had left school at the age of eight, but when the tsar wrote personally to say how much this distressed him, the academy reversed its decision. Two members, Chekhov and the writer and journalist Vladimir Korolenko, resigned in protest. Tolstoy also would have resigned but did not consider himself to be a member.

Gorky was arrested again at the beginning of the 1905 revolution and interned in the Peter and Paul Fortress, whose cells were normally reserved for regicides and other bomb throwers, but again he was soon freed. Saint Petersburg was in turmoil, and the revolutionaries in all their various groups and factions had emerged to conduct their political activity openly. The revolutionary movement was divided between two principal traditions: the *narodniks*, or populists, who had formed the Socialist Revolutionary (SR) Party and looked to the peasants to create an agrarian socialist society that would bypass capitalism, and the newer, fast-rising Marxist movement, organized by the Russian Social Democratic Labor Party, whose members believed that the small but growing urban working class would be the spearhead of the revolution. The Marxists very soon split into two main factions, the Bolsheviks, led by Lenin, and the Mensheviks, who lacked a single commanding leader.

Gorky had no trouble choosing between the Socialist Revolutionaries and the Marxists. He had a childhood memory of being frightened of the peasants who came to town to sell their wares and get violently drunk. As an orphan working as a dishwasher on a Volga steamer, he was much influenced by the ship's cook, a self-educated workingman who told him that "books will tell you everything you ought to know" and warning him that "vodka's the work of the devil" and that "the village is rotten to the core: you'll get lost among all these pigs."[11] Following the cook's advice, he started reading novels and was taken aback by the romantic picture of Russian peasants drawn by writers such as Tolstoy. "I was aware of the striking difference between book muzhiks and actual muzhiks," he wrote. In fiction, the muzhik had a lot to say about class, who owned the land, and "life's injustice and hardships" and spoke respectfully of women. Gorky's experience was that the real-life muzhik was obsessed with God and the church, or whichever religious sect he belonged to, and looked upon women as "a diversion, but a dangerous diversion."[12]

Gorky's first wife, Yekaterina Peshkova, spent most of her adult life working on behalf of political prisoners, under the tsar and then under the Bolsheviks, and was more sympathetic to the *narodnik* movement than he was. But Gorky's success as a dramatist brought the actress Maria Andreyeva into his life, supplanting Peshkova. She was a committed Bolshevik, and it can be assumed that it was her influence that directed Gorky away from the Mensheviks, though neither she nor anyone else persuaded him to accept the discipline demanded of a Bolshevik. He wrote an essay attacking the politics of Father Georgi Gapon, the *narodnik* priest who led the crowds at the start of the 1905 disturbances, and sent it to Lenin with a note saying, "I consider you the leader of the party, without being a member of it myself."[13]

His allegiance was important, because the Bolsheviks desperately needed money. Gorky's success made him wealthy compared with the revolutionaries, and, more important, his status gave him access to people with money and radical sympathies. After troops had fired on a peaceful crowd of petitioners led by Father Gapon, the popular reaction in the capital was so furious that the regime temporarily lost control. As the censorship collapsed, Gorky launched and briefly ran *Novaya zhizn* (New life), the only Bolshevik daily ever published legally under the tsars. His two arrests disqualified him from being its legal publisher, so Andreyeva took on that role. Twenty issues were produced in November and December 1905, of which fifteen were banned and destroyed; those that made it onto the streets reached a circulation of eighty thousand, helping to transform the Bolsheviks from a little band of conspirators to a mass party.

Andreyeva was being pursued by an unhappy young man named Sasha Morozov, who had been born into one of Moscow's richest families and seemed to be ready to put his vast inherited fortune at the disposal of the revolutionaries. To ensure that it went to the Bolsheviks and no one else, Gorky first arranged for the Morozov family to employ Leonid Krasin—a talented conspirator, the leading Bolshevik in Russia in Lenin's absence, and a future Soviet ambassador to London—as a factory manager.[14] Morozov committed suicide soon afterward, though, and it took several more murky developments before the Bolsheviks got his money.

Gorky, meanwhile, had embarked on a major fund-raising trip through Germany and the United States. It was going well until the Russian embassy tipped off the *New York World* that Maria Andreyeva was not his legal wife. The couple were evicted from their hotel, and a meeting Gorky was due to address in Boston, organized by Alice Stone Blackwell, was canceled. "Gorky

is a puzzle and a vexation to me," Mark Twain wrote privately to a friend. "He came here in a distinctly diplomatic capacity—a function which demands (and necessitates) diplomacy, tact, deference to people's prejudices. . . . He hits the public in the face with his hat and then holds it out for contributions. . . . He has made a grave blunder."[15]

For the Bolsheviks, the most embarrassing fact about this trip was that Gorky left Russia before Lenin had returned from exile. A historic first meeting in the heat of revolution was what the story needed, so the ever-disciplined Andreyeva was instructed during the Stalin years to recall an encounter prior to Gorky's departure, something neither Gorky nor Lenin's widow, Nadezhda Krupskaya, mentioned in their published memoirs.

In reality, they first met in May 1907, at what was then the biggest ever gathering of Russian Marxists: the Russian Social Democratic Labor Party's Fifth Congress, held in London. All the leading figures from all the factions and subfactions were there. This was the only occasion before 1917 when Lenin, Trotsky, and Stalin were all in one building. The congress was to have been held in Brussels but was banned by the Belgian government, and money had to be found at short notice for renting a hall in London. A soap manufacturer agreed to advance a loan, on the condition that Gorky stood the guarantee, which was what brought Gorky and Andreyeva to London. There they got to know Lenin, Trotsky, and others, but not Stalin. Gorky was not hugely impressed by his first glimpse of Lenin. "Something was lacking in him," he wrote. "He rolled his r's gutturally and had a jaunty way of standing with his hands somehow poked up under his armpits. He was somehow too ordinary. He did not give the impression of being a leader."[16] After the revolution, he found this absence of conscious grandeur very winning, however. "Lenin is a complete stranger to any lust for power," Gorky told H.G. Wells. "By nature, he is a puritan, he lives in the Kremlin as simply and frugally as he did in Paris as an emigrant. He is a very great man and an honest one."[17]

When the 1905 revolution ended, a warrant was issued for Gorky's arrest, so he settled on the island of Capri, where he hoped to be able to write in peace. From afar, he heard that the Bolshevik faction had been torn apart by a clash between its strongest personalities, Lenin and Alexander Bogdanov, the future founder of Proletkult, whose allies formed a subgroup called the Vperedists that included Lunacharsky, the future people's commissar for enlightenment, and an economist named Vladimir Bazarov, co-author of what for many years was the standard Russian translation of Karl Marx's *Das Kapital*. Gorky's sympathies were with the Vperedists. He liked their "philosophy

of activity," which he compared favorably with Lenin's "historical fatalism."[18] Lenin took no interest in spirituality but remained focused all his life on practical, material matters; Bogdanov and his allies were what he contemptuously called "god-seekers."

In 1909, Gorky helped the Vperedists set up a training school for revolutionaries on Capri, but it was infiltrated by the police and all ten students were arrested as soon as they returned to Russia. That failed experiment prompted Lenin to organize what proved to be a more successful school in Longjumeau, Paris. In 1910, hoping to effect a reconciliation, Gorky prevailed upon Lenin to visit Capri and meet Bogdanov, Lunacharsky, and Bazarov, but Lenin argued so ferociously that Maria Andreyeva told him off for being rude.

Around 1910, Gorky and Andreyeva's affair burned out, though they continued to live under one roof and were joined on Capri by Peshkova and her and Gorky's young son, Max. In 1913 they all took advantage of a general amnesty to return to Saint Petersburg, to an apartment "full of books and Chinese objets d'art" where Gorky ran an open house for visitors from the worlds of art and journalism, including Mayakovsky and his Futurist friends, the aspiring writer Isaac Babel, and later Victor Serge, who found him wearing thick sweaters indoors to cope with the contrast in climate between Capri and north Russia.[19] There is no record of him making contact with Bolshevik agitators. During the war with Germany, he launched the journal *Letopis* (The chronicle), which was antiwar without being a mouthpiece for revolutionaries and so was tolerated by the police.

Now that he was free of Andreyeva's influence, Gorky also cut his ties with the Bolsheviks and drifted in the direction of the softer Menshevik half of the Russian Social Democratic Labor Party. In 1917, after the fall of the tsar, he launched *Novaya zhizn* (New life), for which he wrote passionate denunciations of violence, including the violence of Bolshevik sympathizers taking to the streets in July 1917. "The disgusting scenes of the madness which seized Petrograd the day of 4 July will remain in my memory for the rest of my life," he wrote. Three months later, aware that the Bolsheviks were preparing to overthrow the provisional government, he warned, "This means, again, trucks tightly packed with people holding rifles and revolvers in hands trembling with fear, and these rifles will fire at the windows of shops, at people at anything! They will fire only because the people armed with them want to kill their fear. . . . People will kill one another, unable to suppress their own animal stupidity."[20]

Afterward, protected by his international reputation and his political record, Gorky was the only visible opponent the Bolsheviks did not harass, arrest, deport, or kill. He was, in Victor Serge's words, "the supreme, the righteous, the relentless witness of the Revolution."[21] In summer 1918, when Lenin was in the hospital recovering from an attempted assassination, Gorky revived their old friendship but used it to intercede on behalf of dozens of people who approached him for aid in dealing with the Cheka or the privations of the civil war. Some of those whose only recourse was to approach Gorky found it deeply humiliating to be in his debt, though. One visit to Gorky's richly furnished home reputedly left Anna Akhmatova with a lifelong aversion to carpets that "smelled so much of dust and a kind of prosperity strange in a city that was dying so catastrophically," but many others came away deeply grateful for Gorky's kind concern.[22] Years later Yevgeny Zamyatin, who had no political motive for praising Gorky, claimed in an obituary written from exile that "dozens of people are indebted to him for their lives and their freedom."[23]

Unsurprisingly, his constant interventions sorely tested Lenin's patience. People died by the hundreds of thousands during the civil war from violence, starvation, disease, or the cold, yet Gorky bombarded the authorities with demands to help a relatively tiny number, nearly all of them people with professional qualifications who were not the Bolsheviks' natural supporters. When a letter arrived in September 1919 with a list of intellectuals Gorky believed to have been unfairly arrested, Lenin wanted to know why Gorky was taking up time over "a few dozen gentry" instead of thinking about the thousands who would be slaughtered if the Red Army lost the civil war. Nonetheless, a commission headed by Lev Kamenev and Nikolai Bukharin, two members of the Bolshevik high command who stayed on good terms with Gorky, was appointed to check on the arrests and release any who were not considered dangerous. "I don't remember a single instance when any request of mine met with a refusal from Ilych," Gorky claimed. "If they were not always fulfilled, it was not his fault but the fault of the mechanism in which the clumsy Russian state has always abounded."[24]

He was putting a rosy glow on a relationship that was going steadily downhill. Gorky suspected, probably rightly, that there was corruption within the Petrograd Communist Party, at the head of which sat the small-minded, cowardly Grigori Zinoviev, who had reached his powerful position by serving for many years as Lenin's "maid of all work." "Don't talk to me about that beast ever again," Gorky once exclaimed to Victor Serge. "Tell him that his

torturers are a disgrace to the human image"[25] Gorky's special bugbear was Samuil Zaks, alias Gladnev, head of the state publishing house, Gosizdat, and married to Zinoviev's sister. "I shan't work or discuss with Zaks and his kind," Gorky informed Lenin by letter.[26]

Before long, Lenin was wishing that Gorky would go back to Europe. They met for the last time in Yekaterina Peshkova's flat on October 20, 1920, an event dramatized in the 1938 film *Man with a Rifle*, though it consisted of little more than polite greetings. The following August, Lenin wrote him, "You are spitting blood and yet don't go away? That really is disgracefully impudent. In Europe, in a sanatorium, you will get well and be able to do something else worthwhile."[27] Gorky departed in September 1921 and in his absence became the target of a fairly nasty press campaign. In a moment of exasperation, Lenin wrote Gorky off as "always supremely spineless in politics, a prey to emotion and passing moods," while in 1922, Trotsky described Gorky dismissively as "the artist whom no one takes seriously in politics."[28]

After a stopover in Berlin, where contact with exiled Mensheviks and Socialist Revolutionaries hardened his opposition to the Bolsheviks, Gorky applied to return to Italy even though it was ruled by Fascists. He was permitted the trip to Italy but denied permission to return to Capri, so he settled in Sorrento, on the coast. There he tried to re-create the busy, extended household where he was the patriarch, but it was not like the old days. The majority of Russian exiles reviled him as a Bolshevik fellow traveler, and those who did not were not necessarily keen to visit Fascist Italy. Gorky was particularly disappointed when Isaac Babel visited Europe in 1925 without coming to see him. Though Gorky's son, Max, and his glamorous wife, Timosha, were there, along with their two young daughters, they were not intellectually stimulating company.

On the other hand, he and Andreyeva had found new lovers. Andreyeva's was Pyotr P. Kryuchkov, known as PePeKryu, a stout, efficient youth with receding blond hair, a moonlike face, and unusually hairy hands. Their affair did not last long, but Kryuchkov used it to insinuate himself into Gorky's household in Sorrento and became his secretary and business manager for the rest of Gorky's life. He was also an OGPU informer who would play an insidious role in Gorky's final years.

Gorky's new love was the mysterious Maria Zakravskaya, who was entitled to style herself as Countess Benkenkorf after her first marriage but generally went by the name of Moura Budberg, from her second marriage, to Baron Nikolai Budberg. That second marriage appears to have been a formal-

ity. From it, she gained an Estonian passport, which she needed after her lover, the British agent Robert Bruce Lockhart, was arrested and life under the Bolsheviks became unsafe. After Lockhart had been released, they resumed the affair. She remained an Anglophile, and through her niece's marriage to an English journalist, Hugh Clegg, she became the great-aunt of a future deputy prime minister, Nick Clegg, who remembered her as "a pretty imposing figure, utterly terrifying for a small boy."[29] Too restless to settle permanently with one man, she divided her time among Gorky in Sorrento, Lockhart in Britain, and her other famous English lover, H.G. Wells.

By 1928, with his sixtieth birthday approaching, Gorky was running short of money and feeling the tug of homesickness. It touched him that each time he wrote to a home in Kharkov for boys from troubled backgrounds, of which he was honorary president, he received twenty-two replies.[30] It made him want to be where he was appreciated and admired. But there was an obvious problem: he had left the USSR because he was sickened by the arbitrary cruelty of the Bolsheviks, whose revolution he had opposed from the beginning, and in his absence the regime had become vastly more cruel and was now controlled by a man he did not know.

What worked in his favor was that the USSR's new master wanted Gorky to come back. Whereas both the tsar's and Lenin's governments had worked on the principle that Gorky was incorruptible and had to be either silenced or tolerated, Stalin had a shrewd instinct for all that was weak and base in his fellow humans. He guessed that Gorky was susceptible to flattery and the promise of material comfort.

The first move in a long, painstaking seduction was made on November 17, 1927, when the Politburo appointed a commission to organize the celebration of the fortieth anniversary of Gorky's literary career, which was deemed to have begun when the young itinerant laborer Alexei Peshkov turned up at a newspaper office in Tbilisi, Georgia, in 1892 and handed over a short story titled "Makar Chudra," which appeared under the pseudonym M. Gorky. ("M" was assumed to stand for Maxim, which was Peshkov's father's name, though a couple of decades later Gorky teasingly claimed that he had only ever used the initial and that it was "quite possible" that it stood for Methuselah, or *mrakobes*.[31] In Russian, *mrakobes gor'kii* means a "bitter obscurant.") The commission, chaired by Nikolai Bukharin, was thus given nearly five years to do its work. The timing of the decision was significant: only days earlier, the most famous of Lenin's old comrades, Trotsky, Zinoviev, and Kamenev, had been expelled from the Communist Party. If Gorky could be

persuaded to return to his homeland, it could help repair the reputational damage the party had suffered from this power struggle.

Early in 1928, Gorky announced that he would visit Russia. The timing was awkward: ten days before his arrival, the first of the infamous series of Stalinist show trials, presided over by a creepy lawyer named Andrei Vyshinsky, began in Moscow's Hall of Columns. "The terror has resumed, without the moral foundation or justification that they found for it earlier," Boris Pasternak observed.[32] As in all subsequent show trials, there was no evidence except for confessions made under interrogation. The defendants were fifty Russian engineers and three Germans employed in the coal industry—exactly the sort of people on whose behalf Gorky had so often intervened in Lenin's time. One of the engineers, Pyotr Osadchy, had even visited Gorky in Sorrento, but Gorky now did not allow himself any skepticism about Stalinist justice. Instead he reflected sorrowfully, "After a series of cases of the most despicable sabotaging by a number of specialists, I had no alternative but to change my attitude toward the scientific and technical professionals."[33] It was painful, he added, to have to admit to himself that he had been so wrong. At the end of the sixty-day trial, five of the defendants were shot; the others vanished into the gulag.

Gorky did not allow this show to spoil his visit. His arrival at Moscow's Belorussian train station on May 28, 1928, was a ceremonial occasion dignified by a reception committee of eminent Bolsheviks, led by Bukharin. He was allocated two enormous dachas, one just outside Moscow and the other in the Crimea, complete with a retinue of cooks, chauffeurs, librarians, gardeners, and cleaners—some of whom were likely to have been paid police informers. In Moscow, he met Genrikh Yagoda, effective head of the OGPU, the organization that had put on the show trial. Gorky sometimes had an artist's gift for reading other men's characters, but it failed him spectacularly in the case of Yagoda, who successfully presented himself as an Old Bolshevik from Gorky's native city of Nizhny Novgorod whose two brothers had died for the revolution. Though in his youth he was "spare, slightly-tanned, and trim-looking,"[34] Yagoda had been corrupted by power both physically and psychologically and was now a greedy, lecherous middle-aged man with receding hair, a toothbrush mustache, and an expanding waistline that apparently somehow gave him a "dignified and important" air. He quickly became obsessed with Gorky's attractive young daughter-in-law, Timosha. Later on Timosha's daughter denied that the two were actually lovers, and if they were, Gorky seemingly did not notice, and neither did her husband, Max (or

else he did not care); still, the rumors persisted.[35] That did not prevent Gorky and Yagoda from becoming fast friends. When Gorky's archives were opened decades later, they were found to contain a "huge and staggering correspondence with Yagoda, which is impossible to read without shuddering," according to author and journalist Arkady Vaksberg.[36]

Yagoda introduced Gorky to others, including his brother-in-law Leopold Averbakh. Gorky knew about the activities of RAPP from the flow of letters he had exchanged with Alexander Voronsky while he was in Sorrento. He had told Voronsky that the organization was "antirevolutionary and anticultural," yet he warmed to Averbakh as another link to the city of his boyhood. He also met Semyon Firin, deputy head of the gulag, and Matvei Pogrebinsky, who ran the OGPU's colony for juveniles, and believed that both men shared his passion for reeducation and rehabilitation.

For the next few years, Gorky's routine was winter in Sorrento and summer in the USSR. Pogrebinsky acted as his host during his visit to Solovetsky in 1929. Afterward, Gorky made the long journey to the Black Sea resort of Sochi, where Stalin was on vacation. Stalin worked hard to win him over. A middle-ranking official named Ivan Gronsky watched them at close quarters. "Stalin was a brilliant artist," he recalled years later. "He played out his friendship with Gorky just as artistically while in actual fact not trusting him. This was a very subtle game. Surprisingly, Gorky was a writer, an 'engineer of human souls,' whose very profession, seemingly, presumes knowledge of human nature, but in my opinion, Gorky was never able to penetrate Stalin's core."[37]

By the time of his next visit, the countryside had been ravaged by Stalin's new policy of forced collectivization, which would bring human suffering on an unimaginable scale but no protest from Gorky. Revolution had not diminished his contempt for peasants. While he was in Germany in summer 1922, Gorky published a series of articles, *On the Russian Peasantry*, that analyzed the 1917 Bolshevik revolution as an orderly urban movement in concept but in reality a cruel, anarchic uprising by semisavage peasants. He hoped that Stalin might teach these people to be civilized. "The peasant is a bandit, predator and anarchist but he is not fated, I think, to remain so for long now," he confided to a friend in September 1927.[38]

In December 1930, Stalin wrote to Gorky in Sorrento to explain why Alexei Rykov was being removed from his position as Soviet prime minister, which he had held since Lenin's death, to be replaced by Stalin's crony Molotov. This was a tricky letter to write, because of all the surviving Bolshevik leaders, the ones to whom Gorky felt closest were the "two Ivanovichs," N.I. Bukharin

and A.I. Rykov. Rykov was being sacked because, like Bukharin, he had opposed forced collectivization, but Stalin did not mention that; instead he wrote that Rykov could not "keep up," whereas Molotov was a "bold, smart, very modern leader." He also threw in the fact that Molotov's real name was Scriabin, as if sharing a surname with a renowned composer was an additional commendation.[39]

In the days preceding that letter, the Soviet public had been served with another show trial involving eight officials of the State Planning Commission, who were said to form the head of a secret organization of two thousand saboteurs. (This one, unusually, did not end with death sentences.) Gorky was shocked by what he read of the trial's evidence and told Stalin in one of his letters, "I was utterly shaken by the new acts of wrecking, so deftly organized. . . . At the same time, however, I was encouraged by the work of the OGPU, the truly indefatigable and vigilant guardian of the working class and Party."[40]

His gullibility in that case can be partly excused because it was not inherently implausible that technicians who had earned good salaries under the tsar might conspire against a communist government. By contrast, his silence over the next show trial reveals so much about how his beliefs had changed in less than a decade that it is worth going into the background in some detail. This was the so-called Menshevik Trial, in March 1931.

This was not the first time socialists had been paraded before the court; twelve Socialist Revolutionaries had been put on trial in Lenin's time. Gorky had never identified with the politics of the SRs and was appalled when one of its members shot and almost killed Lenin in August 1918. He might, therefore, have been expected to be ambivalent about the trial, which began just after his arrival in Berlin in 1922, but actually he fired off a letter to the French novelist Anatole France denouncing it as "a cynical and public preparation for the murder of those who have sincerely served the cause of freeing the Russian people." He also wrote to Rykov, asking him to tell Trotsky that if the trial "ends in murder, it will be a premeditated and foul murder."[41]

Since that was how he reacted when Socialist Revolutionaries were on trial, a threat to imprison or execute Mensheviks, with whom Gorky had a much closer ideological affinity, ought logically to have provoked a Vesuvian reaction from the old man in Sorrento, particularly as two of those implicated were known to him personally. Vladimir Bazarov had been his houseguest on Capri twenty years earlier and a collaborator on *Novaya zhizn* in 1917. He was named in the indictment but was not one of the fourteen defendants produced in court. No explanation for his absence was given; it can be assumed

that his torturers failed to break his spirit sufficiently. The most voluble of the defendants was an extraordinary character named Nikolai Sukhanov, who had edited Gorky's wartime publication *Letopis* and had since written what was indisputably the finest eyewitness account of the events of 1917, in which he played only a walk-on part but somehow managed to be omnipresent. It almost defies belief that Gorky could have let go unchallenged a story that Bazarov, or Sukhanov, or any other Menshevik, had turned into a terrorist. The Mensheviks were distinguished from the Bolsheviks by their reluctance to use violence, as Gorky well knew. Yet in public he said nothing. Privately, he sent Yagoda a letter very different from the one he had written in 1922: this one dripped with fury directed at the victims. "It does not surprise me that Sukhanov, a boy with sickly self-pride and a psyche of a swindler, ended up in the dock for criminals," he wrote.[42]

Others who had known Gorky in better days and whose circumstances were now desperate hoped, in vain, that the writer would help them. Some of those who tried to contact him were blocked by the invisible barriers that the authorities had built around their captive author. Gorky had worked with Voronsky, the editor of *Krasnaya nov*, since its foundation. In January 1925, a letter arrived in Sorrento signed by a different editor. Gorky correctly surmised that Voronsky had been ousted by his enemies from RAPP and refused to contribute to the magazine again until he was reinstated. When he learned in August 1927 that Voronsky had been ousted a second time, he severed all contact with *Krasnaya nov*.[43] In autumn 1931, while Gorky was in the USSR and enjoying the celebrity treatment, Voronsky was being harassed by the police. He made three desperate attempts to call Gorky; each was blocked by Kryuchkov, who increasingly ran Gorky's life, taking his instructions from Yagoda.[44]

The talented Victor Serge visited Gorky in Saint Petersburg in the early days of the revolution. Brought up in France, Serge was the child of Russian émigrés. His mother came from Nizhny Novgorod, so he appealed to Gorky's sentimentality about the city of his childhood. By 1931, Serge was in severe difficulties because of his sympathy for Trotsky, which would soon land him in Siberia. He also tried to contact Gorky, only to be blocked by the ubiquitous PePeKryu. He caught a glimpse of the famous writer being driven by a chauffeur along a Moscow street and thought that he looked like "an algebraic cipher of himself . . . thinned and dried out, his head bony and cropped inside a Turkish skull-cap, his nose and cheekbones jutting, his eye-sockets hollow . . . an ascetic emaciated figure with nothing alive in it except the will

to exist. . . . All his collaborators on *Novaya Zhizn* of 1917 were disappearing into jail and he said nothing. Literature was dying and he said nothing."[45]

A new feature of Gorky's winters in Sorrento was a houseguest chosen by Genrikh Yagoda, who evidently was not satisfied with having PePeKryu watching over the semicaptive. One year it was Pogrebinsky, who stayed for four weeks despite the risk of an international scandal if the Fascist authorities had discovered a senior OGPU officer on their soil. In 1931, Gorky's last winter in Sorrento, it was Averbakh.

Stalin did not trust either Yagoda or Averbakh. In July 1929, Stalin had written to Molotov complaining about Averbakh and other young Stalinist toughs, who thought they could turn the party into a "discussion club" where they could "review" policy.[46] In July 1931, Stalin made his first attempt to curb or be rid altogether of Yagoda by inserting an official named Ivan Akulov as first deputy to the OGPU's terminally ill chairman, Vyacheslav Menzhinsky, over Yagoda's head. But for once the general secretary was dealing with an opponent capable of fighting back, and the professionals inside the OGPU rallied to their threatened boss. "The entire party organisation in the OGPU was devoted to sabotaging Akulov," one of them is reported to have confessed subsequently.[47] Stalin had to remove the intruder in October 1932, but it rankled. When he finally moved directly against Yagoda in 1936, he complained that the police were "four years behind" in their work.

Ostensibly, Averbakh went to Sorrento to encourage Gorky to return to the USSR permanently, but it can be surmised that he had another, undeclared mission. He would hardly have spent months in Gorky's company without dropping hints that his brother-in-law Yagoda was being unfairly treated by Stalin. The suspicion that Averbakh was up to something probably explains why Kryuchkov was subjected to the unusual privilege, for a junior functionary, of being summoned to meet Stalin in person. He spent twenty minutes in Stalin's office on March 27, 1932, and was called back for a second session the same evening lasting another half hour. It can be assumed that an intimidated PePeKryu told the dictator everything that was taking place in Sorrento.

Averbakh returned from Sorrento "proud and happy" to report to Yagoda that his mission had succeeded. He had, as events would prove, charmed Gorky, but he also had underestimated Stalin, who moved with the sudden decisiveness that made him a master of the power game. On April 23, 1932, by a decree of the Central Committee, RAPP was suddenly abolished. There would be only one USSR Writers' Union, and Gorky, it was announced soon

afterward, would be its honorary chairman. Ivan Gronsky, the young editor of *Izvestya*, would be its actual boss.

There would also be only one literary style, called Socialist Realism. The term was used first in May 1932 by Gronsky, who later modestly attributed it to Stalin, only to reclaim authorship after Stalin was dead. There was much confusion about what it actually meant, but it certainly required the qualities of *partiinost* (party consciousness) and *narodnost* (popular consciousness), which ruled out works that were either anticommunist or too obscure or experimental to be understood by the masses. The critic Yermilov, who had been named in Mayakovsky's suicide note, defined it as "an artistic expression of the style of socialist reality." In time, it also precluded pessimistic works that did not presage the ultimate triumph of socialism, after another minor party official had laid down the rule that "socialist realism is a style that says 'Yes' to life." It did not demand that published writers have proletarian backgrounds, however.

The message was unmistakable. Averbakh, who was still only in his late twenties, was finished as a literary commandant, and there would be no more policing of writers' social backgrounds. A former aristocrat such as Alexei Tolstoy could be a successful and highly paid "socialist realist" writer as long as he followed the party line. RAPP's leadership was so shocked that the next issue of *Na literaturnom postu* did not even mention the new decree at all and soon closed down, while RAPP's weekly journal, *Literaturnaya gazeta*, which gave it only a grudging mention, was placed under new management.

Meanwhile, almost everyone else in the field of Soviet literature was thoroughly relieved to see the last of Averbakh and his crew. Visiting Herzen House in Moscow on the day of the announcement, Nadezhda Mandelstam came upon the writers Nikolai Tikhonov and Pyotr Pavlenko cracking open a bottle of wine. "But I thought you were a friend of Averbakh," she told Pavlenko disingenuously.[48] The smarter members of RAPP, such as Yermilov and Alexander Fadeyev, quickly abandoned Averbakh, who found himself almost friendless. During the first session of the Organizing Committee of the Writers' Union, in November 1932, he and Gronsky exchanged insults, for which Gronsky won loud applause.

Gorky was in Sorrento during these events, so no matter how much he thought Averbakh was being wronged, it was too late to object when at last he settled permanently in Moscow. Besides, Stalin overwhelmed his misgivings in what was arguably the greatest public display of flattery that any regime in history has ever poured upon a living writer. As Gorky alighted in

the Soviet Union, he learned that his name was to be written all over the map. His native city, Nizhny Novgorod, and its surrounding province were renamed in his honor; the district outside Moscow where Gorky's country dacha was located became Gorky district; and Moscow's main park became Gorky Park. The Moscow Art Theatre, on Tverskaya Street, one of Moscow's oldest streets, became Gorky Theatre on Gorky Street. Ivan Gronsky, who survived many years in the gulag with his faith in the Stalinist system undamaged, claimed in his memoirs that he protested that this was too much adulation, and that if the Moscow Art Theatre were to be renamed after a writer, it should be called the Chekhov Theatre. Stalin replied, "That doesn't matter. He [Gorky] is an ambitious man. We have to bind him to the party."[49]

In his anxiety to "bind Gorky to the party," Stalin also gave the writer a measure of influence and access to the center of power beyond the dreams of any other Soviet citizen. In his history *Stalin*, Simon Sebag Montefiore wrote, "Stalin took his children to see Gorky where they played with his grandchildren. [Anastas] Mikoyan brought his sons to play with Gorky's pet monkey. Voroshilov came for sing-songs. Gorky's granddaughter played with Babel one day; Yagoda the next."[50]

On October 26, fifty writers were invited to another session in Gorky's home, one that would turn out to be the most significant of its kind, although Gorky had taken the sensible precaution of leaving the most independent-minded writers of the day, including Akhmatova, Bulgakov, and Pasternak, off the guest list. After being greeted by Gorky on the stairway, the guests waited, thrilled, for the arrival of Stalin himself with three of his most powerful acolytes, Molotov, Voroshilov, and Lazar Kaganovich. They took dinner, with Gorky sitting at one end and the four most powerful men in the country clustered around him. Stalin gave a speech urging the writers to "show our life truthfully," because if they did, they would show Soviet society moving toward socialism: that, he said, was "socialist realism." Here he delivered what became a famous epigram, that writers were "engineers of the human soul."

Drink flowed freely. One well-known drunkard at the table was Alexander Fadeyev, who had fought a rearguard action in defense of his old comrades in RAPP before comprehensively disowning them and securing for himself a long career at the head of the new writers' union. He proposed that Mikhail Sholokhov should sing a Cossack song. One writer daringly pushed his glass forward to clink glasses with Stalin. A minor poet shouted out that they should drink Stalin's health. At this point a novelist named

Georgi Nikiforov, who was sitting opposite the great man and was embold-ened by having his glass refilled several times personally by him, jumped up and announced, "I'm fed up with this! We have drunk Stalin's health one mil-lion, one hundred and forty-seven thousand times. He is probably fed up with it himself." After a moment's horrified hiatus, Stalin stood, stretched his hand, and shook Nikiforov's fingertips. "Thank you, Nikiforov, thank you," he said. "I am indeed fed up with it."[51] Nikiforov was not made to suffer for this boldness for as long as Gorky was alive. After Gorky's death, he was shot.

Yagoda was not among the guests at this dinner, though it can be surmised that he spent the next day doing his utmost to find out exactly what hap-pened, because Gorky had become something of an obsession with him. Whenever Gorky met Stalin or other members of the Politburo, Yagoda would visit Kryuchkov's flat afterward, demanding a full account of what had been said. He took to visiting the public baths with Kryuchkov. One day in 1932, Yagoda handed his valuable spy $4,000 to buy a car. It is impossible to measure this sum against the weekly wage of a Soviet factory worker, let alone the income of a starving peasant, because ordinary Soviet citizens were for-bidden to hold foreign currency; what can be said is that it represented nearly three weeks' wages for the president of the United States. The next year, Ya-goda handed over another $2,000 toward the cost of closing up the Gorky household in Sorrento. Gorky's lover, Moura Budberg, and daughter-in-law, Timosha, were also wooed with gifts of foreign currency, as part of Yagoda's campaign to "monopolize control of the Gorky household."[52] He also con-stantly went to Gorky's house, regaling him with tales of the grim work he had done to protect the regime, including the story of how a former general in the tsar's army who ran an émigré organization was kidnapped in daylight on the streets of Paris in 1930 and taken away to be killed. Gorky reputedly protested at having to listen to these tales he did not want to hear. One eve-ning, he was having dinner with Isaac Babel when Yagoda appeared unin-vited, sat down, and looked with distaste at the Russian wine they were drinking. He called it "Russian swill" and called for French wine.[53]

Such persistence paid off. In August 1933, a delegation of 120 writers whom Gorky had helped round up visited a vast new engineering project, a 227-kilometer canal that connected Leningrad, on the Baltic coast, with Arkhangel, on the White Sea. The writers worked in the spirit of the Five-Year Plan, planning and producing a three-hundred-page book in only five months. Translated into several languages, it was the first literary work to introduce Western readers to the word "gulag," though not in the pejorative sense that

Alexander Solzhenitsyn inserted into everyday English in the 1970s. In this book, the gulag was a body of outstanding public servants dedicated to rehabilitating criminals by teaching them the value of hard work. It had been an old dream of Russian administrators to construct a quick route from Arkhangel to Leningrad, averting the need to navigate the vast distance around the Scandinavian coast. The gulag's slave laborers made that dream a reality in two years, using wooden spades, handsaws, pickaxes, and wheelbarrows.

The White Sea Canal, edited by Gorky, Averbakh, and Firin—the writer, the cultural commissar, and the deputy commander of the gulag—was indubitably a work that "said 'Yes' to life." It also had uplifting stories of rehabilitation and contained characters remarkably like the fictional revolutionaries who had populated Gorky's novel *Mother*, except that now the heroes wore the uniforms of camp guards. The book had humor, as in the rib-tickling description of how Matvei Berman, head of the gulag, had caught the flu in the far north and discovered that the only people qualified to treat him were a thief, a counterrevolutionary, and a nurse who had thrown acid in her cheating husband's face. Having observed, correctly, that there was antagonism between common criminals and political prisoners, the authors empathized with the criminals, "who regarded themselves, not without pride, as the proletarian elements in the camps."[54] Vasily Grossman's monumental novel *Life and Fate* tells a different story of the cruelty inflicted on political prisoners by violent criminals. It has been conservatively estimated that 25,000 prisoners died in the construction of the White Sea Canal, people who were worked to death in order to construct a waterway too shallow for oceangoing ships, but that reality passed Gorky by.[55]

Being surrounded by luxury and courted by the powerful did not bring Gorky happiness. He was frequently ill and in constant conflict with the vacuous careerists sent by Stalin to work with him. He missed Moura Budberg, who wisely refused to join him permanently in their homeland, though she was able to make unpublicized visits to the USSR with no visa problems, implying that Yagoda valued her highly.

For Gorky, the worst blow was when Maxim Peshkov, the son he adored, fell ill. Two Kremlin doctors, A.I. Vinogradov and L.G. Levin, were called to his bedside, but he died on May 11, 1934. Every morning after his death, his glamorous widow was visited by the balding, middle-aged, and sinister Yagoda, dropping in for coffee on his way to work, grander than ever, because one day before Maxim's death, the nominal head of the OGPU, V.R. Menzhinsky, finally succumbed to the illness that had long kept him away

from the office. Now Yagoda was chief in name as well as in fact of an enlarged department that bore the new name of the NKVD.

Gorky outlived his son by a little over two years. By now, he was virtually a prisoner in his palatial home, watched over by Kryuchkov. His influence had been immense for as long as he needed to be persuaded to settle permanently and lend his prestige to Stalin's rule. Now that his Sorrento home had been cleared out and he was too ill to leave even if he had had a home abroad, his influence went into free fall. Gorky had come to respect and like Lev Kamenev and secured him a job as head of the International Publishing House. Early in 1935, Kamenev was arrested and sentenced to five years in prison. With some difficulty, Gorky arranged to see Stalin on the evening of March 3 to plead for Kamenev. Afterward, as a token of just how little Stalin cared about what Gorky said or thought, Kamenev's sentence was doubled, to ten years.

Gorky fell seriously ill at the end of May 1936. He was seen by Dr. Levin, the same physician who had been at Maxim's deathbed and a good friend of Boris Pasternak, though Pasternak thought his friend's faith in the Soviet system was naive. He was accompanied by a consultant, Dmitri Pletnev. On June 8, when it was thought death was imminent, Stalin paid a call, accompanied by Molotov and Voroshilov. Stalin was in a foul temper, spoke rudely to the women present, and when he saw Yagoda in another room angrily ordered him to get out—an outburst that must have humiliated and alarmed his police chief. Moura Budberg was also there; she stayed for the funeral, then left for Great Britain and did not return to Russia until long after Stalin's time. Stalin returned to the house while Gorky lingered on. He died on June 18 and was accorded a magnificent state funeral in which Stalin and Molotov led the pallbearers.

Maxim Gorky had thrown away the reputation he once possessed worldwide as an incorruptible fighter for justice by choosing to be an apologist for one of the most repressive regimes that has ever existed, a man who visited dreadful labor camps and thought they were enlightened institutions for rehabilitation and was blind to what the rural population suffered during collectivization. Yet it was better for the Soviet Union's intimidated citizens to have Gorky living among them. In the years 1932 to 1935, when Gorky was alive and well, Isaac Babel, to take one example, knew that he was safe from arrest. When asked, he would say that the police would not come for him "while the Old Man is alive." Even a corrupt Maxim Gorky was better than Maxim Gorky dead, when thousands had reason to miss him.

The women in Gorky's life generally prospered after he was gone. His granddaughter entered a dynastic marriage with the son of the police chief Lavrenti Beria, which guaranteed her a privileged position in society until Beria was shot. Moura Budberg made her next appearance in the USSR in 1959 as the companion of the millionaire publisher George Weidenfeld.

But for men, knowing Gorky well proved to be the kiss of death. Yagoda remained in office long enough to organize the first of the great Moscow show trials of the Old Bolsheviks, staged in August 1936, in which Kamenev was one of those sentenced to death. He was sacked in September 1936 and arrested in March 1937. Leopold Averbakh and Semyon Firin, co-authors of Gorky's book about the White Sea Canal, were shot on August 14, 1937. Pogrebinsky, Gorky's former guest in Sorrento, escaped execution by committing suicide. In March 1938, the greatest of all the Stalinist show trials opened in the Hall of Columns. The three lead defendants were the Ivanovichs, Bukharin and Rykov, and Yagoda, all confessing to terrorism, espionage, and other crimes. Further down the list of defendants were Kryuchkov and the physicians Pletnev and Levin. Dr. Vinogradov was absent only because he had died under interrogation. The people they were supposed to have murdered included Gorky and his son.

Yagoda was not a wholly broken man when he appeared in the dock. He readily confessed to crimes he knew would lead to his execution, yet obstinately insisted that it would have made no sense to murder Maxim Peshkov; he secured a small victory when the court went into secret session. What was said then has never been made public, but afterward it was announced that Yagoda had "fully admitted to organizing the murder of Comrade M.A. Peshkov, stating that he had pursued personal aims as well as conspiratorial aims in committing this murder."[56] Fifty years later, when the Soviet authorities finally declared it a mistrial, every defendant except Yagoda was posthumously rehabilitated.

There has been much speculation over whether Gorky, or his son, or both, actually *were* murdered and, if so, by whom. Gorky's death came at a convenient time for Stalin, but it would have been extremely difficult to arrange without the cooperation of Yagoda or Kryuchkov, neither of whom had a plausible motive for wanting him dead. It is more likely that both the exhausted, discredited writer and his sickly, alcoholic son died of natural causes.

5

The Stalin Epigram

"Why complain?" M. used to ask. "Poetry is respected only in this country—
people are killed for it."

—NADEZHDA MANDELSTAM

At around one o'clock in the morning on May 14, 1934, police raided a flat
at 5 Furmanov Street, Moscow, where Osip and Nadezhda Mandelstam had
guests. One was their friend Anna Akhmatova, on a visit from Leningrad;
the other was a poet and translator named David Brodsky, who had invited
himself and would not leave. Brodsky was the only one in the room with a
secure position in Soviet society, but the two women thought he was a bore.
Posterity is with the women: from seven decades' distance, we see a room
peopled by one uninteresting man and three of the most extraordinary cre-
ative spirits of the twentieth century.

To focus, for now, on Osip Mandelstam: no one else in Russian literature
has a posthumous reputation so much greater than any recognition achieved
during his or her lifetime. His contemporaries thought him an odd fellow.
He never held a steady job, nor did he try to conform to the strict norms of
the new Soviet world. He and his tough wife lived like itinerants, scratching
out a living by translating, relying heavily on friends such as the critic Viktor
Shklovsky, who recalled how "Osip Mandelstam grazed the house like a sheep
and wandered through the room like Homer," and the Futurist poet Victor
Khlebnikov, who nicknamed him the "marble fly."[1] In 1986, almost fifty years
after Mandelstam's death, the Nobel Prize–winning Russian exile Joseph
Brodsky complained, "The English-speaking world has yet to hear this

nervous, high-pitched pure voice shot through with love, terror, memory, culture and faith—a voice trembling, perhaps, like a match burning in the high wind, yet utterly inextinguishable—the voice that stays behind when the owner is gone."[2] That voice, which Brodsky likened to that of W.B. Yeats, was kept alive by a dedicated band of friends who loved to hear Mandelstam recite his unpublished poetry. The two most important members were the women in that room, particularly his extraordinary wife, Nadezhda, whom he had met in Kiev during the civil war. Anticipating his arrest, he beseeched her, "Preserve my speech forever, for its aftertaste of unhappiness and smoke."[3] She did so with amazing fortitude.

He was more restless than usual that evening in 1934, not least because of the unwanted guest parked in his front room. The others hoped that an absence of food would induce David Brodsky to leave—but no, he even followed Mandelstam when he went to a neighbor's flat to borrow an egg. Upon their return, he carried on talking from a chair in the main room long after the two women had taken refuge in the kitchen. He was there when the men in heavy overcoats arrived.

The raid had been at least half expected. An incident in the Leningrad Publishing House a few days earlier had scandalized the literary establishment: Mandelstam had assaulted the venerated Alexei Tolstoy. The cause was an incident that had occurred two years earlier, in 1932, when the Mandelstams were living in a single back room in Herzen House and suspected that the couple living opposite the back entrance was spying on them. After a verbal exchange in the yard between Osip Mandelstam and the woman, her partner, a writer named Amir Sargidzhan, came to their door to remonstrate; when Nadezhda opened it, he hit her hard. Tolstoy chaired a writers' "court of honor" to hear Osip Mandelstam's complaint against Sargidzhan, and it dropped the matter, implying that both parties were at fault.[4] Still seething over this inconclusive verdict two years later, Osip Mandelstam slapped Tolstoy's face in front of half a dozen witnesses. The Mandelstams then took the first train back to Moscow. They assumed that the early morning knock on the door was Tolstoy's revenge.

Three officers searched the apartment until dawn, combing Mandelstam's papers as if there were one in particular that they sought but could not find. As the search ended, Brodsky raised his hand, like a schoolchild, and asked to go to the toilet. "You can go home," one of the officers told him, brusquely. "What?" he asked. "Home!" the man repeated. Brodsky survived the Stalin era, became a respected translator and poet, and died in his early seventies,

just in time to avoid the humiliation of having Nadezhda Mandelstam accuse him in her memoirs of being a police agent, probably unfairly. It appears that his presence that fateful night was simply a coincidence.

The officers confiscated about forty-six manuscript pages—not much of a haul for so long and thorough a search, because the Mandelstams were better at hiding manuscripts than the three detectives were at finding them. They took Mandelstam away to be questioned, without a hint of whether the raid was brought on by a complaint from the aggrieved Tolstoy or something much worse. This was the question that exercised the exhausted women as they hurried to the homes of trusted friends to ask them to take care of the manuscripts the police had missed. Akhmatova shrewdly advised against touching the papers that had been strewn across the main room of the flat. This was good advice, because one of the officers came back the next day, still looking for something. Seeing the papers undisturbed, he did not suspect that a haul of incriminating manuscripts had been moved.

The Mandelstams, perhaps surprisingly, had a friend in the Kremlin. Since 1922, when they needed help to rescue Osip's brother from a temporary brush with the OGPU, they had been in contact with Nikolai Bukharin, a major figure in early Bolshevik history who had led the opposition to Stalin's brutal collectivization campaign. Bukharin lacked Stalin's ruthless will to dominate but, unlike most other Bolsheviks who had opposed Stalin, still had influence. Lenin's unpublished testament, which had a postscript calling for Stalin to be removed from office, had described Bukharin as "the favorite of the whole party." Alexander Solzhenitsyn, who seldom had a good word for any communist, conceded that Bukharin was "the man who seems, in the perspective of time, to have embodied the highest and brightest intelligence of all the disgraced and executed leaders."[5] Nadezhda Mandelstam gratefully recorded that "all the pleasant things" they accumulated over twelve years were owed to this invaluable contact in the Kremlin, including their apartment, ration cards, and a contract from the state publishing house that paid Osip an advance for a collection of his poems, although not even Bukharin's intervention could get it published. Long after Bukharin and her husband were dead, Nadezhda Mandelstam imagined she could still hear Bukharin on the phone, in a fury, wanting to know what was holding up publication. Her husband was especially struck by Bukharin's secretary, Korotkova, whom he described as "really and truly, an absolute squirrel, a little rodent. She gnaws a nut with every visitor and runs to the telephone like an inexperienced young mother to a sick baby . . . that little squirrel is genuine truth with a capital

letter and at the same time she is that other truth, that stern card-carrying virgin—Party Truth."[6]

When Nadezhda Mandelstam arrived in Bukharin's huge office at the headquarters of the newspaper *Izvestya* in May 1934, the desperate wife of an arrested man, he was friendly but subdued. She remembered, "He had always been a man of passionate temperament, quick to anger, but his way of venting his indignation changed with the times. Until 1928 he would shout 'Idiots!' and pick up the phone, but after 1930 he just frowned and said: 'We must think whom to approach.'" Pacing the floor, Bukharin inquired anxiously, "He hasn't written anything rash?" Nadezhda reassured him that he had done no such thing.

That was simply untrue. There was a poem that she and Akhmatova were hoping that the police would never find. For years afterward, she felt guilty about lying to Bukharin, but she knew that if she told the truth, he would say that there was nothing he could do to help. Instead, he agreed to do what he could. Others the women approached were too scared of the all-powerful NKVD to get involved.

Unlike so many others who were in trouble, they did not go to Maxim Gorky. Akhmatova had met him in Petrograd before the revolution and did not like the opulence of his heavily carpeted flat. Osip Mandelstam had approached him after the civil war to plead for his signature on a voucher that would have entitled him to a sweater and trousers and was annoyed when Gorky crossed out the word "trousers." Nadezhda never met him and though she did not ask for his help, she never forgave his failure to act after Osip's arrest, even suggesting in her memoirs that Gorky thought that a Jew who slapped a Russian writer deserved to be taught a lesson—an unfair claim to lay against Gorky, who abhorred anti-Semitism.[7] In her distress, she did not notice that her husband's arrest occurred the same week as the death of Gorky's son. She had heard that Gorky's ex-wife, Yekaterina Peshkova, ran the Political Red Cross, an unpaid service for the relatives of prisoners, and went to ask for her help, oblivious that Peshkova might be in deep mourning. Fortunately, Peshkova had an assistant, an obscure hero named Mikhail Vinaver, who gave Nadezhda a wealth of practical advice and information and whom she remembered with gratitude for the rest of her life. Vinaver's position was analogous to that of a doctor who had spent too long caring for patients with contagious diseases: inevitably, in the end, he, too, vanished into the gulag.

Boris Pasternak had an uneasy relationship with Mandelstam. They were rivals who had a mutual respect for each other's gifts, though they were out

of sympathy with each other's attitudes toward poetry and politics. None-theless, he volunteered to help. Nadezhda suggested that he see Bukharin, whom Pasternak did not know. He went to the *Izvestya* office to find Bukharin and ended up leaving a note. Then, according to a memoir published abroad in the 1950s, "it happened about this time that some high government or party dignitary died. In accordance with the custom the body lay in state in the Columned Hall of the House of Unions, while Soviet notables stood guard of honour and the public filed past. Pasternak went to the Columned Hall and noticed among the guard of honour . . . Bukharin."[8] The anony-mous writer evidently did not know that Mandelstam's arrest occurred three days after the death of Vyacheslav Menzhinsky, chairman of the OGPU and the "high" dignitary lying in state.

It is likely that Bukharin had been in a quandary over what to do about the Mandelstam case before Pasternak approached him. To have gone directly to Stalin over an obscure poet who had never made a proper attempt to be a good Soviet citizen might have done nothing other than rouse the dictator's suspicions. Pasternak, on the other hand, was a published poet with a clean record. With the first writers' congress due to be held very soon, Bukharin was able to attach a note to the bottom of a memorandum to Stalin mention-ing that "Pasternak, too, is very upset."

"It was Bukharin's way of indicating to Stalin what the effect of M.'s arrest had been on public opinion," Nadezhda Mandelstam remembered. "It was always necessary to personify 'public opinion' in this way. You were allowed to talk of one particular individual being upset, but it was un-thinkable to mention the existence of dissatisfaction among a whole section of the community—say, the intelligentsia, or 'literary circles.' No group has the right to its own opinion. Bukharin knew how to present things in the right way."[9]

Bukharin went one step further. He raised the case personally with the newly promoted Genrikh Yagoda, only to emerge from the Lubyanka shaken, alarmed, and defeated. When Nadezhda Mandelstam revisited the offices of *Izvestya*, Bukharin's squirrel-like secretary came out of his office in tears to say that there was no point in her coming back. Nadezhda understood why.

Bukharin had gone to Yagoda's office assuming that Mandelstam had been arrested over something trivial, such as the assault on Alexei Tolstoy. Yagoda set him straight by reciting, from memory, a sixteen-line poem that was a direct and insulting personal attack on Stalin. Mandelstam had already con-fessed to being its author. The first four lines described a desolate country

where no one's voice could be heard over any distance above ten paces and all
that people ever spoke about was the mountain man in the Kremlin.

His fat slug fingers greasy as dirty plates
Words exact as leaden weights.

His cockroach whiskers beam
his tall boot tops gleam.

Around, a rabble of thin necked hangers on,
Whose underboss services amuse the don.

Someone whistles, someone whimpers, someone mews,
Only he can point and make the thunder spew,

Tossing orders out like horseshoes, low and high
One in the groin, the forehead, the brow, the eye.

And every hit is a delicious treat
For the broad-chested boss Ossete.[10]

There was a genealogical error in the last line, a mistaken belief that Stalin
was an Ossete. The Ossetes were a small group living in some of the highest
regions of the Caucasus who preferred to be ruled by Russians than by Geor-
gians. This mistake did not in any way disguise who was being described here.
Yagoda may have enjoyed reciting the lines because he did not like Stalin
either—and Bukharin's horrified reaction doubtless amused him—but that
would not deter him from having Mandelstam tortured and shot as soon as
Stalin gave the order.

The Mandelstams never found out which of their friends had betrayed
them. They had never been so foolish as to write the poem down: someone
else had, after hearing it recited, and had handed it in. Nadezhda Mandel-
stam believed that her husband recited it twice, to two groups of six. He
changed one couplet between readings, which ought to have whittled the list
of suspects down to just half a dozen, except that he had been more rash than
she realized. When he saw Boris Pasternak on the Tverskoi Boulevard,
in April 1934, he recited it in that public place and may have done the same
on other occasions. Pasternak was shocked. "I didn't hear this, you didn't

recite it to me," he is reputed to have replied, "because, you know, strange and terrible things are happening now: they've begun to pick people up. I'm afraid walls have ears, and perhaps even these benches on the boulevard here may be able to listen and tell tales. So let's make out that I heard nothing."[11]

Given that the risk was so appalling, it is worth asking what exactly drove Mandelstam to it. It was not that he generally hated Bolsheviks. There were six poets altogether in what is called the Acmeist movement, which emerged in Saint Petersburg in 1912, a cosmopolitan school that Mandelstam defined as "nostalgia for a world culture." Three were minor poets; the other three—Anna Akhmatova, Nikolai Gumilev, and Mandelstam—are recognized as among the greatest of their generation. Of those three, Mandelstam was the least hostile to the Bolshevik revolution. "It is not that Mandelstam opposed the political changes taking place in Russia," Joseph Brodsky wrote. "His sense of measure and of irony was enough to acknowledge the epic quality of the whole undertaking."[12] He had been offered Lithuanian citizenship by that country's ambassador, Yurgis Baltrushaitis, because his father was from Lithuania, but chose to live under communism.

Unlike Gumilev, Akhmatova, or Pasternak, Mandelstam was in contact with the revolutionary underground before 1917. The son of German-speaking Jews, he was fourteen years old when the 1905 revolution broke out and thought of himself as a Marxist until he was approached by a boy from his class named Boris Sinani, the son of an eminent Saint Petersburg physician in touch with the Socialist Revolutionary Party. The younger Sinani, who died just before the 1917 revolution, "offered to be my teacher, and I did not leave him for as long as he lived but followed after him, delighted by the clarity of his mind, by his love of life, by the presence of his spirit."[13] In the Sinani household, Mandelstam met the veteran SR leader Mark Natanson, who had such vast experience as a political organizer that even Lenin was somewhat in awe of him, and a formidable character named Grigori Gershuni, organizer of the terrorist wing of the SR party, who "was possessed of an extraordinary power of influencing those with whom he came into contact."[14] These were examples of the people who so perplexed Gorky: members of the urban intelligentsia who admired what they believed to be the innate nobility and revolutionary potential of the Russian peasant, despite having had little or no contact with actual rural dwellers.

Mandelstam was arrested during the civil war by the White Army in the Crimea and by the Menshevik government in Georgia, but the Bolsheviks left him alone, and, apart from the lasting and valuable link he formed with

Bukharin, he generally avoided them. One day in 1918, he was having breakfast in a café in the Kremlin—which in those early egalitarian days was open to outsiders—when an excited report went around the room that Trotsky was on his way down to have coffee. Mandelstam picked up his raincoat and left, uninterested.

Early on, he was offered a position in the People's Commissariat for Foreign Affairs but turned it down. Bizarrely, in the chaotic early days when anything could happen, there was an attempt to recruit him to the Cheka, although anyone less suited to the work of that grim organization would be hard to imagine. The approach came from a poetry-loving chekist with a strange history.

In 1917, the SR party had divided into two. One group, the Left SRs, whose figurehead was the elderly Natanson, supported the Bolsheviks and briefly held posts in the Soviet government. The arrangement ended in July 1918, when, in defiance of Natanson, younger Left SRs who opposed Lenin's decision to sign a peace treaty with Germany launched a coup with the assassination of the German ambassador, Count Wilhelm Graf von Mirbach. His killer was a teenage Left SR named Yakov Blyumkin, "tall, bony, his powerful face encircled by a thick black beard, his eyes dark and resolute," who worked for the Cheka.[15] The Bolsheviks chose to overlook what they saw as a minor offense and even allowed Blyumkin to retain his post as an officer in the Cheka; in 1921 he was enrolled in the Communist Party.[16] Blyumkin was a poetry lover who could recite the works of living poets from memory. One of Gumilev's last poems records that "the man amidst the crowd who shot the imperial ambassador came up to shake my hand."[17] He met Mandelstam in Mayakovksy's Poets Café early in 1918 and tried to entice him to join the Cheka by boasting about the arrest of an art historian who was likely to be shot, oblivious to how vehemently Mandelstam opposed the death penalty. Mandelstam complained about the arrest to another poetry-loving Bolshevik he knew, a young woman with good political connections named Larisa Reisner, who escorted him to the Lubyanka to appeal directly to the chairman of the Cheka, Felix Dzerzhinsky. The art historian was saved, but Blyumkin was furious. When he encountered Mandelstam later, during the civil war, he threatened him with a gun.

During the 1920s, Mandelstam's worst problems were not with the communist authorities but with fellow inhabitants of the literary world. He made an enemy of Osik Brik, Mayakovsky's acolyte, by refusing to bend to the fashion for producing poetry accessible to a mass audience. "To address poetry to

an audience altogether unprepared for it is just as ungrateful a task as to have oneself impaled. A totally unprepared listener will not understand anything at all; or, alternatively, a poetry liberated from all culture will cease to be poetry,"[18] he wrote in a direct rebuttal of Mayakovsky. According to Nadezhda Mandelstam, it was in the salon run by Brik, where artists and chekists mingled, "that M. and Akhmatova were first branded as 'internal émigrés.'" She added, "In the first phase of the campaign against him, right up to May 1934, the methods used had had nothing to do with either literature or politics, but had quite simply a vendetta on the part of writers' organizations which enjoyed support 'up above.'"[19]

The first truly nasty incident that Mandelstam suffered—worse than having a gun waved in his face—began with careless editing by the Zemlya I Fabrika (Land and factory) Publishing House, which had commissioned Mandelstam to update an earlier translation of a French work. When the book came out, he was alarmed to see that he had been given sole credit and the contribution of the previous translator, A.G. Gornfeld, ignored. Mandelstam insisted on a correction slip and telegraphed Gornfeld to tell him what had happened. Gornfeld, who was much older than Mandelstam, would not accept the explanation and wrote a newspaper article accusing him of plagiarism. Months later, the charge was repeated by a particularly unpleasant journalist named David Zaslavsky, a former Menshevik who was reinventing himself as a Stalinist witch-hunter. Mandelstam feared that this trivial row might destroy him. "To die from Gornfeld is as silly as to die from a bicycle or a parrot's beak, but a literary murderer can also be a parrot," he wrote.[20] The case dragged on for eighteen months and involved an arbitration court in front of which Mandelstam not only had to answer the charge of plagiarism but also was required to explain what he had been doing during the civil war, wandering in and out of areas under Bolshevik control.

Mandelstam's accusers were not speaking for the Communist Party. Even RAPP, which appeared to be functioning then as Stalinism's all-powerful literary arm, came down on his side. A letter disputing the charge of plagiarism appeared in May 1929 in the RAPP journal *Literaturnaya gazeta*, signed not just by the likes of Pasternak and Mikhail Zoshchenko, a gifted writer of short stories about little people and their everyday frustrations, who could be expected to support Mandelstam, but also by RAPP's hatchet men Averbakh and Fadeyev. Fadeyev, who was a strange mix of poetry lover and cold-blooded opportunist and who thought nothing of handing writers over to the police, was also one of the few people in authority who recognized

Mandelstam's gifts. After RAPP wrested control of *Krasnaya nov* from Alexander Voronsky, he toyed with the idea of being the first editor in years to publish Mandelstam but ultimately decided it was too risky.

The plagiarism accusation was something of a catharsis. Mandelstam had not written anything original for five years but was now galvanized, beginning seven years of frenetic creativity, deploying "the voice of an outsider who knew he was alone and prized his isolation"—alone, but not disengaged.[21] He declared:

> It's about time you knew that I'm contemporary too,
> A man of the Moscow Clothing Co-op era.
> Look at the crumpled jacket I wear;
> How I walk and express my thoughts.
> If you wake me to tear me out of this age,
> I vouchsafe that you'd break your neck.[22]

He did not direct his fury at the Stalinist system but at a phenomenon he named *pisatel'stvo*, meaning the condition of being a writer in a politicized world in which writers scrabbled for honors and position. It translates roughly as "writericity." In an essay known by the title "Fourth Prose," which was far too blunt to be submitted for publication anywhere in the Soviet Union, he wrote, "Writericity is a race with a disgusting smell in its hide and the filthiest means of preparing food. It is a race wandering and slumbering in its own vomit, expelled from cities, persecuted in villages, yet all over and everywhere up with authority, who allot them a place in the yellow districts, as prostitutes. For literature all over and everywhere carries out one assignment: it helps the officer class keep their soldiers in a state of obedience."[23]

After the plagiarism case was settled, the Mandelstams took what amounted to a long vacation in Armenia and Georgia, where Osip Mandelstam was fascinated by the sound of spoken Armenian—"a wild cat that tortures me and scratches my ear"—and by the exhilarating experience of treading on soil known to the Greeks and the Romans.[24] "I saw rich Arafat with its Biblical tablecloth and spent two hundred days in the Sabbath land they call Armenia," he recalled.[25] In the ancient holiday resort of Abkhazia, they were allowed to stay in a rest home reserved for high-ranking Stalinist officials, where they struck a rapport with Nikolai Yezhov, who would become one of the greatest mass killers in history, though he showed the Mandelstams none of the sadism that he exercised as chief of police. His wife, Tonia Yezhov,

offended Nadezhda by asking, "Whom do you go and see?"—implying that they could not have found their way into this place of privilege without a well-placed patron. Her husband laughed off the slight by remarking, "Everybody goes to see someone. There's no other way. We go to see Bukharin."[26]

In Tiflis, they were also treated with great kindness by a party official named Vissarion "Besso" Lominadze, "an enormous Georgian, whose huge body was covered with rolls of fat. . . . [He] was very shortsighted and squinted continually."[27] His career had been similar to Averbakh's: he had risen very high very quickly as a young Stalinist, yet in the long run he proved too brash for his own good. Stalin had sent him to China to organize a workers' revolution, which culminated in the pointless slaughter of workers in Canton and Nanchang and alerted Lominadze to the possibility that Stalin's political judgment was not without flaws. When the Mandelstams met him, he was head of the Communist Party in all three of the Caucasian republics, Georgia, Armenia, and Azerbaijan, but was quietly very disturbed by the orders he had received to drive the peasants off their land.

The first unpleasant shock that spoiled their holiday—and an early warning of horrors that lay ahead—came when they saw that posters had been put up all over town in November 1929 announcing that Yakov Blyumkin had been shot, the first person to achieve the grim distinction of being executed for being a Trotskyite. He had been sent on a mission abroad and returned via Turkey, where he paid an unauthorized call on Trotsky at his place of exile in Constantinople.[28] He was executed after returning to Moscow. The news left Mandelstam feeling "depressed and sick."[29]

A few days after Blyumkin's execution, Bukharin, the Mandelstams' protector who had facilitated their trip south, was expelled from the Politburo, a prelude to the next stage in Stalin's brutal campaign against the Soviet Union's rural population. Stalin announced on December 27 that an entire social class, the kulak, was to be eliminated. A kulak was a supposedly rich peasant who exploited the labor of his fellow villagers. In reality, farmers that were wealthy were few; any peasant who owned as many as three or four cows or two or three horses was in the wealthier stratum of the rural population, while only one farm in a hundred employed more than one paid laborer.[30] Stalin's announcement was nonetheless formalized in a decree approved by the Politburo in January 1930, and gangs of urban youths, their heads filled with Stalinist ideology, set off into the countryside to round up and deport these chimerical kulaks. The peasants left behind had to pool their land, livestock, and equipment in misnamed "collective" farms, run by communists.

Collective farm managers were ordered to make the delivery of goods to the towns and storage of grain for next year's planting their first priorities; peasant families had to feed off whatever was left. The number of people who either starved because of the inevitable dislocation in production, were deported, or migrated to the towns was undoubtedly in the millions. Stalin quoted a figure of 10 million to Winston Churchill during World War II. In Russia and Ukraine alone it certainly exceeded 5 million. Predictably, there was violent resistance in places. In Armenia rebels took control of several districts during March and April 1930, and in Azerbaijan about fifteen thousand peasants fled across the border into Iran.[31] Lominadze, whose job was to march the peasants of Armenia, Azerbaijan, and Georgia into collective farms, was so disgusted by what he was forced to do that he circulated a memo to other disillusioned Stalinists suggesting that the general secretary should be removed from office for his "lordly feudal attitude to the needs of the peasants."[32] For this, he was sacked on December 1, 1930, and expelled from the Central Committee. Faced with imminent arrest six years later, he committed suicide.

Mandelstam was working in the archives in Tiflis on the day Lominadze was dismissed. They had seen each other recently, and the Mandelstams were quick to notice that they were under observation; they then decided that their safest course was to leave at once for Russia. In Moscow, they went to see a high-ranking official named Sergei Gusev, but he turned them out of his office, fearful of being implicated in anything remotely involving Lominadze. Mandelstam went on to Leningrad—"my city, where I discovered tears, life, and childhood swellings"—hoping to persuade the writers' organization to allocate him a room, but he was turned down.[33] He became convinced that he was going to be arrested. "The whole night through I await the dear guests, with the door's rattle like the clank of chains," he recorded.[34] Back in Moscow, he noted in April that "I'm hanging on the tram strap of these terrible times, and I don't know why I'm alive."[35] The couple were lucky to secure their new flat on Furmanov Street.

Though he was a city dweller who had rarely been to the countryside, Mandelstam was acutely aware that terrible things were happening to the people who lived there. During a life spent avoiding people who wielded political power, the only activists who had had any influence over Mandelstam were either Socialist Revolutionaries, whose mission was to free the Russian peasant from servitude, or the communists Bukharin and Lominadze, who had been stripped of office and humiliated for opposing forced collectivization.

"I sense without fear that there will be a terrible storm," he wrote in March 1931.[36] Later, he wrote about

> those dreadful shadows from the Ukraine and Kuban.
> The starving peasants dressed in felt slippers
> guard the granary gates, not touching the locks.[37]

He was in no doubt about who was responsible for this crime. The line in his 1933 poem "Ariosto," about a sixteenth-century Italian poet, that "power is as disgusting as a barber's fingers" is likely to have been prompted by what he had heard about Stalin having stubby, greasy fingers, and his essay "Fourth Prose" included a caustic comment about writers who have "sold out to the pockmarked devil"—an unsubtle reference to the marks on Stalin's face left by smallpox.[38] After his arrest, Mandelstam explained to his interrogators what had led to this state of mind: "In 1930 a great depression afflicted my political outlook and my sense of ease in society. The social undercurrent of this depression was the liquidation of the kulaks as a class."[39]

In short, the man arrested by the NKVD in Moscow's Furmanov Street in May 1934 was not, as Bukharin had innocently supposed, a dreamy poet who had quarreled with other writers. And although he was unpublished, he was not forgotten: in 1933, he was permitted to hold a poetry recital in Leningrad, and though there was no advance publicity other than word of mouth, his name filled the hall. He was a political subversive seething with contempt for the father of the Soviet peoples who had committed an offense that carried an almost automatic death sentence.

Mandelstam was left for a day in a small cell shared with another prisoner before being summoned to an all-night interrogation by the NKVD's literary specialist Nikolai Shivarov, alias Khristofovich of the Lubyanka, "a large man with the staccato, overemphatic diction of an actor . . . [who] behaved like a person of superior race, who despised physical weakness and the pathetic scruples of intellectuals," according to Nadezhda Mandelstam.[40] He was the man controlling the police spies in Maxim Gorky's household.

"Why do you think we have arrested you?" he asked Mandelstam early in their first encounter, a standard ruse to get a disoriented prisoner to incriminate himself. When Mandelstam gave a noncommittal reply, Khristofovich suggested that he recite some poems. So, in the middle of the night, in a dreary room somewhere in the Lubyanka, one of the twentieth century's

greatest poets delivered a poetry recital to a man who planned to have him killed.

First, Mandelstam offered a poem he had written during the creative burst that had followed his return from Armenia, one in which he declared his determination to leave something for posterity and predicted his reward would be exile in Siberia, by the Yenisey River.

> This wolfhound age hurls itself on my shoulders,
> But there is no wolf's blood in here:
> So stuff me well, as you would a hat, up the sleeves
> Of the Siberian steppe's hot fur[41]

Khristofovich had heard this one before, but nonetheless he asked Mandelstam to recite slowly as he took it down in longhand, to be preserved in the archive of the Lubyanka. But this poem was not what the interrogator was after. Mandelstam offered another, written the previous November, provoked by something Pasternak had said on a visit to the Mandelstams' new flat on Furmanov Street. Lingering in the hallway, Pasternak admired its spaciousness and said, "Now you have an apartment, you'll be able to write poetry."[42] Amused and riled by the implication that physical comfort was necessary to write poetry, Mandelstam composed some mocking lines about his new flat, where the water can be heard bubbling in the radiator.

> But the accursed walls are thin,
> and there's nowhere better to run,
> and I'm like a fool obliged to play
> on a comb for someone or other.[43]

That one was new to Khristofovich. He wrote it down, line by line.

There was a great deal more stored away in the poet's memory, poems too subversive to be published and yet not incriminating enough to warrant the death penalty, but Khristofovich had heard enough. He opened a file and presented a single sheet to the prisoner. "Did you write this?" he demanded. It was the epigram to Stalin. Khristofovich must have expected that it would take time and pressure to get the confession he wanted, but Mandelstam owned up at once: as a poet, he could not renounce his own work. Khristofovich had Mandelstam recite the poem from memory while he followed the written version before him. By the third or fourth line, he interrupted to ob-

ject that his text was different. In place of the third and fourth lines that Mandelstam recited, he was reading a more incriminating variant:

All we hear is the Kremlineer,
The murderer and peasant slayer.

"That was the first version," Mandelstam replied, explaining that he had altered the poem after the first recital.

Thus, the first day's interrogation ended triumphantly for Khristofovich, with the prisoner signing a confession incriminating enough to warrant his execution. It was not even necessary to give the prisoner a beating, although the practice of mistreating prisoners was so hardwired into police practice that Mandelstam was subjected to a form of psychological torture anyway, to no obvious purpose. He was enclosed in a cell with a bright light that caused his eyelids to become inflamed and given salty food with no drink. When he went to the spy hole to complain, he was dragged to a punishment cell and put in a straitjacket, an object he had never seen before. He shared his cell with a prisoner who tormented him by saying that his friends who had heard the incriminating poem, including Akhmatova and her son, would be arrested and they would all be put on trial together. Mandelstam noticed that the man's fingernails were clean and that he came back from interrogation smelling of onions.

Another torment was the behavior of Pyotr Pavlenko, a novelist who had emerged as a major figure in the writers' union after the disbanding of RAPP. Pavlenko was on good terms with Khristofovich, who invited him to the Lubyanka to hide in a cubbyhole and be a voyeur as Mandelstam was being questioned. This accorded with the spirit of the era of socialist realism, when writers were expected to take some responsibility for policing their profession. Who could accuse Khristofovich of attacking the literary community when a leading writer was watching the proceedings? And Pavlenko did more than merely watch. At one point when Mandelstam collapsed and started having convulsions on the floor, he heard a voice rebuking him, "Mandelstam, Mandelstam, aren't you ashamed of yourself?"[44]

Pavlenko performed another service by spreading reports through Moscow's literary crowd that Mandelstam had cut a ridiculous figure in prison, nervous, incoherent, and confused, with his trousers constantly slipping down because his belt had been confiscated. "In the official literary circles to which Pavlenko belonged, it had been completely forgotten that the only thing with

which someone in M.'s position could be reproached was giving false evidence to save his skin; he certainly could not be blamed for being bewildered and frightened," Nadezhda Mandelstam observed.[45]

Mandelstam was highly strung, and the effect of this ill treatment was to bring on a psychosis. He began to hallucinate. He was convinced he heard his wife's voice in the distance; he could not make out the words, but it sounded as if she were groaning or complaining, and he feared she was under arrest. Then he attempted to kill himself by slashing both wrists with a razor blade he had secreted in his shoe.

All that this torment produced was a written "confession" of Mandelstam's political opinions, revealing that he had turned against the communist system because of collectivization, the text of his poem about starvation in the Crimea, and confirmation of the names of some of those to whom he had recited the epigram to Stalin, all names the police already knew.[46] There were others, including Pasternak and Viktor Shklovsky, whose names Mandelstam withheld.

Yet while Mandelstam was losing his mind in the Lubyanka, strange things began to happen outside. Mikhail Vinaver, the courageous deputy head of the Political Red Cross whose work took him in and out of the Lubyanka, reported back to Nadezhda Mandelstam that "there's a kind of special atmosphere about it, with people fussing and whispering to each other."[47] The Lithuanian ambassador, Yurgis Baltrushaitis, did the rounds of a conference of journalists taking place in Moscow at the time, warning them that the regime was about to repeat the terrible mistake it had made by executing another Acmeist poet, Nikolai Gumilev. In New York, the journalist Max Eastman had just published *Artists in Uniform*, an exposé of the Soviet regime's treatment of its writers. Stalin was aware of Max Eastman: he was the correspondent who had obtained and published Lenin's final testament, with its qualified praise for Trotsky and Bukharin and its uncompromising call for Stalin to be removed from office. A whole chapter in Eastman's new book was about the persecution of Zamyatin, who as a result was quietly allowed membership in the writers' union although he remained in exile. The book also blamed the regime for the suicides of Mayakovsky and Yesenin, which Eastman linked as "a symbol of the devastation wrought in their decade by the twin monsters, Marxian bigotry and Stalinist bureaucracy."[48] This may not have been altogether fair, but it gave Stalin a powerful motive for not wanting another dead poet on his hands, particularly not on the eve of the writers' congress.

The first "miracle" came on May 26, only ten days after Mandelstam's arrest, when a special tribunal sentenced him to three years in exile in the town of Cherdyn, in the Urals, an astonishingly light sentence for the offense to which he had freely confessed. Nadezhda was permitted to visit him in the Lubyanka. Mandelstam noticed that she was wearing her mother's coat, a detail that reassured him that she was not under arrest. Khristofovich's manner had changed, and he revealed that there had been an instruction from above to "isolate but preserve." He rebuked Mandelstam for his suicide attempt and for his foolish habit of signing the daily record of his interrogation without reading it. In what seemed like another miracle, he suggested that Nadezhda should accompany her husband into exile, when she had so desperately feared a forced separation.

When Nadezhda returned to the flat to pack, she discovered that the good news had spread. The flat was filled with well-wishers, mostly women, who had organized a collection. Nadezhda's mother had sold the furniture in her home in Kiev and donated all the money she had made. Akhmatova called on Mikhail Bulgakov, whose wife, Yelena, burst into tears and gave all the money she could lay hands on. Soon Nadezhda was holding more cash than she had ever possessed at any time in her life. Their one-way rail tickets were provided free by the regime, so they had enough money to last the whole of their time in Cherdyn and for two months afterward.

But money was small consolation as Nadezhda watched her husband's mental disintegration. Far from being elated by his light sentence, Mandelstam was convinced that he was marked for execution and did not expect to reach Cherdyn alive. As he descended into suicidal mania, he wrote:

at my side, my wife did not sleep for five nights,
did not sleep for five nights as she coped with three guards.[49]

In Cherdyn, they were handed over to the local NKVD commandant, who gave them a large empty ward on the upper floor of the local hospital with two creaking beds. Nadezhda fell asleep, exhausted, and woke to see her husband in the act of throwing himself from the window. She was at the window ledge in time to grab the shoulders of his jacket but could not prevent him from falling onto a flower bed. The hospital staff carried him back to bed, angry at being put to unnecessary trouble and unaware that he had fractured a shoulder.

Afterward, Mandelstam's mental state rapidly improved. He was oddly comforted by the sight of exiled kulaks wandering through the hospital with strange fixed smiles on their bearded faces. Even in his delirium, Mandelstam could tell a peasant from a policeman and stopped being afraid that everyone around him was trying to kill him. "Imagine how in good old Cherdyn, amid the smell of funnels on the Ob and Tobol, I rushed about in a right commotion," Mandelstam wrote later. "A leap: I was in my right mind."[50]

Mandelstam's brother, Alexander, was not convinced that Osip was in fact in his right mind, however, and submitted a written appeal to the police on June 6 for his brother to be transferred to a city where he could be given proper psychiatric care, warning that he might attempt suicide again. That warning produced a second "miracle." On June 10, less than four weeks after Mandelstam's arrest and only a fortnight into his exile, the special board reviewed his case and commuted his sentence to "minus twelve"—an administrative penalty copied from tsarist times that meant he was banned from the twelve largest Soviet cities for three years but otherwise could live where he chose.

The Mandelstams learned of this development via a telegram from Nadezhda's brother, Yevgeni Khazin. They showed it to the local commandant in Cherdyn, who could not believe it. Even when the official notification arrived, the harassed official feared that it might be a hoax and kept the exiles waiting another two or three days until he had further confirmation. Meanwhile, the other exiles, who had been so open and welcoming, became understandably suspicious of this couple getting such special treatment.

When confirmation arrived, the commandant insisted that they decide immediately where they were going to live next. Mandelstam selected Voronezh, a town on one of the tributaries of the Don about five hundred kilometers south of Moscow. The choice was arbitrary: he had a friend whose father lived in Voronezh and had spoken well of the town, but he may have chosen it simply because he liked the sound of it. *Voron* is Russian for raven, the bird of fate, and the final syllable of *Voronezh* sounds like *nozh*, a knife. A four-line poem Mandelstam wrote in April 1935 ends with the pun *Voronezh—blazh',* *Voronezh—voron, nozh*: "Voronezh's a whim, Voronezh—a raven, a knife."

Just after their arrival in Voronezh, an extraordinary conversation took place in Moscow. Boris Pasternak was working in his room in a housing block in Volkhonka Street when he was told that someone was on the telephone. The phone was in a shared corridor where children were playing. Pasternak was startled when the caller identified himself as Alexander Poskrebyshev,

Stalin's secretary. Poskrebyshev told him to wait, because Stalin wanted to talk to him. As he waited, Pasternak fretted about the noise from the children.

One version of the conversation that followed was written down by the playwright Iosif Prut in the 1950s, during the formal inquiry into whether Mandelstam should be posthumously rehabilitated. In this version, Pasternak took fright when he heard Stalin's dreaded voice asking about Mandelstam. "I don't know him at all well," he is supposed to have said. "He was an Acmeist, while I support a different literary tendency. So I can't say anything about Mandelstam!"

"I can say that you're a very poor friend, Comrade Pasternak!" Stalin is supposed to have replied. Then he put down the receiver.[51]

This version came to light when Pasternak was in disgrace in the Soviet Union because of the *Doctor Zhivago* affair. Nadezhda Mandelstam was a harsh judge of character, yet she was sure that Pasternak said nothing that was either cowardly or dishonorable. The verbatim account that Pasternak relayed to her was longer, more detailed, and more plausible, because it captures Pasternak's personal eccentricities. In his account, no sooner was Stalin on the line than Pasternak was complaining about the noise, which was typical of his fussiness about having a quiet place to live. Stalin cut in to say that Pasternak could stop worrying about Osip Mandelstam, whose case had been reviewed. Then he added a strange rebuke: why had Pasternak not come to him or approached one of the writers' organizations for help? he asked. "If I were a poet and a poet friend of mine were in trouble, I would do anything to help him," Stalin told him.

"The writers' organizations haven't bothered with cases like this since 1927, and if I hadn't tried to do something, you would probably never have heard about it," Pasternak replied.

Pasternak later confessed to Nadezhda Mandelstam that, when asked, he put a distance between himself and the arrested man; she refused to record what he said, fearing that a reader might misinterpret it as cowardly. Pasternak was, of course, in a precarious position, not knowing whether Stalin knew he was guilty of having heard the poem and not reporting it to the police, but she was satisfied that he was being his normal, exact self. Pasternak did not agree with Mandelstam about aesthetics, did not approve of his attitude to the regime, and was annoyed at the position he found himself in after that poem was recited to him; he evidently told Stalin, truthfully, that he did not class Mandelstam as a friend. One version of the conversation has him saying, "You know, Comrade Stalin, you should no more ask one poet what

he thinks of another than you should ask a pretty woman her opinion of another pretty woman's looks."

"Then am I to take it you don't think much of him?" Stalin asked.

"No, no, you've got me wrong. I'm a different sort of poet from him, that's all. I think he's a good writer."[52]

According to the version Nadezhda recalled hearing from Pasternak, Stalin then demanded, "But he's a genius—he's a genius, isn't he?" The implication was that the state could afford to dispose of a minor talent, but not someone whose work was going to live on after him.

"But that's not the point," Pasternak objected.

"What is it then?" Stalin asked.

Quickly changing the subject, Pasternak asked whether they could meet to have a talk.

"About what?"

"About life and death."[53]

Stalin cut him off. Pasternak rang back but was put through only to Stalin's outer office. He asked if he was allowed to repeat the conversation and was surprised to be told that he could talk about it to whomever he wanted. "The aim of the miracle was thus achieved," Nadezhda wrote decades later. "Attention was diverted from the victim to the miracle worker. . . . Nobody thought to ask why Stalin should have rebuked Pasternak for not trying to save a friend and fellow poet while at the same time he was calmly sending his own friends and comrades to their death. Even Pasternak took Stalin's sermon on friendship between poets completely at face value."[54]

The Mandelstams, exiled in Voronezh, did not know about this conversation until months after it happened, and when eventually they heard, they were not persuaded it meant Stalin had good in him. "He will destroy reason and life, Stalin," Osip Mandelstam wrote in a poem early in 1937.[55] The couple suffered a moment of cold terror when Akhmatova was visiting them in Voronezh and there was an unexpected knock on the door. It turned out to be two friends paying a call. Akhmatova wrote a seventeen-line poem about Voronezh, the last four lines of which were excised from the Soviet edition of her works:

> But in the room of the poet in disgrace,
> Fear and the Muse keep watch by turns.
> And the night comes on
> That knows no dawn.[56]

It is, all the same, a remarkable story. Osip Mandelstam had no status in Soviet society. His history as a published author was thin: a book of poems in 1923; his collected poems in 1928; and his essay on *Journey to Armenia* that appeared in a magazine in May 1933, a mistake that cost the commissioning editor his job. Yet there was a public that cared enough about poetry to make his arrest an event whose reverberations reached all the way to the supreme height of the Kremlin. That explains how Mandelstam, even in his despair, could cheer Akhmatova up during her visit to Voronezh by telling her that "poetry is power" and why, on another occasion, he told Nadezhda, "Why complain? Poetry is respected only in this country—people are killed for it. There's no place where more people are killed for it."[57]

Even for a poet, though, Stalin's mercy was never more than temporary. Mandelstam had been reprieved, not saved, and a bad end awaited him.

6

Babel's Silence

I respect the reader so much that it makes me numb and I fall silent.

—ISAAC BABEL

Three months after Osip Mandelstam's arrest, the storyteller Isaac Babel made a strange speech from a public platform in which he thanked the regime for allowing him the privilege of not writing. If that was a suitable cause for gratitude, Babel had much to be thankful for, because he had published very little of note in almost ten years; the work on which his international fame rested had been written before he moved to Moscow in 1924. The occasion for the speech was as extraordinary as the sentiments it contained. It was the First Soviet Writers' Congress, an extravagant homage to contemporary literature unmatched by any that preceded it, during which countless speeches were delivered in praise of the regime's enlightened policies and nobody mentioned Mandelstam or any writer who was under arrest, nor asked why Anna Akhmatova and Mikhail Bulgakov had not been invited.

For all its limitations, the congress was a high point of a comparatively liberal interlude in the Stalin years. The worst horrors of forced industrialization and collectivization were receding, the economy was entering three years of growth, and within the Communist Party there were small signs that the dictatorship might be relaxing its controlling grip at the very moment when Germany was descending into organized barbarism that included the public burning of twenty thousand books.

The same week that Mandelstam was arrested brought an important change to the arrangements for the upcoming congress. The task of delivering the

116

main report on poetry was originally assigned to Mayakovsky's acolyte Nikolai Aseyev. Stalin had not yet pronounced Mayakovsky the greatest poet of the age, but Aseyev was a believer and proselytized that he was. On May 14 (coincidentally the day of Mandelstam's arrest), Aseyev delivered a speech attacking one poet after another, a misjudgment that cost him his position as an official speaker at the congress. On May 23, he was replaced by Bukharin, giving Stalin's former opponent a new platform, one he would use to try to soften the regime's hard edges.

That vast public relations exercise began on August 8, 1934, in the Moscow Park of Culture and Rest, where a crowd estimated to have numbered in the tens of thousands gathered by moonlight for the contemporary equivalent of an open-air rock concert—though the stars were not musicians but writers who wrote stories with titles such as "Cement" or "Time, Forward!" The proceedings began with a deafening orchestral fanfare. One of the first speakers was an eighty-six-year-old Frenchman who reminisced about the Paris Commune. A bard from Uzbekistan sang from the rostrum instead of speaking. "It was all very sincere, naïve, and touching, and like an extraordinary kind of carnival," recalled the cosmopolitan Ilya Ehrenburg, back in Moscow for a time.[1]

The congress continued for fifteen days in Moscow's Hall of Columns, beneath huge portraits of Shakespeare, Balzac, Cervantes, Tolstoy, Gogol, Pushkin, and other greats, its seven hundred delegates augmented by huge parties of visitors from all corners of the USSR: teachers, actors, factory workers, farmworkers, soldiers with red stars on their caps, Young Pioneers in their telltale neckties using trumpets to keep their groups together in the crowd, and railwaymen who communicated with whistles. Collective farm laborers came with baskets of fruit, factory workers brought in samples of machinery; everyone—workers and administrators alike—was, in theory, part of one great production process. Boris Pasternak was on the rostrum, "beaming all the time," when a group of workers from the Moscow Metro marched into the hall, carrying their equipment.[2] Pasternak created a ripple of innocent amusement when he spotted a young woman with a heavy piece of machinery and gallantly jumped down from his seat to take the load from her. She refused to let go but burst out laughing; of course she was far more accustomed than any poet to heavy lifting. Pasternak later referred to the misunderstanding in his speech, saying, "How could the comrades on the platform who ridiculed my intellectual's sensibility know that at that moment this Metro worker was in

some sense my sister, and I wanted to help her as someone close and familiar to me?"[3]

Altogether about 25,000 visitors passed through the hall. Some came bearing resolutions passed at mass meetings, all in the spirit of socialist realism: miners wanted more novels set in the Donbas, women textile workers wanted to read about weavers, railwaymen complained that the dramatic possibilities of transport stories had been neglected. It was reported that hundreds of thousands of messages were coming from workers, collective farmers, students, schoolchildren, scholars, scientists, engineers, and artists, all full of enthusiasm for Soviet literature and good wishes for those who produced it.

The addresses from the leading rostrum speakers mirrored the uncertain state of Soviet literary politics. The head of the cultural department of the Central Committee, Aleksei Stetsky, one of Bukharin's former protégés, denounced RAPP for attempting to impose a "general line." He claimed the Soviet Writers' Congress, in contrast, stood for "free creative discussion of all literary problems" and that it would "cramp the initiative" of writers if each utterance from the platform were to be taken as a "fixed and unalterable" canon.[4] Bukharin's report on poetry was remarkable for a central passage in praise of Pasternak: an acknowledgment that someone who was neither a Marxist nor a proletarian could still be a fine poet and an implied invitation to people such as Pasternak, who were neither enthusiastically for nor hostile to the regime, to involve themselves in public affairs.

Some of the foreign guests were bemused by the report on world literature, presented by the intelligent but morally flawed ex-Trotskyite Karl Radek, which judged the quality of contemporary world literature by the writer's attitude to the Soviet system. It seemed that England had no good writers except George Bernard Shaw; Germany's greatest writer was a member of the Mann family—Heinrich, not Thomas; and the only great names of contemporary American literature were Theodore Dreiser and Upton Sinclair. Onto the condemned list went H.G. Wells, whose work had once been much admired by the Bolsheviks, and Erich Maria Remarque, author of *All Quiet on the Western Front*; both had also had their books burned by the Nazis. As his speech closed, Radek revealed a deep knowledge of his subject when he singled out James Joyce and Marcel Proust as the giants of modern "bourgeois" literature—but then, as if embarrassed by his erudition, he covered himself by declaring, "In the pages of Proust, the old world, like a mangy dog no longer capable of any action whatever, lies basking in the sun and endlessly licks its sores . . . the drawing room heroes of Proust seem to cry aloud

that they are not worth analyzing, that no analysis of them will produce any results." He went on to compare Joyce's *Ulysses* to "a heap of dung, crawling with worms, photographed by a cinema apparatus through a microscope."[5]

The real indicator of what lay ahead was a speech that made little immediate impact at the time, because it was so laden with clichés and because the man who delivered it had the charisma and cultural depth of a provincial office manager. The speaker was Andrei Zhdanov, recently brought from the provinces to be a secretary of the Central Committee and soon to be the dominant figure in Soviet culture. He pronounced that "in an epoch of class struggle, there is not and cannot be a literature that is not class literature, not tendentious, allegedly nonpolitical."[6]

The center of attention was Maxim Gorky, ill, still grieving for his lost son, and in a bad temper. The original draft of his speech had been submitted to the Politburo, four of whose members turned up at his home to insist that he rewrite it, to which he grumpily agreed. Two lesser Stalinist functionaries who tried to tell him what to say had annoyed him so much that he had written a scorching article about them that the editor of *Pravda* had not dared publish. He then made such a fuss about this act of censorship that Lazar Kaganovich, the senior party secretary in Moscow in Stalin's absence, had had to write to the boss, on holiday in the south, asking what to do. Stalin replied that all writers were to be reminded that "the master in literature, as in all other matters, is Central Committee, and no one else." However, as a compromise to avoid the risk of Gorky's banned article circulating illicitly, it was printed and informally distributed around Moscow, where it was read by at least four hundred people.[7]

Even in his amended speech, Gorky had less to say in praise of current Soviet literature than he did in defense of Dostoyevsky, who had portrayed "with the most vivid perfection" the dispossessed, egocentric rebel intellectuals of the mid-nineteenth century. He even suggested reissuing *The Devils*, Dostoyevsky's polemic against the revolutionaries of the 1870s.[8] In passing, Gorky suggested that there could be five writers of genius living in the Soviet Union but did not name them. In that vast and crowded hall there were perhaps just three: Gorky, Pasternak, and Isaac Babel.

Babel was a Bolshevik fellow traveler who had marched and ridden with the Red Army and had high-level friends in the Communist Party; his fame as a writer had spread well beyond the boundaries of the Soviet Union. His popularity with readers guaranteed him financial security and ought to have made him safe from arrest, except that his friends and contacts included Leon

Trotsky and numerous actual or suspected Trotskyites. Watching the infighting and denunciations within the party had sapped his enthusiasm for the cause, but he was confident that he would not be arrested for as long as Gorky protected him. Without Gorky, he knew he would be very exposed.

Babel claimed that he was not an imaginative fiction writer at all but a witness. He observed and brought to life young Red Cossacks fighting in Poland, or middle-class Jews, or desperately poor, downtrodden Polish Jews, or the criminal element in Odessa; but, as he told his friend Konstantin Paustovsky, "I can't make anything up. I have to know everything, down to the last wrinkle, or I can't even begin to write. . . . I've got no imagination. All I've got is the longing."[9]

His political radicalism was a reaction to the poverty and anti-Semitic violence he had witnessed as a boy, though he personally had been spared the worst of it. His parents were middle-class Jews, ambitious for their bright, round-faced, studious son. They made sure that he was fluent in Russian, though they spoke Yiddish at home, and when he was very young, they moved to Nikolayev, a small port a hundred miles from Odessa, where his father established himself as the commercial agent for a foreign firm that sold agricultural machinery. They sent their boy to the Count Witte Commercial School, named after one of the tsar's most enlightened ministers, which did not discriminate against Jews. When they returned to Odessa, it was not to the notorious Moldavanka district, the "dilapidated den of poverty, cheap booze and inventive criminality" where Babel was born in 1894, but to a fine house on the corner of two of Odessa's most fashionable avenues.[10] It was, he wrote in 1916, a city with "a very poor, populous and suffering Jewish ghetto, a very self-satisfied bourgeoisie, and a very pogromist city council [where] the destitute roam through coffeehouses trying to make a rouble or two to feed their families, but there is no money to be made."[11]

There were very few Jewish families in Odessa, rich or poor, who did not lose someone in the pogroms that the authorities deliberately fueled as a diversion from the 1905 revolution. Babel lost a grandfather to the murderous mob. In one of his stories, "The Story of My Dovecote," a delighted Jewish family allows their young son to buy a pet dove because he has won a place in a secondary school for Russian boys, but on his way home he is attacked for being a Jew and his new pet is crushed to death. When he finally reaches home, he sees the corpse of his murdered grandfather. "I came safely through a Jewish pogrom as a child, only they tore my pigeon's head off," Babel told Paustovsky.

Barred from Odessa University on racial grounds, he enrolled in the Finance and Business Institute in Kiev, where one of his fellow students was his future wife Yevgenia Gronfein, whose father, like Babel's, was a dealer in agricultural machinery, though the Gronfeins were more prosperous than the Babels. Early in the war with Germany, the institute and its students were evacuated to Saratov. After completing his course work by the end of 1915 but before taking the final examinations, he transferred to the law faculty of the Petrograd Psychoneurological Institute. He had to live in Petrograd illegally, because of the travel restrictions for Jews, until at last he obtained a three-month resident's permit. It expired in February 1917, which was also the month the Russian monarchy expired. Babel stayed in the capital. Fame came quickly and suddenly when two of his stories were published in Maxim Gorky's journal *Letopis* in November 1916. "Everyone noticed Babel's story and remembered it," the critic Viktor Shklovsky recalled. "They now took note of Babel, too—middle height, high forehead, big head, an unwriterly face, dressed in dark clothes, talks entertainingly."

Gorky advised Babel that he must experience life if he wanted to write about it. Babel enlisted in the army and reached the Romanian front just in time to watch it disintegrate as news came through that the Bolsheviks had seized power. He joined the flow of deserters heading back to Russia but only just made it; he had to hide for twelve days in a basement in Kiev while the Red Army fought for control of the city. He obtained a pass from the Kiev soviet for the train journey to Petrograd but was identified en route as a Jew, robbed, and turned out barefoot into the snow. According to his account of the journey, published years later under the title *The Road*, he was luckier than a Jewish teacher traveling with his young Russian wife in the same carriage who had his genitals cut off and stuffed in his wife's mouth.

In Petrograd, Babel located his former sergeant, now a Bolshevik, who introduced him to the formidable Mikhail Uritsky, head of the Petrograd Cheka, who hired him as a translator. This was in the first months of the Cheka's existence, before the mass executions; those began in August 1918 after Lenin had been wounded and Uritsky wound up killed by Socialist Revolutionaries. Babel understood the Cheka's function, and the fact that he willingly went to work for it shows that there was nothing soft about his allegiance to the Bolshevik cause. He spent the first part of the civil war working with the detachments sent out to seize grain from the villages and served with the army in the defense of Petrograd in 1918. Yet this did not stop him from writing for Gorky's anti-Bolshevik newspaper *Novaya zhizn*,

to which he contributed as late as July 2, 1918, four days before the paper was closed.

In 1919, he went back to Odessa, married Yevgenia Gronfein, and obtained a permit from the Odessa Communist Party Committee to accompany the Red Cavalry as a war correspondent. A border dispute between Ukraine and the newly independent Poland had flared into a full-scale war that saw the Red Army sweep across the country toward Warsaw before being halted by the Poles, aided by French military advisers. The Bolsheviks did not see this as a war between states. They believed that when they seized power in Russia, it was only the beginning of a world revolution that would destroy capitalism everywhere, and they thought that the Red Army was taking the revolution to Europe. Babel believed it too. "Everything is clear," he wrote in his diary, "two worlds, and a declaration of war. We will be fighting endlessly. Russia has thrown down a challenge. We will march to Europe to subjugate the world. The Red Army has become an international factor."[12]

He rode for four months, from June to September, with the Sixth Red Cavalry Division, commanded by twenty-five-year-old Semyon Timoshenko, who would become a household name in Britain in 1941 as the only remotely competent Red Army marshal left alive after the purges and able to face the German invasion. He was named in the original version of Babel's story, but in later versions he became Savitsky, who is quoted telling the narrator, "They send you to us, no one even asks us if we want you here! Here you can get hacked to pieces just for wearing glasses!"[13] In that story, "Moi pervii gus" (My first goose), the narrator gains a kind of acceptance from his fellow soldiers by stealing a goose from a helpless Polish woman and slicing off its head with a saber; he then reads them Lenin's speech to the Second Comintern Congress, which they greatly appreciate. But in another story, "Smert Dolgushova" (Dolgushov's death), the narrator earns the Cossacks' contempt because he cannot bring himself to kill a mortally injured Cossack begging to be finished off rather than be left to the tender mercy of vengeful Poles. Another Cossack performs the mercy killing and turns menacingly on the narrator: "You spectacled idiots have as much pity for chaps like us as a cat has for a mouse."[14]

Babel's enthusiasm for world revolution in no way blinded him to the cruelty of some of the Cossacks he accompanied. Only ten days after he had written those exhilarated words about how the Red Army would subjugate the world, he and a military commissar were seen running frantically along the railway tracks, pleading in vain for the infuriated Cossacks not to slaughter

their Polish prisoners—something they had just been encouraged to do by their divisional chief of staff while the commander looked on without intervening. "They impaled them, shot them, corpses covered with bodies, one they undress, another they shoot, moans, yells, wheezing," Babel wrote in his diary.[15]

"What kind of men are our Cossacks?" he asked himself early in the campaign. "Many-layered: rag-looting, bravado, professionalism, revolutionary ideals, savage cruelty."[16] He could have added "anti-Semitic" to this list. In his diary, he recorded asking a soldier to give him some bread only to be brusquely told that the man did not like Jews. One of his published stories, "Pismo" (A letter), was in the form of a letter dictated by an illiterate young Cossack, informing his mother that one of his brothers had been tortured to death by their father, a soldier in the White Army. The father was then traced to a town called Maikop by another brother, who intended to lynch him, only to find that the local communists—whom the Cossack assumes must all be Jews—do not approve of killing prisoners. The narrator writes down what the Cossack thinks of that: "What did we see in the town of Maikop? We saw that the rear was not of the same mind as the front and that everywhere was treachery and full of dirty Yids like under the old regime."[17]

Not that the Polish army or the Cossacks fighting on the Polish side were any better. The first entry in Babel's campaign diary noted that Zhitomir, near the disputed border, was occupied by the Poles for three days, during which "they cut off beards, they always do, rounded up forty-five Jews in the market, took them to the slaughterhouses, torture, they cut out tongues, wailing over the whole town square."[18] In another Jewish ghetto, he wrote that "hatred for the Poles is unanimous. They looted, tortured, scorched the pharmacist's body with white-hot iron pokers, needles under his nails, tore out his hair, all because a Polish officer had been shot at."[19]

As the Red Army retreated, Babel replied in print to the Polish Red Cross's allegations of Red Army atrocities with a graphic description of yet another massacre whose aftermath he had witnessed, alleging that Cossacks fighting on the Polish side had butchered thirty Jews, injured dozens more, and raped two hundred women, torturing some of them to death. "The event I have just described," he claimed, "is only one among a thousand far worse."[20] He may have been exaggerating for propaganda purposes; in his diary's account of the same massacre, the death toll was fifteen, not thirty, but even so, what he witnessed was disgusting enough: "a child with chopped-off fingers . . . a mother over her butchered son, an old woman curled up, four people in one

hut, dirt, blood under a black beard, they're just lying there in their blood."
But in the privacy of his diary Babel also observed, "Our men are going around
indifferently, looting where they can, ripping the clothes off the butchered
people. The hatred for them is the same. They too are Cossacks."[21]

The stories that brought Babel national fame were written in Tiflis, where
he was posted soon after the Red Army occupation of Georgia. The best
known are those published under the title *Red Cavalry*, though they are not
necessarily the most interesting. He also wrote a series of tales set in Odes-
sa's criminal underworld: half a century before Western audiences saw *The
Godfather* or *Goodfellas*, Babel was exploring the elaborate social rules of crim-
inal society. He also demonstrated that not all Jews are passive victims: his
characters include tough Jews such as Benya Krik, hero of his early story "Ko-
rol" (The king), who learns that the police plan to raid his sister's wedding
and puts a stop to that by having his men set fire to the police station.

Babel returned to Odessa a celebrity, a war hero, and a friend of Maxim
Gorky—the city's "first authentic Soviet writer." According to Paustovsky,
who got to know Babel during the summer of 1921, "He was never alone.
Swarming round him like midges were the 'Odessa literary boys.' They
caught his jokes in mid-air, flew round the town with them, and ran his count-
less errands without complaining. . . . Nor were they alone in their hero-
worship of Babel. Old, established authors (there were several in Odessa at the
time) treated him with as much respect as did the young local writers and
poets."[22]

In 1923, he moved to Moscow. With Gorky out of the country, his highest-
profile contact in the capital was Mayakovsky, whom he had met in 1916.
Artistically, Babel had almost nothing in common with Futurism, but he
submitted a bundle of his stories to Mayakovsky's magazine *LEF*, which pub-
lished "Korol" and three Red Cavalry stories, "Sol" (Salt), "Pismo," and "Smert
Dolgushova." Alexander Voronsky saw that *LEF* was onto a major talent and
bought a larger bundle of Babel's stories for *Krasnaya nov*, which ran a Babel
story in almost every edition for the next two years. Voronsky became Ba-
bel's most important political patron, and Babel was arguably Voronsky's
greatest literary discovery. Voronsky also introduced his protégé to some of
the most famous Bolsheviks of the day, arranging for him to participate in a
small, select literary evening featuring Trotsky and Karl Radek. In one of his
essays, Trotsky approvingly quoted a phrase from Babel's story "My First
Goose" that referred to "the mysterious curve in Lenin's straight line." Even
the dreary critics associated with RAPP acknowledged Babel's craftsman-

ship, though he was accused of being a bourgeois intellectual who apologized for the revolution by appealing to moral principles.

When his first collection of stories was published, in 1926, it was a runaway success. In the same year, Babel began his other profession as a screenwriter by adapting his stories about the criminal mastermind Benya Krik for the cinema. He wrote a fine script, but the resulting film was reputedly secondrate. Nevertheless, *Pravda* singled him out as "a rising star in our literature"; an authoritative entry in the 1927 edition of the *Great Soviet Encyclopedia* placed him next in the line of great romantic writers that stretched from Gogol to Gorky and remarked on the accuracy with which he reproduced the argot of soldiers, peasants, orthodox Jews, and hoodlums from Odessa's Jewish underworld.[23]

One person who did not share the general enthusiasm was Semyon Budenny, the founder and commander of the Red Cavalry. In time, Budenny would earn himself an international reputation as a hopeless Red Army marshal with a very big mustache and a very small brain, but in 1924 he was an acclaimed war hero and a very good friend of Stalin's favorite army commander, Kliment Voroshilov. In March 1924, he made a rare and furious foray into print to demand that the Red Cavalry be protected from "slander" by the "literary degenerate" Babel. This provoked a riposte from Gorky, who compared Babel with Gogol. Budenny returned to the attack four years later, with an open letter to Gorky alleging that Babel had never seen the Red Cavalry in action, but had "hung around with some unit deep in the rear," and accusing him of "crude, deliberate and arrogant slander" and of being obsessed with sex. Gorky dismissed the attack as "an undeserved insult."[24]

Particular trouble arose over a piece in *Krasnaya nov* titled "The Story of a Horse," which described a childish and near fatal confrontation in a town called Radzivillov between a recently dismissed division commander, here named Savitsky, and a squadron commander named Khlebnikov, over a white horse that Khlebnikov had accused Savitsky of stealing. Unable to recover the horse, Khlebnikov wrote a long, whining letter declaring that he was resigning from the Communist Party. There was too much identifiable detail in this tale. Timoshenko, already identified as Savitsky in "My First Goose," really had ridden into Radzivillov on a magnificent white horse after being removed from the command of the Sixth Cavalry Division in August 1920. Moreover, the story had originally been published in Odessa under the title "Timoshenko i Melnikov," confirming that Savitsky was Timoshenko and Khlebnikov was the former divisional commander Parfenti Melnikov.

Melnikov wrote to deny that he had ever resigned from the party. Babel was obliged to send an apologetic letter to the literary magazine *Oktyabr*.

Success made Babel wealthy by the standards of the time, so that "when it comes to apartments, food, services, warmth and peace—I can have it all."[25] What it did not bring was literary inspiration. As early as 1927, Voronsky was chiding him for his silence, and Babel recalled 1924–27, when he was the talk of literary Moscow, as "the most horrible period in my life." Voronsky's patronage and Trotsky's endorsement, which had served him so well in the 1920s, later made his position dangerous, and he relied heavily on Gorky's friendship and protection. He labored at his writing but found it increasingly difficult to produce anything that met his exacting standards and could pass unmolested by the censorship office. The problem was that Babel had truly believed in the revolution and was sufficiently well connected and observant to see what was becoming of it.

There were also problems in his private life. After his father died in 1923, his widowed mother came to live with him in Moscow. His sister, Meriam, emigrated to Brussels in 1924. He fell ill in 1925 and went to the Caucasus to recuperate. The same year, his wife, Yevgenia, emigrated to Paris, ostensibly to study painting. She did not share Babel's enthusiasm for the revolution—indeed, she was becoming a hardened anticommunist—but that was not the main reason for her departure. In 1925, Babel began an affair with a married twenty-five-year-old actress named Tamara Kashirina, who was bored with her life in Leningrad until Babel arrived. She lived into her nineties and in 1992 arranged the publication of 171 letters from Babel, which she had kept despite the enormous risk. Just as she was preparing to start their life together, in summer 1927, by now divorced and pregnant with Babel's child, she discovered that Babel was in Paris, seeking a reconciliation with his wife—so she married the writer Vsevolod Ivanov. Her son took the name Mikhail Ivanov and never knew his natural father.

Meanwhile, on his way to Paris, Babel stopped over in Berlin, where he met up with Yevgenia Gladun, an old acquaintance from Odessa working as a typist for the Soviet trade mission who had married a diplomat. They had drinks, set off on a sightseeing tour in a taxi, and ended the evening at Babel's hotel, where they began a love affair that would turn out to be the worst mistake Babel ever made, one for which he would pay a truly terrible price (but only much later). It is not surprising that his wife could not be persuaded to return to the USSR with him, although his trip to Paris resulted in the birth of their daughter, Nathalie.

In June 1930, Babel sought peace and quiet by taking a job as a secretary for the village soviet in Molodenovo, about thirty miles outside Moscow, close to where Gorky later settled. While he was there, his *Red Cavalry* stories were republished, causing the old controversy to flare up once again—only now Budenny and his friends were more powerful and more dangerous than in the 1920s. But Maxim Gorky intervened again, comparing the work to Gogol's *Taras Bulba*, and Babel was further protected by his vast popularity with the reading public. In December 1930, he wrote his sister, "Gosizdat has just informed me that the latest edition of *Red Cavalry* has been sold in record time—something like seven days—and that they are going to put out yet another printing, which means a new payday for me."[26] In 1932, he asked permission to visit France to join his wife and meet his daughter, then three years old, for the first time. Permission was denied, but he appealed to Gorky, who bombarded the authorities with such persistence that Kaganovich wrote to Stalin, who was on holiday, for advice. "People are calling me up every day. Evidently, Gorky is fairly intense about this," he complained.

It is to be doubted whether Stalin had ever taken the trouble to read any of Babel's work, but he certainly knew who he was. He was the writer who had offended Stalin's crony Budenny and who was admired by Trotsky and by the suspected Trotskyite Voronsky—"our frivolous Babel, who keeps writing about things of which he knows nothing, for example, the cavalry," as Stalin scathingly called him. He replied curtly to Kaganovich's inquiry: "Babel is not worth spending foreign currency on."[27]

But Gorky was lonely in Sorrento and had his heart set on having Babel there as his guest, and he was so persistent that Stalin had a rare change of mind. Babel left Leningrad in September 1932 and spent about ten months in Paris, interrupted by a couple of months as Gorky's guest in Italy. He mingled with émigrés and talked frankly to the historian Boris Souvarine, who had been Trotsky's most prominent supporter in the French Communist Party. Souvarine asked if it was true that there were valuable works of literature in the USSR that could not be published because of the censorship. Babel answered, "Yes. They're in the GPU. . . . Whenever an educated person is arrested and finds himself in a prison cell, he is given a pencil and a piece of paper. 'Write,' they tell him."[28]

After Gorky moved back to Moscow, he missed his protégé and pestered Babel to return to the USSR, which he did. But the authorities did not want him in the capital and dispatched him to the provinces. He visited the Kabardine Republic in the south; explored Cossack country; went down a coal

mine in the Donetz region of Ukraine; met a lot of people, including farmers, high-ranking communists, and intellectuals; but he published nothing. "Nowadays, writing doesn't mean sitting at one's table," he wrote to his relatives abroad. "It means rushing all over the country . . . and suffering a constant feeling of impotence at one's inability to be everywhere one ought to be."[29]

Though he was certainly seeing parts of the country that were new to him, that was not the reason he wrote so little. "I wanted to write a book about collectivization but that majestic process, in my thinking, became torn up into petty and unconnected fragments," he confessed to the interrogators when he was arrested a few years later. "I wanted to write about Kabardia but stopped halfway because I was unable to separate the life of that small Soviet republic from the feudal methods used to rule it. . . . I wanted to write about the new Soviet family. Here again I was a hostage to my deadening objectivity."[30]

That "deadening objectivity" compelled Babel to write what he saw or not write at all, and what he saw could not be written in the USSR. Collectivization had torn through the Cossack lands like a plague, bringing starvation, armed revolts, and mass deportations. Whole villages were depopulated; in others, emaciated, half-starved villagers dragged themselves to work past spreading weeds and dereliction. Arriving in a Cossack village in December 1933, Babel hinted at what he saw in a letter to his relatives abroad, which he expected the police to read before it left the USSR: "The change over to the collective farm system was not easy here and they have suffered hardships, but now it's all going ahead with a great deal of bustle."[31]

Unlike Osip Mandelstam, Babel did not have the option of saying nothing in public: he was too famous. He was expected not only to attend the writers' congress but also to speak at it. The man with the receding hairline, round spectacles, and lines of anxiety across the high forehead of his round, expressive face was not the same clever and stunningly original writer who had captivated Moscow's literary circles ten years earlier. He was a man of forty, trying to hold on to what he had once believed in, but no hint of pessimism or despair must be allowed to seep into his speech. He must sound buoyed by the brilliant communist future; he must praise Stalin and make a personal statement about what he, as writer, could contribute to socialism. To do this without debasing himself or indulging in falsehood was a nearly impossible task, but Babel was an ingenious wordsmith, and he found a way around his dilemma.

Writers were united in struggle, he began; "that struggle does not need many words, but those words must be good words. As to trite, vulgar, com-

monplace contrived clichés—we are very tired of them." He poked fun at those who tried to celebrate what he called the "physical vigor" of the young Soviet state by shouting about how happy they were and making fools of themselves. By contrast, "Look how Stalin hammers out his speeches, how his words are wrought of iron, how terse they are. . . . I don't suggest that we should all write like Stalin, but I do say that we must all work at our words as he does."

The audience was too busy applauding the mention of Stalin's name to notice that this was less than the usual extravagant flattery of the dictator. Babel had simply said that Stalin wrote in terse, carefully worded sentences, which was undeniable.

After a few more sentences, he talked about himself: "I respect the reader so much that it makes me numb and I fall silent. And so I do keep silence. . . . I am not happy about my silence. Indeed it saddens me. But perhaps this is proof of the attitude toward the writer in this country. . . . The Party and the government have given us everything, depriving us of only one privilege— that of writing badly. It must be said frankly, without false modesty: it is a very important privilege that has been taken away from us. . . . Let us re- nounce that old privilege."[32]

He stepped down from the rostrum to ringing applause. His audience thought that they had just heard yet another optimistic, loyal address; the underlying despair passed them by. It was a speech as subtle as any of Babel's short stories.

7

Pasternak's Sickness of the Soul

It was the worst time of my trials, a kind of sickness of the soul.

—BORIS PASTERNAK

In June 1935, emissaries from the writers' union turned up at Boris Pasternak's dacha to deliver what they assumed would be welcome news: he had been awarded a trip abroad, giving him his first chance in twelve years to see Europe and be reunited with his parents and sisters. The organizers of an International Writers' Congress for the Defense of Culture in Paris had been disappointed by the caliber of the Soviet delegation, which was made up of people who could be trusted to mouth the party line. Two of France's most revered writers, André Gide and André Malraux, had complained to the Soviet ambassador, telling him that the only writers living in the USSR whose names resonated with the French public were Gorky, Babel, and Pasternak. This was the time of the Popular Front, when the French Communist Party was under orders from the Comintern to build a broad alliance against the Nazis, so the complaint was taken seriously and reported back to Stalin. Gorky was too frail to travel, and Stalin therefore ordered that Pasternak and Babel were to set out at once.

The year 1935 was a deceptively quiet interlude in Soviet history. The previous December, the Leningrad party leader Sergei Kirov had been assassinated in mysterious circumstances; even at the time, Kirov's death set off rumors within Soviet intelligence that Stalin had orchestrated it to remove a potential rival. After the murder, there were thousands of arrests, and in the Lubyanka, preparations were under way for the terrible purges that would

130

begin late in 1936. Yet outwardly, all was calm. The dictatorship even ap-
peared to be loosening its control over the populace. Nikolai Bukharin was
using his position as editor in chief of *Izvestya* in a final struggle to curb the
dictatorship and broaden the government's base of popular support. One im-
portant gesture was to publish poems by Pasternak in the newspaper and
invite him to sit in on editorial meetings. Pasternak told his parents that
Bukharin was "a wonderful, historically extraordinary man, but fate has not
been kind to him."[1] Pasternak was also a member of the board of the writers'
union. An aura of official approval had hung over him since that telephone
call from Stalin, and the view was spreading that he was the USSR's un-
official poet laureate. Even Babel benefited from the relaxed atmosphere:
in March 1935, his play *Maria* was published, and the play went into rehearsal,
although it never wound up being performed. The American journalist Louis
Fischer—one of the better-informed observers of the Soviet scene—recorded
later that "1935 marks the high water mark of personal freedom in the So-
viet Union."[2]

But when the visitors from the writers' union brought the latest good
news to Pasternak, they were surprised to find him in a sorry state. He was
going through what was possibly the worst depression he had ever experienced.
Tortured by insomnia and general despair, he pleaded that he simply could
not face a trip to Paris. This put his visitors in a quandary: their instructions
came from Stalin; they could not just report back that their mission had failed.
They insisted that the sick man take that responsibility upon himself. Pas-
ternak duly rang the Kremlin and was put through to Alexander Poskreby-
shev, who was Stalin's principal secretary for more than twenty years.[3] The
conversation was short and to the point. "If there was a war and you were
called up, would you go?" Poskrebyshev asked. Pasternak conceded that under
those circumstances, he would. Poskrebyshev told him to consider himself
drafted and get packing.

Babel and Pasternak were put on a train that took them through Nazi Ger-
many to Paris, which they reached on June 24, the fourth day of the confer-
ence. They arrived to a standing ovation. Babel was thrilled to be abroad and
able to see his ex-wife and daughter. Pasternak had spent the long journey
talking about almost nothing but his bad health and had drafted a speech so
full of gloom that Babel and Ilya Ehrenburg sat him down in a Parisian café
to help him redraft it. The speech he delivered was remarkable for what it
did not say: it had no political content and amounted to just a few sentences
claiming that conferences and writers' organizations had no role in the

creative process, which required independence of thought and personal integrity. Such remarks raised the question of whether there was any point in holding this conference, or indeed in his continuing to be a board member of the USSR Writers' Union. He then lapsed into gloomy thought, standing at the microphone, saying nothing. He left the podium to loud, prolonged applause.

The fifth and final day of the conference turned out to be an awkward one for the Soviet visitors when voices were raised in defense of the writer Victor Serge, who was being held in Orenburg in the Urals after his arrest in Leningrad in 1933 for being a Trotskyite. Pasternak and Babel said nothing while the other Soviet delegates, to quote Serge, "declared without a blink that they knew nothing of the writer Victor Serge—these my good colleagues in the Soviet Writers' Union! All they knew of was 'a Soviet citizen, a confessed counterrevolutionary, who had been a member of the conspiracy which had ended in the murder of Kirov.'"[4] When he was back in Moscow, Pasternak wrote to Mikhail Kalinin, the country's titular president, to protest Serge's arrest. Serge was released and deported the following year.

André Gide offered to introduce Pasternak to anyone in Paris he would be interested in meeting, but the offer was spurned. Almost the only person Pasternak wanted to see was a soul mate, the émigré poet Marina Tsvetayeva. She and her husband were thinking of returning to the USSR. Hoping to put her off, Pasternak told her cryptically, "You'll get to love the collective farms." She missed the irony and was disappointed that this man she had loved, platonically, from afar did not have anything more interesting to say about their home country.[5]

Pasternak would have had a rare opportunity to see his parents if he returned overland through Germany. Among its other advantages, the visit would give him a chance to talk seriously to them about the reality of Soviet life. At the time there was a movement among sympathetic émigré intellectuals to return to their homeland. Sergei Prokofiev, the nuclear scientist Pyotr Kapitsa, and the literary critic Prince Dmitri Mirsky followed the call, which in Mirsky's case meant going back to be denounced, arrested, tortured, and executed. Defying Pasternak's advice, Tsvetayeva and her husband arrived later, with similar consequences. Pasternak was anxious that his elderly parents should not make the same mistake. However, the remainder of the Paris delegation was going back to Leningrad by sea, through the Tilbury docks in London, and Pasternak feared that if he set out across Germany alone, he might have a complete mental breakdown. He chose to return by sea instead.

As a result, he never saw his parents again—eventually they settled in England—and naturally he felt terrible about it. He tried several times to explain his decision by letter. "It would have been dreadful if you had seen me like that—worse than a separation," he told them.[6]

Pasternak's traveling companions on the sea route to Leningrad included the newly promoted secretary of the writers' union, Alexander Shcherbakov. He was not a writer but a trained Communist Party organizer who would later rise to great heights, first as the head of the Soviet Information Bureau, and then as the head of the Moscow party organization. Solzhenitsyn knew Shcherbakov's wartime chauffeur, from whom he learned that "the obese Shcherbakov hated to see people around when he arrived at his Informburo, so they temporarily removed all those who were working in the offices he had to walk through. Grunting because of his fat, he would lean down and pull up a corner of the carpet. The whole Informburo caught it if he found any dust there."[7] Yet Pasternak, who could scarcely speak to people he loved or respected, talked volubly to this unpleasant man.

He reached Leningrad "in a state of complete hysteria," sent for his beloved cousin Olga Freidenberg, and burst into tears when he saw her. Olga's mother, Pasternak's maternal aunt, was so alarmed that she insisted he stay with them rather than go home to Moscow, though it meant that mother and daughter had to share a bed.[8] The arrangement ended when Pasternak's wife, Zinaida, arrived, having heard disturbing stories about his health. "It was the worst time of my trials, a kind of sickness of the soul, a sensation of the end without any visible approach of death, a most unimaginable state of depression," he confided to his fellow poet Titsian Tabidze after he had begun to recover.[9] Years later, when he was in a sanatorium recovering from a heart attack, he took comfort in the thought that this was not as bad as the depression he had endured in 1935, when "they went along with me, would send me abroad, and would print whatever stuff or nonsense I might utter; I really was not suffering from any form of illness, but I was incorrigibly miserable and gradually fading away like someone in a fairy tale bewitched by an evil spirit."[10]

Pasternak had been through a psychological crisis once before that drove him almost to self-destruction. The reason for the earlier trauma was domestic. After ten years of marriage to the painter Yevgenya Lurie, Pasternak fell madly in love with Zinaida Yeremeyeva, wife of the renowned pianist Heinrich Neuhaus and the inspiration for Larissa, the glamorous heroine of Pasternak's only novel, *Doctor Zhivago*. The pain the affair was causing

Yevgenya, Neuhaus, and both couples' children made him feel so "trapped in circles of intersecting sufferings" that on February 3, 1932, while he was at the Neuhauses' flat and Heinrich was out at a concert, he seized a bottle of iodine and swallowed half the contents.[11] Fortunately, Zinaida was a trained nurse.

There is no record of a suicide attempt in 1935, but for months he could neither work nor sleep and was overwhelmed by a sense that his life was meaningless. Yet to outward appearances, he had never been so successful. His work as a poet had won him acclaim at home and abroad, his intervention had played a major part in saving the life of Osip Mandelstam, and he had spoken to Stalin. Pasternak's biographer Christopher Barnes surmised that his second bout of existential despair came because he had learned that Zinaida, like the fictional Larissa, had been seduced—or, more likely, raped—by an older man when she was a child. Yet Pasternak had known that from the beginning of their relationship, and throughout his life he was always resilient when confronted by folly or cruelty in others; he was driven to despair only by circumstances for which he blamed himself.

Boris Pasternak set himself exacting standards, which he derived from being the oldest child of very remarkable parents. They were Jews brought up in Odessa who overcame the anti-Semitism that permeated tsarist Russia and lived as middle-class Muscovites. Leonid Pasternak was one of the leading representational artists of his generation, chosen by Leo Tolstoy to illustrate the first edition of *Resurrection*. Boris Pasternak claimed to remember being disturbed in bed when he was four years old by music coming from downstairs and going down to see the great writer, with his bushy beard and peasant garb, in his parents' front room. When Tolstoy died in a little country railway station, amid "a frenzy of international publicity and the whirr of Pathé cameras," the Pasternaks, father and son, were among the well-wishers who hurried there to pay their last respects.[12]

On another occasion soon after the turn of the century, Leonid was absorbed in painting in an aristocrats' drawing room when he became aware of someone standing behind him, watching him work. It was the Grand Duke Sergei, the tsar's uncle who became governor of Moscow in 1891, the same year that twenty thousand Jews were expelled from the city. Leonid Pasternak may well have been the first and last Jew the grand duke ever encountered in a drawing room.

About two decades later, Leonid was called to the Kremlin to paint a group portrait of Lenin, Trotsky, Rykov, and other leading Bolsheviks. The paint-

ing was bought by the state but destroyed in the 1930s because too many of the leaders it portrayed had since been declared enemies of the people.

Boris's mother, Rosa Kaufman, was a concert pianist before her marriage but gave up performing in public because she suffered from what appears to have been a bad case of stage fright. She continued to give recitals at home for discerning guests, including Rachmaninov, the opera star Fyodor Chaliapin, and the pianist Artur Rubinstein, but also suffered illnesses that may have been more psychological than physical. Pasternak described both his parents as "hysterical," but he looked up to them and feared that he would never be able to work with the same steady concentration as his father.[13]

As a family, the Pasternaks cared more about art and the pursuit of perfection than about politics, but generally their sympathies were with the revolutionaries. Leonid worked with Maxim Gorky on a radical journal during the 1905 revolution, and the whole family attended the December 1905 funeral of the Bolshevik Nikolai Bauman, who had been lynched by monarchists—though, to judge from Leonid Pasternak's memoirs, the parents' main concern in that frantic year was that one of their daughters was ill. Alexander, who was twelve at the time, handed out Social Democratic literature, and even fifteen-year-old Boris tore himself from his studies to sample what he later called "the most dreadful and adult of games," disappearing from home for several hours and panicking his parents. He returned with "his hat . . . crumpled, jacket torn, one button hanging on a tattered snatch of cloth, half-belt dangling, and Boris himself beaming, simply beaming," remembered Alexander.[14] He had been watching a demonstration when it was attacked by mounted troops and had taken a beating as the crowd fled. Though he subsequently made light of his "tuppenny-ha'penny revolutionism which went no further than bravado in the face of a Cossack whip," he became part of a generation who "imagined that the Revolution would be staged again, like a once temporarily suspended and later revived drama with fixed roles, that is with all of them playing their old parts."[15]

By 1917, Pasternak was no longer excited by upheaval but had come to see war and political violence as catastrophes that brought out the worst in people. He had also developed an aversion to political or artistic groups or movements, losing his temper with Mayakovsky when he discovered his name had been added to a collective proclamation without his consent. "Every herd is a refuge for giftlessness," a wise uncle tells the hero of Doctor Zhivago. "Only the solitary seek the truth and they break with all those who don't love it

sufficiently."[16] Even before 1914, news spread by word of mouth among Moscow's young intelligentsia that there was a shy and exceptionally gifted young poet in the city. Some saw him as a possible antidote to Mayakovsky and the cultural destructiveness of the Futurists, but Pasternak did not want to be the head of a literary movement, and he was intrigued by Mayakovsky's talent, self-possession, and "rebellious features of Bohemianism in which he draped himself."[17] He resolved early on to stay out of the feuds and rivalries that absorbed the energies of other writers. As the title of his first book of poems, *Above the Barriers*, published in 1917, might imply, he chose to be on his own.

At first he took the same attitude toward the times in which he was living. Though the energy unleashed by revolution inspired him to one of his major surges of creativity, he deliberately took no part in it, believing that it was the artist's role to stand apart. A poem published just after the end of the civil war acquired some notoriety as a statement of political abstention. Bukharin recited part of it from the podium at the 1934 Soviet Writers' Congress:

> Snow will not always fall
> Covering beginnings, ends.
> The sun, I'll suddenly recall,
> Is there as light ascends.
>
> A handheld scarf protects my ears,
> Out through the window my head I bow
> And call to the kids: "My dears,
> Which millennium is it now?"
>
> Who made a path through this wild environ?
> Who cleared the hole blocked with snow
> While I sat and smoked with Byron,
> And drank with Edgar Allan Poe?[18]

Pasternak's reputation spread more by word of mouth than by publication. Paper was scarce in war-torn Russia, and none was available for a poet who made a virtue of staying out of the conflict. Instead people memorized his stanzas and recited them to one another. When at last a new collection of his poems, titled *My Sister—Life*, was published in April 1922, it sold rapidly both in Russia and in Berlin, where there was a huge Russian diaspora that in-

cluded Pasternak's parents and sisters, who had left Russia in 1921 because Leonid needed eye surgery. One morning in June, Pasternak was recovering from a party he had given the night before to mark the fact he had received permission to visit Berlin when the telephone rang with an unexpected summons. Soon a motorcycle and sidecar arrived to take him to his one p.m. appointment at the Revolutionary Military Council, where Leon Trotsky was conducting research for his book *Art and Revolution*.

Pasternak's conversation with the people's commissar for war lasted more than half an hour. Trotsky complained about intellectuals who were given permission to travel and then, once abroad, spread "insidious tittle-tattle and distortions of the truth" about life under Soviet rule. He wanted to know why Pasternak avoided writing about social questions. He was trying, evidently, to sound out whether Pasternak was a friend or enemy of the revolution and whether he intended to come back from his trip to Berlin or stay abroad to denounce the Bolsheviks. Pasternak replied with a defense of "genuine individualism." There was precious little meeting of minds, though Pasternak came away charmed and impressed by the revolutionary leader. "From [Trotsky's] point of view, everything he said was absolutely true," Pasternak acknowledged—the unwritten implication being that, from Pasternak's point of view, it was all false.[19] Dr. Zhivago's reaction to meeting the fanatical Red Army leader Strelnikov is notably similar.

Trotsky apparently could not decide what to make of Pasternak. When his book came out in 1923, it included assessments of Mayakovsky, Akhmatova, Tsvetayeva, Nikolai Klyuev, and other poets, but not Pasternak. Yet in May 1924, when Trotsky was being barracked at a meeting of the Central Committee press department by the young fanatics from RAPP who wanted only proletarian poets such as Alexander Bezymensky to be published, the people's commissar told them firmly, "Bezymensky wouldn't exist as a poet if we didn't have Mayakovsky [and] Pasternak."[20] That was the only endorsement Pasternak received from that quarter. A decade later, while in exile, Trotsky grumbled to André Malraux that he could not understand why young Russians idolized this apolitical poet. If those remarks were reported back to Stalin, they would have done Pasternak nothing but good.

In Berlin, Pasternak had to make a decision that would affect the rest of his life. For the last and only time, he and his parents, his sisters, his young wife, and his newborn son, Yevgeni, were all together. He could speak fluent German and was a celebrity within Berlin's huge Russian émigré community, where Prince Mirsky, Marina Tsvetayeva, and Ilya Ehrenburg were all

promoting his reputation. The case for staying was strong, but the young couple chose to go back to Moscow.

When it was known that he had rejected a life abroad and tied his future to the revolution, Pasternak picked up allies in high places. In November 1924, Pasternak's wife wrote to his cousin, who was seeking an appointment with the people's commissar for enlightenment, to reassure him that "so far Lunacharsky has never refused to see Borya"—though Pasternak himself claimed in 1927 (possibly with false modesty) that he had encountered Lunacharsky only "once in three or four years."[21] He was also talent spotted by Voronsky and was the only poet of any note to be published in the first issues of *Krasnaya nov*.[22] Years later, when Voronsky was in semidisgrace, he and Pasternak had a drinking session during which Pasternak recited some anti-Stalin verses that have been lost to posterity because he took the sensible precaution of never writing them down.

The Marxist critic Vyacheslav Polonsky, who edited *Novy mir*, the only literary journal with a reputation to rival that of Voronsky's *Krasnaya nov*, had been agitating for Pasternak's work to be published as early as 1921 and encouraging him to give poetry readings. Pasternak came to regard him as a friend. In 1927, he was shocked when Mayakovsky's acolyte Nikolai Aseyev attacked Polonsky in language unpleasantly similar to that of the literary policemen from RAPP. Pasternak publicly severed relations with Mayakovsky and *New LEF* in response.

In 1925, Pasternak made his contribution to the flood of literature commemorating the 1905 revolution with two poems, "1905" and "Lieutenant Schmidt," almost the only poems he ever wrote about real events. The poem "1905" opened with the assassination in February of Grand Duke Sergei by a bomb-throwing Socialist Revolutionary and proceeded through Pasternak's personal recollections of that year, many of which had no relation to politics. "Lieutenant Schmidt" was even more of a departure from his usual output, a meticulously researched account of an officer executed for siding with the mutineers aboard a ship. Pasternak did not think of it as his finest work. "I knowingly compounded this piece of comparative vulgarity as a part of a voluntary, idealistic compact with the time," he later said in a letter a fellow writer.[23]

Such was Pasternak's "idealistic compact with the time" that the Mandelstams feared that he was going to be sucked into the system. "Watch out: they'll adopt you," Nadezhda Mandelstam warned him in 1927. Her words stuck in his mind. He quoted them back at her thirty years later, during the *Doctor Zhivago* affair, yet she was correct when she wrote that Pasternak "never

shunned or tried to leave" the literary establishment.[24] He turned into the sort of person the communists denounced as an "internal émigré" only after the regime had acted in such a disgusting manner that he could not continue his "idealistic compact" without dishonoring himself.

By the end of the 1920s, he was becoming profoundly disengaged. All the influential Bolsheviks with whom he had good relations—Lunacharsky, Voronsky, and Polonsky—had been sacked after the Stalinists consolidated control. "Generally, terrible confusion reigns; we are caught in waves divorced from time," he wrote to his cousin Olga in May 1928.[25] He was sickened by a campaign orchestrated by RAPP against his friend and fellow writer Boris Pilnyak, who was Russia's second bestselling fiction writer, after Gorky. Pilnyak had a contract with an agent who organized the publication abroad of everything he wrote, a standard arrangement for writers who needed to protect their interests abroad, where the USSR had no copyright protection, but it created an unforeseen problem in January 1929 when Pilnyak's latest story, "Mahogany," was banned in the USSR but published in Berlin. Pilnyak was also chairman of a small writers' union, which made him an automatic target for RAPP, which did not tolerate rival organizations. The RAPP seized the opportunity to run a virulent press campaign linking Pilnyak with Zamyatin as supposed agents of foreign interests infesting Soviet literature.

Pasternak was one of the few people in Moscow who dared speak in Pilnyak's defense. He went to a meeting of the Moscow Writers' Union in September 1929 in the hope of brokering some sort of compromise, and when that failed he resigned from the union, alongside Pilnyak, on September 21. The poem "To a Friend" that Pasternak wrote the following year was originally titled "To Boris Pilnyak." It is worth noting that his fictional alter ego, Dr. Zhivago, died in August 1929: to Pasternak, it may have been the year when Soviet literature itself died.

In January 1930, the year in which he would turn forty, he was sent on a writers' visit to the countryside, where he saw long columns of peasants, accused of being kulaks, being herded onto trains to be deported. The sight left him with an impression of "such inhuman, such unimaginable distress, such terrible misfortune that it almost seemed to verge on the abstract."[26] Writing to his sister Lydia, he had to be careful to use language that would not alert the censors as he hinted at what was happening: "The burden weighing down the lives of town-dwellers is a positive privilege compared with what's going on in the countryside. Measures are being imposed that are of the most far reaching significance."[27]

That spring came first the shock of the execution of the twenty-eight-year-old poet Vladimir Sillov for writing what he thought of the regime in a private diary he had kept hidden in his room. "By virtue of the purity of his convictions and of his moral qualities" Sillov was, to Pasternak, "the only one of my main acquaintances whom I felt to be a living reproach to me that I wasn't like him." That murder was closely followed by Mayakovsky's suicide. "A sense that the end is imminent constantly haunts me," he wrote to his cousin. "I played no part in creating the present, and for this life I have no love."[28]

Nonetheless he was persuaded to go on another writers' visit, to Chelyabinsk in the Urals in June 1931, to witness the wonders of the Five-Year Plan. Pasternak was impressed but not for the reasons the organizers of the trip intended. He left Chelyabinsk before the visit was complete and wrote to Zinaida that though the scale of the construction was vast enough to evoke folk memories of Peter the Great, "run-of-the-mill human stupidity nowhere emerged to such a degree of bovine standardization as in the circumstances of this journey . . . behind the vacuity and banality which always put me off there is nothing but organized mediocrity; and that there is no use looking for anything else."[29]

Though he confided his growing contempt for the Stalinist system to Zinaida, in public he retreated into the argument that art, as distinct from craftsmanship, does not follow a plan made by someone else but sets its own rules. In autumn 1931, an autobiographical essay that he had been working on for several years finally appeared in book form, with the title *Okhrannaya gramota*—usually translated as *Safe Conduct*, a reference to the notice that the Bolsheviks placed on old buildings during the civil war to spare them from being demolished in an excess of revolutionary enthusiasm. It was a subjective memoir of his early visits to Germany and Venice, rounded off with his lyrical account of Mayakovsky's death, and did not mention the revolution. It was never going to be welcomed by the Soviet critics, even if they missed the Aesopian significance of a discursive passage on the history and architecture of Venice: "The emblem of the lion figured diversely in Venice. And so the slit for posting secret denunciations on the staircase of the Censors, next to the paintings of Veronese and Tintoretto, was carved in the semblance of a lion's maw. It is obvious how great a terror this '*bocca di leonie*' instilled in its contemporaries."[30]

Appearing at a time when writers were supposed to be serenading the glory of the Five-Year Plan, the book attracted sustained abuse from the moment of its appearance—particularly from RAPP, whose boss, Leopold Averbakh,

was apparently ready to begin a major campaign against Pasternak's subjective view of the world. He was cut short by the sudden abolition of RAPP. When that happened, Pasternak was too engrossed with his domestic crisis to join the general rejoicing; he split from Yevgenya, his wife of ten years, to camp for several weeks in Pilnyak's apartment.

During 1931, when he and Zinaida needed a refuge from their disintegrating marriages, he accepted an invitation from a recent acquaintance, the Georgian poet Paolo Yashvili, to stay with him in Tiflis. In Georgia, Pasternak saw scenery that inspired him to write lyrical poetry, and he made two of the most important male friendships of his life with Yashvili and the poet Titsian Tabidze. "The first years of my acquaintance with Georgian lyrical poetry are a special, bright and unforgettable page of my life," he said later.[31] In 1933, he learned that he had been selected to join another writers' visit to the Urals and lobbied hard for a transfer to the delegation to Georgia, which was led by Mandelstam's tormenter Pyotr Pavlenko. Pasternak also recruited a friend from Leningrad, the poet Nikolai Tikhonov, who was well connected with the authorities, to join him on the trip and in his newfound project of translating Georgian poetry. At the end of the trip, as the train drew away on their return journey, he was so overwhelmed by the beauty of the country and its people that he could not bear to speak to any of his fellow passengers. "I was carrying away great riches in my soul and there was no one with whom I could share them," he wrote to Titsian and Nina Tabidze.[32]

Pasternak had never been much interested in the leaders and heroes of the revolution before then, but it appears that his love affair with Georgia stimulated his curiosity about that small country's most famous son, whose image was everywhere. That would explain his strange reaction to the news broadcast in November 1932 that Stalin's wife, Nadezhda Alliluyeva, daughter of an Old Bolshevik, had died at the young age of thirty-one. Messages of condolence deluged the Kremlin. On November 17, a group of thirty-three writers that included Pilnyak, Shklovsky, and Fadeyev published a collective letter in *Literaturnaya gazeta* offering their condolences. Pasternak was invited to sign, but he had a long-standing aversion to adding his name to collective proclamations. Instead, he wrote a curious tribute that was printed alongside the collective letter, under his signature alone: "I share the feelings of my comrades. On the evening before, I had for the first time thought about Stalin deeply and intently as an artist. In the morning I read the news. I am shaken as if I had actually been there, lived through and seen everything."[33]

During the *Doctor Zhivago* affair in the late 1950s, there was speculation about why Pasternak lived unmolested through the Stalinist purges that consumed hundreds of thousands of people who had never been anything but obedient servants of the leader. An émigré Russian officer named Mikhail Koryakov hypothesized that this strange message, containing the words "as though I had seen it all," had secured Pasternak's survival by giving him a "mystic" hold over Stalin, who deduced that Pasternak was psychic, like a holy fool, and somehow knew the dark secret of Alliluyeva's death: she had shot herself after quarreling with her husband.[34]

Emma Gerstein, one of the great witnesses to the Stalin years, also believed that message gave Pasternak a special status in Stalin's mind, though not for any mystical reason. She suggested that Stalin in 1932 was not yet the pitiless tyrant that he would become—Trotsky and the many others who believed that Stalin was already a cold-blooded killer before his rise to absolute power were wrong.

> This generalization ignores the formation of character and, in the present case, the gradual transformation of a human being into a bloodthirsty monster. For the time being, Stalin was engaged in a cruel and deceitful struggle only with those of his political rivals (Trotsky, Kirov) who might displace him. This was not the same as murdering, in a fit of rage or perhaps jealousy, his wife and the mother of his two children. Someone had to pity if not forgive the murderer. Chance helped him learn of the poet's genuine compassion.[35]

It is attractive to think that a poet was able to touch the cold heart of a tyrant, but this story has no supporting evidence. It is not necessary to evoke mysticism or psychology to explain Pasternak's survival through the Stalin years; generally, the regime did not kill artists with international reputations. Stalin never displayed any interest in Pasternak, except on that one occasion when Osip Mandelstam's arrest might have interfered in the success of the impending writers' congress. Rather, it was Pasternak who was, for a time, fascinated by Stalin.

Pasternak owed his entry into the world of high politics not to Stalin but to Nikolai Bukharin, who ended five years of enforced public silence when he was appointed editor in chief of the country's second most important newspaper, *Izvestya*, on February 22, 1934. Under his control *Izvestya* became the most popular and widely read of all Soviet newspapers.[36] He expanded *Izvestya*'s cultural coverage, hoping to demonstrate that the regime could

broaden its base of support against the menace of fascism by relaxing the dictatorship. To this end, it has been suggested that "it was Bukharin who needed—and found—support from Pasternak, not vice versa."[37]

Pasternak had avoided contributing to newspapers for several years, as if it were demeaning to the status of poetry to use such a transient medium, but such concerns now took second place to his anxiety about the news from Germany.[38] The Pasternaks were a highly assimilated family who thought of themselves as Russians rather than Jews. "I'm all for complete Jewish assimilation, and personally I only feel at home in Russian culture," Pasternak once said.[39] On another occasion, he jokily listed the big mistakes he had made in his life, the second of which was "being born a Jew—a remarkably dumb thing to do."[40] One of Osip Mandelstam's many grumbles about Pasternak was that he had converted to Russian Orthodoxy and worried about allowing his first son to have a nanny who had been brought up in the Pale of Settlement in what is now Belarus, lest he pick up her accent. Yet the fact that his parents and sisters did not look or sound like Jews proved inadequate protection in Nazi Germany. One of the books consigned to the flames during the Nazis' infamous book-burning ceremony was a short biographical study of Leonid Pasternak.

The news from Germany prompted Pasternak to think again about the Bolsheviks. A few weeks before the approach came from Bukharin, he was trying to re-create in his mind the "enchanting midnight conversations" that must have taken place in revolutionary circles when Lenin and Stalin were young: "How out of their minds the ravings of those revolutionary Russian aristocrats make them seem *now*, when the smoke has turned to stone and their conversation has become part of the geographical map—and how solid a part! Yet a more aristocratic and freer light than this has never been seen, our naked and loutish reality that is still cursed and deserving all the groans it provokes."[41]

His first contribution to *Izvestya* appeared on March 6, only two weeks after Bukharin's appointment, in the form of a selection of Pasternak's translations of the works of Yashvili and Tabidze. Exactly a week later, Mandelstam was arrested. This implies that it was at the very time when Pasternak was beginning his collaboration with the authorities that his fellow poet, whom he had always respected as an artist despite their personal differences, approached him in the street and recited that highly subversive poem. Pasternak was appalled not just because of the risk but because he thought it the wrong time to be writing invective directed at Stalin, the potential

protector of the Jews. He made a revealing comment about it to Nadezhda Mandelstam. "How could he write a poem like that when he's a *Jew?*" he exclaimed. She, of course, bristled at this slur on her husband and offered to recite the poem so that Pasternak could tell her exactly which part it was that a Jew should not write, but Pasternak recoiled and pleaded with her to do no such thing. "I still do not see the logic," she declared sniffily in her memoirs, many years later.[42]

That he disapproved of the poem did not prevent him from going into overdrive to try to get Mandelstam released. According to Pasternak's third wife, Olga Ivinskaya—not a wholly reliable witness, it should be said—one reason that he moved into action so decisively was that he was afraid the Mandelstams might think that he was the one who had gone to the police. First, he wasted time pleading with the Kremlin's court poet, Demyan Bedny, who drove him around Moscow in his car—a symbol of Bedny's elevated status—while talking effusively, but not about Mandelstam. Then he approached Bukharin.

For a moment, a brief interest in this much talked about poet flickered to life in Stalin's mind—not because of his art but because Pasternak knew Bukharin. Stalin was intrigued by Bukharin, the man Lenin had once called the "favorite of the whole party." He was also envious of him. He lived in Bukharin's old Kremlin apartment. Bukharin was happily married to the teenage daughter of an Old Bolshevik, while Stalin's marriage had terminated in a suicide. "Nikolai, you've outgalloped me again," he told Bukharin.[43]

Pasternak anguished over that telephone conversation. He went over it again and again in his mind, fretting that he had said the wrong thing, yet the people likely to have judged him most harshly—Osip Mandelstam, Nadezhda Mandelstam, and Anna Akhmatova—all believed he had behaved honorably and had avoided the most dangerous trap by not letting on that he had heard or even knew about Mandelstam's incriminating poem. He also was embarrassed by the social status he had suddenly gained as someone who had spoken directly to Stalin. "One could so easily be tempted to flaunt the fact, without meaning to. If one didn't conceal it, it could give one an unrealistic sense of euphoria," he confessed.[44] He did not tell his young son about the call, and after the initial rush to spread the news, he stopped telling others about it altogether. It took until the late 1940s for the news of the conversation to leak to the Russian émigré press, whereas Bulgakov's telephone call was reported abroad within months of it happening.

Despite his reticence, Pasternak soon found official favor conferred on him in multiple ways. At the end of the writers' congress, he was unanimously elected to the board of the USSR Writers' Union, alongside some of the century's dreariest literary policemen. Soon afterward, he secured a thousand-ruble advance for a grand novel he was planning, which was to be in the style of Charles Dickens. The project would go through several stages over the course of twenty years before becoming *Doctor Zhivago*, much changed from its original concept. Bukharin even persuaded Pasternak to write a poem about Stalin for *Izvestya* that appeared early in 1936. It opened with the line "I am very fond of the obstinate temperament" and described the Kremlin recluse as "not a man, but deed incarnate," who, despite his superhuman deeds, has "remained a human being." He wasn't proud of this poem in later years, but it was less sycophantic than many of the other contributions to the Stalin cult.

During one of Anna Akhmatova's visits to Moscow, Pasternak tried to induce her to join the writers' union and described how he had been invited to an *Izvestya* editorial meeting, where he had the honor of sitting next to Karl Radek.[45] Akhmatova was unmoved. He later put his newfound influence to use when Akhmatova came to him in desperation because her husband and son had been arrested. Pasternak walked to the Kremlin to hand deliver a plea on their behalf, and the following morning Poskrebyshev called to say that they had been released.

Pasternak's favorite cousin, Olga Freidenberg, was one of the very large number of people affected by the assassination of Kirov in Leningrad on December 1, 1934. The avoidable death of Kirov the good communist, murdered on Stalin's secret instructions, is the political theme of the monumental novel *Children of the Arbat* by Anatoli Rybakov, written in the 1960s but suppressed for twenty years. The real Kirov was possibly not as attractive as he appeared in the afterglow of his death. The Yugoslav Trotskyite Ante Ciliga recalled a man hated in Leningrad, a "foreign conqueror" living in isolated luxury, like some high-ranking official of the Austrian Empire. "In the offices of Kirov, governor of Leningrad in 1929, one felt that the revolution had already been tamed and canalized," he wrote.[46] It is also possible that his murder, like John F. Kennedy's, was the work of a loner and not a conspiracy.

In its immediate aftermath, there were mass arrests in Ukraine, Azerbaijan, and Leningrad, where thousands of so-called Leningrad aristocrats were deported to the provinces, taking with them only what they could carry and

lacking any means of support upon their arrival. Anna Akhmatova and Na-
dia Mandelstam went to the station to see off a frail woman who was being
deported to Saratov with her three small sons and had to battle their way past
people sitting on trunks and suitcases, spotting the faces of people they knew,
including granddaughters of revolutionaries exiled in Pushkin's time. "I never
knew I had so many friends among the aristocracy," Akhmatova remarked.[47]

At the Leningrad Institute of Philosophy, Language, Literature and His-
tory where Olga Freidenberg had finally, after years of frustration and pov-
erty, obtained a job suitable to her immense talents as the founding head of
the department of classical philology, the director was arrested and the insti-
tute newspaper urged staff and students to "discover people's secret thoughts."
"The atmosphere became unbearably charged," she wrote in her diary. "Some
of the students began intriguing, informing, creating a feeling of secret dis-
content, fault-finding censure . . . the rumors, the ringing of the phone, the
whispered stories, the latest news coming from second and third hand sources
poisoned my life and shattered my nerves."[48]

The start of these ominous developments found Pasternak, curiously, in
high spirits and full of plans. On December 25, 1934, he told his parents,
"I've become a particle of my time and my nation, and its interests have
become mine."[49] The following April, he told his cousin, "You know, as time
goes on, the more I believe in what is happening to us, despite everything.
Much of it strikes one as absurd, but then again, amazing. Even so, consid-
ering Russia's resources, basically untouched, the people have never seen so
far into the future, with such a sense of self-worth."[50]

He was the Soviet Union's premier poet. Artistically, his only peers were
Akhmatova, Mandelstam, and Tsvetayeva, of whom one was in internal
exile, one had not had anything published for more than a decade, and
the other was abroad. Pasternak was the one great living poet with official
status. At a meeting in Gorky's home in May 1931 that brought together
all the most important writers and officials in Soviet literature besides Pas-
ternak, Alexei Tolstoy proposed a toast in his absence to the USSR's "pre-
mier poet." At the time, Tolstoy was rebuked by a people's commissar, but
by the end of 1934 the toast was almost in line with official thinking.

At some point around May 1935, Pasternak was overwhelmed by a sense
of the falsity of his position. He had built up a public following over the years
so that they could share his poetry, not so that they could look at him. He
did not even want to be a celebrity, like Mayakovsky. "Life without privacy
and without obscurity, life reflected in the splendor of a plate-glass showcase

is inconceivable to me," he wrote.[51] To be in a position where people were flattering and cultivating him because he had accidently acquired an influential social position was worse: "I was forced to witness, instead of real work, real achievements, nothing but other people's opinions, baseless fairy-tales hashed up all over again, applause, ovations, and a lot of fuss being made of my own sick self."[52]

For four months, including the period of the Paris trip, he was close to a mental breakdown. He complained later that he lay awake, night after night, sleeping for only a few hours. He could not write anything. On occasion, false praise and unwanted attention reduced him to tears. He feared that he had irrecoverably ruined his reputation among people who loved his poetry.

He began to recover during the few hours that he hid away in his aunt's apartment in Leningrad, but the real cure came unexpectedly, from the Kremlin. Stalin had had enough of Bukharin and was preparing to move in for the kill (literally), and therefore Bukharin's poet was of no use to him anymore. He was also ready to discard the dying Gorky, who had had a lasting aversion to Mayakovsky. To show his contempt for them both, he suddenly, arbitrarily ruled that Mayakovsky was the greatest poet of the Soviet era.

It is doubtful whether Stalin gave even a moment's thought to how Pasternak might react. It certainly would not have occurred to the grim dictator that he would get a long thank-you letter from a grateful poet who felt he had been released from the degradation of official sanction.

Dear Josif Vissarionovich

It vexes me that I did not follow my first wish and thank you for the miraculous and instantaneous release of Akhmatova's family. But I felt ashamed to disturb you a second time and decided to keep to myself a warm feeling of gratitude to you, being assured that it would, in any case, and by means unknown, in some way reach you.

Yet another uncomfortable feeling. To begin with, I wrote to you in my own style, wordy and with digressions, submitting to that mysterious something that, beyond what all people understand and share, draws me to you. But I was advised to abridge and simplify the letter, and I am left with the terrible feeling that I have sent you something that is foreign and not mine.[53]

Two paragraphs followed, explaining that Pasternak had been wanting to offer a gift of one of the "modest fruits of my labors," settling eventually for

a translation of Georgian lyric poetry, "the honor and glory of which belong wholly to the authors themselves." He went on:

> In conclusion, let me thank you warmly for your recent words about Maya-kovsky. They correspond to my own feelings; I love him and have written an entire book about that. However, your lines about him have also indirectly had a saving effect on myself. Recently, under the influence of the West, I have been terribly overpraised, and an exaggerated importance has been attributed to me (it even made me ill): they began to suspect a major artistic force in me. Now that you have put Mayakovsky in first place, I have been freed of this suspi-cion, and with a light heart I can live and work as before, in modest silence, with the unexpected and mysterious occurrences without which I would not love life,
>
> > In the name of that mystery,
> > I remain, your warmly affectionate and devoted,
> > B. Pasternak.

For a few more months, Pasternak remained intrigued by Stalin, whom he watched from afar, though there were no more letters, nor any direct or in-direct contact. Then he lost interest. What remained was an abiding horror of false fame, which he expressed in a poem he wrote in 1956, just before the *Doctor Zhivago* affair made his name known around the world.

> It is unworthy, being famous:
> Celebrity doesn't elevate . . .
>
> How shameful, when you stand for nothing
> To be the talk of everyone.[54]

Within weeks of writing that, Pasternak was the most talked-about writer anywhere in the world.

8

Stalin and the Silver Screen

Eisenstein loose [sic] his comrades confidence in Soviet Union.

—JOSIF STALIN

Sergei Eisenstein and his companions left the Soviet Union with a sense that the world was opening its doors to welcome them. They returned humbled and defeated and would never again experience the exuberant, freewheeling creativity that had gone into the shooting of *Potemkin*. They had learned the hard way that Hollywood could be brutal.

They were joined in Berlin by Ivor Montagu, communist grandson of the founder of the merchant bank Samuel Montagu & Co. (Ivor's older brother Ewen later became a renowned British intelligence officer, though Ivor was a Soviet fellow traveler, possibly even a Soviet agent.) He led his guests to a Berlin museum of homosexuality, complete with "a glass case full of tiny colored sailors nude except for their naval caps, boots, bandoliers, etc., and painted red as if bleeding," where the curator explained how the combination of naval uniforms and pain heightened the joy of gay sex.[1] The effect of such a visit on Eisenstein, who had kept his sexuality rigidly suppressed while he was in Russia, can only be surmised, but its liberating impact may have contributed to the disaster that was to follow.

From Berlin it was on to Switzerland, for the First International Congress of Independent Cinematography, and then Paris, where Eisenstein met James Joyce, whom he revered as one of the greatest writers alive—a view that would soon conflict sharply with the communists' official line. The next stop was London, where Montagu had been orchestrating a three-year campaign

against the ban on *Potemkin* imposed by the Board of Film Censors, gaining support from H.G. Wells, George Bernard Shaw, and many others. Eisenstein was in the audience when the London Film Society screened *Potemkin* for the first time, on November 10, 1929, a screening for club members only. The first public showing in the UK was organized by a miners' lodge in Jarrow, in the northeast of England, in December 1934. The ensuing police prosecution failed to convict.

In Paris, Eisenstein met Paramount's Jesse Lasky, who offered him a six-month contract at the eye-watering salary of $500 a week. Eisenstein insisted that Paramount hire Alexandrov and Tisse too, which Lasky was reluctant to do. He was, after all, buying Eisenstein's fame rather than the excellence of the team that made *Potemkin*, but he raised the offer to $900 a week, out of which Eisenstein could pay his companions. They crossed the Atlantic and then the United States, becoming stars of the Hollywood dinner circuit at a time when full diplomatic relations between Washington and Moscow were still a presidential election away. Several ideas for films were taken up and rejected, until one evening over dinner at his Hollywood home, Lasky told his "Rooshian" protégés that Paramount owned the rights to a massive novel called *An American Tragedy*, by Theodore Dreiser, the story of a poor boy who almost makes good when he courts a rich man's daughter, only to be thwarted by the inconvenient reappearance of a pregnant girlfriend, whom he takes boating on a lake, where she drowns. He is executed for her murder. Eisenstein—who suspected that Paramount's executives had not read the novel—seized on its social implications.[2] In his screenplay, the drowning was accidental and an innocent youth was sent to the electric chair as an offender against social norms. Paramount accepted it and dispatched Eisenstein, Alexandrov, Tisse, and Montagu to New York to inspect locations so that filming could start without delay.

At this point came the first in the series of disasters that would bedevil Eisenstein's sojourn in America, brought to him by "professional patriot" Major Frank Pease, president of an organization called the Hollywood Technical Directors Institute, which had made its reputation by campaigning against the film *All Quiet on the Western Front* because it supposedly threatened the fighting spirit of U.S. servicemen. Eisenstein had been gone from Hollywood less than a week when, on June 17, 1930, Lasky received this telegram:

> If your Jewish clergy and scholars haven't enough courage to tell you and you yourself haven't enough brains to know better or enough loyalty toward this

land, which has given you more than you ever had in history, to prevent you importing a cut-throat red dog like Eisenstein, then let me inform you that we are behind every effort to have him deported. We want no more red propaganda in this country. What are you trying to do, turn the American cinema into a communist cesspool? It won't take any Samson to pull down the Bolshevik temple you are starting and at this rate it won't be long now *Mene mene tekel upharsin.*[3]

The telegram was supplemented by a twenty-four-page document titled "Eisenstein, Hollywood's Messenger from Hell," which was circulated throughout California and depicted the Russian visitor as a sadistic Jew steeped in Bolshevik atrocities. Amid this libelous rubbish, even the one seemingly uncontroversial assertion, that Eisenstein was a Jew, was wrong: his mother was Russian, and though his father was probably of German Jewish descent, the marriage would not have been recognized in Russia had he been a practicing Jew. That made no difference. When Pease's relentless campaign resulted in the creation of a congressional committee to investigate communist influence in Hollywood—chaired by Hamilton Fish III, a future Nazi fellow traveler—Paramount took fright. Eisenstein and companions were called into Lasky's New York office and told, "Gentlemen, it is over. Our agreement is at an end." Dreiser's novel passed to another director but would not be realized as a film until 1951, with George Stevens's *A Place in the Sun.*

Paramount would have liked to bundle their guests back to the USSR as quickly as possible, but Eisenstein was not ready to give up. He returned to Hollywood and confided to Charlie Chaplin that he dreamed of making a film in Mexico, a country that had fascinated him since his days as a set designer, when he had worked on a play based on the Jack London story "The Mexican." Chaplin referred him to the novelist Upton Sinclair, author of *The Jungle*, the classic exposé of the Chicago meat trade, whose wife, Mary, came from a wealthy Mississippi family and agreed to put up not less than $25,000 in return for sole and complete ownership of the proposed film. With that, the stage was set for the next disaster.

Eisenstein, Alexandrov, and Tisse checked in at the Regis Hotel in Mexico City in December 1930, accompanied by Mary Sinclair's brother, Hunter Kimbrough, whose task was to guard his sister's interests. The tireless Major Pease somehow knew of their whereabouts and contrived to have them arrested, but by December 22 Kimbrough was able to reassure Sinclair that they were "all out of jail and will resume work tomorrow."[4] Four days later, they

received a gracious apology from the Mexican secretary of foreign relations. Another farcical delay ensued when the district governor insisted on meeting the visitor, under the impression that he was Albert Einstein. Once that was cleared up, they moved south into the tropical heat of Tehuantepec, where Alexandrov and Tisse fell ill and Eisenstein underwent something like a religious epiphany.

> It was not that my consciousness and emotions absorbed the blood and sand of the gory corrida, the heady sensuality of the tropics, the asceticism of the flagellant monks, the purple and gold of Catholicism, or even the cosmic timelessness of the Aztec pyramids: on the contrary, the whole complex of emotions and traits that characterize me extended infinitely beyond me to become an entire, vast country with mountains, forest, cathedrals, people, fruit, wild animals, breakers, herds, armies, decorated prelates, majolica on blue cupolas, necklaces made of gold coins worn by the girls of Tehuantepec and the play of reflections in the canals of Xochimilco.[5]

Besotted with his surroundings, he was in no hurry to finish his work. He was contracted to deliver a film in four months, but three months passed before he shot the first frame. When shooting finally began, Eisenstein had to cope with the problem of being far from any technical facilities; because they could not be sure that every "take" was usable, Tisse shot most of them twice. The rushes were forwarded to Sinclair in Hollywood for processing. Sinclair's first reaction was wild enthusiasm. He wrote the Mexican foreign minister in April 1931 that they were "gorgeous beyond all telling," but eventually he began to fret as more and more reels arrived—each negative subject to an import tax—for a film that could not be marketed because it did not yet have a title or story line.[6] Soon the batches of copious, unsellable film came accompanied by requests from Eisenstein for more money and self-pitying complaints from Mary Sinclair's spoiled, sheltered brother. Upton Sinclair would later claim that Hunter Kimbrough had not known that homosexuals existed until he met Eisenstein.[7] After nine months together in the Mexican heat, he had evidently learned something, because a plaintive message charged not only that Eisenstein was arrogant, egotistical, and careless with other people's money but also that "many people here, including myself, think he is some kind of pervert."[8]

Sinclair must have shown this letter to someone at Amkino, the Soviet company that exported and imported films from and to the United States,

which meant that its allegations were fed back to Moscow. Eisenstein in turn heard about it and fired off a riposte, his anger clear from the erratic spelling.

I am sorry to mention that most of the time in lesser or greater degree Hunter is drunk, which absolutely disenables me to do things with him. This item by itself is a question of very big financial importance. . . . Besides costs on licors etc., entertainings (10% of which might be of use for the picture!), parties, girls and other pleasures which go ahead with it and constitute many a heavy and entirely useless bill, the thing ruinously affects any business movements. . . . At the actual moment all my personal contact with Hunter has seased])—I think it quite natural after his declaring that he considers me a dishonest person and my behavior towards you as blackmailing. (You understand very well these statements cannot affect me when said by a person who was put in jail in Merida for public indecency in a bordello, after a wild adventure with throwing whores in the swimming pool).[9]

Mary Sinclair soon wished that she had never met Eisenstein. Her harassed husband wrote to Gosizdat, the state publishing house in Moscow, asking to be paid $25,000 out of the royalties he was owed for the sales of his novels in the USSR, promising that every cent would go into Eisenstein's project. Without his knowing it, this letter landed Eisenstein in serious trouble. No one at Gosizdat would have dared release so large a sum of foreign currency without referring the matter upward. The request went all the way up to the supreme authority, the Politburo, who—with Stalin absent on holiday in the south—shifted the decision to the second most important committee in the land, the Orgburo, who in turn decided to do nothing except delegate the head of Agitprop to send Eisenstein a summons ordering him to return to the USSR. Stalin was informed while he was still on holiday and smelled treachery. Though he could not remember Eisenstein's name accurately, he instantly detected a plot to extract money from the Soviet state to fund a new life abroad. He warned his deputy Lazar Kaganovich, "The American writer Sinclair has written a letter where he asks for support for some enterprise launched by Sinclair and Aizensteid [sic] ('our' well known film maker who fled from the USSR, a Trotskyite if not worse). Apparently Aizensteid wants to hoodwink us through Sinclair. In short, the whole thing smells fishy."[10]

Eisenstein did not know it yet, but whatever chance he still had of finishing the film over which he had lingered so lovingly was already lost. Only

distance and poor communications kept him in happy ignorance. After about three months, a telegram from Stalin arrived at the Sinclairs' Pasadena home:

> Eisenstein loose [sic] his comrades confidence in Soviet Union. He is thought to be deserter who broke off with his own country. Am afraid the people here would have no interest in him soon. Am very sorry but all assert it is the fact. Wish you to be well and to fulfil your plan of coming to see us. My regards, Stalin[11]

Sinclair's immediate reaction was to rise honorably to Eisenstein's defense. He replied with a long letter asserting that neither he nor anyone else who had worked with Eisenstein had ever heard him utter a disloyal word about the Soviet Union, that the delays in Mexico were not Eisenstein's fault, and that there was no risk of his defecting. He also withheld news of the telegram from the crew in Mexico, hoping that Eisenstein would come back quickly with a marketable film.

In December, the Politburo discussed Eisenstein again and reprimanded the officials responsible for allowing resources to be squandered on his project. A few days later Sinclair was summoned by telegram to New York for a meeting with Soviet officials, but he pleaded that he was too ill to travel.

Finally, in January 1932, Sinclair gave up, cut off Eisenstein's money supply, and left him with no choice but to say good-bye to Mexico. Eisenstein decided to play a valedictory prank on Kimbrough, using hundreds of drawings he had made while he was in Mexico. He put the drawings at the top of his trunk, where they would be seen by anyone who opened it, and then asked Kimbrough to take the trunk back to the United States. It was opened at the Texas border, where customs officers discovered a vast collection of sacrilegious and homoerotic images, including a drawing of Christ on the cross, his penis extended to the length of a hose with its end in the mouth of one of the thieves.

Even if the tiresome Kimbrough had earned this humiliation, it was a foolish and self-defeating stunt, one that permanently turned Upton Sinclair against Eisenstein. After months of defending him against all his accusers, the novelist wrote a long, angry letter to the new head of Amkino, describing the incident at the border and implying that Eisenstein might, after all, be a potential defector, as Stalin had suspected. "Of course, if he does not want to go back to Russia, nobody wants to make him go. All we are saying is that we shall never see him again, nor deal with him in any way," he wrote.[12] His anger was still hot when, years later, Sinclair spoke to Eisenstein's biog-

rapher Marie Seton: "We realized that he was simply staying in Mexico at our expense in order to avoid having to go back to Russia. All his associates were Trotskyites, and all homos. Men of that sort stick together. . . . I had come to realize that Eisenstein was a man without faith or honor, or regard for any person but himself."[13]

Eisenstein paid another, more painful price for his folly at the Texas border. He hoped to recover the rushes from his uncompleted film, now titled *Que Viva Mexico!*, and edit them in Moscow, but Sinclair refused to hand them over unless he was paid at least $50,000 to recoup what he and his wife had lost on the project. The Soviet authorities had no intention of paying a cent. Sinclair tried a direct appeal to Stalin by telegram, in which he accused Eisenstein of "shameless conduct, slanders, misrepresentations, intrigues," but it accomplished nothing.[14] Eisenstein's work was then cut and edited without his permission, and released in 1933 as *Thunder over Mexico*, with Eisenstein credited as the director. Seven years later, it was turned into another film, *Time in the Sun*. In the 1950s, Upton Sinclair handed all the unedited material over to New York's Museum of Modern Art, which in turn passed it to the USSR the following decade. In 1979 Alexandrov produced a version as close as possible to Eisenstein's intention. By then, Eisenstein was long dead, having spent many years mourning his lost creation.

Eisenstein returned to Moscow unaware of the part Stalin had played in his recent misfortunes, but it did not take him long to understand that the creative freedom he had enjoyed in the 1920s was over. In his absence, the industry had abandoned silent movies. *Odna*, variously translated as "Alone" or "A girl alone," was the first major Russian film to be accompanied by a soundtrack, released on October 10, 1931. Directed by Grigori Kozintsev and Leonid Trauberg, it was about a young graduate from Leningrad sent to teach in the wilds of Altai, where she is almost murdered by village elders who do not want their sons in class when they could be working. One of the soundtrack's contributions by Dmitri Shostakovich became the first hit song to emerge from a Russian cinema.

What defeated Eisenstein was not the new technology, however, but changes in the regime. During his early career, Sovkino had raised the money to fund films like *Potemkin* by importing cheap Hollywood comedies and adventure stories that played to packed houses. That was no longer allowed. Sovkino had been given the impossible task of making films that were both politically instructive and profitable, while the censors pushed up costs by ordering scripts to be rewritten, scenes reshot, and entire projects abandoned.

In 1928, the last year in which the old freedoms of the New Economic Policy (NEP) years applied, Sovkino had turned out 148 new films; by 1933, that figure had fallen to 35. Moreover, the slogan of the Five-Year Plan— "Everything with Our Own Machines and from Our Own Materials"— demanded that film crews use Soviet-made equipment wherever it was available, regardless of quality. The first Soviet factory for producing raw film opened in 1931, but it would be years before it turned out film that met Western standards. When the first sound movie came out, only two theaters in the country were equipped to show it, one in Moscow and one in Leningrad. The number of cinemas quadrupled from 7,331 in 1928 to just under 30,000 during the 1930s, but the number equipped with sound projectors had reached only 300 by 1933. No Soviet-made portable sound projectors existed until 1934.[15]

After various changes in management, the task of pulling together and expanding this new industry was entrusted to an Old Bolshevik named Boris Shumyatsky, who had once been in the same exiles' colony in a remote part of Siberia as Stalin. He came from Krasnoyarsk, in the east, and until the mid-1920s had never been employed anywhere west of Tehran, where he had served as Soviet ambassador. Suddenly he was in charge of a rapidly changing industry about which he knew nothing. He set out to quadruple the sale of cinema tickets, multiply the industry's profits by a factor of ten in two years, and more than double the output of new films. A junior official who had worked with Shumyatsky in Tehran found him "gifted with astounding energy, capable of working all day and all night, eager and uncompromising . . . the stuff of which leaders are made" and reckoned that his job was made impossible by the demands imposed on him by the Kremlin.[16] Inevitably, he made enemies. The author of the first history of Soviet cinema, Jay Leyda, an American student who had worked with Eisenstein, claimed that on the day when Shumyatsky was finally sacked "all of Moscow's film makers gave parties" to celebrate.[17] If so, celebration was premature, because his successor, Semyon Dukelsky, a former NKVD officer, made Shumyatsky seem "like a sophisticated gentleman and a patron of the arts,"[18] according to historian Peter Kenez. Dukelsky's successor, Ivan Bolshakov, who held the job for many years, "had as much connection with cinema as a policeman on point duty," in the opinion of the film director Leonid Trauberg.[19]

Regardless of who was chairman of Sovkino and later Soyuzkino at any given time, the real boss of Soviet cinema was always the same: Stalin had become a film buff. In a life of few pleasures and little relaxation, Stalin had created a refuge in his private cinema. After the 1920s, he never visited

the Russian countryside and almost never left the Kremlin except to walk to his dacha along a heavily guarded underground tunnel or to take his summer vacation in the south. His only images of everyday life outside Kremlin walls came from the heavily censored films that Shumyatsky and his successors produced. The Montenegrin communist Milovan Djilas described sitting through one of these private viewings after the war: "They put on not a war film, but a shallow, happy, collective-farm movie. Throughout the performance Stalin made comments—reactions to what was going on, in the manner of uneducated men who mistake reality for actuality."[20] The film Stalin is said to have loved more than any other was the 1938 Hollywood production *Boys Town*, starring Spencer Tracy as Father Edward J. Flanagan, a real-life character who ran a home for delinquent boys. He enjoyed one scene so much that he would "grab the arm of the person sitting next to him, squeeze and say 'Look at that, look at that!'" whenever it came on-screen. He apparently watched the film 256 times.[21]

Knowing that no film could go on to general release until Stalin had approved it, directors took the precaution of submitting screenplays for his approval before shooting began, or they arranged private viewings of the early rushes of partially completed films to get his comments, thereby adding more delays in an industry whose output was already far below target. Sometimes Stalin imposed so many changes on a film that he could justifiably have been credited as a co-writer. In January 1937, he read the script of *The Great Citizen*, based on the life and death of Sergei Kirov, while one of the great Moscow show trials was in progress, at which Grigori Piatakov, Karl Radek, Grigori Sokolnikov, and other Old Bolsheviks were confessing to Kirov's murder. Shumyatsky was served a list of detailed changes, plus general political guidance on how the film's political message should be put together, including a complaint that the villains looked older than the current leaders; he did not want the public reminded that the lead defendants in the show trials were old enough to have done long service in the pre-1917 revolutionary movement. He also did not want Kirov's murder to be the high point of the drama—a greater evil than the Kirov murder was the conspiracy against Stalin. "Any terrorist act pales before the facts disclosed at the trial of Piatakov and Radek," he wrote.[22]

Submitting a film for Stalin's approval was an experience that could induce abject terror. Shostakovich reputedly told a story of an unnamed director sitting in front of Stalin at a private screening of his film who found himself in such a state that "he turned into a giant receiver set; every squeak that

came from Stalin's seat seemed decisive, every cough seemed to toll his fate."
During the screening, Stalin's secretary, Poskrebyshev, came in and handed
the boss a dispatch that he read in the dark, and then exclaimed, "What's
this rubbish?"—whereupon the poor director passed out.[23]

Though it was terrifying to meet Stalin, it could also be the making of a
director's career. The last great Soviet masterpiece of the silent era was the
1930 film *Earth* by Ukrainian director Alexander Dovzhenko. The plot re-
volved around a former landowner's attempt to ruin a successful collective
farm as it prepared to receive its first tractor. The film was not simply propa-
ganda—it was a philosophical examination of death and renewal that opened
with a close-up of a dying man taking intense pleasure from the taste of an
apple and ended with the slow funeral of the collective farm's chairman. In
the uncensored original, there was also a glimpse of a naked woman, the
grieving fiancée of the chairman, which even Eisenstein regarded as an aes-
thetic error. In time, the film came to be regarded as one of the classics of
silent cinema; polled by the British Film Institute in 2002, Karel Reisz, one
of the greatest British film directors of the 1960s, put it second, behind only
Luis Buñuel's 1972 surreal masterpiece *The Discreet Charm of the Bourgeoisie*,
in his list of the greatest films ever made. Yet in its day the film met with the
fury of Soviet culture's political guardians. The "proletarian poet" Demyan
Bedny devoted three columns of *Izvestya* to a furious assault on the "defeat-
ism" of *Earth*, which Dovzhenko was obliged to reedit.[24]

As his problems worsened and the attacks on him grew shriller, Dovzhenko
resorted to a direct appeal to Stalin. Twenty-two hours after dispatching the
letter, he was in the Kremlin and reading the script of his next project, *Aero-
grad*, to an audience of four: Stalin, Voroshilov, Molotov, and Kirov. Stalin
was all charm and suggested that after *Aerograd* Dovzhenko should make a
film about a Ukrainian guerrilla fighter named Nikolai Shchors, who had
been killed during the civil war. After his Kremlin visit, the difficulties that
had plagued Dovzhenko disappeared and work on *Aerograd* proceeded apace,
obstructed only by a series of newspaper reports pressuring him to get started
on the film about Shchors. The director was summoned again to the Krem-
lin, to be told by Stalin: "I was merely thinking of what you might do in
Ukraine. But neither my words nor newspaper articles put you under any ob-
ligation. You are a free man. If you want to make Shchors, do so—but if you
have other plans, do something else."[25]

He was not, of course, a "free man." As he put aside his work on *Aerograd*
and pressed ahead with the leader's "suggestion," Dovzhenko learned a pain-

ful insight into how capricious Stalin could be. After the draft screenplay of *Shchors* was submitted to the Kremlin, Dovzhenko was denounced at a party meeting by Shumyatsky for serious political errors. Shumyatsky clearly took his cues from Stalin. Dovzhenko's request for another meeting with the supreme film critic was denied, causing him to write a pitiful letter pleading, "I am a Soviet worker. This is my life, and if I am doing it wrong, then it is due to a shortage of talent or development, not malice. I bear your refusal to see me as a great sorrow." The response was a curt note from Stalin ordering five major alterations to the script.[26]

Stalin had mentally logged Eisenstein as a defector during the disaster in Mexico, and his return to the USSR did not prove Stalin wrong. Stalin was never wrong: Eisenstein continued to be a defector, albeit one who had not in fact defected. Angry that certain influential people, including Maxim Gorky and leaders of the Young Communist League (Komsomol), had welcomed the director back—and having now mastered the spelling of his name—Stalin admonished Kaganovich, "Take note of Eisenstein, who is trying to get himself back among the top filmmakers of the USSR. If he achieves his goal because the CC's [Central Committee's] department of culture and propaganda is asleep on the job, his triumph will look like a prize for all future (and present) deserters. Warn the CC of the Komsomol."[27]

To add to his problems, that folly on the Texas border meant that Eisenstein had to assume that the Soviet authorities knew of his homosexuality. Curiously, the USSR was one of the few countries in the world where homosexual acts between men were not illegal, thanks to the burst of freedom that followed the revolution—unfortunately little more than a technicality in a state where anybody could be punished for anything.

That technicality would come to an end due in part to a particularly notorious old poet named Nikolai Klyuev, a descendant of Archpriest Avvakum, who was burned at the stake in 1682 for opposing reforms to the Russian Orthodox Church. Ivan Gronsky, the bureaucrat who claimed to have coined the term "socialist realism," had a sister-in-law married to a young writer named Pavel Vasiliev, who came under the influence of Klyuev. Trotsky had marked Klyuev out in 1923 as the literary voice of the "independent, well-fed, well-to-do peasant loving his freedom egotistically," and the 1931 edition of the *Literary Encyclopaedia* described him as the "father of kulak literature."[28] Yet this supposedly dangerous man was still doing the rounds of private apartments in the early 1930s, reciting his evocative poetry, full of

gloomy religious prophecies about the desecration of Russia's countryside. Sophia Tolstoy, grandchild of the author of *War and Peace*, was one of several people who hosted these evenings.

There was more. Vasiliev revealed to his horrified brother-in-law that Klyuev was actively homosexual. Past and present lovers included the bisexual poet Sergei Yesenin, who committed suicide in 1925, and Nikolai Arkhipov, the curator of the Peterhof Palace museum. Fearing that Vasiliev might be next, Gronsky rang Genrikh Yagoda to demand that Klyuev be removed from Moscow within twenty-four hours. He then rang Stalin, who approved the action. Klyuev was arrested on February 2, 1934, and cross-examined by the same interrogator who later confronted Mandelstam. He faced this brute courageously, telling him that the Bolshevik revolution had "plunged the country into an abyss of misfortune," making Russia "the unhappiest land in the world." Industrialization had been "a violent attack by the state on the nation [that] destroys the foundations and beauty of the Russian popular way of life, and is accompanied, moreover, by the sufferings and death of millions of people."[29] He was sentenced to five years' exile and settled in Tomsk. Then he simply vanished. An examination of the Tomsk KGB archives years later revealed that he was arrested in Tomsk in June 1937 and shot in October. His ex-lover Arkhipov was also executed. Gronsky's intervention secured his talented young brother-in-law's release, but it was only a temporary reprieve. When Bukharin was arrested in 1937, Vasiliev went public to defend him as "the conscience of peasant Russia" and described the self-serving denunciations published by fellow writers as "pornographic scrawls." That cost him his life: he was executed on July 16, 1937. Maxim Gorky was told about Vasiliev's arrest in 1934 and approved.

It may have been anxieties about the sexuality of his son, Max, that set Gorky wondering why there was no law against homosexuality. The discovery that several high-ranking Nazi Brownshirts were homosexual finally set the old man off. "In fascist countries homosexuality, which ruins the youth, flourishes without punishment," he claimed in an essay titled "Proletarian Humanism," which appeared in *Pravda* on May 23, 1934. "Exterminate all homosexuals and fascism will vanish." Stalin always had a ready ear for any suggestions from Gorky, particularly if they were repressive. On March 7, 1934, homosexual acts between men were made punishable by five years in the labor camps.

Eisenstein had never flaunted his sexuality, but he had hardly kept it secret. Talking to Waclaw Solski in 1925 about the way the authorities had

censored his film *Potemkin*, he remarked, "It is true that the public didn't like it very much, but that was because of the NEP. The NEP men would rather see half-naked girls on the screen than a serious film. But I'm not a NEP man and I'm not interested in girls." At this point, Solski recalled, "Gregor Aleksandrov suddenly burst into a short laugh, but quickly stopped and turned red. I couldn't see what he was laughing about. Not until later, when I learned what everyone in Moscow knew, did Alexandrov's odd behavior become understandable."[30]

In the 1930s, "what everyone in Moscow knew" put Eisenstein in serious danger. He and Alexandrov had a painful parting of ways, and each found a wife. Just seven months after homosexuality became a criminal offense, Eisenstein married a selfless woman named Pera Attasheva Fogelman. He told Marie Seton that the only two people he could trust were Tisse and Pera. The marriage was platonic. In 1937, at the height of the terror, he also started making public appearances as the "husband" of an older woman, the actress Yelizabeta Telesheva. She died in 1943 and left him her money. There is a telling Freudian slip in the manuscript of his memoirs when he mentioned her death: he absentmindedly wrote the name Yulia, and then, "I suddenly came to, crossed the name out and inserted the right one."[31] Yulia was his mother's name.

Eisenstein needed to redeem himself with a new film, but he made his situation worse by withdrawing into himself, grieving over the loss of *Que Viva Mexico!*, and devoting his time to lecturing on theory at the Cinema Institute. Shumyatsky suggested that he make a jazz musical called *Happy Guys*, but Eisenstein turned him down. *Happy Guys* was reassigned to Alexandrov, who had a salutary shock during filming, in October 1933, when the police arrived on the set to arrest three of his scriptwriters. Shumyatsky was nonetheless delighted with the finished product, which he regarded as the first film in a "good start to a new genre, the Soviet film comedy."[32]

In January 1935, the industry celebrated what it claimed to be its fifteenth anniversary with a whole month of film screenings, culminating in an international film festival. As the first national cinematographers' conference opened on January 9, Eisenstein had it painfully brought home how isolated he was. While the critics were sniping away at *Potemkin*, the most acclaimed film in the Soviet repertoire proved to be *Chapayev*, a dramatized life of a civil war hero that premiered on the seventeenth anniversary of the revolution and was the first Soviet-made film that successfully combined communist propaganda with an exciting story capable of pulling in mass audiences. "The

whole country is watching *Chapayev*," a triumphant editorial in *Pravda* declared two weeks after its release. "It is being reproduced in hundreds of copies for the sound screen. Silent versions will also be made so that *Chapayev* will be shown in every corner of our immense country."[33] The film's appeal was like that of a Hollywood Western: it had a hero and plenty of violent action. In May 1933, senior party officials in the Kremlin interrogated officials of the Pioneer movement about the kind of films that appealed to the young and were told that they liked "fights—wherever there are fisticuffs, wherever people are leaping around."[34]

The opening address at the cinematographers' conference, by a party official named Sergei Dinamov, lasted four hours. Much of it was taken up with criticizing Eisenstein, mainly on the grounds that his films lacked *Chapayev*-like heroes: they were a celebration of mass action against oppression—not something the Stalinist regime wanted to see resurrected. In response, Eisenstein presented a rambling defense full of strange cultural references, including birth customs on Polynesian islands; basically, he claimed that his films were right for their time. Speaking the next day, Dovzhenko raised laughter by saying that if he knew as much as Eisenstein he would "literally die." Then, turning directly to Eisenstein, he pleaded, "Sergei Mikhailovich, if you do not produce a film at least within a year, then please do not produce one at all. . . . All his talk about Polynesian females, all your unfinished scenarios I will gladly exchange for one of your films." It was only on day three that Lev Kuleshov, a colleague from the Cinema Institute, courageously came to Eisenstein's defense, saying, "Dear Sergei Mikhailovich, it is not knowledge that exhausts people, but envy."[35] Kuleshov had been a pioneering director even before Eisenstein's arrival. He lived to an old age but was never permitted to make another film.

On the final evening, held in the Bolshoi Theatre in the presence of Stalin and a galaxy of important officials, awards were handed out like Oscars: Orders of Lenin for Shumyatsky, Dovzhenko, the directors of *Chapayev*, and several others; followed by Orders of the Red Banner; then Orders of the Red Star, one of which went to Grisha Alexandrov; then a list of People's Artists; and finally a list of Honored Art Workers. Eisenstein and Tisse were in the last group. The insult was deliberate and the message clear. Eisenstein had to end his retreat into film theory and make another film or risk very unpleasant consequences.

He abandoned teaching and took up a suggestion from the experienced writer Alexander Rzheshevsky, who had been commissioned by Komsomol

to produce a script about young farmworkers. Rzheshevsky had gone to live in a place called Bezhin Meadow, the setting for a story by Turgenev, to compare life there with how it had been eighty years earlier. He then transported into this setting a more recent story emanating from a wild area east of Sverdlovsk, where European Russia ended and Siberia began, a murder story that became a myth. On September 6, 1932, the bodies of two young boys, Pavel and Fyodor Morozov, were discovered with multiple stab wounds after they had been out picking berries. The story told by the prosecution at the subsequent murder trial was that Pavel Morozov was a conscientious Pioneer, murdered by members of his family after he had denounced his kulak father for profiteering and his father was deported. Four of the boys' relatives were convicted and executed.

This case took on mythical status after a journalist sent a book he had written about the murder and trial to Maxim Gorky. Gorky panned the book but was intrigued by what he saw as an uplifting tale of a child martyred for breaking free from the backward world of the Russian peasantry and showing a higher loyalty to humanity. Gorky moved into action and soon monuments were raised to honor the dead boy, streets were named after him, a museum was opened, he was lauded in songs and books, and his story became known to every Soviet schoolchild. After driving millions of peasants to exile, starvation, or death, the regime gave its suffering rural population the myth of an innocent boy murdered because he stood for progress. In 2005 an exhaustive study of the case by Catriona Kelly cast doubt over whether the actual murder had any political motive. It is not even certain that the boys' father was denounced by Pavel. It is possible that the murders were committed by Pavel's teenage cousin and a young neighbor because of a trivial quarrel. Pavel's father may have run off with another woman, and the accusation that he was a class enemy was initiated by his abandoned wife, who would live a long, comfortable life as the mother of the martyred Pavel Morozov.[36]

After Eisenstein had hired professional actors for the adult parts, he began a typically thorough search for a child to play the boy, named Stepok in his film. His assistants photographed six hundred boys out of two thousand paraded in front of them, but none had the looks Eisenstein was seeking until he spotted an eleven-year-old army chauffeur's son named Vitka Kartashov. "He seemed to have everything and everyone, including Rzheshevsky, against him," according to Jay Leyda, who worked on the project. "His hair grew in the wrong way, insufficient pigmentation of the skin gave him white blotches on his face and neck, and at the test his voice grew stiff and dull—until he

was told to ask us riddles, when he produced a clear, fine, almost compelling voice. Only E. was able at once to see the positives, later clear to all."[37]

They began work with a scene halfway through the film, titled *Bezhin Meadow*, in which an entire village sets off to harvest, but their path is crossed by four saboteurs who had planned to set the harvest on fire being marched by militiamen to the local jail; only Stepok's courageous intervention saves the malefactors from a lynching. Filming involved moving thousands of farmworkers, tractors, combines, fire wagons, motorcycles, bicycles, automobiles, and trucks along the road, past a hole where Tisse was concealed with his camera. After that, there were frustrating delays. Eisenstein went down with smallpox, and while he was convalescing Shumyatsky examined the rushes of what had been filmed so far and uncovered an abundance of images that, in his view, owed more to religion than to Marxism. He declared a scene in which the collective farmworkers stripped a church to convert it into a club "a veritable bacchanalia of destruction," when the changeover to collective farming should be shown as orderly and disciplined. Shumyatsky was also offended by the way the young hero, Stepok, was portrayed like a holy youth: "In some scenes, for example, the light source is placed behind Stepok in such a way that this fair-haired boy in a white shirt is depicted as radiating light."[38]

The scriptwriter, Rzheshevsky, was sacked, and Eisenstein recruited Isaac Babel to help recast the story. The choice made sense artistically but did nothing to improve the film's chances of getting past the censors, since Babel was even more a target of Stalin's malignant mistrust than Eisenstein. The pair worked together in Babel's apartment, arguing furiously. Babel believed in art that recorded reality and did not approve of Eisenstein's wilder surreal ideas, such as having the sky open and God peer out to speak to a kulak's wife. After Eisenstein left, Babel would hurriedly destroy the obscene doodles his guest left behind; while Babel admired their execution, he did not want his wife, Antonina Pirozhkova, to see them.[39]

Shooting began again toward the end of 1936. By January 1937, when the film was around two-thirds complete, the strain overcame Eisenstein, who fell ill again, this time with severe influenza. But the reception at viewings of the completed sections was ecstatic. At a conference that month, Shumyatsky was confronted with what seemed to him like a campaign to promote the unfinished film, organized by the Moscow film studio and the culture department of the Central Committee. Early in February, the magazine *Soviet Art* carried a piece in praise of the unfinished film by the French writer Lion Feuchtwanger. In Kiev, Pyotr Pavlenko, the writer who behaved so de-

spicably during the Mandelstam affair, boldly spoke up in Eisenstein's defense. It was all too much for Shumyatsky, who fired off a complaint to Stalin, copied to others, alleging that "we have in Moscow a number of individuals who overtly and covertly are conducting a campaign of struggle in defense of Eisenstein, in this way helping some scoundrel abroad wage this very campaign in defense of Eisenstein against a nonexistent enemy."[40]

The only way this dispute could be resolved was for the great film buff in the Kremlin to see the rushes for himself. Stalin did not share Gorky's enthusiasm for the Morozov myth. Gorky was the child of loving parents who received his first beating from his grandfather only after his father's premature death, a shock that made him ill; he would never have struck his own children and identified with a story of a child defying adult ignorance. Stalin was a brutal father to his two sons and believed a child should defer to authority. It was reported he left a private showing of *Bezhin Meadow* muttering angrily about the idolization of a disobedient child.[41] On March 5, 1937, the Politburo decided to ban the film and make it an explicit rule that in the future Shumyatsky could not allow shooting to begin on any film until it had a fully worked-out screenplay with complete dialogue, and no director would then be allowed to wander off the approved script during shooting.[42] The kind of inspired improvisation that had produced *Potemkin* was forbidden.

Two weeks later, on March 19, a three-day conference opened in Moscow that turned into something resembling a show trial of Eisenstein and all who were responsible for the banned film. Shumyatsky, by now a frightened man, delivered the opening speech, apportioning the blame among Eisenstein, the film studio, and the State Directorate for Cinema, which had allowed work to proceed unsupervised. As before, Eisenstein's fellow directors joined in. "Formalism, formalism, and once again formalism," one now-forgotten director ranted. "This is a terrible disease with you. Formalism condemns you to loneliness; it is a worldview of pessimists, who are in conflict with our era."[43] At the same time Shumyatsky placed a long article in *Pravda* in which he complained that even after Eisenstein had been warned about the scene where the church was set on fire, he repeated the offense, creating a scene in which saboteurs set the collective farm office on fire; as the workers try to douse the flames, they "rush around senselessly in the clouds of smoke as if they were performing some religious rite." The film as a whole, he added, was "a direct slander against our soviet countryside."[44]

On March 28, Shumyatsky wrote to Molotov, complaining that there was a conspiracy to save the film and naming seven suspects. Three were

prominent writers whose status afforded them a degree of protection; the others were the deputy head of the Central Committee's cultural department, Aleksei Angarov; the head of the film department, E.M. Tamarkin; the head of the USSR's largest film studio, Mosfilm, V.A. Babitsky; and Babitsky's deputy Yelena Sokolovskaya. He wrote, "A meeting has already been held of some writers and playwrights in order to work out a line of defense for Eisenstein and to discredit me as the stifler of the 'brilliant work of S. Eisenstein.'" Mosfilm had even organized a private viewing for sympathetic journalists and film industry professionals, he added. "At this viewing, not only was material from a film banned by the CC shown but Eisenstein was also given an opportunity to deliver an extended report about what he had not yet shot. Eisenstein gave his speech the character of an appeal against the production ban."[45] What the film would have done for Eisenstein's reputation is another matter, given the grim contrast between the myth he was creating and the reality of collectivization. The historian Peter Kenez suggested it would have been ethically "his most reprehensible film."[46]

Bezhin Meadow was never shown in public, and Shumyatsky set out to destroy all the rushes to ensure that it would never be seen again. He did not quite succeed: in the 1960s two directors created a fifteen-minute film made up of stills from *Bezhin Meadow*—evidence that Eisenstein would have given Soviet cinema a very powerful and beautifully crafted film had it been allowed. But the immediate reality was that around 5 million rubles had been sunk into a canceled production. In eight years Eisenstein had added two expensive failures to his CV but no completed films. It had been twelve years since he had made the film on which his reputation rested. On April 16, he wrote to Shumyatsky, pleading desperately for a chance to make another. Shumyatsky forwarded the note to Stalin with a recommendation that Eisenstein never be allowed to make a film again. Angarov, from the culture department, submitted a countermemorandum on May 9, challenging Shumyatsky's judgment. Fortunately for Eisenstein, Shumyatsky was rapidly losing favor with Stalin: the Central Committee ruled that Eisenstein should be found a suitable subject for another film.

The story ended badly for almost everyone involved apart from Eisenstein. On January 9, 1938, *Pravda* carried an excoriating assessment of Shumyatsky's eight years at the head of the industry, during which the yearly output of new films had scarcely improved, reaching sixty-five in 1937—which at least was more than in the preceding years. The author of the article considered this clear proof that Shumyatsky had fallen into the hands of "saboteurs."[47] It did

not take long to find one such "saboteur." A projectionist who worked in Stalin's private cinema named Konstantin Korolov was apparently carrying out repairs when he dropped a glass of mercury, which he carefully cleaned up. Korolov had a Kremlin pass, issued on Shumyatsky's instructions. That was all the evidence the NKVD needed to prove that there had been a conspiracy to poison Stalin. Shumyatsky, Korolov, and a clutch of other unfortunates were shot.[48]

Those who had taken the risk of defending Eisenstein against Shumyatsky fared no better. Angarov, Tamarkin, and Babitsky were shot in 1937. Sokolovskaya lasted a little longer, long enough to help Eisenstein restart his directing career, but she, too, was shot, in 1938. Technicians and others Eisenstein knew were also consumed by the terror, but the major film directors were protected by their fame. Some of Sergei Eisenstein's most productive years were still to come.

9

Stalin's Nights at the Opera

Even if they cut off both my hands and I have to hold my pen in my teeth,
I shall go on writing music.

—DMITRI SHOSTAKOVICH

Even as Russia's cultural community enjoyed an Indian summer of relative freedom in the year 1935—and the likes of Maxim Gorky and Nikolai Bukharin were trying to draw the intelligentsia into more active involvement in the regime in the hope of creating a loyal opposition that could rein in the dictatorship—others who were driven by ambition, fear, or stupidity were priming Stalin with flattery and lies that encouraged him to believe that he was infallible and that any real or imagined challenge to his authority was malicious. Before Mikhail Kalinin, nominal president of the USSR, set off for his annual vacation on the Black Sea, he consulted two fellow Politburo members, Lazar Kaganovich and Anastas Mikoyan, about what to say to Stalin when they met down south. "We told him to say that 'the country and party are so well charged up with energy that although the chief marksman is resting, the army is still firing.' For example, what has happened with the grain procurements this year is our completely unprecedented stupefying victory—the victory of Stalinism," Kaganovich boasted to a colleague.[1]

One of those who joined Stalin on holiday was his fellow countryman Lavrenti Beria, the sinister new ruler of Georgia, Armenia, and Azerbaijan who in 1935 commissioned a history of the early years of Bolshevism in that region to glorify the young Stalin. Old Bolsheviks whose memories differed from what was now the official record were vilified, humiliated, and in some

cases arrested. Stalin's daughter, Svetlana, recalled how Beria "flattered my father with a shamelessness that was nothing if not Oriental . . . in a way that caused old friends, accustomed to looking on my father as an equal, to wince with embarrassment."[2]

Trotsky's former hanger-on Karl Radek, a talented, treacherous journalist anxious to work his way back into favor, wrote a conceit titled "The Architect of a Socialist Society." While Kaganovich praised Stalin's current achievements and Beria focused on reinventing his past, Radek cast flattery into the future by imagining a lecture delivered at an interplanetary symposium on the fiftieth anniversary of the revolution in which the speaker marveled at the grandeur of Stalin's achievements: "Notwithstanding the great strides made by science in communist society, it cannot yet answer the problem of personality. It can only reveal the local conditions which nurtured the leader, who, like a pillar of fire, marched in front of mankind and lit up the way."[3]

But the gold standard for slobbering sycophancy seems to belong to a forgotten poet named Aleksander Avdienko who reportedly said in a speech to the Seventh Congress of Soviets in January 1935:

> Thank you, Stalin. Thank you because I am joyful. Thank you because I am well. No matter how old I become, I shall never forget. . . . Centuries will pass, and the generations still to come will regard us as the happiest of mortals, as the most fortunate of men, because we lived in the century of centuries, because we were privileged to see Stalin, our inspired leader. . . . I love a young woman with a renewed love and shall perpetuate myself in my children—all thanks to you, great educator, Stalin. . . . And when the woman I love presents me with a child the first word it shall utter will be "Stalin."[4]

With such creepy adulation ringing in his ears, it was revealed to Stalin that his self-taught judgments on film, poetry, music, medieval Russian history, and later on linguistics were more accurate and incisive than the opinion of any educated specialist. He even knew better than the professionals how fast it was possible for a train to travel. "There was, until recently, a group of professors, engineers, and other experts—among them Communists—who assured everybody that a commercial speed of 13 or 14 kilometres per hour was a limit that could not be exceeded," Stalin revealed in a speech on November 17, 1935. These gainsayers could not fool Stalin: he overrode their advice, and on his command trains were designed that could travel at eighteen

or nineteen kilometers per hour. As for the wretched experts, "we had to give these esteemed individuals a light tap on the jaw and very politely remove them." Stalin went on to declare it an example of how "life has improved, comrades, life has become more joyous."[5]

His remarks inspired riotous applause. In the midst of his ecstatic audience sat one of Russia's greatest composers, the young Dmitri Shostakovich, who had been called away from rehearsals of his ballet *The Limpid Stream* to listen to the speech. "After hearing Stalin I completely lost any sense of moderation and shouted 'Hurrah!' along with the whole hall and applauded endlessly," he recorded.[6]

Shostakovich was an enigmatic character, eternally cautious in the presence of authority and with a penchant for sly self-mockery. So adept was he at keeping his opinions to himself that after his death there was a ferocious academic controversy over what he really thought about Stalin and the communist system. His description of himself mindlessly applauding Stalin's speech might seem to provide the answer—except that it was written in a private letter to his closest friend, the music critic Ivan Sollertinsky, and he was obviously poking fun at himself. Any kind of humor related to Stalin was subversive, so Shostakovich's remarks could equally be taken as evidence that he was a covert anticommunist, even in the early days when he had no cause to complain about how the system had treated him. Yet he was there, listening, and on his feet applauding. The balance of evidence holds that the young Shostakovich accepted the communist system as a fact of life and dutifully followed the biblical instruction to render unto Caesar that which is Caesar's.

Shostakovich was only eleven years old when the Bolsheviks seized power, growing up in a family hostile to the old regime. His paternal grandfather, who was Polish, joined the revolutionary underground in the 1860s. His father was born in exile in Siberia. His maternal aunt Nadia was an Old Bolshevik. One of his early political memories was of an uncle taking him to the Finland Station in Petrograd in April 1917 to witness Lenin's return from exile.

The worst period began when his father died, in 1922. He had to concentrate on earning money for himself, his mother, and his younger sister until his prodigious talent rescued him from drudgery. He completed his First Symphony at the age of eighteen. Its premiere, in Leningrad in March 1926, was a sensation, not least when the composer took his awkward bow and the audience saw how young he was.

The teenage composer soon acquired a powerful patron, a much-needed asset in the emerging communist system. Mikhail Tukhachevsky was the greatest Red Army commander of his day. At the age of twenty-seven, he commanded the forces that invaded Poland; a year later, he led the suppression of the Kronstadt revolt. He was also a music lover and amateur violinist. Evidently, word of the Leningrad teenager who had written a symphony reached him, and he decided to take the youth under his wing. Soon after the nineteen-year-old Shostakovich moved from Leningrad to Moscow, his mother must have been relieved to hear that "Tukhachevsky has found me a room and a job." A subsequent letter informed her, "Yesterday I had lunch with Tukhachevsky. . . . He fetched me for the concert yesterday in a very stylish automobile."[7]

Shostakovich's Second Symphony, subtitled *To October*, was produced in time to mark the tenth anniversary of the revolution and dedicated "Proletarians of the World Unite." He subtitled his Third Symphony *The First of May*. He then claimed to be working on a grandiose symphony titled *From Karl Marx to Our Own Days*, created to celebrate the fifteenth anniversary of the revolution, though this unenticing-sounding opus was never more than an unkept promise. In 1927, the Kremlin permitted him to compete in the International Chopin Competition in Warsaw. By December 1931, the authorities trusted him enough to allow a correspondent for the *New York Times*, Rose Lee, to interview him at the apartment on Nikolayevskaya Street where he lived with his widowed mother. He told the journalist that music was a "weapon in the struggle," that Wagner and Scriabin were reactionary composers, and that Beethoven was a revolutionary who had the power to inspire the masses.[8] She reported that he was "on the way of becoming a kind of composer-laureate to the Soviet state."

Perhaps she was deceived and Shostakovich did not believe a word of what he said to her. He almost never discussed what his music meant, so the "meaning" of any of his major works varies according to what the listener is inclined to hear. The musicologist Lev Lebedinsky, who came to know Shostakovich long after Stalin's death, thought he detected an anticommunist message even in the First Symphony, because the timpani in the last movement sounded like an execution. He suggested to Shostakovich that "you were the first to declare war against Stalin." The composer "did not deny it."[9]

Nor did he confirm it. No one can be certain about what the young Shostakovich privately thought: we know only that outwardly he paid homage to

the regime, and the regime allowed him the freedom to create. That peace lasted until Stalin decided that he knew more about classical music than any composer.

On January 17, 1936, Stalin paid a visit to the opera with a group of high-ranking officials to see a new work, *The Quiet Don* by Ivan Dzerzhinsky, based on the novel by Mikhail Sholokhov. It was Dzerzhinsky's first opera. He had entered it for a competition, which he lost—but then he had revised it with help from Shostakovich, to whom he dedicated the finished version. Stalin liked it and called Dzerzhinsky and the director to his box to point out various ways in which the work could be made even better, while praising its "considerable ideological-political value." His remarks were blazoned across the Soviet press, bringing Dzerzhinsky instant fame. Instant, but not lasting: none of his works are ever performed now.

Nine days later, on January 26, Stalin and his entourage were at the Bolshoi to see another work, one that remains among the most popular and enduring operas of the twentieth century: Shostakovich's *Lady Macbeth of Mtsensk*, based on a short story by the nineteenth-century writer Nikolai Leskov. Its heroine is a provincial woman who escapes a suffocating marriage by committing adultery and three murders. In one scene, Katya and her new man enjoy illicit sex just out of the audience's sight. As the action moved to Siberia, the audience was invited to empathize with the convicts, prisoners of the tsar, at a time when everyone knew that the labor camps were filling up again, though no one spoke of it. The Bulgakovs, who knew Shostakovich, wondered if their friend was walking into trouble. "Shostakovich probably was mistaken in taking such a gloomy, depressing plot," Yelena Bulgakova wrote in her diary.[10]

Despite some carping from officials in the Union of Composers, the opera was a sensation from its opening night in January 1934 onward. Even Andrei Bubnov, the cipher who had taken Lunacharsky's place as people's commissar for enlightenment, was enthusiastic. A special edict was published, hailing "the start of the brilliant flowering of Soviet operatic creativity."[11] The first time that Eisenstein met Maxim Gorky, the older man proclaimed, "It's a work of genius, a work of genius!"[12] The critic Ivan Sollertinsky wrote that there had been no opera of such scale and depth since Tchaikovsky's *Queen of Spades*. During 1934 alone, the Maly Opera Theatre put on forty-nine performances, selling 93 percent of the available seats.[13] The work was broadcast on radio five times in its first five months. There was a similar reaction as it traveled across Europe, with the first negative reaction coming from the

far side of the Atlantic, where the *New York Times* critic judged that "Shosta-kovich is without doubt the foremost composer of pornographic music in the history of opera."[14] Unaffected either by praise or by criticism, Shostakovich wrote dismissively in February 1934, "Basically this is all boring."[15]

A visit to the opera by Stalin, Molotov, Zhdanov, and Mikoyan could not be treated so casually. Shostakovich was in Moscow on the evening of Janu-ary 26, preparing to take a train to Arkhangelsk, in the far north, where there was to be a performance of his cello sonata with Viktor Kubatsky as the solo-ist. Summoned to the Bolshoi, he arrived "white with fear," according to Mikhail Bulgakov. Shostakovich could hear the slightest fault in any public performance of his work and had to listen as the nervous musicians played too loud under the direction of a conductor who leapt about in agitation until he was dripping with sweat. Most of the audience heard nothing amiss and applauded vigorously, but Stalin and his entourage ominously departed without a word.

What Shostakovich did not know was that his career had already been scru-tinized by the supreme critic, thanks to Stalin's fascination with the cinema. Shostakovich was one of the first composers to write film soundtracks, having briefly made his living when young by providing live piano accompaniment to silent movies. Stalin had seen every film with a score by Shostakovich. He was fascinated by "Song of the Counterplan," written for the 1932 movie *Counter-plan*, produced under the personal supervision of Kirov to mark the fifteenth anniversary of the revolution, a film "distinguished neither by artistic qual-ity nor aesthetic innovation," according to one critic, but imbued with a po-litical message thoroughly approved by the Kremlin.[16] Shostakovich also provided music for the 1934 film *Maxim's Youth*, which Stalin watched twice in three days; during the second viewing, on December 18, 1934, less than three weeks after the Kirov murder, the private cinema in the Kremlin re-sounded with the noise of Stalin and his acolytes singing along to one of Shostakovich's compositions.[17] Another film, *Girlfriends*, Stalin saw with his children, Svetlana and Vasili, for the third time on December 25, 1935. He liked everything about it except Shostakovich's score and apparently con-cluded that the composer's work for cinema was slipping because too much of his time was being taken up writing more complex compositions, such as opera.

Not knowing what Stalin had thought of *Lady Macbeth of Mtsensk*, Shosta-kovich anxiously fulfilled his engagements in Arkhangelsk. On January 28, two days after Stalin's visit, he bought that day's edition of *Pravda* and came

upon an unsigned article headed "Muddle Instead of Music" complaining that "fawning musical criticism" had gone to his head and that his opera was a "deliberately dissonant, muddled stream of sounds" that was too difficult to follow. In places, it was said, "the music quacks, hoots, pants and gasps."[18] The effect on Shostakovich as he read these words, five hundred miles from home, must have been terrifying. He sent a telegram to his friend Isaak Glikman, asking him to take out a subscription to a newspaper clippings service. "It was the first time he had ever, to my knowledge, shown the slightest interest in press notices of any kind, even when, as they generally were, they were eulogistic," Glikman noted.[19] Within twenty-five days, the first seventy-three-page scrapbook was full. All over the country, employees were holding meetings in offices and factories to record their spontaneous anger over the technical flaws and ideological errors in *Lady Macbeth of Mtsensk*. Meanwhile, after his engagements in Arkhangelsk had been completed, Shostakovich took the train to Moscow, bypassing Leningrad, where a musicians' meeting was scheduled expressly so that his colleagues could condemn his work.

On February 6, *Pravda* struck again. Shostakovich's ballet *The Limpid Stream* was the antithesis of *Lady Macbeth*, a light comedy featuring collective farmworkers and Kuban Cossacks in traditional dress that made fewer demands on the listener. According to *Pravda*, that was exactly what was wrong with it: "The music is therefore without character. It jangles and expresses nothing." In other words, as Shostakovich's biographer Solomon Volkov observed, the composer was "wrong whatever he does."[20]

On the same day, Shostakovich was admitted into the office of Platon Kerzhentsev, the Old Bolshevik with the pince-nez who had been Bulgakov's nemesis. It was the right place to be, because the government had just announced the creation of a USSR State Committee on Culture with Kerzhentsev as its inaugural chairman. Kerzhentsev was a rare example of an Old Bolshevik who would not be arrested in the coming purge, which suggests that he was good at reading Stalin's mind and therefore probably knew that Shostakovich's position was not as bad as two hostile *Pravda* editorials implied. He gave the composer a homily on wasting his time writing music that the masses could not appreciate and admonished him to refocus his efforts, keep working, and avoid the company of his friend Sollertinsky, who was deemed a bad influence. Whatever Shostakovich felt about being lectured in this manner, he decided that if he were to continue with the vocation that he loved, he would have to put up a show of humility. After the meeting,

Kerzhentsev reported to Stalin and Molotov that the composer "acknowledged" his mistakes without fully understanding what he had done wrong: "I said that for us the most important thing was that he reform himself, reject Formalist errors, and in his art attain something that could be understood by the broad masses."[21] He also passed on a request from Shostakovich for a meeting with Stalin. It was not granted.

Most of the Soviet population would have been uninterested in the fate of an opera they were never going to see anyway, but there was a minority, mainly in Moscow and Leningrad, to whom classical music mattered intensely. Before the revolution, music, ballet, and opera had been Russia's greatest cultural exports. The country's battered and bullied intelligentsia had been forced to accept that cinema, fiction, poetry, and drama were subject to political control, but receiving orders on what their taste in music was supposed to be was something new and came with Stalin's personal imprimatur. It provoked the last show of passive resistance to the regime before the paralyzing horror of the show trials and great purges. According to the memoirs of the violinist Yuri Yelagin, "Moscow art circles greeted this discussion with a demonstrative silence and refused to take part in it. The discussion on formalism had to be conducted by critics and officials."[22]

Not all opposition was silent, in fact. When the Leningrad composers' union called a meeting so that all present could express their wholehearted condemnation of Shostakovich's opera, his friend Sollertinsky scandalously praised it. He was followed by another speaker who thought *Lady Macbeth of Mtsensk* was a "brilliant" work and a third who added for good measure that the Dzerzhinsky opera Stalin thought so highly of was rubbish.[23] The NKVD collected and filed informants' reports of similar comments. The gifted writer Andrei Platonov suggested that "someone very high and mighty happened to stop by the theatre, listened without understanding the music, and sabotaged it." The critic Abram Lezhnev, an Old Bolshevik, declared, "I look on the Shostakovich incident as a phenomenon of like category to the book burning in Germany"—no prizes for guessing whether Lezhnev lived to see out the decade.[24] When Isaac Babel was under arrest four years later, he confessed to his interrogators in the Lubyanka that "it was common ground for us to proclaim the genius of the slighted Shostakovich. . . . We declared that the articles opposing Shostakovich were a campaign against a genius."[25]

One reason such people felt emboldened to speak was that others much higher up the Soviet *nomenklatura* also thought that this time Stalin had gone

too far, notably the formidable Marshal Tukhachevsky. Shostakovich went to see him, looking, according to one witness, "crushed and distraught," but emerged from a long talk in Tukhachevsky's study a "new man."[26] When he returned home to Leningrad, he was surprised to receive a telephone call from the commander of the Leningrad Military District, who had been asked by Tukhachevsky to make sure that he was all right.

In earlier times, Stalin might have made some gesture to appease the public mood and divert resentment away from himself, but not this time. On February 13, there was yet another *Pravda* editorial, titled "Clear and Simple Language in Art," rebuking those who, struggling to understand Stalin's intentions, had concluded that battle was to be waged on two fronts, against the kind of "bourgeois innovation" exemplified by *Lady Macbeth* and against "primitive" art masquerading behind simplicity and accessibility. No, said the editorial, the campaign was against "lies and falsehood," such as films that distorted "historical truth." What began as the bullying of one gifted composer became a campaign of intimidation across the whole gamut of the arts. On February 20, it was the architects' turn to be subjected to a homily on "Cacophony in Architecture"; on March 1, the target was "Mess-Making Artists"; on March 9, it was "Outward Brilliance and False Content" in the theater.

The vice the authorities said they were stamping out was "formalism." On the face of it, formalists were those who experimented with form at the expense of a clear, intelligible message, as Shostakovich was accused of doing by writing an opera that made too many demands on the listener. But if ever there were a twentieth-century Russian artist who played around with form it was Mayakovsky, whom Stalin had only recently declared to be the greatest poet of the era. "Shostakovich is Mayakovsky in music," the writer Yuri Olesha remarked, a comment promptly passed on by a police spy.[27] Olesha had just completed a film script that, as he feared, was judged to be formalist and banned.

No one had worked more closely with Mayakovsky than the great theatrical experimenter Vsevolod Meyerhold, who was no great friend of Shostakovich and thought the young composer needed to have his ego punctured, but not with the excessive cruelty of the *Pravda* onslaught. Meyerhold was working on a new production of *The Bedbug* when the criticism of formalism began, and he was forced to defend the whole of his long career in the theater. In March, he delivered a talk with the ironic title "Meyer Against Meyerholdism," in which, according to the diary of a woman who was in the

audience, he formally acknowledged the Communist Party's right to intervene in the cultural sphere but remarked pointedly that "the path to simplicity is not an easy one. Each artist goes at his own pace, and they must not lose their distinctive way of walking in the quest for simplicity . . . the angry, cruel headlines of the *Pravda* articles trumpet the high standards of the party." The diarist recorded "thunderous applause" for Meyerhold's defiant statement that "Soviet subject matter is often a smoke screen to conceal mediocrity."[28] The speech kept the authorities off his back, but only for a few months.

While it made sense in its way to condemn Meyerhold as a "formalist" because his productions were experimental, the same charge could not reasonably be leveled at Mikhail Bulgakov. His first play, *The Day of the Turbins*, or *The White Guard*, had meticulously observed the basic unities of time and place and was still playing to packed houses as of 1935. Stalin had seen it again as recently as November 1934, accompanied by Kirov and Zhdanov. Bulgakov's latest play, *Molière*, or *A Cabal of Hypocrites*, was another example of straightforward storytelling that no one would have difficulty following. It had its first dress rehearsal at the Moscow Arts Theatre on February 5, 1934, a week after the initial attack on Shostakovich. All three dress rehearsals drew wild applause, ensuring that the first performances, on February 17 and 24, were sold out.

However, Bulgakov now had a very powerfully placed enemy in Kerzhentsev, who had fought so hard in the 1920s to have Bulgakov's work removed from the theater. The chairman of the State Committee on Culture knew better than to complain about Stalin's favorite play but made it his business to make sure that neither the general secretary nor the theatergoing public would ever be treated to a performance of *Molière*. He read the script and extracted some of the lines that Bulgakov put into the mouth of the Molière character in the final act, when, driven to despair, Molière cries, "All my life I've licked his spurs and only thought of one thing—don't crush me. And now he has crushed me all the same, the tyrant. . . . I haven't flattered you enough? Your Majesty, where will you find another plate-licker like Molière? . . . What more must I do to prove that I'm a worm?"[29] He copied these sentiments in a memo to Stalin. Just in case the general secretary missed the point, Kerzhentsev added, "The political meaning Bulgakov invests in his work is sufficiently clear, although most viewers may never even notice these hints. He wants to evoke in the viewer an analogy between the writer's status under the

dictatorship of the proletariat and under the 'arbitrary tyranny' of Louis XIV." To give Kerzhentsev his due, almost anyone who watches a modern performance of *Molière* would agree that he had captured Bulgakov's intentions precisely.

Kerzhentsev was not, however, asking for a Politburo decree banning the play. He had a better idea. He proposed that the MAT should "remove this production not by formal prohibition but through the theatre's conscious rejection of this production as mistaken and distracting from the line of Socialist Realism."[30] Stalin read the memo and wrote across the front page, "I think Com. Kerzhenstsev is right. I favor his proposal." Seven other Politburo members added their signatures in agreement.

Bulgakov never knew the political pressure that had been put on the MAT. By coincidence, he and Yelena were at the Bolshoi watching someone else's play four days after the Politburo had endorsed Kerzhentsev's suggestion when Stalin, Molotov, and Grigori Ordzhonikidze arrived for the second act. At the end, Stalin joined the applause and waved to the actors. He seemed then to be a friend of the theater, just as he had once appeared to be Bulgakov's protector.

Bulgakov visited Kerzhentsev's office for a meeting that lasted an hour and a half, during which the sly bureaucrat exuded hypocritical friendliness and urged him to keep working. Bulgakov's startling response was that he was considering writing a play about Stalin. He did, in fact, write a play called *Batum*, set in prerevolutionary times, in which Stalin featured, perhaps thinking this was the only way he was going to get anything he wrote staged. If so, he was wrong: it was banned, which is possibly just as well for the sake of Bulgakov's posthumous reputation.

Bulgakov did not live to see another of his plays on stage. Shattered by the banning of *Molière*, he almost lost the will to work at all and misdirected his anger and disappointment at Stanislavsky and the MAT. The management there did the best they could to placate their furious writer with various suggestions for other projects, but he handed in his notice on February 16, 1936, and found alternative employment at the Bolshoi. To all outward appearances, he stopped writing.

Actually, he was working in secret. In a few months, he wrote the rollicking satire *Black Snow*, his private revenge on Stanislavsky and the MAT, and completed his masterpiece, *The Master and Margarita*. Knowing that the latter had no chance of being published, he threw away realism and freed himself of the normal expectations that a novel would tell a linear story. Instead, he

had Satan wandering through Soviet Russia and creating havoc with two accomplices—one a cigar-chomping cat—before switching the story to ancient Palestine with Jesus in a whimsical retelling of the gospels. There is a heroine, who for obscure reasons spends much of the novel stark naked, and a hero, who appears to be Bulgakov himself, writing manuscripts even the devil cannot destroy. It is a world of arbitrary mishaps in which nothing is permanent except the manuscript itself.

Though he had been appallingly treated by any normal measure, Bulgakov was a privileged Soviet citizen by the standards of his time. Just as Molière had dined at Louis XIV's table in Bulgakov's imagination, he had figuratively dined at Stalin's and could sit out the terrible years of the mass purges without the constant fear of a nighttime knock on the door. Unlike so many others caught up in those terrible events, he behaved with exemplary dignity. He never denounced anyone. He wrote one letter to Stalin, dated February 4, 1938, which was remarkable for its brevity and for the absence of sycophantic flattery. He asked for nothing for himself: what concerned him was the fate of a close friend, Nikolai Erdman, famous for having written an outstanding play, *The Suicide*, in the 1920s, who had fallen foul of the authorities and only recently come back from three years in exile. Bulgakov petitioned Stalin to intervene so that Erdman could find work. The petition was ignored, and Erdman was condemned to a long life of obscurity. The following year Bulgakov fell fatally ill. He died on March 10, 1940, and was buried in the same cemetery as Stanislavsky and Chekhov.

Shostakovich's position was more exposed even than Bulgakov's, but he was equally determined to keep working. "Even if they cut off both my hands and I have to hold my pen in my teeth, I shall go on writing music," he told Isaak Glikman.[31] He needed that kind of determination to face the trials that lay ahead. His main project was the Fourth Symphony, the longest he would ever write apart from the *Leningrad*. On May 30, 1936, he was at home with friends when two visitors arrived unannounced: Sollertinsky, the critic he was supposed to be avoiding, and Otto Klemperer, who was in the USSR to give a concert of Beethoven symphonies. They stayed till until one a.m., talking French, the one language everyone present understood. That morning, Shostakovich became a father for the first time. Klemperer and several Russians, including Sollertinsky and Glikman, turned up for a champagne celebration at noon and composed a letter to Shostakovich's wife, Nina, congratulating her on the safe arrival of the girl, Galina, handwritten in French by the

German visitor. Shostakovich then went to the piano to give the company a taste of his Fourth Symphony. Klemperer promised to include it in the coming season, which seemed to mean that it was guaranteed a wide audience and much-valued foreign earnings.

Instead, the Fourth would become Shostakovich's "missing" symphony. The premiere was scheduled for December 11, 1936, but rehearsals by the Leningrad Philharmonic were interrupted one day by a visit from the secretary of the Union of Composers and an official from the regional party headquarters. The philharmonic's director called Shostakovich into his office. A quarter of an hour later, Shostakovich emerged in gloomy silence and set off for home with Isaac Glikman. On the way he announced "in flat expressionless tones" that the premiere was canceled.[32] It was not performed until twenty-five years later, on December 30, 1961, after which it was acclaimed across the Western world. *Lady Macbeth of Mtsensk* took even longer to escape from the memory hole, emerging again only at a closed performance in December 1962, ahead of the "official" premiere on January 8, 1963, in a slightly cleaned-up version and with a new title, *Katerina Izmailova*, to minimize the link to a work an entire generation had been taught to associate with all that was pernicious in music. Shostakovich's *Four Romances on the Text of Pushkin*, completed in January 1937, did a little better; it was first performed in December 1940. In this bleak period, Shostakovich's income tumbled to between a quarter and a fifth of what it had been before Stalin's visit to the opera, while his marriage and Galina's birth had pushed up his household expenses, which included a housekeeper and a nanny. He was also providing for his widowed mother. For the first time since his student days, he was running up debts.

In April 1937, he embarked on his Fifth Symphony, which he completed in a matter of weeks, despite the terror that by now was gripping the entire Soviet elite, including his family. His brother-in-law, Vsevolod Frederiks, was arrested in spring 1937. His sister, Mariya, was exiled to Central Asia, and his mother-in-law, Sofya Varzar, was sent to a labor camp. His high-ranking friend in the Leningrad NKVD, Vyacheslav Dombrovsky, a violinist and music lover, was arrested and shot. Boris Kornilov, who had written the words for Shostakovich's hit song for the film *Odna*, was arrested and shot because of his association with Leopold Averbakh and RAPP. At one point, in May 1937, Shostakovich panicked because he had not heard from Sollertinsky for a month and thought that he, too, had been arrested.

The one person Shostakovich knew well who was surely too powerful to be touched by the purges was Marshal Tukhachevsky. He was one of only

five officers with the newly created rank of marshal and was in charge of re-equipping the military to answer the threats from Germany and Japan. Yet in May 1937, as Shostakovich and Nina returned from a short break at a spa in Crimea, the composer received a terrifying summons to the Big House, where the Leningrad NKVD was headquartered. An interrogator whose name was Zanchevsky, or something phonetically similar, plied him with questions about Tukhachevsky. Had the composer overheard the marshal plotting to kill Stalin? Shostakovich insisted that they had talked only about music. That was not good enough. He was given the weekend to think it over and told to come back on Monday. Shostakovich returned as instructed and asked for Zanchevsky, but there was no Zanchevsky: he, too, had been arrested.[33] That did not save Marshal Tukhachevsky. He and several more of the Red Army's most talented commanders were shot on June 12, 1937.

In this grim atmosphere, Yevgeni Mravinsky, a relatively unknown conductor, agreed to risk conducting the Leningrad Philharmonic in a performance of Shostakovich's Fifth Symphony. "To this day, I can't understand how I dared take on such a proposition," he recalled years later. "My excuse is that I was young and did not realize the difficulties that lay ahead."[34] The opening night, November 21, 1937, must rank as one of the most dramatic in the history of classical music because of what it meant to the fear-ridden audience to hear a work by Shostakovich again and how fervently they wanted the performance to go well. Shostakovich likely felt as if his physical survival hung on its success. He later said he arrived feeling like "a fish in a frying pan."[35] He was cheered by a comic moment in the interval, after the audience was warmed up with a performance of Tchaikovsky's *Romeo and Juliet*, composed sixty-eight years earlier, and the writer Mikhail Zoshchenko, a bashful man whose stories Shostakovich loved but whose knowledge of music was pitiful, came up to congratulate him on writing such a melodious work.

Men and women were to be seen crying during the slow third movement of the Fifth. As it reached the finale, according to one observer, "the whole audience leapt to their feet and erupted in wild applause—a demonstration of their outrage at the hounding poor Mitya [Shostakovich] has been through. Everyone kept saying the same thing: 'That was his answer, and it was a good one.'" As Shostakovich took a bow, he was as "white as a sheet" and appeared to be close to tears.[36] After half an hour of exultant applause, the conductor, Mravinsky, lifted the score and waved it over his head. There would be a similar reaction at subsequent performances; once, members of the

audience went up onstage and decided to send the composer a congratulatory telegram.

Even the drunken Stalinist Alexander Fadeyev, the same literary bureaucrat who could coldly send fellow writers to their deaths, was moved by the grandeur of the Fifth Symphony, though he confined his thoughts to a private diary, where he interpreted the finale as a statement of "irreparable tragedy." When Shostakovich found that out many years later, he reportedly remarked that Fadeyev "must have felt it with his Russian alcoholic soul."[37]

The reaction on the first night alarmed Sollertinsky, who feared that the authorities would interpret it as a political demonstration and hustled Shostakovich away as quickly as he could. He was right to be afraid. In no time, petty officials were sniffing around for evidence of subversion and conspiracy. The chairman of the Leningrad Composers' Union, Isaak Dunayevsky, submitted a memo to the authorities that this clamor of praise was an "unhealthy phenomenon"—a "psychosis" even—that was drowning "the healthy, or at least justified, sentiments of doubts and negative criticism" that the work merited.[38] A couple of party officials came to investigate during one of the later performances; one, named B.M. Yarustovsky, was heard making a constant stream of disapproving comments during the applause. Those applauding were not "normal concert-goers" but had been "hand-picked," and the symphony's reception had been "scandalously fabricated." Afterward, according to the composer Mikhail Chulaki—no friend of Shostakovich—"echoes of the 'symphonic scandal' stirred up by these two officials continued to reach Leningrad. I had to write explanations, fill in questionnaires and prove the absence of a criminal. Then these passions died down, and in the meantime the symphony continued its life."[39]

Passions died down for the simple reason that timeservers like Dunayevsky and Yarustovsky were waiting for guidance from the top, but it never came in the form they anticipated. Stalin was expected at the Moscow premiere but did not turn up. The nearest thing to an official response was an article in *Izvestya* in December 1937 by the writer Alexei Tolstoy, an aristocrat who was doing even better under communism than he had under the tsar and who likened the symphony to the "formation of a personality," adding that "it is a credit to our age that we can produce such treasures of sound and ideas in abundance. It is a credit to our people that it brings forth such artists."[40] Or at least someone wrote these glowing words that appeared under Tolstoy's byline. The count had once been a gifted writer but had become a drunkard; Shostakovich believed the piece was ghostwritten.[41] Even so, he borrowed

the phrase "formation of a personality" when he finally gave in to pressure to outline the meaning of his new work in an essay titled "My Creative Answer," published in January 1938. "It was man, with all his sufferings, that I saw at the center of this work," he wrote, adding that he had been particularly pleased by the words of one critic, who had described the Fifth as the "practical creative answer of a Soviet artist to just criticism."[42]

With this oblique act of obeisance and, more important, by continuing to work instead of lapsing into silence, like Isaac Babel, Shostakovich had done enough to win a pass. Stalin had other things occupying his attention and did not intend to deprive his regime of a world-renowned composer and earner of foreign currency. Having wiped one Shostakovich opera and one symphony off the repertoire, the authorities left it at that.

10

Pasternak in the Great Terror

A perfectly Soviet person—but he could not sign a verdict with his own hand.

—YURI OLESHA

Dr. Zhivago, the eponymous hero of Boris Pasternak's novel, is delighted by the size and position of a table he comes upon in a hut in a wild part of Siberia in the middle of the civil war. "What a wonderful spot you have here!" he exclaims. "And what an excellent study, conducive to work, inspiring."[1]

Pasternak spent much of his adult life longing for a quiet place where he could spread out and work undisturbed. His difficulties in finding somewhere suitable worsened after he split with his first wife and left her the apartment; he was a lodger in the apartment of his friend Boris Pilnyak for several weeks before finding a room for himself and Zinaida. Eisenstein remembered him living on the Arbat, a Moscow street habituated by artists, with the new metro rumbling underneath: "He wrote by night and the subterranean scrapes, cracks, clanks and squeals disturbed him. Urbanism was burrowing its way beneath the poet. One morning, he could not leave his flat. The building had subsided. It had started to bow, and this prevented the door from opening. Pasternak leant out with his elbows on the broad windowsill. It was evening."[2]

In the summer of 1936, he was offered something that he had wanted for years. Litfund, an organization that originated under another name as a nineteenth-century charity for writers but was now an immensely well-funded arm of the writers' union, had acquired an estate in Peredelkino village, north-

east of Moscow, formerly the property of the Samarin family, one of whose younger members Pasternak had known as a student. There was space in the village for forty writers and their families, most of whom would live rent free. Pasternak's senior position in the writers' union meant that he qualified for a precious two-story dacha.

His first inclination was to turn it down, in disgust at the vilification of Shostakovich, but Zinaida knew what that sacrifice would have cost him. She seized the initiative, organized the move, and got him settled in what would be his home for the remainder of his life. Here he lived through the great terror, when Stalin turned his attack dogs on the Soviet elite, putting them through horrors comparable to what the peasants had experienced. Though the number of victims was smaller, the purge reached into every branch of the state and every level of society; no one was unafraid.

Two unusual visitors called to see Pasternak just before the terror began and soon after he had moved to Peredelkino. André Gide, doyen of French writers, had come to the USSR for Maxim Gorky's funeral and was concluding a three-month tour of the country. There was a formula for visits by distinguished visitors: they were shown model villages and introduced to well-trained guides and officials, whose task was to convince them that they had seen a new civilization in the making. Gide had gone through the whole procedure but was not taken in. He arrived at Pasternak's dacha with a French communist named Pierre Herbart, curious to hear from someone who could be relied upon to be truthful. There is no record of what was said at this first meeting, but it was interesting enough for Gide to pay a second call, late in July 1936. He was accompanied again by Herbart and by another interpreter, a woman. Gide asked her to leave the room lest she hear anything compromising.

Gide then unburdened himself. Nothing that he had witnessed in the USSR was as he had expected, he said. Nothing that he heard from officials rang true. He saw apathy, stagnation, and propaganda everywhere. He had ceased to believe there was freedom of speech here. He intended to write a book about his visit once he returned to France. He asked for Pasternak's advice: should he write what he believed to be true, and risk creating a rift in the Popular Front, or keep silent for the sake of solidarity against the Nazis?

Pasternak was at first reluctant to be drawn in. He pointed out that Maxim Gorky and Romain Rolland—both better known, at least in Russia—had witnessed what Gide had seen without writing anything critical of the USSR. He demurely suggested that the journalist Mikhail Koltsov would be better

placed to give an opinion. Both Frenchmen threw up their hands and declared that Koltsov was nothing but a mouthpiece for the authorities. Then Pasternak finally opened up and spoke frankly.

Pasternak had traveled a long distance, intellectually, since he had visited Gide in Paris. The depression he had suffered the summer of 1935 had been cured; he was no longer trapped in the mental prison he had created by trying to be a participant in Soviet public life; he had withdrawn into the privacy that suited his temperament. He was sick of the pettiness of middle-ranking officials such as Vladimir Kirshon, a "proletarian" playwright and friend of Leopold Averbakh who had been included in the Soviet delegation in Paris. Pasternak referred to him and his kind dismissively as "a load of Kirshons." He told his French guests that Ivan Gronsky, the editor of *Novy mir*, who had introduced the practice of printing a portrait of Stalin and a poem to his glory in almost every issue, was "stupid" and talked only in political clichés—"but it is impossible to blame him for that."

"When they built our dachas here, they set up something like a permanent private estate, and they think that watching the navvies and carpenters at work under my window, I'll want to rejoice that they were so kind as to build this dacha for me. Rubbish! I'm too old to change," he told them. Around and around went the falsehoods, the incredible stupidity, and the parading of bad taste, he added. He had been under pressure to write an article praising the new delivery system offered by one of the state shops, with a carload of groceries arriving at his door.[3]

Gide returned to France without meeting Stalin. His book *Retour de l'U.S.S.R.*, published in Paris in November 1936, scandalized the French Left with its criticisms of the communist dictatorship and the supine intellectuals who complied with it. In Moscow, writers were called upon to express their indignation in articles or by signing open letters. Obviously, it was required of Pasternak that he, too, should put on a show of outrage, but he insisted that he could not comment on something he had not read. His attitude did not impress some of his fellow writers. "Pasternak's moral squeamishness struck the others as affected and provocative, though nothing could have been further from what he intended," recalled the playwright Alexander Gladkov, who first met Pasternak around this time. "I remember a writer called V., who had signed and was quite genuinely indignant with Pasternak: 'Well, he didn't read it, but so what? Neither did I. Does he think any of the others did? Why does he want to be different from everybody else?'"[4]

Pasternak had another visitor on August 2, a few days after Gide. His identity is not known for certain, but he was probably A.V. Fevralsky, one of the editors of the complete works of Mayakovsky. Whoever he was, he was a police informer. Pasternak either blindly trusted him or his natural openness made him decide to let the authorities know, by proxy, what he had said to Gide. For whatever reason, he ran through the whole conversation, and in no time a written account attributed to "Fevralsky, lit. critic" was on the desk of the head of the Secret Political Department of the NKVD, G.A. Molchanov.

Had Pasternak been an ordinary Soviet citizen, he could have expected to be arrested that night and probably shot, but Molchanov did not dare take action against someone who had received a personal telephone call from Stalin. Instead he forwarded the report to the Central Committee of the Communist Party, and a copy went into the files kept by the fearsome Nikolai Yezhov, the party secretary in charge of overseeing the police. But nothing was done: Pasternak was not even summoned to police headquarters for questioning, unlike the unfortunate woman who had been assigned to Gide as his interpreter. Although she had been sent out of the room so that she would not hear anything incriminating, she was executed anyway.

Yezhov and the NKVD department heads were exceptionally busy during the month of August 1936, preparing the most spectacular display of Stalin's power yet: a show trial of sixteen victims, including Lenin's old comrades Zinoviev and Kamenev, confessing to crimes they had never committed under the sneering tutelage of prosecutor general named Andrei Vyshinsky. Afterward, they were all shot. It was the start of the great terror.

As the show trial opened, Pasternak was visited by Vladimir Stavsky, a timid drunkard who had just been appointed secretary of the USSR Writers' Union. He came with an open letter headlined "Wipe Them from the Face of the Earth" that he wanted Pasternak to sign. Pasternak knew none of the defendants—except presumably Kamenev, who had sat on the board of the writers' union—and did not know whether they were implicated in the murder of Kirov, which was the main charge against them. It is more than likely that he shared the "indescribable discomfort" that André Gide experienced on reading confessions he found impossible to believe, but in any case he had given up signing collective letters and declarations in his early twenties and did not intend to begin by signing one that implicitly called for sixteen men to be executed.[5] He sent Stavsky away empty-handed.

While there was something in Pasternak's character that made him almost incapable of doing something that he knew to be ignoble, Stavsky possessed no such impediment to his self-preserving cowardice. The terrified official faked the signature that Pasternak had refused to supply rather than have the Kremlin find out that he had failed in his assignment. Pasternak could have had his name removed at the proof stage, however, but Stavsky pleaded with him to leave it in, and he gave in.

His unhelpful attitude was discussed a few days later at a meeting of the presidium of the writers' union. Yuri Olesha, Isaac Babel's old companion from Odessa, was the only participant who dared speak in Pasternak's defense, saying that Pasternak was "a perfectly Soviet person, but he could not sign a verdict with his own hand." Pasternak was also roundly criticized at an editorial meeting of the journal *Znamya* on August 31.

The bizarre upshot was that when the letter appeared in *Pravda* on August 21, it bore Pasternak's name but not that of Vladimir Kirshon, the playwright Pasternak so despised as a communist hack, who would willingly have signed but was not asked. This snub sent Kirshon into a blind panic. He was a long-standing friend and drinking companion of Leopold Averbakh, the former head of RAPP, a connection that allowed him to socialize regularly with Yagoda—but Yagoda was about to lose his position as head of the NKVD. Kirshon correctly surmised that his friendships with Averbakh and Yagoda had been a catastrophic misjudgment and sent a distraught letter to Stalin's deputy Kaganovich, pleading to be restored to favor and offering to denounce Averbakh, if required. The offer was not taken up, and a few months later Kirshon joined Averbakh and several former NKVD officers as they lined up in the Lubyanka for a bullet in the back of the head.

On August 22, as the show trial moved to a close, Vyshinsky read out the names of yet more Old Bolsheviks said to be implicated in the great Trotskyite-Zinovievite conspiracy. There were eight names on the list, half of them people Pasternak knew or had met. They included Nikolai Bukharin, still nominally editor of *Izvestya*. Isolated in his dacha with his young wife and baby son, Bukharin threatened a hunger strike, with apparent success. Either Stalin was not yet in a position to strike against the man Lenin had described as the "favorite of the whole party," or he indulged in the sadistic pleasure of giving a victim false hope before the final blow. On September 10, Vyshinsky announced that the investigation into Bukharin had been called off. Afterward, Bukharin was deeply touched to receive two goodwill messages. One

was a telegram from Romain Rolland, writing from Villeneuve, in the south of France, congratulating him on his rehabilitation. Rolland also wrote privately to Stalin, continuing to plead Bukharin's case. The other letter was from Pasternak, who risked his freedom and his life to offer a word of comfort to a man he had learned to like.

At a writers' meeting in December, Stavsky delivered a long complaint about Pasternak's behavior, asking how the union could deal seriously with the tasks before it when someone in a prominent position was so uncooperative. The newspaper *Vechernyaya Moskva* followed with a list of all the offensive comments Pasternak had made in meetings and condemned his isolation. Pasternak defended himself in a letter to *Literaturnaya gazeta* in January 1937, in which he gently suggested that Stavsky had misread his poetry. An editorial pronounced that Stavsky's interpretation was correct: it was Pasternak, by implication, who had misread his own work.

In the same month, another show trial began, and Pasternak knew at least three of the seventeen defendants personally. He had met the ex-Trotskyite journalist Karl Radek during editorial meetings in the offices of *Izvestya*, had been at school with the former people's commissar Grigori Sokolnikov, and had been to a literary evening at the home of the ex-Trotskyite Leonid Serebryakov. The defendants were paraded into the courtroom as the Soviet press bristled with articles and collective letters demanding that they be shot. Even Babel and Olesha buckled under the pressure and signed denunciations, but Pasternak refused. When a special writers' meeting was convened in order to pass a hysterical resolution condemning the Trotskyite terrorists, Pasternak did not attend. Afterward, he had second thoughts and sent a letter to the writers' union, pleading that illness had prevented from going to the meeting. He added an obtuse paragraph that hinted at what he really believed, stating that "one has no wish to expiate on anything, but only to work more fervently and industriously at the expression of truth—a truth that is open and unblustering, and which precisely in this respect defies subversion by any disguised and fratricidal falsehood."[6]

In February 1937, the Central Committee convened to hear Bukharin and his old ally Rykov being denounced by the rabid Nikolai Yezhov, who had supplanted Yagoda as head of the NKVD. Officers waited outside to arrest Bukharin and Rykov. Bukharin's young wife, Anna, who would endure seventeen years of imprisonment, was allowed to remain for a few months in their Kremlin flat, a social outcast among the building's privileged inhabitants.

There were no more messages from Romain Rolland or anyone else—except, astonishingly, a letter from Pasternak, who risked his life yet again just to let Anna know that he still did not believe Bukharin was guilty.[7]

One day in May, a car drove into Peredelkino, bringing yet another official from the writers' union who wanted Pasternak's signature on yet another collective letter, this one in praise of the arrest and execution of several of the finest Red Army commanders, including Shostakovich's patron, Marshal Tukhachevsky. Pasternak knew at least one of the dead men, Robert Eideman, who had dabbled in literature and had criticized Pasternak at more than one writers' meeting for lacking political commitment. That did not in any way inspire Pasternak to sign a document glorifying his or anyone else's killing. He shouted at the unwanted visitor and refused to sign. The next day, the formidable Pavlenko, Mandelstam's tormentor, came with the same mission, and met with a stubborn refusal.[8] "This is torture!" Pasternak complained afterward to his neighbor Boris Pilnyak. After learning that Pilnyak knew Eideman's wife, Pasternak begged him to visit her and convey his sympathy.

This time he was not to be left alone. There was, he recalled later, a "tremendous hue and cry," led by the pathetic Stavsky. "He was scared stiff he would be accused of not watching things more closely," he said. "They tried to put pressure on me, but I wouldn't give in. Then the whole leadership of the Union of Writers came out to Peredelkino—not to my dacha, but to another one, where they summoned me. Stavsky began to shout at me and started using threats. I said that if he couldn't talk to me calmly, I wasn't obliged to listen to him, and I went home."

Zinaida was now pregnant and pleaded with him to consider the risk he was taking. Fearful that he would be arrested, she packed a small suitcase for him to take with him. He apparently wrote yet another letter to Stalin the same day he left Stavsky, but it has not yet surfaced anywhere; thus, we do not know whether it arrived, what it said, or what impact it may have had. "We expected that I would be arrested that night," he recalled, "but just imagine, I went to bed and at once fell into a blissful sleep. Not for a long time had I slept so well and peacefully."[9]

The next day, *Izvestya* carried a "Letter from Soviet Writers" demanding that the state's enemies should be shown no mercy. One of the names was Pasternak. Once again, the terrified Stavsky had forged the recalcitrant writer's signature. A furious Pasternak traveled to Moscow to see Stavsky and demand a printed correction. Stavsky shouted at him that he was putting the whole union leadership in jeopardy and sent him home in a car.

The great purge was now raging like an epidemic. Denunciations, arrests, torture, deportations, and executions spread into every corner of the Soviet Union. Local officials who could not be trusted to behave with sufficient brutality were themselves consumed in the purge and replaced by the more efficiently ruthless. In Georgia, that was not necessary. The little republic and neighboring Azerbaijan and Armenia were under the control of Laventi Beria, who was as sadistic as Stalin himself. In May, Beria publicly attacked Georgian intellectuals, singling out, among others, Pasternak's friend Paolo Yashvili, who was secretary of the Georgian writers' union. Yashvili was investigated and hauled before various meetings to be denounced; at one such meeting on July 22, he produced a gun and shot himself.

When the news reached Moscow, which took some time, it hit Pasternak harder than anything in recent years. Georgia had been the place of his "second birth"; Yashvili, who vividly reminded him of Mayakovsky, was linked in his mind with the beginning of his relationship with Zinaida. All that remained was to give himself up to the "purifying force of grief." "When again and again I tell myself that I shall never again see that extraordinary face with its high, expressive forehead and dancing eyes and never hear the voice that could be heard overflowing with intriguing ideas, I weep, I sink into despair," he wrote to Samara Yashvili.[10]

Years later, he saw Yashvili as a victim of a moral sickness of the kind displayed by Shigalev, a minor character in Dostoyevsky's *The Devils* who envisaged the society of the future. In his memoir, he wrote, "I can't help feeling that Paolo Yashvili was no longer capable of comprehending anything at all when, bewitched by the ideas first enunciated by Shigalev, which were so prevalent in 1937, he gazed at his sleeping daughter at night and imagined that he was no longer worthy of looking at her and in the morning went to his comrades and blew out his brains with the shot from his double-barreled gun."[11]

October brought news that his other close Georgian friend, the poet Titsian Tabidze, had been arrested. He was tortured and quickly executed after his arrest, but his distraught family did not know for years whether he was dead or alive. "Last winter, when everything was linked *only* with horror and suffering, I sometimes woke up in tears, thinking that my anguish was not strictly mine, but that I had become part of your suffering," he wrote to Nina Tabidze in 1938.[12] As late as 1940, Pasternak helped Nina draft a petition for the release of her long-dead husband.

On October 28, 1937, Pasternak dropped by the dacha next to his in Peredelkino to congratulate the writer Boris Pilnyak and his actress wife, Kira

Andronikashvili, on their son's third birthday. Pilnyak was a contradictory character, easily bought off by luxury and flattery and yet capable of immense courage. In 1929, he had been subjected to a ferocious public attack from RAPP at the same time as Bulgakov's friend Zamyatin. Unlike Zamyatin, Pilnyak bowed to communist discipline and was assigned Nikolai Yezhov as his personal censor as he worked on his Five-Year Plan novel, *The Volga Flows into the Caspian Sea*, which came out in 1930. While writing it, Pilnyak complained bitterly to Victor Serge that "he has given me fifty passages to change outright!" and added, "There isn't a single thinking adult in this country who has not thought he might be shot."[13] Serge thought the fact that Pilnyak's highly popular novels were on sale around the world made him invulnerable, but to protect himself further Pilnyak paid tribute to Stalin as "a truly great man, a man of great determination, of great deeds and words" in a statement that was helpfully added to the file the police kept on him.[14] After a group of industrial managers were arraigned in the first of the Stalinist show trials, Pilnyak dutifully joined other Leningrad-based writers in calling for the death penalty. Such compromises brought him valuable rewards, including permission to travel to Paris, New York, and Tokyo. He wanted Pasternak to accompany him to Japan, but Pasternak turned him down because he did not want to be separated from Zinaida. Pilnyak returned dressed in tweed, "childishly pleased" with his reception in the United States. "You people are finished!" he told Serge. "Revolutionary romanticism is out! We are entering an era of Soviet Americanism: technique and practical soundness!"

Though Pasternak had spoken disparagingly of Pilnyak to André Gide, he was evidently fond of him and had dedicated a poem to him. Pilnyak had shown some spirit when, on September 1, 1936, he was hauled before the editorial board of *Novy mir*, then still edited by Gronsky, who was understandably fearful because at least one of the writers whose work he published regularly, Galina Serebryakova, had just been arrested. He berated Pilnyak for his past thought crimes, including sending money to Karl Radek when he was in exile in Tomsk and speaking up in defense of Victor Serge when he was arrested in 1933. This attack neither cowed Pilnyak into submission nor saved Gronsky from disaster. In 1937, Gronsky was condemned for publishing Pasternak and was sacked from *Novy mir*; he disappeared into the gulag, only to return in the 1950s with his faith in communism undimmed.

Meanwhile, far away in Barcelona, one of the most infamous incidents of the Spanish civil war occurred in June 1937, when the NKVD kidnapped,

tortured, and killed Andrés Nin, a socialist who had broken with the Spanish communists to found the Workers' Party of Marxist Unification (POUM), whose varied members included a bewildered George Orwell. Nin had also translated Pilnyak's stories into Catalan. As Stalin's agents rifled through his papers, they made the scandalous discovery that Pilnyak had secretly been corresponding with Nin for years and had raised the Serge case with him to help generate international pressure for Serge's release.

After Pasternak left on that evening in October 1937, the police came to fetch Pilnyak. Both his wife and his ex-wife were arrested later and sent to labor camps. Pilnyak had not been in the NKVD's care long before he was confessing that he had been a Japanese spy since his visit to Tokyo, which Pasternak had fortunately not joined. Like anyone else in the hands of the NKVD, he was required to name accomplices, but the record of his interrogation shows him struggling to incriminate as few people as possible, naming mostly those who were dead or already under arrest. He was, however, compelled to give testimony against Pasternak. If they did not already know it, the police now learned that Pasternak had refused to sign the document exalting the execution of Marshal Tukhachevsky. Pilnyak was shot on April 21, 1938, but once again the NKVD failed to act on its expanding dossier of evidence against Pasternak.

Osip and Nadezhda Mandelstam reappeared in fear-ridden Moscow during this terrible period. Osip's three years of exile had ended in May 1937. The previous winter, Mandelstam had forced himself to write an "Ode to Stalin," a task he found so stressful that for the only time in his life he behaved like a normal writer. His wife recalled, "Every morning, he seated himself at the table and picked up the pencil, as a writer is supposed to . . . after sitting for half an hour or so in this posture of a real man of letters, he would suddenly jump up and curse himself for his lack of skill."[15] Even while he was striving to be a hack writer, the poet in him kept breaking out like an illness. As he searched for the words to praise the recluse in the Kremlin, he also composed these lines:

Inside the mountain, the idol's inert,
secure in the immensity of his sparse chambers

. . .

He thinks in his bones and feels in his forehead,
and struggles to remember his human appearance.[16]

Not everyone was pleased to see the Mandelstams back in town. The oc-
cupant of their former flat was particularly put out but actually had no need
to worry: by sharing her husband's exile, Nadezhda had sacrificed her resi-
dent's permit, which meant neither of them had a legal right to be in Mos-
cow. They took lodgings in the nearby town of Kalinin. During their regular
visits to the capital, they had to impose themselves on those with the cour-
age and generosity to take them in, such as the critic Viktor Shklovsky and
Valentin Katayev, the writer who had been Mayakovsky's host the night be-
fore his suicide. Katayev and Shklovsky arranged for Mandelstam to meet
the president of the writers' union, Alexander Fadeyev, who was supplanting
Stavsky as the man in charge of policing literature. Despite his cold-blooded,
opportunist cruelty, Fadeyev loved Mandelstam's poetry so much that listen-
ing to a recital moved him to tears.[17] Fadeyev would visit Pasternak at Pere-
delkino, drink heavily, and pour out unwanted confidences to his unwilling,
embarrassed host, who had no illusions about how far he could rely on
Fadeyev's friendship. "Fadeyev is well disposed towards me personally, but if
he received orders to have me hung, drawn and quartered he would carry them
out conscientiously without batting an eyelid—though the next time he got
drunk he would say how sorry he was for me and what a splendid fellow I
was," Pasternak reckoned.[18]

The Mandelstams also called at Peredelkino, where Pasternak was happy
to see them. He hurried off to the kitchen to share the news with Zinaida,
who was baking a cake, but her reaction was that the Mandelstams were trou-
ble and the best course would be to send them on their way. So Pasternak
went to see them off and became engrossed in a long conversation at the sta-
tion, leading them to miss one train after another. "Pasternak was still ob-
sessed by Stalin and complained that he could not write poetry anymore
because he had not been able to get a personal meeting with him," Nadezhda
recalled. Mandelstam smiled sympathetically, but his wife felt "nothing but
dismay" that someone of Pasternak's intelligence should be so gullible.[19]

Mandelstam was arrested for the second and final time as summer returned.
It was common practice at the time for an intended victim to be offered false
hope before the final blow—so it was with Mandelstam. He was granted an
audience with Stavsky, who arranged for the couple to have a two-month holi-
day in a rest home in Samatika, outside Moscow. Before they set out, they
ran into Fadeyev, who gave them a lift in his car, where he could talk to them
without being overheard. He told them gloomily that he had been to see one
of the highest-ranking officials in the party, Andrei Andreyev, to suggest that

Mandelstam be given a job but had been turned away. Fadeyev knew the implications of that refusal were ominous. He also noticed that they had not been offered a holiday at one of the writers' rest homes, but in a place twenty-five kilometers from the nearest railway station, where there would be no fellow writers to react if anything happened to them. But Fadeyev did not take the risk of warning them. Instead, the Mandelstams, elated by what they imagined was a change in their fortunes, tried to cheer up their gloomy companion.

After the May Day holiday, the police turned up to take Osip Mandelstam away to die in the gulag. For the rest of her life, Nadezhda believed that it was Stalin himself who ordered his arrest. "The police had to wait for a decision from Stalin or someone close to him, without which it was impossible to arrest M. because of Stalin's personal order in 1934 to 'isolate but preserve' him," she claimed.[20] The archival evidence does bear this out, suggesting that his nemesis was Stavsky. Having received Mandelstam cordially in his office, Stavsky must have fretted that he would get into trouble for allowing someone with Mandelstam's record to go undenounced. The newspapers were carrying daily reports of the last and greatest of the Moscow show trials, with Bukharin as the main defendant. It ended on March 15, 1938, with death sentences for all but three of the defendants. Stavsky must have recalled the old connection between Bukharin and Mandelstam. On March 16, he wrote to Yezhov to report that "part of the literary world is very nervously discussing the problem of Osip Mandelstam"—who, he reminded the police chief, had been exiled for writing "obscene libelous verse." Yet "he often visits his friends in Moscow, for the most part writers. They support him, collect money to help him, and make of him a figure of suffering, a brilliant and totally unrecognized poet." Some, like Katayev, were openly and outspokenly defending him, Stavsky complained.

On April 28, Yezhov's deputy, Mikhail Frinovsky, signed a warrant for Mandelstam's arrest. Five days later, a pair of detectives and a doctor turned up at the Mandelstams' holiday home, complaining that it was not their fault they were serving a warrant that was almost a week old: there was just too much to do.

Even in 1938, when a Politburo member or a Red Army marshal could disappear in the night to be tortured and killed, there remained a modicum of sensitivity about disposing of this itinerant, unemployed ex-convict who was rumored to be the author of great poetry. The overworked mass murderers in the Lubyanka therefore took the precaution of summoning an expert, the

reliably hostile Pyotr Pavlenko. Pavlenko was neither a poet nor a critic but felt qualified to judge that Mandelstam's verses were "cold and dead" and that they "smell of Pasternak." The only half-good poem, in Pavlenko's judgment, was the wretched "Ode to Stalin," and even that had "clumsy phrasing" that failed to do justice to its wonderful subject.[21]

In the Lubyanka, Mandelstam's interrogators made a desultory effort to make him confess to being a terrorist and to being in league with foreign agencies through Victor Serge, whom Mandelstam knew only slightly. Instead he stuck staunchly to the truth, though that meant admitting that he had been visiting Moscow without permission and reading poetry. His interrogators did not bring up the notorious epigram about Stalin—a strange omission, but the NKVD interrogators were processing the cases of thousands of innocents, and there was little continuity of experience among them since Yezhov had ordered the arrests of 2,273 officers who had served under Yagoda. Khristofovich, who had handled Mandelstam's case last time, was gone. So it may have been just an administrative error that they overlooked the deliberate insult Mandelstam had composed about the Father of the Soviet Peoples. He was sentenced on a minor charge to five years in the labor camps—as good as a death sentence for a forty-seven-year-old man with Mandelstam's high-strung temperament. He did not survive his first winter in the Magadan region and died of heart failure on December 26, 1938. Fortunately for those who love Russian literature, his extraordinary widow, Nadezhda, did survive and hoarded her sweet and angry memories.

It is now the accepted view that there were four great Russian lyrical poets living intertwined lives below the spreading shadow of Stalinist tyranny, all of whom pass through the pages of Nadezhda Mandelstam's memoirs. Anna Akhmatova is accorded almost unqualified respect, and though Nadezhda was often exasperated by Boris Pasternak's struggle to be a dutiful Soviet citizen, she pays him the compliment of calling him Osip Mandelstam's "polar opposite," meaning that despite their contrasting temperaments they were of comparable stature. About Marina Tsvetayeva she was less kind. She recalled going to Tsvetayeva's apartment to say good-bye before Tsvetayeva moved to Berlin in 1921: "At the sight of M. [Osip] she gasped with pleasure, but it was all she could do—not taking her eyes off him for a moment—to offer me her hand. She made it quite plain that she had no time at all for wives."[22] Presumably, Nadezhda either knew or guessed that Marina and her husband had once been lovers.

Marina Tsvetayeva and Boris Pasternak never had a physical relationship, but they entered into a passionate exchange of letters when he was in Moscow and she was abroad that Pasternak had begun after he had come upon a typewritten copy of one of her poems. "You are filled with such beauty, you are a sister to me, you are my life, sent directly from heaven, and a time of my soul's greatest ordeal," he wrote. In turn she wanted to name her newborn son Boris, but his father insisted he be called Georgi. Word of this correspondence reached Leonid Pasternak in Berlin, causing him understandable anxiety about the possible impact on his son's marriage. "Can it be that among poets the exchange of books with total strangers is accepted practice?" he inquired.[23] He need not have worried: the love affair by letter burned itself out after a few months.

The greatest love of Tsvetayeva's life was Sergei Efron, whom she married when she was nineteen and with whom she had a daughter, Ariadna, born in 1912, and a son, Georgi, born in 1925. Efron fought in the White Army in the civil war and fled abroad to avoid retribution. For months, she did not know whether he was alive or dead, but when she learned that he was in Prague, she obtained permission to emigrate, joining him after a lengthy stopover in Berlin. After nearly twenty years abroad, she, Efron, and Ariadna were homesick. Ariadna disliked émigré life so much that she went back to Russia without her parents. Efron tried to earn a pardon and by the mid-1930s was effectively an agent of Soviet intelligence.

In summer 1937, Ignace Reiss, a Polish employee of the foreign department of the NKVD who had sought asylum in France, was found shot dead by the road near Lausanne. The murder was obviously political. As the French police investigated, Efron came under suspicion, though it is unlikely he was involved. According to the memoirs of the former NKVD hit man Pavel Sudolplatov, the two assassins were Bulgarian, and "claims that Sergei Efron was involved in betraying Reiss to the NKVD are false . . . [he] had no idea of Reiss's whereabouts."[24] Nonetheless, Efron fled to the USSR, leaving Marina isolated in Paris with their son.

Tsvetayeva had been warned against returning to the USSR—not least by Pasternak, whom she was able to meet face-to-face during his 1935 visit to Paris—but she was friendless in a foreign capital amid growing speculation that war was imminent. She set sail in June 1939 with Georgi, who was now fourteen years old, but soon learned that she moved from a bad predicament to something worse. Her sister and nephew had vanished: it was not wise to ask where. So had old contacts from the intelligence services. Efron and his

colleagues were kept in isolation in a dacha in a suburban village outside Moscow belonging to the Ministry of Foreign Affairs. Pasternak seems to have been one of the first to discover that she was back in the country, while others who had been reading Tsvetayeva's poetry for years had no idea that she was in Russia once again.[25]

Her already desperate isolation took a horrible turn for the worse on August 27, 1939, when Ariadna, then twenty-five years old, was arrested. She was beaten and deprived of sleep until she confessed to being a French spy, for which she was sentenced to eight years of hard labor. Sergei Efron was arrested on October 10 and executed two years later. Pasternak was now the only friend the grieving, frightened, and still isolated Tsvetayeva could turn to. She saw him in Moscow and deposited some notebooks with him. According to Pasternak's son, he visited her in Bolshevo in November.[26] After she had moved to Moscow, where she lived in a single tiny room in her sister-in-law's apartment, Pasternak was able to help find her somewhere slightly more spacious, in a house in Golitsyno, near Moscow, that belonged to the writers' union. In April, she arrived late at one of his public readings of his translations. Seeing her at the door, Pasternak stopped reading, went to kiss her hand, and led her to a seat in the front row. He appealed to Fadeyev to give her financial help from Litfund but was turned down. In August 1940, she wrote to Pavlenko, pleading for help, and Pasternak appended a note supporting the appeal, which was also turned down.

At the same time, despite the obvious risk of consorting with the wife of an "enemy of the people," Nina Tabidze was staying with the Pasternaks. Unaware that her husband was already dead, Pasternak courageously sent another appeal to Beria for his release.

In the summer of 1941, Tsvetayeva visited Peredelkino. She still did not know what had happened to her husband, and her mental state was deteriorating. Zinaida did the round of their neighbors to collect enough money to ensure that she could at least pay her rent. In August, Tsvetayeva decided to join the evacuation from Moscow, fearing that her son would be conscripted. Pasternak went to the port to see them off by steamship down the Kama River to a town called Yelabuga. Before the departure they discovered she was still sufficiently unaccustomed to Soviet life to assume that there would be a buffet on board; Pasternak and another writer had to rush around buying them supplies for the ten-day trip. On the journey, she stopped off in the town of Chistopol, where a number of writers and their families had been evacuated, including Zinaida and her children, but not Pasternak. She arrived in Yelabuga

on August 17 but a week later sailed back to Chistopol to plead for permission to move there. She returned to Yelabuga on August 27 and told Georgi that they were going to move to Chistopol, but they never left. On August 31, she hanged herself.

That winter, Pasternak traveled to Chistopol to see Zinaida. Before he left, he bundled together about a hundred letters he had received from Tsvetayeva and other letters from the famous, which he handed to a student for safekeeping. Aware of their significance, the student kept them with her everywhere she went. Soon after the end of the war, she was returning exhausted from Moscow to her home in Bolshevo and absentmindedly left the precious collection either in a railway carriage or under a fir tree in a wood where she sat down to rest. "There you have the fate of objects around me," Pasternak remarked, telling the story in a letter to his sisters.[27] It was also, in a sense, the fate of too many whom he knew in the late 1930s: one day, they were gone.

11

Sholokhov, Babel, and the
Policeman's Wife

Sholokhov has great artistic talent. In addition, he is a profoundly honest
writer. . . . Not like "our" frivolous Babel.

—JOSIF STALIN

Of Stalin's favorite author, Mikhail Sholokhov, it can be said that either he
wrote one of the greatest novels of the twentieth century or he was a plagia-
rist. His name appears on the title pages of two long novels, *Tikhii Don*, which
translates literally as *The Quiet Don*, and *Virgin Soil Upturned*. Both were pub-
lished in installments, beginning in 1927 and 1932, respectively. There is no
dispute about the authorship of the inferior novel, *Virgin Soil Upturned*.
Sholokhov's reputation rests on *The Quiet Don*, particularly on its first two
parts, known in English translation as *And Quiet Flows the Don*, with its evo-
cation of life in a Don Cossack village on the eve of the Great War and of
young Cossacks setting off to fight, which Boris Pasternak singled out as an
example of prose writing achieving the intensity of poetry. The charge of pla-
giarism revolved around those early chapters, describing events that Sholok-
hov was too young to remember.

The Don Cossacks' territory is on the Russian side of the Caucasus Moun-
tains, close to the homelands of the Chechens and numerous other small
nations. They were the largest of the frontier communities created under the
tsars to patrol the Russian borders. With their martial traditions, they con-
sidered themselves superior both to their Muslim neighbors and to the Rus-
sian peasants; they prided themselves on being the world's finest cavalry. There
is a passage in *The Quiet Don* in which a Cossack woman has her family in

200

hysterics laughing at her description of the arrival of the Red Cavalry, who sat so badly in their saddles that "they'll wear holes in their trousers."[1] They had owned their farms for generations, which meant that they owed nothing to the revolution, unlike Russian peasants who had been serfs until the 1860s and who rose in 1917 to evict the landlords and seize the land. When monarchist generals founded the White Army with the intention of over-throwing the Bolsheviks, they established their first base in Don Cossack territory, in the mistaken belief that the Cossacks would fight to restore the tsar. Actually, what the Cossacks wanted was independence: in 1918, their first elected ataman, a White general named Pyotr Krasnov, allied himself to the Germans to keep out the Russians. None of this commended them to the Bolsheviks, and when their territory had been subdued by the Red Army, the commissars watching over them had good reason to mistrust and dis-courage their traditional way of life.

There was, however, a Don Cossack who wielded considerable influence among the Bolsheviks. He was an elderly writer who published under the name Alexander Serafimovich and was the author of one of the first acclaimed socialist realist novels, *The Iron Flood*; he had been involved in revolutionary circles for so long that he had known Lenin's older brother, who was hanged in 1887. Serafimovich feared the destruction of Don Cossack culture. In 1927, word reached him that the literary magazine *Oktyabr* had received and rejected an unsolicited manuscript excerpt from a novel set in his homeland. Serafimovich read it and insisted that it be published. It ran in four con-secutive issues of the magazine. Within a remarkably short time, a second volume of the novel turned up, describing how Soviet power first came to the region of the Don Cossacks. It was published in the same magazine be-tween May and October 1928. Russia's alert reading public quickly spotted a major new talent. The two volumes were published in book form, and such was the demand that by 1931 the various print runs totaled almost half a mil-lion copies and the publishers had been inundated with readers' letters prais-ing the work.

The second volume was fearlessly truthful. It incorporated a real incident in which a Cossack turned Bolshevik named Fyodor Podtelkov shot dead a prisoner named Chernetsov. In the official Soviet version, Chernetsov was killed in self-defense; in the novel, the deed was depicted as an unprovoked murder, which so disgusted the fictional hero, Gregor Melekhov, that he joined the White Army and would spend much of the rest of the novel fighting the Bolsheviks. The novel also graphically described the lynching

of Podtelkov and a commissar named M.V. Krivoshlykov by infuriated villagers in May 1918. It was implied that the whole catastrophe owed much to the ineptitude of the Rostov soviet, which was headed by a Bolshevik named Sergei Syrtsov. By the time the novel appeared, Syrtsov had become a very high-ranking official, the prime minister of the Russian Republic.

Both volumes were so packed with minute details of Cossack life and foibles and captured the idiosyncrasies of Cossack speech so accurately that it seemed the author must be a Cossack who had lived through the events he described. The name Mikhail Sholokhov was known slightly in Moscow because a young man of that name had spent four years bombarding magazines with his short stories before disappearing from the literary scene in 1926. He was now living in Veshenskaya, a small town on the bank of the upper Don roughly halfway between Rostov and Stalingrad. He was not a Cossack. Though he lived among Cossacks, he was the product of an illicit affair between the Russian manager of a mill in Veshenskaya and a Ukrainian maid. Born in May 1905, he was too young to have such clear recollections of Cossack life before 1914. He had not served in the Russian army or indeed any army. He had left school at fourteen to serve in one of the squads that confiscated Cossack grain to feed the towns. He was only twenty-two years old when the first two volumes of *The Quiet Don* were ready for publication.

These incongruous circumstances soon gave rise to a theory that Sholokhov was a front man who had somehow obtained a manuscript written by someone who had, like Gregor Melekhov, fought in the Great War and had fought for the Whites. It was suspected that Serafimovich was prepared to allow the young Sholokhov to pose as the author because if the truth had come out, the novel would never have been published. The rumors were prevalent enough for a commission to be set up to investigate them, made up of Serafimovich and that sinister quartet of literary policemen Averbakh, Fadeyev, Kirshon, and Stavsky. The five of them signed a letter, published in *Pravda* on March 29, 1929, warning that "enemies of the people" were spreading the story that Sholokhov was a plagiarist and called on the public to assist in "exposing individual ill-wishers so that they can be brought to justice."[2]

To throw the story forward, the charge of plagiarism flared again with particular force just as the Soviet authorities were ready to make Sholokhov's seventieth birthday the occasion for a nationwide celebration of his life and work. He had won the 1965 Nobel Prize for Literature, the only citizen of

the Soviet Union ever to win that prize with his government's approval; all the other Russian Nobel laureates during the Soviet period were exiles or dissidents. Though he had written another novel and other stories, there was never any doubt that his international reputation rested on *The Quiet Don*. But another Nobel laureate, Alexander Solzhenitsyn, was expelled from the USSR in 1974 and reached the West armed with an essay that had been circulating illicitly in Russia, written by a scholar known only as D., claiming that *The Quiet Don* was the work of two writers, one of whom was exceptional, while the other was a lesser writer who had inserted some banal passages into the early chapters to make them more politically acceptable and had added an ending in which Gregor Melekhov finally became reconciled to Soviet power. D. hypothesized that Sholokhov was the lesser of the two writers and the greater was a Cossack named Fyodor Kryukov, who died in 1920 during the retreat of the White Army. Solzhenitsyn called on the Nobel Prize committee to investigate the claim with a view toward stripping Sholokhov of his award. The historian Roy Medvedev, living in the USSR and no friend of Solzhenitsyn, wrote a book published in 1975 that supported the same hypothesis.

In the West, there was a willingness to believe the worst of Sholokhov because of the appalling comments he had made in 1966 at the Twenty-Third Congress of the Communist Party of the Soviet Union about Andrei Sinyavsky and Yuri Daniel, two writers recently sentenced to long terms in the gulag for smuggling their work to be published abroad. Sholokhov was better placed than anyone to defend the imprisoned writers with little risk to himself. Instead he denounced them as "renegades" and "immoral men" who, he reckoned, had got off lightly when compared with what would have been done to them in the 1920s. "Oh dear me, these werewolves would have got a different sort of punishment then!" he said, to applause. "And yet, I tell you, they go on about the severity of the sentence!"

What spoiled the theory of Sholokhov the plagiarist was that in 1976 a Norwegian scholar used computer technology to compare sentence lengths and word usage in the known writings of both Kryukov and Sholokhov and in the disputed parts of *The Quiet Don*. He concluded that "we may exclude Kryukov as the author of *The Quiet Don* . . . whereas no significant difference can be established between Sholokhov and the author of *The Quiet Don*."[3] In the light of that study and in the absence of any other hard evidence, the only safe conclusion is that Sholokhov really did write this extraordinary novel, in which case his achievement was similar to that of Stephen Crane, who

was twenty-two and had never been to war when he wrote *The Red Badge of Courage.*

All of Russia's rulers, from Stalin onward, have believed in Sholokhov's genius. In 2005, Vladimir Putin paid a ceremonial visit to Veshenskaya for the unveiling of huge bronze statues of the tempestuous lovers Gregor Melekhov and Aksinia Astakhova, hero and heroine of *The Quiet Don.* The town also boasts a Sholokhov museum, run by the author's grandson, and when the Don Cossacks decided to revive the title of ataman, repressed by the tsar and later by the Bolsheviks, their first elected ataman was Mikhail Sholokhov, the writer's son.

Though Sholokhov could stop worrying about the rumors of plagiarism once the writers' commission had reached its verdict, he was still criticized for the politics of the novel, even getting a gentle public warning from the highest authority of all. In July 1929, in an open letter to an Old Bolshevik on a different matter, Stalin added that "a famous author of our time, Comrade Sholokhov, commits a number of very gross errors in his Quiet Don and says things which are positively untrue about Syrtsov, Podtelkov, Krivoshlykov and others; but does it follow from this that The Quiet Don is no good at all and deserves to be withdrawn from sale?"[4] He was inviting the answer "no."

That hint appears to have prompted Sholokhov to write the opening part of *Virgin Soil Upturned* in haste. It was the time of the campaign against the kulaks, which brought so much suffering to the countryside. Sholokhov knew very well that genuine kulaks, actual rich farmers, were thin on the ground. Privately, he wrote that out of 13,629 farms in the region where he lived, just eighteen were even "two cow" enterprises, yet in his novel kulaks abound, planning a campaign of violent resistance to collectivization, abetted by a former tsarist officer who had infiltrated the area illicitly and was part of a vast conspiratorial organization based abroad with access to weapons, artillery, ships, and aircraft.[5] The novel had its positive characters, too, one of whom was so moved when eulogizing the greatness of Stalin that tears came to his eyes.

Virgin Soil Upturned is so different from the disciplined plot construction and subtly drawn characters of *The Quiet Don* that it is no wonder that Solzhenitsyn and others could not believe that both books came from the same author. One novel depicts in realistic detail how war and revolution disrupted the village way of life and altered human behavior. In the other, the private farms are closed down by order of a distant authority; the inhabitants are all

conscripted onto a collective farm; and, despite an organized, malicious conspiracy to disrupt the process, life carries on without serious social dislocation. As Sholokhov was writing his second novel, thousands of Cossack farmers were being deported, including his own father-in-law and brother-in-law. The first round of collectivization provoked such a violent reaction across the Soviet Union that Stalin had to order a retreat, transferring blame onto officials who were only doing as he had instructed. He announced his sudden, temporary reversal in *Pravda* on March 2, 1930, in an article headed "Dizzy with Success." In *Virgin Soil Upturned*, that article appeared at precisely the right moment to thwart the conspirators' plan to start an armed rebellion.

One of the most striking differences between the novels is in the attitude toward women. *The Quiet Don* has several strong, powerfully drawn female characters. Cossack women, it suggested, are more confident and independent than the repressed wives and daughters of the descendants of serfs. "You can tell a Cossack woman among a thousand," Gregor Melekhov remarks. "She dresses herself to show everything: 'Look if you want to, and don't if you don't!' But you can't tell the back from the front of a peasant woman. She covers her body in a sack."[6] There are also searing descriptions of violence against women, including a particularly distressing passage in which a servant girl is gang-raped by young Cossacks away from their villages for the first time in their lives due to the outbreak of war in 1914. Aksinia Astakhova's husband does not seem greatly upset when he learns of her illicit affair with Gregor Melekhov, but a cheated husband is expected to uphold his honor by beating his wife. She even expects a beating and announces that she is not going to run away. Within minutes, she is on the ground and streaming blood. The scene is all the more shocking for the economy of the writing and for the passing appearance of an amiable one-armed Cossack:

> Armless Alexei Shamil walked past the gate, looked in, winked, and split his bushy little beard with a smile; after it all, it was very understandable that Stepan should be punishing his lawfully wedded. Shamil wanted to stop to see whether he would beat her to death or not, but his conscience would not allow him. After all, he wasn't a woman.
>
> Watching Stepan from afar, you would have thought that someone was doing the Cossack dance, and so Gregor thought as through the kitchen window he saw Stepan jumping up and down. But he looked again, and flew out of the hut.[7]

In *Virgin Soil Upturned* women are part of the background, no more es-
sential to the story than the farm animals, and insofar as they are heard at all
their opinions are unimaginative and reactionary. An erring wife receives a
beating from her father; it hurts her to sit afterward, so she has to pretend
there is a boil on her buttock. This is meant to be funny.

Assuming both books are the work of a single author, the explanation for
these glaring differences must be found in the audiences at which they were
aimed. When Sholokhov was a young and unknown writer working on the
opening parts of *The Quiet Don*, he was writing for Russia's literature-loving
public, reared on Tolstoy and Pushkin. Once he was in the public eye, he had
to reckon with critics and ideologues, especially the greatest literary critic of
all. Stalin read the early chapters of *Virgin Soil Upturned* while he was on holi-
day in Sochi in summer 1932. "An interesting piece of work," he wrote to his
deputy, Lazar Kaganovich, who was in Moscow and running the party in
his absence. "Sholokhov has obviously studied the collective-farm system
on the Don. I think Sholokhov has great artistic talent. In addition, he is
a profoundly honest writer: he writes about things he knows well. Not like
'our' frivolous Babel, who keeps writing about things of which he knows
nothing."[8]

Sholokhov must have made a very good impression on Stalin when they
first met in 1930. The respect was mutual: Stalin recognized an acclaimed
writer who would be useful to the regime, and Sholokhov evidently convinced
himself that Stalin was benevolent and that the abuses of power he had wit-
nessed were the fault of junior officials. This can be seen in an extraordinary
twenty-year correspondence between the Kremlin recluse and the writer liv-
ing more than six hundred miles away in Veshenskaya. The relationship was
so strong that Sholokhov was even forgiven for protesting the sudden deci-
sion to close down RAPP in 1932. He soon abandoned that cause, and the
official line was that he had been temporarily led astray by the manipulative
genius of the young Leopold Averbakh.

Sholokhov and his wife, who had married in 1926, were protected from
the horror of collectivization that he would later celebrate as a triumph in *Vir-
gin Soil Upturned*, despite being one of the wealthiest couples in the region.
They lived in a house that looked like a palace to other villagers because it
had a second floor. In a region where, by Sholokhov's own calculations, fewer
than one household in 750 could afford more than one cow, he employed a
farmhand and owned a car, two horses, several cows, and a number of dogs.

Their wealth was easily sufficient for them to have been classed as kulaks; instead honors were heaped upon him. He was elected to the local Communist Party committee, though his attendance record was poor, and one of the newly created collective farms in his area was given the name Sholokhov Farm.

To his great credit, he was not blind to what his neighbors were suffering, nor was he afraid of complaining to Stalin. A major cause of the terrible famine of the early 1930s was that when peasant families were told that the livestock they had reared was being taken away to become the property of a collective farm, they instead chose to slaughter most of their stock for a final family feast. The animals that were transferred were liable to die from neglect because the peasants who had looked after them when they were their families' property now had to work the fields under the eyes of collective managers terrified of failing to make their targets for wheat production. Twelve of the sixty-five horses belonging to the families who made up one collective farm died; in another, 113 out of 180 horses were dead, leaving the farm with just 67; and in a third district that had caught Sholokhov's attention, he wrote in January 1931, "Comrade Stalin, without exaggerating, conditions are catastrophic!"[9]

On April 4, 1933, he sent Stalin a blockbuster letter more than six thousand words long, whose opening sentence went directly to the point: "The Veshenskaya region, just like many of the other regions of the North Caucasus territory, has not fulfilled its plan for procuring bread or storing seed. In this region, as in other regions, collective farm workers and individual farmers are dying of starvation." Adults and children were eating bark and marsh roots, he reported. In their zeal to force through collectivization and deliver grain, officials had killed a mass of peasants and had tortured prisoners. An investigator named A.A. Pashinsky was forcing prisoners to drink large quantities of water dosed with salt, wheat, and kerosene. Another, A.A. Plotkin, forced prisoners to undergo interrogation while sitting on a red-hot stove. Sholokhov was particularly incensed about a local commissar named Ovchinnikov, who seemed to be incompetence embodied. Even B.P. Sheboldayev, the first secretary of the North Caucasus regional party and the most senior party official in all of south Russia, was not spared his ire. "If all that I have written merits the attention of the Central Committee," he concluded, "send genuine communists to Vesenshkaya district, with courage enough to unmask, without fear or favor, all those guilty of inflicting fatal

damage on the district's collective farm economy, who will genuinely investigate and expose not only all those who have used disgusting 'methods' of torture, beating and violation, but also those who put them up to it."[10]

He sent another letter less than two weeks later. It was shorter, but the complaints were similar: Veshenskaya's people needed food quickly, preferably delivered by steamship.

Any party official who addressed Stalin with such familiarity would not have lived to see out the 1930s, but to Stalin's mind Sholokhov was not a threat but an asset. He sent Molotov a note telling him to arrange for eighty thousand poods (nearly thirteen hundred tons) of grain to be dispatched for the residents of Veshenskaya and another forty thousand to neighboring Verkhnedonsk, adding callously that it "means little to us, but it is decisive right now for the population of these two districts"—as if the rest of the USSR's rural population was not also starving.[11] He then sent Sholokhov a telegram to tell him that food was on the way. People living in and around Veshenskaya could be thankful for the famous writer living in their midst.

Next, Stalin dispatched one of his most effective hatchet men, Matvei Shkiryatov, to deal with the party officials who were annoying Sholokhov. Though Trotsky remembered Shkiryatov as a "crushed, submissive, slightly drunken workingman," he proved to be cunning enough to stay in his line of work for the whole of Stalin's reign and was utterly merciless in doing Stalin's bidding.[12] His instructions were to do enough to placate Sholokhov without interfering with the drive toward collectivization that was at the root of the trouble. That was laid out in the next telegram from Stalin to Sholokhov, telling him to expect Shkiryatov's arrival and issuing the mildest of rebukes to the outspoken young writer.

> Thank you for your letters, which exposed the failings of our party and soviet workers, and exposed how our workers in their eagerness to suppress the enemy sometimes unintentionally resort to sadism. But that doesn't mean that *I totally* agree with you. You see *one* side: you're not bad at that. But that is not the *only* side of the story. . . . The other side is that the esteemed grain growers of your district (and not only your district) were on an "Italian strike" (sabotage!) and were not averse to leaving the workers and the Red Army without bread. The fact that the sabotage was silent and outwardly nonviolent (with no bloodshed)— that does not alter the fact that the esteemed grain growers were waging a "silent" war on soviet power. A war of starvation, dear Comrade Sholokhov.[13]

Shkiryatov was in the region for ten days, beginning May 10. While he was there, the torturers Pashinsky and Plotkin were arrested, Pashinsky was sentenced to death, and Veshenskaya's public prosecutor was sacked. "The results of my investigation in the Veshenskaya district fully corroborate Comrade Sholokhov's letter," Shkiryatov reported to Stalin on May 28. Back in Moscow a week later, Stalin, Molotov, Kaganovich, Voroshilov, and Shkiryatov met in Stalin's office. Sholokhov and some of those he had accused were also invited to make the six-hundred-mile journey to take part. The quartet from the Politburo sacked Ovchinnikov, about whom Sholokhov had complained at such length, and another high-ranking party official but appear to have decided that Shkiryatov had been too hard on Pashinsky and Plotkin. Pashinsky's death sentence was revoked. Both men were severely reprimanded and banned from working in Sholokhov's hometown.

Later in the year, Stalin decided to divide the vast North Caucasian territory into two administrative units. Sheboldayev, who was also mentioned in Sholokhov's long letter, was given charge of the western half, while the half where Sholokhov lived—which retained the old name for a time before being redesignated the Rostov region—acquired a new Communist Party boss who took office on January 1, 1934, a sinister individual named Yefim Yevdokimov, a "strange man with an immovable stony face" about whom there are several unverifiable stories.[14]

Though Yevdokimov's official biography claimed he was an anarchist before the revolution, it was said that he was actually a common criminal, set free when the prisons were opened in 1917. Isaac Babel cultivated him as a source of information on the prerevolutionary criminal underworld in Odessa. The first Stalinist show trial, in which dozens of engineers from Ukraine's coal-mining district were accused of sabotage, was primarily Yevdokimov's work. His boss, Menzhinsky, reputedly tried to put a stop to it but was overruled by Stalin. Another well-sourced NKVD rumor was that Stalin had tried to impose Yevdokimov as head of the Leningrad NKVD, an appointment Kirov successfully resisted. The implication was that if the appointment had gone ahead, he would have been entrusted with organizing Kirov's assassination. Rumors aside, Yevdokimov was the USSR's most highly decorated police officer, the first to be transferred to a major party position in the Communist Party apparatus. His relations with Yagoda were bad, which meant he was particularly highly valued by Yagoda's murderous successor, Nikolai Yezhov. While almost every other regional first secretary was removed and

arrested during 1937, Yevdokimov stayed in his job because he could be entrusted with inflicting terror on his own subordinates and those in the adjoining territory, which he did with brutal enthusiasm.

In summary, it was highly advisable not to cross this dangerous man. Yet he did not frighten Sholokhov, who was protected by his patron in the Kremlin. The mass arrests ordered by Yevdokimov swept up several people Sholokhov knew personally, including his best friend, P.K. Lugovoi, the secretary of the Veshenskaya party committee, who was arrested in August 1937. Sholokhov was due to go to Spain, where left-wing writers were assembling in republican-held territory for a follow-up to the 1935 Paris Congress for the Defense of Culture but refused to leave while his friend was in danger.

Again, Stalin sent a personal emissary to Veshenskaya to find out what was upsetting his favorite writer. This time, it was the timid drunkard Vladimir Stavsky who visited the writer at home and found him in near-suicidal despair. To his credit, the acclaim he had won early in life had not gone to his head. Far from basking in conceit, he was fretting that the second half of *The Quiet Don* would not match the artistic quality of what was already published. The story was becoming more bleak and hopeless as the action dragged its way through the civil war. It had taken him barely two years, between 1926 and 1928, to write the first part of the novel, while the job of completing it dragged on until 1940. His integrity as a writer was in conflict with what was expected of him politically: he understood that he ought to devise a happy ending in which the hero, Gregor Melekhov, sees his political errors and learns to love the revolution, but "I just can't make him be a Bolshevik," he told Stavsky.

Yet he retained total confidence in Stalin and the correctness of the party line and attributed the folly and cruelty he saw around him to local incompetence and malice. Sholokhov also revealed to Stavsky a detail that throws light on the economic waste that was a side effect of these years of terror, when everyone in authority was either too terrified or too busy hunting enemies to concentrate on day-to-day tasks. Vast quantities of grain were being left to rot, Sholokhov complained, which wasn't very surprising, since Yevdokimov had begun his campaign of terror around harvest time. Stavsky checked and then reported back to Stalin that in fact ten thousand tons of wheat had been left to molder on the bank of the Don; only in the past few days had anyone even thought to cover it with tarpaulins. That discovery only led to yet more arrests.

What upset Sholokhov more than anything was the arrest of his friend Lugovoi. "If they condemn him, that means I'm guilty too," he declared. He was not alone in this opinion; Yevdokimov had evidently reached the same conclusion. There was an NKVD officer permanently on Sholokhov's tail, and when Stavsky visited regional party headquarters, Yevdokimov made a heartfelt complaint: "If it weren't Sholokhov, with his name, he would have been arrested long ago."[15] According to what Stalin later told Sholokhov, Yevdokimov asked twice for permission to arrest this annoying writer, and twice Stalin said no.[16]

Stavsky seems to have been unsure about whose side he was supposed to take and came cautiously down on Yevdokimov's: he suggested that Sholokhov should be persuaded to move out of Veshenskaya, where he had too many friends, and into a city, though he acknowledged that the writer would not willingly leave. Stalin's response was as indulgent of his protégé as ever: Stavsky should tell Sholokhov to drop by and see him in Moscow, an invitation that Sholokhov would have been foolish not to accept. He saw Stalin on November 4, 1937, and must have come away reassured that he was on safe ground, because the following February he wrote another long, extraordinary letter that spoke truth to Stalin in a way that no one else now could.

Though Lugovoi and two others Sholokhov supported were out of prison and back in their old jobs, the fact remained that they had been falsely arrested and tortured, and one of them had broken under torture and incriminated Sholokhov. He rightly demanded to know how the authorities could casually admit that they were innocent but do nothing about the people who had persecuted them. First he had complained to Yevdokimov, who fobbed him off by saying that it was a matter for Nikolai Yezhov at NKVD headquarters. "He can imprison people, but he can't talk about releasing those who were wrongly imprisoned," Sholokhov caustically pointed out to Stalin. He asked for another visit from Shkiryatov and someone senior from the NKVD: "Let them familiarize themselves with the Rostov cases and take a good close look at Yevdokimov! He's crafty, that lame old fox! . . . If Yevdokimov is not an enemy but simply a sorry old geezer, then is this really the kind of leader we need in our region?"[17]

Shkiryatov duly returned to the Rostov region accompanied by an NKVD department head, as Sholokhov had demanded, but his second visit produced less of a result than the first. Shkiryatov reported back on May 23 to say that Sholokhov's complaints were only partly justified and no drastic action was required. One drastic action had already been taken, however: Yevdokimov

had been sacked. Luckily for him, he still had a friend in Yezhov, who in April had been given responsibility for running the Soviet Union's vital inland waterways. Yevdokimov was appointed his deputy at the People's Commissariat for Water Transport.

Sholokhov had taken a risk making an enemy of a dangerous man, but his unique relationship with Stalin had seen him safely through. His next step was to cross someone even more dangerous: Nikolai Yezhov, one of history's greatest mass murderers and the man who then had more frequent access to Stalin than any Politburo member apart from Molotov. In a twenty-five-month period beginning October 1, 1936, the period known to Russians as the Yezhovchina—when this vile diminutive man, known as "the bloodthirsty dwarf," was running the NKVD—1,565,041 people were arrested and 668,305 executed, an average of almost 880 executions a day, seven days a week. Yezhov could not, of course, have personally selected every victim, but a very large number of names crossed his desk. He sent Stalin 383 lists containing more than 44,000 names of people who had been arrested, of whom about 39,000 were marked for execution. He gave an order that all prisoners over seventy should be shot since they could not be put to work. "Beat, destroy without sorting out," he ordered regional NKVD heads, adding that "a certain number of innocent people will be annihilated too," but that this was "inevitable."[18] During the preparation of the first show trial, he reputedly broke Lenin's old comrade Lev Kamenev by threatening to have his wife and son shot. An officer who watched him in action said, "I have never seen such a villain: he does it with pleasure."[19]

But in spring 1938, Yezhov put aside time in his busy schedule to act as Sholokhov's host during one of the writer's visits to Moscow. Sholokhov was invited to Yezhov's dacha to meet his young wife, Yevgenia, who greatly enjoyed the company of writers. Though Yezhov behaved like a maniacal sadist at work, a curiously soft side of him showed in his private life. Osip and Nadezhda Mandelstam met him during a holiday in Sukhumi, in Georgia, as his career was about to take off. "The Sukhumi Yezhov was a modest and rather agreeable person," Nadezhda recalled. "He was not yet used to being driven about in an automobile and did not therefore regard it as an exclusive privilege to which no ordinary mortal could lay claim. We sometimes asked him to give us a lift into town, and he never refused."[20] Yezhov was there with his first wife but was flirting openly with a student.

By the time he had met Sholokhov he had divorced and remarried. In the only photograph of Yevgenia Yezhova, she is dressed in a white smock with

a drab hairstyle common in the 1930s and looks like a standard-issue Kremlin wife: docile, submissive, and spoiled. Actually, she was a lively, demanding woman who had been freed by the revolution from the grim poverty of the Jewish quarter of Gomel, in Belorussia (as Belarus was then known), a scene of particularly virulent anti-Semitic riots in the early part of the century. She seems to have closed her mind to her husband's terrible work in order to enjoy her newfound status and set herself up as a society hostess whose parties were literary affairs.

One of her regular guests was none other than Isaac Babel, the very writer Stalin had contrasted unfavorably with Sholokhov. It was a dangerous association for both of them, but Babel kept up the contact out of a writer's curiosity to understand the horror of Yezhov's activities. "He sometimes went to see her, aware that this was unwise, but wanting, as he told me 'to find the key to the puzzle,'" Ilya Ehrenburg wrote. While Sholokhov and to some extent even Pasternak settled for the comforting falsehood that Stalin did not know what atrocities were being committed in his name, Babel was not deceived. "It's a not a matter of Yezhov. Of course, Yezhov is very active, but that's not at the bottom of it," he told Ehrenburg.[21]

Babel knew a large number of Old Bolsheviks and Red Army officers and talked about them recklessly. Upon hearing of the arrest of an Old Bolshevik named Yakov Livshits, he told his wife, "They expect me to believe that Livshits wanted to restore capitalism. He comes from a working-class family and, believe me, nobody was worse under Tsarism than working-class Jews."[22] While on that occasion there was no one within earshot to report his remark to the NKVD, many of his other comments were overheard by ubiquitous informers and added to his file at police headquarters.

Chatting with Eisenstein in Odessa when somebody was listening, Babel described Lev Kamenev, who had suffered so appallingly at Yezhov's hands, as a "brilliant connoisseur of Russian language and literature." Trotsky, in exile in Norway and portrayed as a satanic criminal mastermind in Stalinist propaganda, was someone Babel remembered from a pleasant evening listening to poetry at Voronsky's flat. "You can't imagine his charm and the strength of his influence on the people he met," he told Eisenstein.[23]

Another pair of ears listened when Babel unburdened himself of his opinion of the great show trial of March 1938, in which Bukharin was the lead defendant. It was a "monstrous trial" that was actually about ideology, rather than the tales of murder, sabotage, and espionage that formed the indictment, as Bukharin had tried to explain but was prevented from saying, Babel

remarked. One of the defendants, Christian Rakovsky, who had once had what has been described as "perhaps the only lasting and intimate friendship in Trotsky's life," was attacked for being a landowner's son.[24] "It's true, but he gave all his money to the revolution," Babel said. He noted that alongside these Old Bolsheviks of real standing, the prosecution had placed some shady characters, "criminals, Tsarist secret policemen and spies" such as Vasili Sharangovich, the former Stalinist boss of the party machine in Belorussia. "I was told awful things about the way he behaved in Belorussia—excluding people from the party, organizing provocations etc.," Babel said.

He went on: "The Soviet system only survives thanks to ideology. Without it all would have been over ten years ago. It was ideology that enabled them to carry out the sentence on Kamenev and Zinoviev. People are becoming as accustomed to the arrests as to the weather. The subservience with which the party and members of the intelligentsia accept the idea of imprisonment is horrifying. All this is typical of a state regime. The present leadership of the party know perfectly well what people like Rakovsky, Sokolnikov, Radek, Koltsov, and so on, represent. They just won't say so in public. They are marked with the stamp of great talent, and stand head and shoulders above the mediocrities of the present leadership."[25]

All of this went into his file. (He was, by the way, ahead of himself when he appeared to list the journalist Mikhail Koltsov among the arrested, but it was actually just a matter of time.) Yezhov must have known about the NKVD's expanding file marked "Isaac Babel," and though he apparently did not meet Babel socially after 1936, he seems to have known that his wife had maintained this dangerous friendship. Curiously, he did nothing about it. For all his pathological brutality, he seems to have genuinely cared about his wife.

Yevgenia Yezhova knew that Babel held dangerous opinions but seemed to have regarded it as a harmless eccentricity or ailment. On the day it was announced that Marshal Tukhachevsky and other Red Army commanders had been shot, Babel turned up at a social evening organized by one of Yezhova's friends in a foul temper. When a fellow guest, Semyon Uritsky, asked what was wrong, Yezhova answered for him, explaining that some of the condemned had been Babel's friends: the list of the dead included two cavalry commanders he had known in Poland. As Uritsky and Yezhova walked back to the Kremlin, she confided that she was afraid that Babel would land himself in trouble. She hoped that his international reputation would save him.

Another potentially dangerous aspect to the Yezhov mismarriage was that he had been an active homosexual when he was young and would be again in the interlude between his fall from power and his arrest, whereas she was joyously heterosexual. One reason that she was so solicitous of Babel was that they were former lovers. She had originally been married to a diplomat and had had a fling with Babel in Berlin in 1925. Uritsky was another in an impressive roll call of ex-lovers; he edited a magazine where Yevgenia had once worked. She had moved to another magazine, *SSR na stroike* (USSR under construction), edited by another of her numerous lovers, and she had arranged for Babel to be a paid contributor. Far from humiliated at receiving the patronage of an ex-girlfriend, Babel was initially pleased that she had done so well. "Our girl from Odessa has become the first lady of the kingdom!" he exclaimed.[26]

During the summer of 1938, Sholokhov visited Moscow again and dropped by the office of *SSR na stroike*, supposedly to discuss the possibility that he might write for it. Afterward he accompanied Yevgenia home. In August, he was back again, this time with Fadeyev. The three had dinner at the National Hotel. The following day, Sholokhov visited Yevgenia's office yet again, this time without Fadeyev and apparently without any fear that dallying with the wife of one of the world's most prolific killers might have its risks. He invited her to his hotel room, where she stayed for several hours. Neither of them considered the possibility that the room might be bugged.

Late the next day, an aggrieved, drunken, and violent husband returned to the Yezhov household with an incriminating document in his briefcase. "Did you sleep with Sholokhov?" he shouted at his wife. Yevgenia's best friend Zinaida Glikina witnessed the scene as Yezhov brandished the incriminating transcript, which Yevgenia read with growing agitation. Yezhov passed it to Glikina, who read observations such as "our love is difficult, Zhenia" punctuated with stage directions like "they kiss" and "they lie down." Yezhov beat his wife, pummeling her face, breasts, and other body parts with his fists.[27] He destroyed the incriminating transcript. A month later, he divorced her. As he went through her possessions, he came upon old love letters from Isaac Babel.

Back in Veshenskaya, Sholokhov learned he was under surveillance and reacted in the now familiar way by complaining to Moscow. On October 23, 1938, he went to the Kremlin for yet another meeting with Stalin, which lasted nearly an hour. The dictator summoned Yezhov to explain. Yezhov had

already lost Stalin's confidence for reasons unconnected with Sholokhov. A frightened man who was drinking heavily and exhibiting signs of rapid mental disintegration, he denied knowing why one of his officers was snooping around Veshenskaya. Stalin gave him a week to find out.

They all met again on October 31. This time there were eight others in the room, including Molotov, the overweight young bureaucrat Georgi Malenkov, Sholokhov's friend Lugovoi, and I.S. Pogorelov, the NKVD officer who had been shadowing Sholokhov. Pogorelov said that he was carrying out an order that came straight from Moscow. A more senior NKVD man at the meeting said it was understood that the order had come from Yezhov. He denied it.[28]

It was another demonstration of Sholokhov's extraordinary invincibility and an almost public humiliation for Yezhov, which can only have contributed to the panic overtaking him. The NKVD, like any other large organization, required efficient management to keep its core business of nighttime arrests, torture, show trials, and maintenance of the gulag running smoothly, and although Yezhov was desperate to please Stalin, he was an erratic administrator. In July 1938, Lavrenti Beria—a methodical, efficient, strong-willed sadist, as well as a "good boss who went to a great deal of trouble to look after the welfare of his staff," according to one of his subordinates—was transferred from Georgia to become Yezhov's nominal second-in-command.[29] Only the day before that second meeting in the Kremlin, Beria had had two of Yezhov's department heads arrested, and he was looking into the possibility of having Yevgenia Yezhova charged with being a British spy. Yezhov was advised by Sholokhov's old adversary Yevdokimov to get rid of any witnesses who might be used to make a case against him. To that end, he had Yevgenia's first husband and her ex-lover Semyon Uritsky arrested, but Uritsky's execution was not processed quickly enough and he passed alive into Beria's hands.

Yevgenia grasped the horror that was creeping up on her. Between Sholokhov's first and second meetings with Stalin, she had a nervous breakdown and was admitted to a sanatorium, where Yezhov arranged for a large quantity of the phenobarbital drug Luminal to be smuggled to her room. She took the hint, and on November 17 she committed suicide, after writing Stalin a piteous letter saying, "I will not give up the right to love you, as everybody does who loves the country and the party."[30] When Babel learned that she had killed herself, he told his wife that Stalin would not be able to understand why, because "his own nerves are made of steel, so he can't understand how, in others, they give out."[31] Yezhov missed her funeral because he was

preparing for his final four-hour meeting with Stalin, at the end of which he "resigned" from the chairmanship of the NKVD. The announcement, on November 25, named Beria as his successor.

Yezhov remained, nominally, people's commissar for water transport until the department was subdivided the following April. At that point he vanished, and for half a century no one knew how his story ended. There was a rumor, which may have had official encouragement, that he became deranged and killed himself. He was not the only one to disappear without explanation: the same happened to Isaac Babel, whose widow was led to believe that he was alive until she was finally told in the 1950s that he had been dead for fifteen years. Even then there was confusion about the date of his death.

Another person who simply vanished was one of the USSR's best-known journalists, Mikhail Koltsov, a foreign correspondent for *Pravda* who had played a conspicuous role in the defense of Madrid in the latter stages of the Spanish Civil War. He was Ernest Hemingway's model for the character of Karpov in *For Whom the Bell Tolls*. Until the end of his life, Ilya Ehrenburg wondered why Koltsov, who did everything Stalin asked of him, should have been consumed in the purges when someone like Pasternak, or Ehrenburg himself, was left untouched. The British journalist Claud Cockburn, who also covered the Spanish war, remembered Koltsov as "a stocky little Jew with a huge head and one of the most expressive faces of any man I ever met. . . . He unquestionably and positively enjoyed the sense of danger and sometimes— by his political indiscretions, for instance, or his still more wildly indiscreet love affairs—deliberately created dangers which need not have existed."[32] Koltsov's older brother, Boris Efimov, was Stalin's favorite cartoonist, and by the time he died in October 2008, shortly before his 109th birthday, he was reckoned to be the world's oldest Jew. Efimov was over ninety before he found out why his brother suddenly disappeared, and he had not been the only one mystified by his disappearance. Soviet textbooks recorded that he had been sentenced to ten years in the labor camps, where he was supposed to have died in 1942. That was false. When the archives were opened after the collapse of the USSR, it emerged that these three disappearances were all connected. The common link was Yevgenia Yezhova.

When Yezhov was arrested, he of course knew what was done to prisoners who did not give the authorities in the Lubyanka the confessions they wanted and cooperated with them from the start. At first, he volunteered that he had had homosexual relations with three of his subordinates since losing his post as head of the NKVD. This was noted, but it was not what Beria required:

he had not given up the idea that Yevgenia Yezhova had become a British spy when she was abroad. On May 11, 1939, Yezhov was interrogated by one of Beria's cronies, Bogdan Kobulov, a gigantic Georgian capable of killing a prisoner with his bare hands, and delivered a long written confession that included these lethal words:

> I suspect, though only on the basis of my personal observations, that my wife and Babel were also involved together as spies. . . . I observed that in his dealings with my wife Babel was demanding and rude and I could see that my wife was simply afraid of him. I realised that the explanation lay in something more serious than my wife's literary interests. . . .
>
> When I asked my wife several times if she also had the same relations with Babel as with Koltsov, she either kept silent or weakly denied it. I always supposed that she replied in this non-committal way simply to conceal from me her spying connections with Babel.[33]

Whether Yezhov was taking revenge on his dead wife's ex-lovers or merely thrashing about because he was ready to say anything to avoid torture, with these words he sentenced both Babel and Koltsov to death.

Four detectives arrived at Babel's flat on Nikolo-Vorobinsky Street at around five a.m. on May 16 with an arrest warrant signed by Bogdan Kobulov. They searched the premises and confiscated nine folders full of manuscripts, notebooks, and letters. Babel was not there, but his young wife, Antonina Pirozhkova, was. They made her dress and go with them in a police car to the writer's village in Peredelkino to witness his arrest. He had time to whisper to her to get a message to André Malraux, and during the grim ride back into Moscow she promised to wait for him. He urged her to make sure that their daughter should be "not miserable."[34]

In the Lubyanka, Babel's case was handled by two teams of interrogators headed by a pair of officers named Rodos and Schwartzmann. Lev Schwartzmann was a revolting torturer who also had interrogated the theater director Vsevolod Meyerhold, whose hideous sufferings were noted in writing and tidily filed, but even his reputation as a thug was eclipsed by that of Boris Rodos. When Nikita Khrushchev delivered his famous Secret Speech to the 1956 Communist Party Congress, Rodos was the only junior officer he mentioned, described as "a vile person, with the brain of a bird, and morally completely degenerate."[35] The many unfortunates who passed through his hands included a fellow NKVD officer who, though released shortly after his

arrest, needed a stick to help him walk for the rest of his life because of the beating he had received from Captain Rodos.[36]

Rodos was tried and executed in the 1950s. During the hearing, he was asked by the judge whether he knew who Babel was. "I was told he was a writer," he replied.

"Have you read a single one of his stories?"

"What for?"[37]

In the hands of these two thugs, it is surprising that Babel did not break immediately. However, he had once sought the advice of the former police chief Yagoda, when they were leaving Maxim Gorky's house together, on what to do if he ever fell into the hands of the NKVD. Yagoda told him to "deny everything; whatever the charges, just say no, and keep on saying no: if someone denies everything, we are powerless."[38] For several days, Babel struggled to follow this friendly advice, giving his interrogators a voluble account of his life and work without making any incriminating admission, until something happened that made him sign a statement saying that he had been recruited by André Malraux to spy for France and was part of a network organized by Yevgenia Yezhova whose aim was to assassinate Stalin. He was also induced to incriminate friends, including Eisenstein and Ilya Ehrenburg.

Once the torture had ended, he tried desperately to repair the damage he had done to those he had named. In November, he sent two plaintive letters to the procurator's office, placing it on record that he had given false evidence against innocent people. A third letter followed in December, in which Babel listed eight people he had falsely implicated. "This is all lies, with no basis in fact. I know these people to be honest and loyal Soviet citizens. This slander was prompted by my own faint-hearted behaviour during cross-examination," he pleaded.[39] For whatever reason, none of those he had named suffered as a result.

Babel was making no attempt to save his own life. All that concerned him was that others might suffer because he had been "faint hearted"—under unbearable torture, no doubt. All that he asked for himself, in a plea addressed directly to Beria, was that his pile of unpublished manuscripts, accumulated over eight years, should be returned to him so that he could put them in order. That request was refused.

On January 16, 1940, Beria sent Stalin a list of 457 recently arrested "enemies of the people" and proposed that 346 should be shot. Nikolai Yezhov was on the list, along with at least sixty former NKVD officers and almost

everyone from Yevgenia's social circle, including the friend who had seen her being beaten by her husband. Sholokhov's adversary Yevdokimov, who in Beria's eye was too closely associated with Yezhov to be allowed to live, had a wife and a teenage son, and, with refined cruelty, Beria put all three on the death list.

As he ran his pencil down the page, Stalin may have paused as he came to the names of Koltsov and Babel. In previous years, their international reputations might have saved them, but Western Europe was now at war, the USSR was in uneasy alliance with Nazi Germany, and it no longer mattered to Stalin what the progressive intellectuals of Paris thought. He signed off on the entire list. Even so, either he or Beria, or both, decided as a precautionary measure not to give the massacre any publicity.

Babel's twenty-minute trial was held on January 26, 1940. He denied everything, repudiating his own signed confessions, and told his judges, "I am totally innocent. I have not been a spy and I have never committed any acts against the Soviet Union. In my testimony, I libeled myself. I have only one request: that I be allowed to complete my work."[40] He was shot at one thirty a.m. on January 27. His body was burned, and his ashes, and those of the other victims of Beria's secret massacre, were probably thrown into the mass grave in the old Donskoi Monastery.

In death, Yevgenia Yezhova had brought disaster on almost everyone who had had the misfortune to be called her friend—with one notable exception. Sholokhov returned to Veshenskaya and resumed his old life. From time to time, he used his protected status to try to help others. He tried, unsuccessfully, to secure the release of Lev Gumilev, Anna Akhmatova's son. He successfully pleaded the case of the fifteen-year-old son of Andrei Platonov—who is now recognized as one of the greatest Russian writers of his day—but the boy had caught tuberculosis in the gulag and died soon after his release, after infecting his father. Sholokhov's curious relationship with Stalin brought him influence, wealth, all manner of formal honors, and immunity from arrest, but it ruined him as a writer. He struggled to finish his two novels, at times reputedly taking refuge in alcohol. His inferior novel *Virgin Soil Upturned* took him almost thirty years to write: he completed it in 1960. The work for which he is justly famed did not give him quite so much trouble. Having written the part known in English as *And Quiet Flows the Don* in two years, he labored for more than a decade over its longer but lesser sequel, *The Don Flows Down to the Sea*. When he finally completed it, he and his wife had a little

domestic ceremony: they opened a bottle of wine given to him by Stalin during one of their many meetings. The date was December 21, 1939, when the entire country was celebrating what was thought to be Stalin's sixtieth birthday (he had lied about his age: he was actually sixty-one). Afterward Sholokhov wrote to Stalin to tell him what they had observed on his special day.

12

Altering History

The new cult . . . is Ivan the Terrible.

—BORIS PASTERNAK

In the 1930s, Stalin took it upon himself to be the final authority on ancient Russian history, adding to his many other roles. This field of learning had been dominated by the Old Bolshevik Mikhail Pokrovsky, an academic who had joined the party during the 1905 revolution, at the comparatively advanced age of thirty-seven. After the revolution, his career rose and fell in exact parallel with that of the much younger Leopold Averbakh and for the same reason: ancient history was not an important enough subject to engage Stalin's full attention while he was locked in power struggles over his leadership position, leaving it open to someone who talked the language of Bolshevism to take control. By 1929, the same year that RAPP was at the peak of its influence, any professional historian who challenged Pokrovsky's version of history was liable to be arrested. By 1932, the year RAPP was disbanded, the Pokrovsky school of history was finished.

Russian children in the nineteenth century were taught respect for the military heroes who had made the Russian Empire great and abhorrence of the peasant rebels who had attacked the throne. Pokrovsky, a Marxist, taught that history was driven by economics rather than by the actions of great or evil men. "Formerly there were holy tsars, ministers and philanthropists. Today we have great rebels, revolutionaries and socialists," he wrote. "In a sense this is progress. It is better that children learn to understand the Pugachev rebel-

lion than the terrible regime of Catherine II. . . . But it was not necessary to spill so much blood to achieve such petty results."[1]

Pokrovsky wrote that, for people in the developed nations to the west—the Ukrainians, Lithuanians, Poles, and Jews—the Russian Empire was "a prison of peoples . . . not at all a peaceful settlement of southern lands by 'cultured' Slavs. It was the rape and oppression of a rather densely populated agricultural country."[2] He argued that both the 1812 war with Napoleonic France, of which Russian patriots were so proud, and the 1914 war with Germany were provoked by Russia. For most Russians Peter I was the greatest figure in their history; to Pokrovsky, "Peter, whom fawning historians have called the Great," had waged a prolonged war of aggression against Sweden and "lowered the well-being [of the populace] terribly and led to a colossal increase in the death rate."[3]

Stalin entered this field of study by a side route, in his role as the supreme literary critic. The Kremlin's court poet, Demyan Bedny, had written a couple of poems on historical themes that conformed to Pokrovsky's historiography. The man Simon Sebag Montefiore described as a "Falstaffian rhymester, with good-natured eyes gazing out of a head like a huge copper cauldron" had had a good run in the 1920s: as the son of a Russian peasant, he had the right social background as well as good political credentials, having helped Lenin launch *Pravda* in 1912.[4] His status and his willingness to turn out rhymes in defense of the latest turn in party policy on short notice had made him a rich man, a car owner, and the only writer to be allocated rooms in the Kremlin. Then in December 1930 came disaster: a Central Committee resolution censured two of his historical poems. Not understanding why, Bedny wrote Stalin a plaintive letter asking what he had done wrong and was favored with a long reply. "Revolutionary workers of all countries unanimously applaud the Russian working class, the avant-garde of Soviet workers [and] are greedily studying the instructive history of Russia's working class, its past, Russia's past," Stalin wrote. "And you? Instead of comprehending the greatest of all revolutionary processes in history . . . you've slipped into depression . . . proclaiming to the whole world that Russia in the past was a vessel of abominations and desolations."[5] Born in Georgia, Stalin was not Russian but nevertheless grasped that Russian nationalism was the glue that held the Soviet Union together, and encouraging self-determination by the lesser nations would threaten the central power.

Instead of heeding the warning, Bedny thought he could play other party leaders off against Stalin. He showed the people's commissar for defense

Kliment Voroshilov the script of a play he had written about the Red Army. Voroshilov liked it and persuaded the Politburo to let it go into production, but then Stalin read it, just after he had ordered the disbanding of RAPP (with which Bedny was prominently associated), and decided that it was "mediocre, rough around the edges, exudes a bawdy atmosphere and is full of barroom-type jokes." He shared these thoughts in writing with senior party secretary Lazar Kaganovich, who agreed, replying, "Being a people's proletarian writer in no way means sinking to the level of the negative qualities of our masses as Demyan Bedny does."[6]

To the public, Bedny remained a privileged citizen, but privately Stalin was through with him. He was evicted from the Kremlin but still could not understand why, and he talked more freely than was safe. He told Osip Mandelstam that he had been betrayed by a secretary who had read his private diary, in which he had commented on Stalin's annoying habit of borrowing his books and leaving greasy finger marks on the pages, which seems to have been the source of the line in Mandelstam's famous epigram describing Stalin's fingers "fat as grubs."[7]

Bedny tried to redeem himself by writing a comic opera to music by Alexander Borodin. It was a parody of a popular type of Russian fairy tale and folk epic, not dissimilar to the legend of King Arthur, featuring knights known as *bogatyrs*—though Bedny turned the legends upside down by depicting the knights as exploiters and the brigands who fought them as revolutionary heroes. In November 1936, after the first few public performances of *The Bogatyrs* at the Chamber Theatre, Stalin struck again. A Politburo resolution condemned Bedny's libretto on the grounds that "it indiscriminately blackens the *bogatyrs* . . . the bearers of the heroic characteristics of the Russian people [and] gives an antihistorical and mocking depiction of Old Russia's acceptance of Christianity, which was in reality a positive stage in the history of the Russian people." The shock caused Alexander Tairov, director of the Chamber Theatre, to have a heart attack, while Bedny shut himself indoors and would not speak to anybody for three days. There was no noticeable sympathy for him in intellectual circles because of his reputation as a bully. He was the one, for instance, who had stepped forward on behalf of RAPP to denounce Mayakovsky for committing suicide. Even Mikhail Bulgakov, who very rarely took pleasure in others' misfortunes, made an exception for Bedny. "He's not going to be chortling over anyone else. Let him feel it for himself," he remarked. Eisenstein's reaction was the same: "I'm extremely pleased, if only because they gave Demyan a good drubbing. That's just what

he needs."[8] Bedny was expelled from both the party and the writers' union and died seven years later.

Pokrovsky avoided a similar fate by dying of natural causes just before the rise of Nazi Germany and the revival of Japanese militarism gave the Soviet leadership an added impetus to teach people to respect the old Russian Empire and its military victories. A decree published on May 16, 1934, trashed Pokrovsky's life's work, though without mentioning his name, and accused the teaching profession at large of failing to teach history in "a lively manner." Within a few years, Pokrovsky would be posthumously blamed for providing the "basis" for the entire Trotskyite-Bukharinite conspiracy. History curricula were rewritten and some "bourgeois" historians who had been arrested during Pokrovsky's heyday were allowed to return to work as if nothing had happened.

The lesson was not lost on the talented opportunist Alexei Tolstoy, who had returned to Russia in 1923 after backing the wrong side in the civil war. Guided by the Pokrovsky school, he wrote a stage play about Peter I titled *On the Rack*, premiered in 1929, in which the tsar who founded Saint Petersburg was portrayed as having "suppressed everyone and everything as if he had been possessed by demons, sowed fear, and put both his son and his entire country on the rack."[9] In 1937, he turned out another play about Peter called *Peter the First*, very different from its forerunner. Here the builder-tsar was portrayed as a kind of "super-proletarian" who hated war, loved hard work, recognized honesty and industry in the humbly born, and made the idle sons of nobility change their ways. Stalin went to see it but walked out before the end, setting off speculation that Tolstoy had overdone it. Critics took his cue and trashed the play, until Tolstoy received a note from the greatest theater critic of all telling him, "A splendid play. Only it's a pity Peter was not depicted heroically enough." Stalin then summoned him to the Kremlin to give him advice on his other great project, an epic novelized life of Peter. He also turned out a third version of the play, in 1939, in which Peter no longer hated war but was a great military organizer protecting the motherland against its menacing neighbors. Tolstoy ended his days as a very wealthy writer with a serious alcohol problem.

Another artist who unexpectedly benefited from the rewriting of history was Sergei Eisenstein, who was allowed to work again after his nemesis Shumyatsky was arrested and killed. *Alexander Nevsky*, his first completed film in ten years and his first to use sound, would not have been allowed to go into production when the Pokrovsky school of history prevailed; now it was

exactly what the party line required. To avoid disaster, Mosfilm appointed a co-director to keep watch over Eisenstein and chose as his scriptwriter the cold-eyed Stalinist Pyotr Pavlenko, who had played a sycophant's role in the persecution of Osip Mandelstam. Nadezhda Mandelstam remembered Pavlenko as one of the most sinister men she had ever known, but to his credit he had also been one of the few who had defended Eisenstein when he was being vilified. His script, completed late in 1937, retold the story of the Battle of Lake Peipus, fought on the frozen lake in the winter of 1242, when the army of the princedom of Novgorod defeated Teutonic knights. Eisenstein's early films had been about the masses in action, in which the villains were the capitalist class. In *Alexander Nevsky*, there was no class enemy: Russians of every class (with the exception of a couple of shifty-eyed traitors) rallied behind their prince against the German invaders. The characters paraded in *Alexander Nevsky*—the gratuitously cruel German commander convinced that his army was invincible; the robotically disciplined uniformed German soldiers defeated by freer spirits fighting for what they believed; the strong, handsome hero who used few words; the two companions who argue all the time but are prepared to die for each other; and the clownish foot soldier who is unexpectedly heroic in battle—would all become stock figures in war movies, but Soviet cinemagoers in 1938 had seen nothing like it before. The film's centerpiece was one of the finest battle scenes ever shown in cinema, with montage used to good effect to re-create the sense of confusion, ending with the defeated knights, weighed down by their armor, trying to flee only to sink into the water as the ice breaks. This scene was shot in July. The "ice" was a mix of asphalt, glass, white sand, and chalk. Every single shot of the battle itself was created by old partners Eisenstein and Tisse.[10] Eisenstein explained how the final, remarkably realistic effect was achieved: "the 'ice,' weighing 17.5 tons, was supported by pontoons filled with air and concealed under water. At a signal, the air was released from the pontoons, the 'ice' submerged," and the knights were dragged down into the water.[11]

The film was made in the interlude between the Nazi anschluss in Austria and the first act of Hitler's dismemberment of Czechoslovakia. In case any viewer was so obtuse as to miss the film's political message, it ended with a written warning across an otherwise blank screen that destruction awaited any army that attacked the motherland. Eisenstein reinforced it with a magazine article titled "My Subject Is Patriotism," in which he declared, "We want our film not only to inspire those who are in the very thick of the fight against fascism, but to bring spirit courage and confidence to those quarters

of the world where fascism seems as invincible as the Order of Knights appeared in the thirteenth century."[12] *Alexander Nevsky* was shown privately to Stalin late one evening in November 1938, after Hitler's invasion of Czechoslovakia. For the first time, the dictator allowed a film by Eisenstein to be shown exactly as it was made, with no changes.

The film is another demonstration of Eisenstein's superb eye for visual detail. Some film buffs say this was the greatest film ever made under a communist regime, greater even than *Potemkin*. In the 2005 edition of Halliwell's Top 1,000 list of the greatest films ever made, it placed thirty-third, but today it is not remembered primarily for the images on-screen but for the accompanying music. It is unusual for a film score to be regularly performed at classical concerts, but Prokofiev's *Alexander Nevsky* suite is. Neither Sergei Prokofiev nor Sergei Eisenstein was easy to work with. One was a former enthusiast for Bolshevism battered by experience, the other a former émigré only recently resettled in Russia, yet they struck up a rapport from the moment that Mosfilm brought them together. Eisenstein was delighted by the stock of French palindromes the composer retrieved from his phenomenal memory.[13] He noted that his new collaborator was "profoundly nationalistic," which would have been a handicap in the 1920s but was now almost a requirement. Above all, he marveled at Prokofiev's ability to create music that exactly fit what was on-screen. "It never remains merely an illustration, but reveals the movement and the dynamic structure in which are embodied the meaning of an event," he wrote. "Whether it was the March from *The Love for Three Oranges*, the duel between Mercutio and Tybalt in *Romeo and Juliet*, or the galloping of the Teutonic knights in *Alexander Nevsky*, Prokofiev had grasped before anything else the structural secret that conveys the broad meaning of a subject."[14]

But why was Prokofiev back in the Soviet Union?

He had left six months after the Bolshevik revolution, found fame abroad, and started a family. He did not return to Russia for almost a decade. During one of his infrequent visits, in May 1933, he and his wife, Lina, were at a concert in Moscow when Stalin arrived late. Lina looked around, made eye contact with him, but "his gaze was so intense that she immediately turned away."[15] Notwithstanding that telling glimpse of the dictator, in the summer of 1935 the Prokofievs decided to take their two young sons to Moscow and settle there permanently. They were not making a political choice, and in fact their Christian Scientist beliefs were incompatible with communist materialism. They moved to Russia because Prokofiev had been courted

assiduously by the Soviet authorities with promises that were never kept, and he was under the impression he could continue to live the cosmopolitan life of a world-famous composer, simply using Moscow instead of Paris as his home base. Moscow was cheaper and subsidized music more generously than Paris—plus the works of Igor Stravinsky, with whom Prokofiev had had a bad falling-out, were never performed there.

He seemed unaware that personal eccentricities found acceptable abroad could be dangerous in the USSR, where people were expected to look and behave like Soviet citizens. The young pianist Svyatoslav Richter was startled to meet Prokofiev in the street, "his clothes chequered all over with bright yellow shoes and a reddish orange tie."[16] Lina, who was Spanish, Polish, and French, sought out the company of diplomats and other foreign nationals based in Moscow, unaware that anyone seen socializing with foreigners was likely to be suspected of passing information. They enrolled their sons in a school for the children of diplomats, where classes were conducted in English.

For a time, the authorities humored their unwittingly captive composer. No sooner had he arrived than Prokofiev was granted permission to tour Europe and North Africa, which meant he was in Prague and Lina was in Paris when they read about the campaign against Shostakovich. Instead of taking this as a portent of his own future, "Prokofiev allowed himself to believe that, with Shostakovich under a cloud, he had automatically become the preeminent Soviet composer," according to his biographer Simon Morrison.[17] He returned in March 1937 with a new, streamlined blue Ford. A month later, on April 9, apparently thinking he was bulletproof, he delivered a speech warning that the campaign against "formalism" was in danger of excusing laziness and becoming an impediment to striving for perfection; he cited Dzerzhinsky's opera *The Quiet Don* as a poor example of how Russian folk songs could be wasted. To attack that particular opera, which Stalin had singled out for praise, was either brave or blind.

Renewing contact with his homeland nonetheless brought on one of the most creative periods of Prokofiev's life. His first two return visits to the Soviet Union, in 1927 and 1929, had not been particularly notable, although on the second he was harangued by the ideologues from RAPM, the musical wing of RAPP. His third visit, in December 1932, had a lasting result, however. He was commissioned to write his first film score, for a now-forgotten film for children called *Lieutenant Kizhe*. In it the mad Tsar Peter II was presented with a recommendation that he decorate an officer with the peculiar name Kizhe. No one dared tell the tsar that there was no Lieutenant Kizhe:

a flustered clerk had written "Poruchik Kizhe" instead of "Poruchiki zhe," meaning "When the lieutenants." The error could not be undone; the nonexistent lieutenant must have a military career, marry, be bundled out of Saint Petersburg because the tsar wanted to meet him, and die a hero's death. The film had mixed success. Jay Leyda, the American who worked with Eisenstein, described it ambiguously as "unlike any soviet film I have seen" and wondered whether it would have worked without "Prokofiev's biting score."[18] The score includes a jingle accompanying a ride in a troika, a carriage pulled by three horses, that many thousands of people can hum from memory without having any idea of its origin.

While he was working on that commission, Prokofiev also decided to try his hand at musical agitprop and began work on a *Cantata for the Twentieth Anniversary of October*, a project that would bring him considerable grief from the authorities, who thought he was not trying hard enough, and condemnation from posterity because he attempted it at all. In spring 1934, he was commissioned by the theater director Sergei Radkov to write the ballet *Romeo and Juliet*. This also caused him months of trouble, setbacks, and alterations before becoming one of the most popular ballets of the century.

In the midst of it all, he dashed off an even more familiar piece. Soon after the Bolshevik revolution, a remarkable fifteen-year-old named Natalya Sats, from a well-connected family of revolutionaries, had founded a children's theater in Moscow. She had been managing it for eighteen years when she saw Prokofiev in the audience with his two sons, enjoying the show almost as much as the children. She approached him in April 1936 and persuaded him to compose something for her theater. It took Prokofiev less than a week to have a piano score ready to try out on an audience of children. The official opening night of *Peter and the Wolf*, at the Moscow Philharmonic on May 2, 1936, was not a success, in part because Sats was ill and someone else had to stand in as narrator. Once it transferred to the children's theater, it took off, however, and has delighted children ever since. Unfortunately, very soon afterward Sats was again unavailable to be its narrator. Her lover was the amateur violinist Marshal Mikhail Tukhachevsky, and when he was shot, in June 1937, she was arrested. She staunchly refused to sign any confession that could be built into a case against her and was sentenced to five years in the gulag, followed by perpetual exile in Kazakhstan, which thereby gained a children's theater. She was not seen in Moscow again until the 1950s.

The punishment of Sats was one of the first events that brought home to Prokofiev the nature of the regime into whose hands he had delivered

himself and his family and from which there was now no escape. As part of the general tightening of the dictatorship, his freedom to travel was suddenly limited: in the future, even when he was allowed out, his sons were kept behind as hostages. Platon Kerzhentsev, Bulgakov's nemesis, did not like Prokofiev's *Cantata* because Lenin's words were set to music too complex to hum. Prokofiev won the first round against Kerzhentsev by complaining about him to Marshal Tukhachevsky, having presumably heard either from Sats or from a musician about the famous marshal's interest in music. Tukhachevsky contacted Molotov, who overruled Kerzhentsev; but if Prokofiev thought his *Cantata* would be safe from interference from then on, he was mistaken. After Tukhachevsky's arrest, Kerzhentsev suppressed the work altogether. Prokofiev had been dead thirteen years before it received its first public performance.

Prokofiev was annoyed and dispirited by this defeat but not intimidated. To make sure it did not happen again, he wrote *Songs of Our Days* to be easy on the listener, and it was performed without political interference—though, coinciding with the drama of Shostakovich's Fifth Symphony, it did not add much to Prokofiev's reputation. The lyrics of one song, written by a journalist, included the lines

> There's a man behind the Kremlin wall,
> The people know and love him all.
> Your joy and happiness from him came.
> Stalin! That's his great name!

Early in 1938, Prokofiev took what turned out to be his last trip abroad, accompanied by Lina, while the boys stayed behind. They crossed Europe to the United States, where old acquaintances were shocked by how withdrawn and unhappy Prokofiev appeared to be. Nicolas Nabokov judged that he was suffering from a "profound and terrible insecurity."[19] In that grim period, the chance to work on *Alexander Nevsky* must have come as a relief, and its success put Prokofiev in a stronger position to choose his next project. He selected a short story by Valentin Katayev set during the civil war and proposed to turn it into an opera. He wanted Vsevolod Meyerhold as its director; he owed Meyerhold an old debt for suggesting the subject of Prokofiev's first opera, *The Love of Three Oranges*, which premiered in Chicago in 1921 and established his international reputation. In 1929, Meyerhold had produced Prokofiev's *Le pas d'acier*, in the teeth of RAPM's disapproval.

Professionally, Meyerhold had won himself a reprieve by engaging in self-criticism early in the campaign against "formalism"—until the authorities returned to the attack and identified "Meyerholditis" as a corrosive influence on Soviet theater. During what seems to have been a nervous breakdown, his actress-wife, Zinaida Raikh, wrote a long, rambling letter to Stalin in April 1937 hinting that a conspiracy by RAPP and the Trotskyites had driven Mayakovsky to his death and was now hounding her husband.[20] It did no good. In December 1937, Kaganovich went to a Meyerhold production and walked out early in disgust. On January 7, 1938, the Politburo ordered that his theater, which he had founded during the civil war with the intention of making it the first truly "Soviet" theater, be closed on the grounds that "throughout its entire existence, the Meyerhold Theatre has been unable to free itself from thoroughly bourgeois Formalist positions."[21]

Meyerhold was consequently desperate to direct Prokofiev's opera *Semyon Kotko*, and its story line about guerrilla war against the German occupation of Ukraine in 1918 promised to be a hit like *Alexander Nevsky*. It was written against a background of growing fear and urgency, heightened by the sudden death on August 7, 1938, of Meyerhold's main protector: his old rival Konstantin Stanislavsky, whom the communists treated with reverential respect and who had generously found Meyerhold a position in the MAT when no one else would. The opera's slow progress was interrupted when Meyerhold was unexpectedly assigned to choreograph a spectacle in Leningrad involving thirty thousand athletes. He asked that Prokofiev be commissioned to write music for it. In June 1939, he addressed a conference of theater directors presided over by Andrei Vyshinsky, who had achieved immortal fame as the sneering prosecutor at the Moscow show trials. Meyerhold reportedly announced, "I must talk bluntly: if what you have been doing with the soviet theater recently is what you call anti-formalism, if you consider what is now taking place on the stages of the best theaters in Moscow as an achievement of the soviet theater, then I would prefer to be what you consider a 'formalist.' In my heart, I consider what is now taking place in our theatres frightful and pitiful."[22]

Afterward, he went to Leningrad, arriving on June 20, 1939. None of his friends ever saw him again. A few days later intruders broke into the Moscow flat he shared with Zinaida Raikh and stabbed her a dozen times, gouging out her eyes. Her murder was never solved, and no more was heard of Meyerhold for fifty years. After the collapse of the Soviet Union, the archives revealed that one of his last acts had been to write down in precise detail what

had been done to him while he was in the care of the NKVD, who brought him back to the Lubyanka under arrest. This sixty-five-year-old man, whom Eisenstein remembered as "the incomparable, god-like Meyerhold" and who reminded Shostakovich of Marshal Tukhachevsky, was forced to lie facedown while his spine and the soles of his feet were beaten with a rubber strap. Then he was placed in a chair so that his feet could be beaten from above "with considerable force" until they were a morass of red, blue, and yellow bruises. After the first beating, on July 8, the torturers returned on ten separate days over the next four months, led by Lev Schwartzmann, who was also busy beating a confession out of Isaac Babel. They continued beating Meyerhold's bruises, causing a pain "so intense that it felt as if boiling water was being poured on these sensitive areas." Screaming and weeping, Meyerhold discovered that he could "wriggle, twist and squeal like a dog when its master whips it" and was left shaking and jerking like a typhoid patient. In the end, he decided that an early death was preferable to this awful suffering and agreed to incriminate himself.[23] He was shot on February 2, 1940. Before his execution, the police methodically photographed him on his last night alive and stored this grim portrait in its archives.[24]

Prokofiev had left for a holiday in Kislodovsk in summer 1939 without knowing that Meyerhold was under arrest. In Kislodovsk, he was approached by an actress named Serafima Birman, who told him that she had been assigned to take over the production of *Semyon Kotko*. Prokofiev habitually kept his emotions buttoned up and did not display what he felt about Meyerhold's disappearance, but he left Birman in no doubt that he did not trust her and did not think she was up to the job. Nevertheless, rehearsals continued, conducted in bad temper, even after the production faced a new threat from a quite unforeseeable direction. On August 23, 1939, Molotov, recently appointed USSR foreign minister, signed the infamous pact with his German counterpart Joachim von Ribbentrop, which left the Nazis free to invade Poland while the USSR expanded to reconquer places that had been under Russian rule before 1917. Suddenly, works that portrayed Germans as an aggressive enemy were out of order. *Alexander Nevsky* was withdrawn from cinemas. Somehow the authorities seemed not to notice that *Semyon Kotko* might also offend Nazi sensibilities until a few days before its premiere in April, when the Soviet Foreign Ministry suddenly intervened. The opening night had to be delayed two months while the libretto was rewritten and all the German characters were reinvented as Ukrainian nationalists.

Though his mood must have been grim, Prokofiev still had his fame to protect him. A song he wrote to commemorate Stalin's official sixtieth birthday, in December 1939, was a smash hit, broadcast on loudspeakers everywhere. He also wrote a song in praise of the Red Army with lyrics by a young woman named Mira Mendelson, whom he had met in Kislodovsk the previous year. They seem to have become lovers during that grim summer of 1939, and Prokofiev's marriage to Lina Codina came to a stormy end the following March. Prokofiev packed a suitcase, walked out of their Moscow suite, and moved into a single room in Mira's parents' apartment. For several years, he would have no home of his own.

He even won his long, frustrating battle to get *Romeo and Juliet* onstage. After the ballet's acclaimed premiere in Brno, Czechoslovakia, the Soviet authorities hastily allowed it to go into production. The ballerina Galina Ulanova, who would become famous in the role of Juliet, found Prokofiev bad-tempered, suspicious, and nearly impossible to work with, an opinion that the rest of the troupe shared. Despite that and the fact that the opening night in Leningrad, on January 11, 1940, coincided with a blackout because Stalin had started a war with Finland, the production was a triumph.

During this interlude while the USSR stayed out of the war with Germany, Boris Pasternak sensed another adjustment to ancient history. "Our Benefactor, it seems, has decided that we've been too sentimental, and it's time we came to our senses," he wrote to his cousin in February 1941. "Peter the Great has turned out not to be a role model anymore. The new cult, openly proselytized, is Ivan the Terrible, the *oprichnina* [private army], the brutality."[25]

Pasternak was right, and the change brought startling good fortune into the life of the historian Robert Vipper, who had left Russia to settle in his native Latvia in 1924 to avoid living under Bolshevik rule. When the Red Army overran Latvia in 1940, fifteen thousand Latvians were herded into cattle trucks and deported to the east, but Vipper was transported to Moscow, allocated a large new apartment on Leninsky Prospekt, and, although he was over eighty, given a teaching post at Moscow State University. More honors followed during the war.

The explanation for this extraordinary turn in his fortune was that, before he left Russia, Vipper had published a short biography of Ivan the Terrible portraying him as a kind of people's tsar who suppressed the arrogant, parasitical boyars, or aristocracy, and chose men from humble backgrounds to make up his *oprichnina*. He argued that the reason Ivan survived catastrophic defeat in war, unlike the Romanovs in 1917, was that he governed Russia well.

This was not how Ivan's reign was interpreted through the Pokrovsky school of history. As late as 1933 the *Great Soviet Encyclopaedia* denounced Vipper's thesis as "counterrevolutionary."[26] Pokrovsky did not believe that the course of history could be altered by a strong-willed tsar and argued that the power of the boyars already had been undermined by improvements in agricultural techniques; instead a powerful urban bureaucracy and merchant class had pushed Ivan to act as he did. "The *oprichnina* owed its rise to a considerable extent to the support of this class. Ivan the Terrible addressed his appeal . . . precisely to the Muscovite bourgeoisie," he wrote.[27]

But the myth of the all-powerful tsar who protected the people's well-being by the ruthless destruction of his rivals held obvious appeal for Stalin, who had the 1922 edition of Vipper's book with sentences underlined and comments in the margin in his personal library in the Kremlin. Early in 1941, Vipper's book was republished with added references to Marx and Stalin, and the public was informed that Alexei Tolstoy was at work on a stage version and Eisenstein on a film version of Ivan's life. Ivan's only fault, Stalin remarked in a letter to the Central Committee secretary Alexander Shcherbakov around June 1941, was that he was not terrible enough.[28]

On the morning of June 22, 1941, Stalin awoke to confused and alarming reports from the western border of Soviet-occupied Poland. Commanders were claiming that they had been fired on by the Germans. By noon, a quarter of the Soviet Union's military aircraft had been destroyed while on the ground, and the Red Army had begun a retreat that would continue without interruption for seven weeks. Within eight days, 799,910 Soviet troops and 12,025 tanks had been captured. By the end of the year, Ukraine, Belorussia, and the Baltic States had been overrun; Leningrad was surrounded; and the Germans were approaching Moscow—such was the scale of Stalin's miscalculation in placing his trust in Adolf Hitler. It says something for the terror he exercised and for his steel-like nerves that he recovered from this colossal blunder and took personal charge of the war effort—though his immediate reaction was to sink into depression, during which apparently he genuinely believed the Politburo might turn on him and get rid of him.

While it was a catastrophe for millions, for some the war offered an opportunity to achieve glory. Dmitri Shostakovich emerged a national and international hero. The story behind his Seventh Symphony, the *Leningrad Symphony*, is one of the great wartime legends. After the war, the critics argued over the artistic quality of the work and what hidden meanings it contained; during the war, it was received as a magnificent, patriotic renunciation

of fascism. He wrote it at great speed during the German advance. In August 1941, he invited his friend Isaak Glikman to his apartment, and he sat at the piano to play "the magnificent, noble exposition of the Seventh Symphony and the variation theme depicting the Fascist invasion. We were both extremely agitated. . . . We sat on, plunged in silence, broken at last by Shostakovich with these words (I have them written down): 'I don't know what the fate of this piece will be. . . . I suppose that critics with nothing better to do will damn me for copying Ravel's Bolero. Well, let them. That is how I hear war.'"[29]

Shostakovich was evacuated to Kuibyshev (Samara) in the Urals before Leningrad was encircled by the Germans. The symphony had its first performance there, on March 5, 1942. The second took place in Moscow's Columned Hall of the House of the Unions on March 29. One microfilm copy of the score was flown to Tehran, and from there to London, where it was performed in the Royal Albert Hall on June 22. Another copy was flown by night across German lines into besieged Leningrad, where a team of copyists worked around the clock to prepare the parts. The only orchestra still in the city was the truncated Radio Orchestra, which had to be augmented by players summoned from the trenches. The concert was broadcast live by loudspeaker on August 9, 1942, across the city, and was said to have been heard by the frontline German troops. The military commander had ordered a special preperformance bombardment to keep the Germans quiet while the symphony was in progress.[30]

It was not until years later that Shostakovich hinted that the work could be interpreted as a lament for those who had suffered under Stalin before the war as much as a tribute to the war spirit. At the time the Seventh Symphony lifted him into a symbol of Russia's resistance. A photograph of him taken on July 20, 1941, wearing a helmet while doing fireguard duty on the roof of the Leningrad Music Conservatory, made the cover of *Time* magazine. He was also a finalist in the competition to compose a new national anthem, though he lost in the final round to Alexander Alexandrov, founder of the choir that bears his name. Prokofiev's entry hadn't made the short list.

Prokofiev was evacuated first to Nalchik, near Russia's southern border, then across the mountains to Tbilisi. His wife refused to come with him because Mira was in the same party, and stayed in Moscow with their sons. On March 23, 1942, Prokofiev was handed a letter that had been written four months earlier and had taken that long to find its way through the chaos. It was from Eisenstein, at work on his film about Ivan the Terrible and

wanting to renew their partnership, an offer Prokofiev eagerly accepted. *Alexander Nevsky* was now not only a box office hit in the USSR but due to open in New York. The main problem was that Eisenstein was more than sixteen hundred miles away in Alma Ata (Almaty), in Kazakhstan. It took Prokofiev and Mira until June 15 to arrive, exhausted, in a town so full of evacuated actors, directors, and others involved in the film industry that it was known as "Hollywood on the Chinese border."

Eisenstein was wading in deep waters, given that Stalin identified himself as the modern Ivan the Terrible. Even the malleable opportunist Alexei Tolstoy had the production of his play shut down and the script returned to him to be rewritten because it failed to give Ivan his full due as "the outstanding statesman of sixteenth-century Russia."[31] In his youth, Eisenstein had not been an admirer of Ivan the Terrible. In 1928, he wrote, "The 'great' and 'illustrious' personages of the past ruled the fate of millions according to their limited views. . . . It is time to reveal the bunk about these romantic heroes. The concealed traps of official history must be exposed."[32] Since then, hard experience had taught him that unless he discarded the opinions of his youth, he would never be allowed to make another film. Nevertheless, his new project was as meticulously researched and planned as those that preceded it.

Eisenstein intended to produce a three-part epic—*Ivan Grozny, The Boyars' Plot*, and *Ivan's Wars*—with Nikolai Cherkasov, who had played the title role in *Alexander Nevsky*, as Ivan. He cast the actress Faina Ranevskaya as Ivan's mother but was overruled by the head of the industry, Ivan Bolshakov, who objected to her "Jewish features." Uncomfortably for Prokofiev, the part then went to Serafima Birman, the director who had been imposed on him after Meyerhold's arrest. She, too, was Jewish but evidently looked Russian enough to get by.

They had to take the risk of beginning work before the script had been approved. While Stalin was micromanaging a war in which more than 9 million men were engaged along a front line stretching for thousands of miles, both Eisenstein's script and Tolstoy's revised script lay on his desk awaiting his personal attention. In the period between the greatest tank battle in history, at Kursk in July 1943, and the retaking of Kiev, Stalin read the scripts in tandem. Tolstoy's failed the test: it took him until 1944 to write a version the dictator approved of, and not long afterward he died. Eisenstein's passed, and Stalin even praised the way in which he had portrayed Ivan as a "progressive" leader and the *oprichnina* as his "logical instrument."[33]

Even that authoritative endorsement did not stop nervous officials on the State Committee for Culture from interfering when Eisenstein returned to Moscow in autumn 1944, with the rushes of an almost complete *Ivan Grozny* conveyed in metal crates on the long train journey from Kazakhstan. The film began with a message placing Ivan in the violent context of his time, as a contemporary of Catherine de' Medici and Philip II of Spain; the prologue described Ivan's disturbed childhood, explaining his subsequent cruelty, and in a final scene Ivan received an ominous oath of loyalty from his *oprichnina* guardsmen. All of that was removed by order of the committee, and a new written message was inserted at the start that simply described Ivan as the ruler who "united our country." Thus doctored, the film was ready for the all-important private screening in the Kremlin in December 1944. The dictator let it pass for release without making any public comment, and the film had its premiere in January 1945, as the Red Army was encircling Budapest and East Prussia. Part one of Eisenstein's planned trilogy had passed every obstacle, and he could only hope that he would have as little trouble with part two.

Abroad, *Ivan the Terrible, Part 1* (as it was known to Western audiences) was not received as another masterly expression of Russian patriotism like *Alexander Nevsky*. It reached Western cinemas at a time when victory over Germany was in sight, and people were wondering nervously what would become of the triple alliance of the United States, Britain, and the USSR when the war was over. It did not escape critics' notice that Eisenstein's new work was an apology for tyranny. James Agee, one of the greatest American film critics, praised it as "a visual opera . . . an extraordinarily bold experiment, fascinating and beautiful to look at," but added, "It is a study of what such a fanatic becomes, given unprecedented power and opportunity. . . . Ivan, as Eisenstein presents him, is a fair parallel to Stalin; but he is still more suggestively a symbol of the whole history of Russian communism."[34]

The film was also casually imperialist, though this point went over the heads of anyone who was unfamiliar with the ethnicities of the Soviet peoples. Riga, the capital of Latvia, and Narva, in Estonia, are mentioned in Eisenstein's script as if they were Russian cities under foreign occupation. The audiences were also invited to take heart from the crushing of the Tatar Khanate in Kazan and to understand that the Crimean Khanate was the next threat. With that, Eisenstein unwittingly provided political cover for a war crime: on May 18, 1944, during the making of *Ivan the Terrible*, Beria's

officers scoured the Crimea, rounding up all 160,000 of its Tatar inhabitants, regardless of age, and deporting them to special settlements in Siberia and Kazakhstan. It was not until 1968 that the first small groups of Tatar families were allowed to trickle back into Crimea.[35]

Within the USSR, the critics were not sure how they should react. *Pravda* took the precaution of commissioning two reviews, a hostile one by Pyotr Pavlenko, who had concluded after working on *Alexander Nevsky* that Eisenstein was politically suspect, and an alternative one by the playwright Vsevolod Vishnevsky, who praised the film's "historically accurate" portrayal of a "progressive leader." The galley proofs of Pavlenko's review were ready, but it was hastily spiked when word came down that the viewing in the Kremlin had gone well. The officials who awarded Stalin Prizes—which were to the Soviet cinema what the Oscars are to Hollywood—did not know what to do either and played it safe by choosing a short list that excluded *Ivan the Terrible*. When that provisional list was presented to a plenary meeting in March 1945, Bolshakov, who had been at the Kremlin screening; the committee chairman, Solomon Mikhoels, who was one of the Soviet Union's greatest actors; and Mikhail Chiaureli, the only film director present, were all in favor of adding Eisenstein's work, yet the committee decided by twenty votes to twelve to keep it off.[36] Then, after a long delay, it was announced in February 1946 that Eisenstein, Prokofiev, Cherkasov, Birman, and two cameramen who had worked on *Ivan the Terrible* had all been awarded Stalin Prizes, First Class. The committee had been overruled. The message was unmistakable: the critic in the Kremlin liked the film.

Boosted by this endorsement, Eisenstein drove through the production of *The Boyars' Plot*, which is usually known as *Ivan the Terrible, Part 2*. The film was an artistic departure for him. None of his previous films had shown character development: a single shot would tell the audience whether a new character was good, bad, weak, or strong, and everything that character did remained consistent with this first impression. That simple rule, so easy for an audience to grasp and so convenient for making propaganda films, was abandoned as Eisenstein delved into the question of what turned an intelligent and strong-willed tsar into a monster. He created a portrait of a man driven by the times in which he lived to commit acts of frightful cruelty and who was tormented by what he had become. Predictably, given Stalin's known interest in the subject, the film was sending waves of panic through Mosfilm long before it was completed, but with a Stalin Prize on his CV Eisenstein refused to be distracted by frightened officials. The final rushes, which he sent

to a laboratory on February 2, 1946, were a work of art, but the strain of producing it took its toll, and a few hours later, during the celebrations that followed the Stalin Prize awards, Eisenstein collapsed from a heart attack.

He emerged from his medical emergency directly into a political crisis. *Ivan the Terrible, Part 2* was ready to be shown to the culture committee. Its members were impressed with its technical quality but frightened by its politics, and they put together a list of proposed changes. Exhausted either by his brush with death or by fifteen years of dealing with cowed bureaucrats (or both), Eisenstein was in no mood to go back to work and fulfill a set of debilitating petty instructions; he became fixated on the idea that the film should be shown to Stalin as it was. He seems to have hoped that Stalin would rise above his advisers and approve the work. The officials who stood between him and the Kremlin did not agree. The argument went on for days, with Eisenstein bombarding officialdom with his single demand. His old colleague Grigori Alexandrov, who was well thought of by Stalin, intervened, and wrote a brave and thoughtful letter to the dictator—"as a man who is attentive to people and their misfortunes, a responsive and emotional man"—pleading with him not to make a ruling yet, anticipating that it would not go in Eisenstein's favor and fearing that the shock might kill the already sickly, overwrought director.[37] Thus nothing happened until May, when Eisenstein wrote to Stalin from his bed in the Kremlin hospital to say that he had recovered physically but was emotionally downcast because Stalin had not yet seen the film.

Eisenstein had his way. There was a viewing in the Kremlin, and the reaction was every bit as bad as those who had been advising against it had anticipated. Stalin delivered his opinion on this and a couple of other films in August 1946, at a session of the Orgburo, a subcommittee of the Central Committee that supposedly handled party organization rather than politics. That was normally the province of the Politburo, but that body did not function during the war years. Stalin told them that the film was "vile" and that the *oprichniki* were made to look like the Ku Klux Klan, when they should have been portrayed as the force that Ivan needed to unify Russia into a central state, while Ivan, far from looking like the resolute, visionary leader that Stalin believed him to have been, agonized like Hamlet. The Orgburo resolution condemning the film was published in September.[38]

The shock did not kill Eisenstein, as Alexandrov had feared it might; it made him only all the more convinced that he must make direct contact with Stalin. He wrote another letter to the dictator, who read it while he was on

holiday in Sochi in November. For weeks, Eisenstein heard nothing. Stalin later said that he had thought about replying in writing but changed his mind. It was a measure of how important Ivan's image was to him that he decided instead to see Eisenstein and Cherkasov personally. They were summoned to the Kremlin to meet Stalin, Molotov, and Zhdanov at eleven p.m. on February 25, 1947.

A transcript of the conversation, published forty-five years later, reveals that it was Cherkasov, a reliable communist, who did most of the talking from their side, with only a few sparse comments from an obviously uncomfortable Eisenstein. After the opening formalities, Stalin went straight to the point, repeating the complaints with which Eisenstein was already familiar. His weak reply to the charge that he had made the *oprichnina* look like the Ku Klux Klan was that the Klan wore white hoods, whereas he had dressed Ivan's guardsmen in black. Molotov snapped that it made no difference. Next, Stalin delivered a homily on why Ivan was not merely a great tsar but the greatest of them all. Thirty years earlier, the Bolsheviks had thought that their revolution would spread out from Russia across the world. Now the aging dictator was obsessed with keeping the rest of the world out. Peter I, Stalin said, had been wrong to open his court to foreign influence, and Catherine was even worse in that respect; the courts of the twentieth-century tsars were more German than Russian. Ivan's great wisdom was that he "wouldn't allow foreigners into the country," and he had kept foreign influence at bay by preventing his subjects from running import or export businesses. Stalin told them, "Ivan the Terrible's remarkable enterprise was the fact that he was first to introduce a state monopoly on foreign trade . . . Lenin was the second."

Zhdanov and Molotov then weighed in. Zhdanov repeated Beria's opinion that Ivan had been portrayed as a neurotic, while Molotov complained that the film had excessively focused on "inner psychological contradictions" and featured too many arches and cellars and not enough of Moscow's fresh air. Stalin added that Ivan lingered too long kissing his wife and then made a very self-revealing observation: "Ivan the Terrible was very cruel. You can show that he was cruel, but you have to show why it was essential to be cruel. One of Ivan the Terrible's mistakes was that he didn't finish off the five major feudal families. . . . [He] would execute someone and then spend a long time repenting and praying."

After some more observations about the role of Christianity in Russian history and where Demyan Bedny—dead but not forgotten—had gone wrong,

Cherkasov spoke up to say that this criticism was helpful and he was confident that the project could be rescued. At this, Stalin turned to his two acolytes to ask, "Well, what do you say, let's try it," as if their opinion counted. The charade that he was simply a helpful critic had to be upheld. When Eisenstein tactlessly asked if Stalin had any more instructions, the man who could have sent them to their deaths that same night replied, "I'm not giving you instructions. I'm expressing a viewer's remarks."

Yet the instructions kept coming. Zhdanov complained that the camera lingered too long on Ivan's beard. Eisenstein promised less beard. Cherkasov asked whether Stalin had any objection to three particular scenes and was told that all three could stay in. Stalin wanted to know how the film would end, so Cherkasov painted a verbal picture of Ivan looking out over the Baltic after the defeat of Livonia and vowing, "We stand at the seas now and forever"—which could not fail to appeal to a dictator who had recently incorporated Estonia, Latvia, and Lithuania into his empire. Cherkasov asked whether the revised screenplay should be submitted to the Politburo and was told it need not. Eisenstein remarked that they should not rush to complete the film, a point on which everyone agreed. Stalin complained that the actress chosen to play Ivan's wife was wrong for the role. Eisenstein replied that she was the best they had been able to get in Alma Ata, for which Stalin told him off for giving in too easily.

The ordeal lasted seventy minutes in all. At the end, Stalin asked after Eisenstein's health upon learning, to his surprise, that the director had never seen the completed version of his own film because of his heart attack.[39]

Eisenstein was, in fact, too ill to revise *The Boyars' Revolt* even if he had possessed the will to do so. He died in his apartment less than a year later, on February 11, 1948. The existing version of *The Boyar's Revolt* was suppressed for as long as Stalin was alive and had its belated premiere in 1958. It was neither a critical nor commercial success. In 1963, *Novy mir* published Alexander Solzhenitsyn's story of life in the gulag, *One Day in the Life of Ivan Denisovich*, a literary sensation that incidentally struck a blow against Eisenstein's posthumous reputation. Halfway through the story, its protagonist overhears a conversation between two other prisoners in which one declares that *Ivan the Terrible* was "a work of genius." The other, an old man known only as X 123, replies angrily, "It's all so arty that there's no art left in it. . . . And then, that vile political idea—the justification of personal tyranny." When his fellow *zek* protests that no other interpretation of history was

allowed at that time, X 123 retorts, "Then don't call him a genius. Call him an arse-licker, obeying a vile dog's order. Geniuses don't adjust their interpretations to suit the taste of tyrants!"[40]

To dismiss Eisenstein as an "arse-licker" is harsh. He learned a hard lesson, first in America and then in Moscow, that if he were to make films, he would have to master his tendency to rebel against any and every figure of authority. He had to stay on the right side of whoever controlled the studio, the equipment, and the budget or accept that his career as a director ended when he was thirty. In America, he would have had to adjust to the whims and demands of Hollywood; by returning to his homeland, he condemned himself to the grimmer task of placating Stalin. Eisenstein did not make films to please Stalin any more than Shostakovich or Prokofiev wrote music to please Stalin; he tried to please Stalin so that he might be allowed to make films.

13

Anna of All the Russias

What we accomplish will disturb the Twentieth Century.

—ANNA AKHMATOVA

Perhaps the most emotionally charged meeting that ever took place between a Soviet citizen and a Western visitor was held in Leningrad, in the third-floor room of a once grand building six months after the end of the war in Europe. Hoping to learn more about the closed society that Winston Churchill described as "a riddle wrapped in an enigma," the British government had dispatched Isaiah Berlin to its Moscow embassy. He was no diplomat but an Oxford don who had grown up in Riga and Saint Petersburg. Before embarking, he exchanged letters with a fellow specialist. "Mandelstam is, I am pretty sure, dead, starved by being put on the bottom of the list of food tickets because of his disloyal verses," wrote his correspondent, Maurice Bowra, master of Wadham College. "What about Akhmatova? Said to be alive in Leningrad."[1]

Leningrad was recovering from one of the greatest episodes of human endurance in history. Blockaded by the Germans, with supplies coming in only during the winter months, when trucks could make the dangerous journey across the frozen surface of Lake Ladoga to the east, the city held out from September 8, 1941, until the Red Army broke through on January 27, 1944. Inside the blockade, the death toll from bombardment, disease, and malnutrition was at least 641,000, including 200,000 just in January and February 1942.[2] Isaiah Berlin wanted to see this war-ravaged city of his youth, not least because he had heard that prices in the bookshops were lower than they were

in Moscow. He took the train from Moscow and, on his second day in Leningrad, visited a bookshop on the Nevsky Prospekt with Brenda Tripp, another member of the embassy staff. The old man behind the counter invited them into the back, where a literary critic named Vladimir Orlov was browsing the poetry section. Berlin asked first about the siege and then about any writers living in the city. Orlov assumed there could be only two living writers in Leningrad who would interest a foreigner: Mikhail Zoshchenko, a half-forgotten writer of satirical short stories, and Anna Akhmatova.

"Is Akhmatova still alive?" Berlin asked, surprised.

"Why yes, of course," said Orlov. He gave Berlin her address, which was nearby, in Fountanny Dom (the Fountain House) on the Fontanka River, and asked if the visitor would like to meet her. "It was as if I had suddenly been invited to meet Miss Christina Rossetti," Berlin wrote later. "I could hardly speak: I mumbled that I should indeed like to meet her."[3]

The encounter was fixed for three o'clock that afternoon. Berlin went back to the Astoria Hotel, returning to the bookshop alone. He and Orlov walked across the Anichkov Bridge and turned left along the embankment until they came upon "a magnificent late baroque palace with gates of exquisite ironwork for which Leningrad is famous, and built around a spacious court not unlike the quadrangle of a large Oxford college." After climbing a steep, dark staircase, they came to a room furnished with only a wooden chest, three or four chairs, a sofa, and a portrait of the young Akhmatova by Modigliani on the wall above the unlit stove. The person who greeted them was not the charismatic poet whose angular features were immortalized in a 1914 oil painting by Nathan Altman but a stately gray-haired lady with a white shawl across her shoulders, a noble head, an unhurried manner, and a face that expressed a lifetime of suffering.

Only a few minutes into their conversation Isaiah Berlin had a strange experience, like an aural hallucination. He thought he heard an upper-class English voice calling, "Isaiah! Isaiah!" It was impossible that anyone from Britain could be looking for him here in Leningrad, so he ignored the sound and focused on the regal figure before him.

Anna Akhmatova had been a cult poet twice in her life. During the cultural renaissance that swept through Europe in 1912, bringing fame to Mayakovsky, Mandelstam, Prokofiev, and others, poetry circles in Saint Petersburg were enthralled by the recitals given by a reserved, proud twenty-three-year-old with the bearing of an aristocrat. Her fame was interrupted by World War I and the civil war, but in the early 1920s Petrograd's poetry

lovers again crowded into halls to hear her. She and Mayakovsky were rivals to succeed Alexander Blok as Russia's favorite living poet. There was a minimal overlap in their respective followings; while Mayakovsky managed to win recognition from the Bolsheviks, Akhmatova never received nor asked for official approval. As far as the outside world was concerned, she was silent.

In 1910, at the age of twenty, she married the poet Nikolai Gumilev, who had been pursuing her since she was thirteen. He was a kind of Russian Rudyard Kipling: a poet, an explorer, and a romantic patriot whose work was never seen in Russian bookshops from the 1920s until after the collapse of communism. Victor Serge met him in France in 1917, when Gumilev was trying to establish himself as a foreign correspondent. "He defined his position right from our first conversation: 'I am a traditionalist, monarchist, imperialist and pan-Slavist. Mine is the true Russian nature, just as it is formed by Orthodox Christianity. You also have the true Russian nature, but at its extreme opposite, that of spontaneous anarchy, primitive violence, and unruly beliefs. I love all Russia,'" he told Serge.[4]

Marriage to this persistent suitor enabled the young Anna Gorenko to leave Ukraine, where her mother had settled in 1905 when she separated from Anna's father; visit Paris; revisit the little town of Tsarskoye Selo, where the royal family spent their summer vacation and where she was brought up; and settle in Saint Petersburg, reinventing herself by adopting the name Akhmatova, after her maternal ancestor Khan Akmat, Russia's last independent Tatar ruler and a descendant of Genghis Khan. She, Gumilev, Osip Mandelstam, and three others created the "Acmeist" school of poetry at the same time that Mayakovsky and his friends were launching Futurism in Moscow. In 1912 she had a son, Lev, who was raised by his grandmother while his parents pursued their vocations. Otherwise the marriage was a failure, a succession of stormy arguments; the couple separated in 1917 but did not divorce. One of her poems, written in 1911, began:

Under her dark veil she wrung her hands . . .
"Why are you so pale today?"
"Because I made him drink of stinging grief
Until he got drunk on it."[5]

One might guess that jealousy and artistic rivalry drove these two talented, tempestuous individuals apart, but actually that was not a problem. It's true Gumilev was scathing about his young bride's early attempts at verse. But after

one of his adventurous journeys to Abyssinia, she met him at the railway station, where he gave her a severe look and asked if she had been writing. When she replied that she had, he ordered her to read her poetry aloud. "Good, good" was his reaction, and from that moment onward—according to a story she told at least twice—he acknowledged and respected her as a fellow poet, while being grossly unfaithful to her as a sexual partner.[6] He set off on his travels again in 1913, while she stayed behind, the star of the Saint Petersburg literary scene, nicknamed Anna of All the Russias in imitation of Nicholas II's title of Tsar of All the Russias. She had written her first poem at the age of eleven and wrote her two hundredth about ten years later. Her first book of poetry, *Evening*, was published in 1912; a second, *Rosary*, came out in March 1914. *Rosary*, as she put it, "was allotted a life of approximately six weeks. In early May the Petersburg season was beginning to die down; little by little everybody was leaving. This time the parting with Petersburg was forever. We returned not to Petersburg but to Petrograd; from the nineteenth century we were suddenly transported to the twentieth."[7]

Gumilev was excited by the glory of war. He learned to ride and joined the cavalry. Akhmatova despaired of the slaughter, and unlike most of the intelligentsia she also had forebodings from the start about the revolution and wrote very little until 1921, when she had a second creative burst that lasted even through the terrible events that blighted her summer that year. Gumilev was also enjoying the craze for public poetry readings. After one of his performances, a tough-looking man in a leather jacket started reciting Gumilev's verses from memory, as if drunk on the poetry. It turned out to be the former assassin Yakov Blyumkin, who had tried to enlist Mandelstam in the Cheka. Gumilev liked men of action even if he loathed Blyumkin's politics, and they shook hands. It was, as Akhmatova's biographer remarked, a "meeting of two men marked for death."[8] A month later, on August 10, Akhmatova was at the funeral of Blok, a very distressing event in itself and made much worse when she learned from fellow mourners that Gumilev had been arrested a week earlier for his association with a professor of geography at Petrograd University named Vladimir Tagantsev. Tagantsev was accused of being at the center of a conspiracy involving army officers and others who had hoped that the revolt by the Kronstadt sailors would mean the end of Bolshevik rule. Gumilev and sixty-one others were executed on August 25, 1921. "Terror, fingering things in the dark / Leads the moon beam to an axe," Akhmatova wrote on August 27 or 28.[9]

For the rest of her life, she was marked as the widow of a man executed for anti-Soviet activities, and the consequences would be worse for Lev, then only eight years old, who carried the name of the father he idolized. At the time, however, nothing worse followed. Akhmatova's third small book of poetry was published in 1921, followed in 1922 by the larger collection *Anno Domino MCMXXI*. By then, she was so well established that an entire book was published about her by a critic named Boris Eikhenbaum, who recalled how his generation had been "puzzled, amazed, ecstatic" when they first encountered her work. Describing the heroine of her poetry, rather than Akhmatova herself, he noted her "contradictory" or "double" image—"half 'harlot' burning with passion, half 'nun' able to pray to God for forgiveness."[10] That observation would be used against her a full twenty-four years after it was written.

The writer Kornei Chukovsky published a seminal essay in 1922, suggesting that all Russia was divided between Mayakovskys and Akhmatovas, one embodying the future and the other all that was most valuable in the prerevolutionary past. He intended this as praise but inadvertently reinforced the message in party circles that Akhmatova was a relic of the old regime. In autumn 1922, *Pravda* excerpted two chapters from Trotsky's forthcoming book on literature, in which he acknowledged that Akhmatova was "very gifted" but added a sarcastic reference to how God pervaded her poetry. "How this individual [God], no longer young, burdened with the personal and too often bothersome errands of Akhmatova, Tsvetayeva and others, can manage in his spare time to direct the destinies of the universe, is simply incomprehensible," he mused.[11]

In this pre-Stalinist period, it was permissible to challenge the opinion even of the people's commissar for war, which a critic named Nikolai Punin daringly did by praising Akhmatova as "the most original poet of the preceding generation."[12] After a second, unhappy marriage, this time to a specialist in Babylonian history who proved to be a possessive domestic tyrant, Akhmatova adopted freer, postrevolutionary sexual mores and moved in with the musician Artur Lurye, seemingly sharing him with an actress named Olga Sudeikina, before forming a lasting but tense relationship with Punin.[13] She moved into Punin's apartment in the Sheremetev Palace on the Fontanka— now the location of the Akhmatova Museum—where Isaiah Berlin met her decades later. Punin's long-suffering wife, Anna Ahrens, had nowhere else to go and moved into a back room with their four-year-old daughter, Irina,

while Akhmatova and Punin took up residence in the study. The household became yet more crowded and emotionally complicated in 1928 when Lev Gumilev, now sixteen years old, left his grandparents' home and moved to Leningrad to study. He was an intelligent and studious youth but emotionally marked by his childhood. He resented Punin, who had written scathingly about his father's poetry. Punin considered himself the head of the household, and, although Akhmatova could be fierce in asserting her independence, the unalterable fact was that legally it was his flat and she and her son were his lodgers.

More distressing than these domestic tensions was the unwritten ban that stopped her work from appearing in any Soviet publication after 1925, bringing her extreme financial hardship. Late in 1932, Boris Pasternak was shocked to learn that she was ill and out of money and with some difficulty persuaded her to accept a gift of 500 rubles.[14] Yet her reputation gave her a certain immunity that others would have liked to possess. Thousands of supposed "Leningrad aristocrats" were rounded up and deported after Kirov's murder in December 1934, but Akhmatova, whose forebears included Tatars as well some very wealthy Russian businessmen, was spared. Instead, the authorities found another, particularly cruel way to intimidate her, by persecuting her son. In 1933, Lev Gumilev, now twenty-one and a hardworking student, was in the middle of an informal tutorial on the Middle East when the police arrived. He spent nine days in prison, but his tutor disappeared. In autumn 1935, both he and Punin were arrested, along with several students Lev knew from the history department at Leningrad University. On friends' advice, Akhmatova addressed an appeal directly to Stalin. She traveled to Moscow, where she stayed with Pasternak and his wife, and Boris Pilnyak drove her to the Kremlin so that she could deliver it. She wrote:

> I give you my word of honour that they are neither fascists, nor spies, nor members of counterrevolutionary societies. I have been living in the USSR since the beginning of the revolution. I never wanted to leave a country to which I am connected by heart and mind, despite the fact that my poems are not published any more. . . . The arrest of the only two people who are close to me gives me the kind of blow from which I shall not be able to recover. I ask you, Iosif Vissarionovich, to return my husband and son to me.[15]

Her appeal was reinforced by another from Boris Pasternak, written on the same day, November 1, 1935. Stalin read both letters and scrawled on

Akhmatova's, "To Comrade Yagoda. To free from detention both Punin and Gumilev and reply that this action has been carried out. Stalin." Poskrebyshev phoned the Pasternak household with the good news. Punin was set free in the middle of the night and was so taken aback that he asked in vain to be kept in his cell until the morning, when he would be able to find a taxi.[16] Given the conditions of the time, it was a "miracle." The only person who did not join in the general rejoicing was Akhmatova, who was so exhausted that they could hardly rouse her from sleep. She muttered something upon hearing the news and went back to sleep.

The next time, there was no miracle. The dean of Leningrad University, Mikhail Lasorkin, courageously allowed Gumilev to return in 1937 and take his exams, but soon afterward Professor Lasorkin was arrested and killed while under interrogation. His body was thrown from a window so that his death could be attributed to suicide. During a history lecture, Gumilev bravely but rashly entered into a public argument with a lecturer who denigrated his dead father. He was arrested on March 10, 1938, beaten, and sentenced to ten years in the labor camps. It was only in October, six months after his arrest, that Akhmatova was at last allowed to see her son. To cheer her up, he wore a borrowed scarf, quoted some lines of Blok, and told her, "I've been given the same as Radek—ten years!"[17] It was cold comfort: Karl Radek was murdered long before his sentence was complete. Gumilev was sent north to work on the White Sea Canal, where he accidentally cut his foot with an axe, inflicting a wound that could have been fatal in the extreme conditions of forced labor—except that fortuitously his case came under review and he was hauled back to Leningrad to answer a charge of "terrorist activity."

While Lev was in Kresty Prison, a tall, graying, proud woman one or two people recognized as the poet Anna Akhmatova joined the desperate queue of wives, mothers, and lovers hoping for news or trying to deliver food parcels. Nearly twenty years later, she added the following short prose message, titled "Instead of a Preface," to the start of her grim, powerful poem "Requiem":

In the terrible years of the Yezhov terror, I spent seventeen months in the prison lines of Leningrad. Once, someone "recognized" me. Then a woman with bluish lips standing behind me, who, of course, had never heard me called by name before, woke up from the stupor to which everyone had succumbed and whispered in my ear (everyone spoke in whispers there):

"Can you describe this?"

And I answered: "Yes, I can."

Then something that looked like a smile passed over what had once been her face.

The poem that followed included the lines:

The verdict . . . And her tears gush forth,
Already she is cut off from the rest,
As if they painfully wrenched life from her heart,
As if they brutally knocked her flat,
But she goes on . . . Staggering . . . Alone . . .[18]

In August 1938, Lev was deported to Norilsk, the most northern human settlement in the world, where he became a skilled geologist. His mother's relations with Punin ended soon afterward. The formalities consisted of a change of rooms in the Fountain House: Akhmatova moved into the back room, and Punin's ex-wife, Anna Ahrens, moved back in with him.

Late the following year, her fortunes took a surprising turn for the better. Stalin suddenly remembered her and during a literary gathering in February 1939 asked where she was and why she was not writing. The story is told that he did so as "Papa's gift to Svetlana," Stalin's young poetry-loving daughter, but this seems unlikely—in her memoirs Svetlana attributed her discovery of Akhmatova's work to a book she was loaned by a lover she first met in 1942.[19] For whatever reason, Akhmatova was invited to prepare a selection of poems to be called *From Six Books*, and in January 1940 she was admitted to the writers' union, which meant an immediate improvement in her personal finances. Pasternak, Alexei Tolstoy, and Alexander Fadeyev, then the chairman of the writers' union, even suggested that she be considered for a Stalin Prize for *From Six Books*. But these were false hopes. On September 25, 1940, a minor official named D. Krupin addressed a report to Andrei Zhdanov, the Leningrad party boss, about the publication of poetry that lacked any revolutionary or Soviet theme and had nothing to say about socialism. Zhdanov took note and sent a furious memo to the head of Agitprop, Georgi Alexandrov: "It is simply a disgrace when these collections, if one can call them that, are brought out. How could this 'lechery of Akhmatova's with a prayer to the glory of God' be published? Who promoted it?"[20] One month later, the Central Committee secretariat issued a reprimand to the editors who had been

so remiss. On the decree was a written note from Andrei Andreyev, chairman of the Central Control Committee, ordering that the seditious book of verse was to be seized. Akhmatova's nine months as a published poet again had come to an end.

After the regime had recovered from the initial shock of the Nazi invasion, the police resumed their usual duties. Viktor Zhirmunsky, one of the first critics to recognize Akhmatova's gifts, acclaiming her in 1916 as "the most significant poet of the younger generation," was among thousands arrested as the German army tore across Ukraine and encircled Leningrad. And yet neither the regime's brutality nor its stupid failure to prepare for this disaster prevented a surge of patriotism as Russians saw their homeland being invaded. Akhmatova's reaction was encapsulated in a short poem she wrote less than a month after the invasion.

And she who is parting with her sweetheart today—
Let her forge her pain into strength.
By the children we swear, we swear by the graves,
That no one will force us to submit![21]

Although she was sick with worry for her persecuted son, when the city authorities approached Akhmatova to make a broadcast she readily agreed. In September, radio listeners in the city heard the voice that had been silenced for so long:

My dear fellow citizens, mothers, wives and sisters of Leningrad, for a month now the enemy has been threatening to take our city captive and inflict serious injury on it. The city of Peter, the city of Lenin, the city of Pushkin, Dostoyevsky and Blok, the city of a great culture and industry is being threatened by the enemy with death and disgrace. I, like all Leningraders, am mortally wounded by the very thought that our city, my city, could be razed. My entire life is tied to Leningrad—I became a poet in Leningrad, Leningrad gave me my poems.[22]

The bombing made the house on the Fontanka unsafe, and Akhmatova moved into a friend's basement flat. Her new status as a member of the writers' union worked in her favor. She was flown to Moscow at the end of September and headed east on a train full of writers, artists, and actors, including Pasternak and Fadeyev. She and Pasternak traveled in the same carriage,

chatting affably. The poet Margarita Aliger noted how the two of them "had a knack of behaving simply and naturally and of being themselves, despite what was happening around them—probably because of their breeding."[23] By November, Akhmatova was in Tashkent, where she spent nearly three years in a little community of evacuated writers. "In Tashkent I learned for the first time what the shade of a tree and the sound of water can mean in scorching heat," she wrote. "And I also learnt what human kindness is—I was often seriously ill in Tashkent."[24] She caught typhus in 1942 and scarlet fever the following year.

She flew back to Moscow in May 1944 and arrived by train in Leningrad in June, eager to be reunited with the man she believed to be her current lover, a doctor named Vladimir Garshin who had stayed in Leningrad through the siege. Garshin was waiting at the station when she reached Leningrad, and they walked up and down the platform in intense conversation for about ten minutes, during which she discovered that he was not the man he had once been and the relationship was over. Garshin can hardly be blamed after what he had witnessed. One winter his wife had collapsed from hunger in the street. When he went to the mortuary, he could identify her only by her clothes: her face had been eaten by rats.

Akhmatova had no choice but to return to the war-damaged house on the Fontanka, where everything of value had been looted. Her books had been burned to provide warmth during the freezing winters. The rooms were soon full, though: Punin was back with his widowed daughter, granddaughter, and a new wife.

Worse than her disappointment in love and these friction-inducing domestic arrangements was her perennial anxiety about her son. Lev's sentence had come to an end in 1943, and the distinction he achieved as a geologist allowed him to enlist and go to the front. She was terrified that he would be put in a penal battalion and sent to his death; though that fear proved unfounded, she had been through too much to have naive expectations about what would follow after the war ended. In 1945, she wrote:

There's a silhouette of Faust in the distance—
As in a town where there are many black towers

. . .

The one who summoned the devil, who bargained with him
And deceived him, and for our inheritance
Left us this deal[25]

Yet there were small signs of improvement. During her stopover in Moscow in May 1944, she was permitted to read a poem at a huge gathering in one of the capital's buildings (either the Polytechnic Museum or, in another version, the House of Columns). Later that year, the Leningrad Writers' Union organized a public performance, and word spread that Akhmatova would read. A Polish aristocrat named Sophie Ostrovskaya, who had heard Akhmatova's recitals in 1921, was so excited that she secured a front-row seat. Riotous applause greeted the chairman of the Leningrad Writers' Union, a minor poet named Alexander Prokofiev (not to be confused with the composer), as he called Akhmatova to the stage and Ostrovskaya saw her for the first time in more than twenty years, writing, "She still had that same regal, supple gait, and her carriage was still erect, swanning and proud . . . a tall, dark, regal woman, trailing behind her an invisible mantle of fame, sorrow, great losses and hurts."[26]

This was the woman Isaiah Berlin came upon in a Spartan upstairs room. Her manner was so regal and severe that he bowed to her, as if she were a monarch, thanked her for agreeing to meet him, and said that people in the West would be relieved to know that she was well, because they had not heard from her for so long. She replied that, on the contrary, there had been an article on her poetry in the *Dublin Review*, and someone in Bologna was writing a thesis on her. She asked how London had coped with the blitz. As he was replying—shyly because he found her manner intimidating—he still had that curious sensation of hearing his name being called out in clipped English. Though he tried to ignore it, the sound persisted. He went to the window to check, and outside, standing in the great court and looking like a drunken undergraduate, was a well-dressed man in early middle age bawling, "Isaiah!"

Berlin recognized him instantly though it had been fifteen years since they had last seen each other. The man was Randolph Churchill, son of the former prime minister, who was in the USSR as a correspondent for an American newspaper. He had been Berlin's fellow student at Corpus Christi College, Oxford.

For a moment, Berlin was so astonished that he could not move, but then he mumbled an apology and hurried downstairs, with Vladimir Orlov at his heels. Churchill was in the throes of a crisis more important to him than all the poetry in the world: he needed an icebox to store his caviar but could not make his needs understood by anyone at his hotel. He had demanded help from the consular service, and Brenda Tripp had unfortunately let on that

Isaiah Berlin was in town visiting someone who lived on the Fontanka. Churchill decided that Berlin would serve as an interpreter.

Isaiah Berlin disposed of his unwanted visitor as fast as he could and returned to the bookshop to obtain Akhmatova's telephone number. He rang to apologize and ask if he might reschedule the visit. She replied that she would be waiting for him at nine o'clock. Their conversation lasted through the night. At first a third person was present, a female pupil of one of Akhmatova's ex-husbands who plied Berlin with questions about English universities that did not interest Akhmatova. The real conversation began around midnight, when Berlin and Akhmatova were left to each other's company. She asked about old friends who had emigrated and was deeply moved to learn that a maker of mosaics named Boris Anrep had made one of her that he called *Compassion*. She showed Berlin a ring with a black stone that Anrep had given her in 1917. She talked freely about other people from her past, including Mandelstam. Tears came to her eyes as she spoke of Gumilev's execution.

She then offered to recite some of her poems—but only after reciting part of Byron's *Don Juan* from memory. Her pronunciation was so erratic that Berlin could barely understand a word and had to turn his face to the window to hide his embarrassment. Then she spoke lines of her own, including her unfinished "Poem Without a Hero," and, Berlin recalled, "I realized I was listening to a work of genius."[27] She also read *Requiem* from a manuscript, breaking off to talk about the years 1937–38 and the queues outside the prisons. When he asked about Mandelstam, a long tear-filled silence followed until she begged him to change the subject. At about three a.m., they were interrupted by Lev Gumilev, who had been demobilized the previous November and finally had been able to complete his degree in history at Leningrad University, where he was now enrolled as a postgraduate student. He had been on good terms with his mother since his return from the front. He made a dish of boiled potatoes, which was all they had available, while his mother delivered a diatribe about Tolstoy's attitude to sex as exhibited in *Anna Karenina* and *The Kreutzer Sonata*, both of which she considered misogynist. She talked about Pushkin and then about Pasternak, whom she adored, and questioned Berlin about his private life. She remembered her girlhood, the artists she had known in the 1920s; she also talked about Beethoven and the meaning of art. After Berlin left, she wrote a poem inspired by their meeting, which she gave to him when he returned to say good-bye before leaving Leningrad on January 5.

This man who arrived unexpectedly from a country where people spoke their minds freely, who brought news of friends she had not seen or heard from in a quarter of a century, was the last great love of Akhmatova's life. On the manuscript of her "Poem Without a Hero," she wrote a third and final dedication to the "Guest from the Future," an obvious reference that was considered so dangerous that the Soviet editors of her posthumous collected works reluctantly left it out.[28] He is probably also the person she was referring to in these lines written in 1956:

> He will not be a beloved husband to me
> But what we accomplish, he and I,
> Will disturb the Twentieth Century.[29]

It appears that she harbored a secret hope that Berlin would return and marry her, an idea impractical on so many levels that their age difference—she was fifty-six and he was thirty-six when they met—was almost the least of the obstacles. When Berlin next visited the Soviet Union, in the freer atmosphere of 1956, Pasternak told him that Akhmatova was in Moscow and wished to speak to him over the telephone but not to meet. She had found out that he was married.

"How long have you been married?" she asked when they spoke.

"Not long," he said.

"But exactly when were you married?"

"In February of this year."

"Is she English, or perhaps American?"

"No, she is half French, half Russian."

"I see," she said. There was a long pause, and then she added, "I am sorry you cannot see me. Pasternak says your wife is charming." After that, she changed the subject.[30] When that poignant conversation took place, Akhmatova had been without a lover for twenty-five years. There would not be another.

By the time of that telephone call, Akhmatova had been put through experiences that would have driven someone less strong willed to madness or suicide. The ever-watchful police, whose acronym had changed from NKVD to MGB, would doubtless have known about her visitor anyway, but just in case they did not, the noise of Randolph Churchill clattering around the courtyard and shouting in English guaranteed that they would be on the alert. The matter was reported up to Stalin. There is no written record of his

reaction; all we have is the verbal account that got back to Akhmatova and became part of the Stalin mythology, in which he is reputed to have said, "So our nun is receiving foreign spies," and then added a comment so obscene that Akhmatova was too embarrassed to repeat it.[31] It was Stalin's habit to use obscene language to dehumanize those he intended to victimize. The dictator in the Kremlin had clearly begun to take an interest in the elderly poet living in a flat on the top floor of a house in Leningrad.

Many people, including Isaiah Berlin, hoped that after the victory in Europe Stalin would relax the dictatorship a little and allow his long-suffering people a little freedom, but, with his seventieth birthday not far off, there was no rest or joy of any kind in the old man's soul and no prospect of a quiet retirement. Though he was exhausted by the stress of the war and in failing health, he had to ensure that the younger, ruthless men around him, all handpicked by him, remained in fear of him; otherwise, his power might drain away, and he might have to answer for his crimes. He was trapped in his lonely Kremlin aerie by a system of his own creation. His declining years were occupied by a restless search for new enemies to persecute and destroy, including the Yugoslav communist leadership; a little nation called the Mingrelians, in Georgia; and, ultimately, the Jews.

But first, there was Leningrad. Stalin felt no gratitude toward the city that had held out under siege for a thousand days. He had purged its communist elite in 1926 and its social elite in 1935, but still he feared a revival of the city's traditional independence. Its communist leaders were protected for the time being by the reemergence of the short, podgy, and energetic Andrei Zhdanov, the former Leningrad party boss who was now a party secretary, director of the agitprop department of the Central Committee, and Stalin's heir apparent. In order to prove that he was fit for the trust that Stalin had placed in him, however, Zhdanov needed to make an example of someone from his old bailiwick. The lady living alone in the Fontanka, writing poems unfit for publication, was a ripe target.

On August 15, 1946, Akhmatova paid a call at the office of Litfund and noticed how everyone stood aside to observe her with wary attention. Everyone who saw her was astonished by her quiet self-control, but she did not know why. On her way home, she stopped to buy some herring and was accosted on the Nevsky Prospekt by Mikhail Zoshchenko. She did not know him well, though their names were sometimes mentioned together (as Vladimir Orlov had done when talking with Berlin). Like Akhmatova,

Zoshchenko had been a popular writer in the 1920s, before the regime silenced him, and specialized in short, witty tales of ordinary people struggling with the frustrations of city life. For example, in *The Bathhouse*, published in 1925, the narrator's visit to the public baths is complicated by the rule he must retain two tickets, one for his clothes and another for his coat and hat, while he is naked. Having nowhere else to keep them, he ties them to his legs. He waits an hour for an empty tub. Afterward, he is handed the wrong trousers and finds the ticket for his coat and hat has fallen off the string around his leg. While he is trying to resolve these problems, he forgets his precious bar of soap. Returning to retrieve it, he is told that he cannot go back into the bathhouse unless he undresses again.[32] During the war, he had written a knockabout farce in which an ape escaped after a zoo was bombed, causing chaos and alarm until a boy adopts him as a pet.[33] Zoshchenko's stories may have been funny and telling, but they did not contribute to the glory of the revolution. His story about the runaway ape was written at a time when authors were expected to be turning out fiction that commemorated the glorious war effort.

When Akhmatova encountered him, Zoshchenko was visibly distressed and blurted out, "Anna Andreyevna, what shall we do?" She assumed that he had had another argument with his wife and told him to be patient, because everything would be all right.[34] Only when she got home and unfolded the newspaper in which the herring was wrapped did she discover why Zoshchenko was so agitated.

One week earlier, on August 7, Akhmatova had given what would be her last poetry recital for many years, in Leningrad's Bolshoi Dramatic Theatre, where she read a poem she had written in June 1946. Sophie Ostrovskaya was in the audience again and noted in her diary how "Akhmatova was greeted with such a storm of applause that I turn my back on the stage and look at the lighted hall. They were mainly young men—they stand, applaud, grow wild, roar. She is flushed, pleased, hypocritically humble."[35] A tale told as part of an oral tradition, in a country where stories passed along in whispers substituted for reliable news, was that when the audience's behavior was reported to Stalin, he is supposed to have asked, "Who organized this?" Nadezhda Mandelstam heard the story from Zoshchenko. "The remark, as Pasternak said, was so much in character that it could not have been invented," she wrote. "It was quite beyond the Boss to imagine that anybody might have achieved popularity without the aid of the *apparatchiks*, who specialized in 'promoting' the idols of the day."[36]

On the evening of that recital, Zhdanov received a report from Georgi Alexandrov, the head of the agitprop department of the Central Committee, whom the Montenegran communist Milovan Djilas remembered as "a short pudgy, bald man whose pallor and corpulence proclaimed that he never set foot outside his office."[37] Alexandrov was familiar with Akhmatova's work: he had initiated the decision to suppress her collection *From Six Books* in 1940. After Akhmatova's stage appearance, he received a furious memo written by some minor agitprop employee accusing her of writing about only two subjects, free love and God.[38] Alexandrov used the memo to compile a report to Zhdanov targeting two journals, *Zvezda* and *Leningrad*, which were guilty of publishing Akhmatova's poetry and Zoshchenko's story "The Adventures of an Ape." He, or someone else working in agitprop, also dug up the quote from the book of criticism written two decades earlier by Boris Eikhenbaum, in which the voice in Akhmatova's poetry was described as being "half 'harlot' burning with passion, half 'nun' able to pray to God for forgiveness" and drew that to Zhdanov's attention.

Alexander Prokofiev underwent the terrifying experience of being hauled in front of the Orgburo, in Stalin's presence, knowing that a misjudged word could mean arrest and torture. Given the circumstances, the minutes reveal that he showed some courage in defending the two publications. "I don't think it's such a great sin to have published Anna Akhmatova's poems. She is a poet with a quiet voice, and it's normal even for Soviet people to express such sadness," he argued.

"Apart from the fact that Anna Akhmatova has a name that has been well known for some time, what else is there to see in her?" Stalin demanded.

"There are some good poems in her postwar work," said Prokofiev.

"You can count them on the fingers of one hand."

"She doesn't write poems on present-day subjects, Josif Vissarionovich. She is a poet of the old school, with fixed views, and cannot offer anything new," Prokofiev replied.

"Then she should be published elsewhere. Why in *Zvezda*?"

At this point, a stressed Prokofiev retreated into a bureaucratic excuse, noting that the same work that had appeared in *Zvezda* had also been published in a Moscow journal. Stalin ominously retorted that the Moscow publication would also have to be sorted out.[39]

That was on August 9. Five days later, the Central Committee passed a resolution condemning the two Leningrad journals specifically for publishing Akhmatova and Zoshchenko, who learned about the resolution from the

following day's newspapers. On August 16, Zhdanov descended on Leningrad for a hastily convened meeting of the local writers' union. Zoshchenko, who was still officially a member of the editorial board of *Zvezda*, turned up only to be barred at the door, but writers, journalists, camera crews, and officials of every description poured in, creating an ominous sense of occasion. Zhdanov made his grand entry at five p.m. and was heard speaking into a weird silence, as if, according to the writer Innokenty Basalayev, the huge hall had become "totally mute, frozen, turned to ice."[40] One woman fell ill but was refused permission to leave.

The centerpiece of Zhdanov's speech was his attack on Akhmatova's reputation:

> Anna Akhmatova is one of the representatives of a reactionary literary quagmire devoid of ideas. . . . The range of her poetry is pitifully limited—this is the poetry of a feral lady from the salons. It is based on erotic motifs linked with motifs of mourning, melancholy, death, mysticism and isolation. . . . She is half nun, half whore, or rather both whore and nun, fornication and prayer being intermingled in her world. . . . Such is Akhmatova, with her petty, narrow private life, her trivial experiences and her religious-mystical eroticism. Akhmatova's poetry is totally foreign to the people.[41]

The meeting lasted until nearly midnight, with sycophantic speeches and hysterical self-criticism from the floor. At the end, Akhmatova and Zoshchenko were expelled from the writers' union in absentia. The purpose of this ritual was not, of course, simply to silence two artists whose work had already been suppressed for years but to intimidate the entire intelligentsia and foreclose foolish hopes that the regime was going to loosen its grip on people's private thoughts and cultural pleasures just because the war was over. Terrified academics read the lesson and redoubled their efforts to conform and to criticize. As Emma Gerstein put it, the event "cast a shadow of philistinism over our entire culture for many years."[42]

Eisenstein's *Ivan the Terrible, Part 2* was denounced by the Central Committee less than three weeks after Zhdanov's performance in Leningrad. On the same day, there was another incidental casualty of the affair. Boris Pasternak was still a member of the national board of the writers' union and was therefore expected to be in Leningrad, showing support for the party line, but he had refused to go, pleading illness. Well-wishers privately advised him to write something condemning Akhmatova, but he retorted that it was

absolutely impossible because he loved her. Pasternak's friend the poet Niko-
lai Tikhonov lost his position as head of the writers' union after only two
years as a punishment for not keeping *Zvezda* under stricter control and was
replaced by Fadeyev. On September 4, the newly restored Fadeyev accused
Pasternak of "currying favor" with someone who did not share the commu-
nist ideology and expelled him from the board.[43]

The Central Committee decree of August 14 was included in the school
curriculum, which meant that every student, as well as every adult, in the
Soviet Union knew that in Leningrad there lived a reactionary poet who was
"half nun, half whore." People crossed the street to avoid Akhmatova. Other
writers rushed to denounce her and Zoshchenko. After their expulsion from
the writers' union, they were permitted just one ration card a month. She
might have starved if it were not for the kindness and courage of friends,
mostly women, who risked exposure and arrest by giving her money and food
from their own sparse rations. Some mailed ration cards to her anonymously.
Boris Pasternak ignored the very public warning he had received and visited
her to hand over 1,000 rubles. Though the relationship with her ex-husband,
Nikolai Punin, had ended before the war, he insisted that Akhmatova eat with
the rest of his family. His daughter, Irina, was in Riga visiting relatives when
Akhmatova was mentioned on the radio. She rushed back to be with her step-
mother. Even under the terrifying gaze of the Stalinist state, civil society
rallied to one of its greatest poets.

Fortunately for them, Stalin's paranoia about Leningrad's spirit of inde-
pendence settled on a different target after Zhdanov died suddenly from a
heart attack, in August 1948. Thousands of officials who had formed Zhdanov's
power base, obedient Stalinists all, were arrested and either imprisoned or
shot for no reason other than to keep everyone in a state of perpetual fear.
One of the most senior, Alexei Kuznetsov, who had served as a secretary of
the Central Committee, refused to confess under torture and was finished
off with a meat hook through the neck.[44] Under Stalin, it was more danger-
ous to be a powerful communist official than to write suspect poetry.

As before, the authorities did not risk a reaction abroad by arresting
Akhmatova but hounded her with the same cruel methods used on her in
the 1930s. Punin was arrested during a new purge of Leningrad's scholars
on August 26, 1949, and died in a labor camp in August 1953. Lev Gumilev
had taken all his exams and written his dissertation before his mother was
anathematized. Barred from defending his dissertation, he found a job as a

librarian in a psychiatric institution but was arrested on November 6, 1949, tortured as usual, and sentenced to ten years in a camp in Karaganda.

For several years, Akhmatova lived between two cities, because every month she went to Moscow to hand in money for her son. If the money was accepted, it meant that Lev was alive: if ever it was handed back, she would know that he was dead. She also had an arrangement with a woman who had worked with Lev to send him a parcel every month from outside Leningrad. The strain made her ill; in 1951, she had a heart attack. The previous year, she was finally driven to do what she had refused to do for twenty-five years: she paid homage to the system by writing a cycle of poems, *In Praise of Peace*, which she sent to Fadeyev and to Alexei Surkov, the editor of the magazine *Ogonyok*. They were published in May and June 1950 and are the only poems she wrote that could be classed as "socialist realist." If the point of writing them was to get Lev out of jail, they failed.

In the end, this tough old lady outlived her tormentors. One pleasing irony is that Alexandrov, the official behind the idea of calling her "half whore," was suddenly sacked from his post as USSR minister of culture in 1955, when the public learned that this unprepossessing little man was a sexual degenerate who ran a private brothel. Akhmatova lived so long—as chapter 15 will show—that she was in Britain during the Beatles era.

14

When Stalin Returned to the Opera

Over there, almost all my symphonies are played, whereas here they are forbidden.

—DMITRI SHOSTAKOVICH

Stalin was as brutal to his sons as his father had been to him, but to his daughter, Svetlana, he showed flashes of paternal affection that lightened long periods of neglect and the occasional act of cruelty. While traveling with the teenage Svetlana by train one day in November 1948, he asked what she was reading. It was an illustrated magazine article about the nineteenth-century painter Ilya Repin, whose realistic style was much honored by the communists. Stalin remarked that he had never seen any of Repin's work other than in photographs, Svetlana recalled, "with such sadness in his voice that I became quite upset. For a moment I tried to imagine what would happen if my father descended on the Tretyakov Gallery. . . . Lord, what a fuss there'd be over that! What a lot of nonsense and running around, and how much idle talk later! Probably my father himself was aware that it just wasn't open to him."[1]

On January 5, 1948, flanked by the usual entourage of Politburo members, Stalin went to a closed performance of a new work by a Georgian composer named Vano Muradeli at the Bolshoi, and Lord, what a fuss there was over that! Muradeli was, by general consensus, a mediocre composer and a sycophant who appears to have studied and drawn on the opera by another mediocrity, Ivan Dzerzhinsky, which Stalin had so memorably praised twelve years earlier. His work, variously titled *The Extraordinary Commissar* or *The*

Great Friendship, recounted the civil war career of the Georgian Bolshevik Sergo Ordzhonikidze, who was instrumental in persuading the mountain tribes of the North Caucasus to side with the Bolsheviks during the civil war. What Muradeli did not know was that the "great friendship" between Ordzhonikidze and Stalin had ended in an argument so brutal that Ordzhonikidze committed suicide, but he must have noticed the changed demographics of the North Caucasus, where there had once been a Chechen "autonomous republic," one for the Ingush, and another shared by the Balkars. All disappeared off the map when the peoples of those nations were deported en masse to Kazakhstan and Siberia. Muradeli was unwittingly asking Stalin to sit through an opera praising the small nations of the North Caucasus for rising against their Russian oppressors, led by a man whose death was on his conscience. Instead of being gripped by the drama, Stalin walked out in a fury. The director of the Bolshoi, Yakov Leontiev, subsequently had a fatal heart attack reportedly brought on by the shock.

The next day, all members of the opera company were summoned to a meeting at the Bolshoi, in the presence of Andrei Zhdanov. Some of the performers spoke up courageously in defense of the new opera only to be left hanging by Muradeli, who renounced his own work, denounced the Dzerzhinsky opera that had inspired it, and blamed his lapse into "formalism" on the bad example set by other composers. This self-abasement served him well: within a few years, he was head of the Moscow Composers' Union.

Even before these events, there had been rumors of impending trouble among composers. The foreign correspondent Alexander Werth, who had good contacts in Moscow, noted that "some sort of row was going on—the general public knew little about it; but musicians, when one talked to them, were uneasy."[2] Dmitri Shostakovich was certainly worried, although outwardly his career was prospering as never before after the success of the *Leningrad Symphony*. He was world famous and by Soviet standards very wealthy. After the war, his family was generously allocated two adjoining apartments with separate entrances on the Mozhaiskoye Highway that came with a grant of 60,000 rubles for furnishings. Stalin and his police chief, Lavrenti Beria, had made the decision, and Beria had personally phoned the composer with the good news. In May 1946, Shostakovich wrote to Stalin to say how "extraordinarily happy" he was. He wrote again eight months later to say that they had finished moving in and he dearly hoped his work would justify the great leader's generosity.[3] He and Nina took up one apartment, where there was a bedroom, a study, and two large grand pianos; the other

apartment was given over to the children, Maxim and Galina. They were not sent to school but had tutors come to give them lessons in arithmetic, history, Russian, French, and music at home. The Shostakoviches also had that rare luxury, a car. They rang in the New Year with Flora Litvinova, daughter-in-law of the former people's commissar for foreign affairs Maxim Litvinov, and her son Pavel. Despite the ample food (which was the envy of the woman who waited on them), Litvinova remembered that "everything seemed dreary, listless and uncosy that evening . . . a sense of foreboding hung in the air."[4]

The agitprop department of the Central Committee was also preparing for trouble, though they were not sure precisely who would be the targets. The podgy pervert Georgi Alexandrov was still deputy head of agitprop at the time and had watched a rehearsal of Muradeli's opera some weeks ahead of Stalin's visit. He then compiled a long report complaining that the only revolutionaries it depicted were from the small nations: there was "not a single positive Russian character in the opera." But before anyone acted on his report, he was shifted sideways. Alexandrov's replacement was Dmitri Shepilov, a future USSR foreign minister and a charming, treacherous functionary who was said to be able to sing all of Tchaikovsky's opera *The Queen of Spades* from memory. He was not shown Alexandrov's memorandum when he first arrived in his new office, and his own investigations led him to conclude that the bigger names, Shostakovich and Prokofiev, were to blame for everything that was wrong with Soviet music, with Shostakovich's Eighth and Ninth Symphonies and Prokofiev's opera *War and Peace* the worst sources of infestation. After Stalin's visit to the opera, Shepilov must have had a shock upon discovering that his predecessor had correctly anticipated where the blow would fall. He forwarded Alexandrov's memorandum to Zhdanov on January 9 with a self-justifying note blaming a subordinate named Lebedev for overlooking it.[5]

Shepilov need not have worried, though, because he was on the right track. Stalin was not interested in a nonentity like Muradeli. There was a genuine problem with the financial management of the composers' union, which was not a centralized bureaucracy like the writers' union but a committee dominated by the leading composers—Aram Khachaturyan, whose *Sabre Dance* remains one of the Western world's favorite short pieces; Shostakovich; Prokofiev; Dmitri Kabalevsky; and the composer and pianist Gavriil Popov—with local affiliates and a fund controlled by Muradeli that dispersed millions of rubles (and not just on Muradeli's own opera). In the war-ravaged USSR,

the average salary was below 6,000 rubles a year; yet in 1946–47, Prokofiev was paid 309,900 rubles and Shostakovich 230,200 rubles. The fund had also loaned an additional 182,000 rubles to Prokofiev, 24,000 to Khachaturyan, and 23,000 to the composer Vissarion Shebalin.[6] Here lay a genuine scandal, but to do anything about it would draw public attention to the vast wealth disparities in Soviet society. Stalin and Zhdanov decided instead to launch another campaign against "formalism" in music.

On January 10, 1948, more than seventy composers, musicians, and music lecturers gathered in the Kremlin for a three-day conference. The group included the "big four": Prokofiev, Shostakovich, Khachaturyan, and the elderly and much-venerated Nikolai Myaskovsky, who had been Shostakovich's tutor in the 1920s. Two enduring legends came out of this meeting. One concerned the behavior of Prokofiev, who is said to have rudely refused to take instruction on how to write music from any party functionary, even if it was the all-powerful Andrei Zhdanov. This story may be true. The other persistent legend was that Zhdanov sat at the piano to demonstrate how good music should be composed. A version of this story inspired the 1980s stage play *Master Class* by David Pownall, but it is a canard.

There was a stellar lineup of hatchet-faced luminaries from the Central Committee apparatus, including Shepilov, the sinister Matvei Shkiryatov, and the newcomer Mikhail Suslov, who would be chief guardian of party ideology in the post-Stalin era until his death in 1982. Zhdanov was the only one of this phalanx who is recorded as having spoken. He reprised the case against Muradeli's opera using language almost identical to *Pravda*'s denunciation of Shostakovich twelve years earlier. "The tendency that was then condemned is now alive, and not only alive but setting the tone to soviet music," Zhdanov pronounced. He invited contributions from the audience, saying, "If the Central Committee is wrong in defending realism and our classical heritage, then please say so openly."[7]

The first response was from a sixty-year-old composer named Yuri Shaporin, who had vivid memories of the earlier anti-Shostakovich campaign, when, according to a police informer's report, he had expressed fears that "they're driving Shostakovich to the point of suicide."[8] He delivered a mild warning that too much emphasis on tradition could cause composers to turn out nothing but poor imitations of Tchaikovsky. Any effect that warning might have had was quickly dissipated by the next contribution, from Muradeli, who spoke up like a witness for the prosecution, confessing his guilt and blaming

others for misleading him. He was particularly offended by the ecstatic reception that Shostakovich's Eighth Symphony had received in Prague, a city not then under communist rule. Well aware that audiences abroad wanted to hear works by Shostakovich but not by him, he claimed the Soviet state should not be governed by Western tastes.

A songwriter named Vladimir Zakharov, who had been an activist in the 1920s in RAPM, the musical offshoot of RAPP, did not stop at denigrating a Shostakovich symphony but went on to imply that there was no point in writing any complex works because the general public did not want them. He claimed that only "reactionaries, bandits, and imperialists" liked Shostakovich's three most recent symphonies, which included the renowned *Leningrad Symphony*.

Ivan Dzerzhinsky cut a sad figure, with his one moment of glory in the 1930s long behind him, as he complained that young composers seemed only to want to please Shostakovich, Prokofiev, and Myaskovsky: "Nobody writes about me." Israel Nestyev, from Moscow Radio, also scolded Prokofiev and Shostakovich for writing music that the public found more difficult than the familiar nineteenth-century classics. He would later achieve prominence as Prokofiev's first biographer.

Though these were skillful manipulators and bureaucrats all, they were outclassed by a thirty-five-year-old named Tikhon Khrennikov, who would go on to be the senior composer-politician for two generations. When the musician Yuri Yelagin met the twenty-two-year-old Khrennikov, he saw a "stocky, gay young fellow with a typical Russian face, an upturned nose and sly squinting eyes" who showed promise as a composer, revered Tchaikovsky and Shostakovich in equal measure, but married a sharp, angry, and ambitious woman who was determined to make a success of him. Thereafter, Yelagin reported, "Tishka began to change before our eyes; his friendly attitude vanished, and his manner became deliberate and dignified; it made us self-conscious about calling him Tishka."[9] According to Solomon Volkov, Shostakovich had thought well enough of the young Khrennikov to offer what was intended to be a helpful critique of one of his early works in writing; far from appreciating the advice, Khrennikov, now presumably under his wife's influence, saw it only as a maneuver to prevent him from winning an award.[10]

Under the eyes of Zhdanov and other cultural policemen, Khrennikov resorted to a rhetorical trick much favored by people who want to ingratiate themselves among the powerful: he pretended that he was courageously speaking out against powerful interests. He complained that Shostakovich's

Seventh Symphony had been greeted as if it were "a work of super-genius, compared with which Beethoven was a puppy" and claimed that no one but he alone dared speak the truth that Prokofiev's Sixth Symphony and Aram Khachaturyan's *Symphonic Poem* had their premieres in half-empty halls, and that everyone thought Khachaturyan's Cello Concerto was rubbish. This speech set Khrennikov on a very long and successful career. Later in the year, he was named general secretary of the USSR Composers' Union, a post he held for forty-three years, until the breakup of the Soviet Union. He lived to be ninety-four. Late in life, he was challenged by the BBC journalist Martin Sixsmith over what he had said in 1948 and fell back on what is sometimes called the Nuremberg defense: "They told me—they forced me—to read out that speech attacking Shostakovich and Prokofiev. What else could I have done? If I had refused, it could have been curtains for me."[11]

Khachaturyan, who admitted aloud that he was nervous, managed nonetheless to defend himself with some dignity. He denied that he or his colleagues deliberately set out to be complicated or that they were under Western influence, though he confessed that composers of more complex works might be guilty of ignoring popular taste in the belief that the public would catch up eventually. Zhdanov interrupted to tell him that such an attitude constituted "extreme individualism." Another speaker who showed some spirit was Vissarion Shebalin, the composer and director of the Moscow Conservatory, who complained about the conditions under which his students worked, which included overcrowding, a shortage of instruments, and a leaking roof, and about the attitude of certain unnamed "servile idiots." He also accused the obnoxious Zakharov of talking as if he enjoyed "papal infallibility."

Shostakovich spoke twice. On the first day, he said that composers should be more critical of one another and not resent such criticism; if the pathetic Dzerzhinsky was not having any success writing operas, he suggested that Dzerzhinsky try something else. As the conference was drawing to a close, he spoke again, taking a swipe at Muradeli by suggesting that composers accept responsibility for their own failures, adding that the criticism of his own work would only make him try harder. Shostakovich's reaction to persecution was always to immerse himself in work.

Zhdanov closed the conference with a rallying call for the "healthy, progressive aspects in soviet music" to join in a "fierce struggle" against "formalism alien to soviet art [that] under the banner of innovation conveys a rejection of classical heritage"—seemingly implying that classical music was "progressive" only if it sounded like something Tchaikovsky could have written.

Nothing in the published transcript suggests that Zhdanov sat at the piano to show the ensemble how music should be written, but soon after the conference Werth reported that "all kinds of people started saying, nobody knew on what basis, that Zhdanov was an accomplished musician."[12] Ilya Ehrenburg, who was not at the conference, heard the story and included it in the first edition of his memoirs, published in 1965, provoking a furious letter from Shostakovich, who told him that it was a tale invented and spread by "toadies."

A Central Committee resolution dated February 11, 1948, condemned six "formalists" for the degenerate state of Soviet music: Shostakovich, Proko-fiev, Khachaturyan, Shebalin, Popov, and Myaskovsky, in that order. On February 14, the State Repertoire Committee published a long list of works that it was now illegal to perform, including almost every composition by any of the six "formalists," all of whom were stripped of their positions within the USSR Composers' Union. Shebalin was forced to sit onstage at the Moscow Conservatory in order to be denounced in front of his students and publicly sacked; this affected him so badly that he suffered a stroke, while the elderly Myaskovsky died within months of being vilified.

The first All-Union Congress of Soviet Composers, which opened on April 19, 1948, soon resounded with speeches thanking Stalin and Zhdanov for their great service to Soviet music. Four of the six named by the Central Committee failed to turn up, pleading ill health, while the two who were present, Shostakovich and Khachaturyan, said nothing until the Leningrad delegation met and put together an open letter condemning their "conspiracy of silence." On the fifth day, Shostakovich decided that someone would have to speak to avoid reprisals falling on all their heads. His name had been at the top of the guilty list, and he may have felt a sense of responsibility for everyone who was under threat. He delivered a subdued oration similar to the ones he had given in front of Zhdanov in which he acknowledged the party's guidance as correct and vouchsafed that his future compositions would be more melodious and patriotic.

He is said to have looked the picture of misery as he stepped down from the tribune and resumed his place in the hall. This second ordeal may have been less frightening than the first, because he must have known this time that Stalin would not order his arrest and that the intention was to intimidate, humiliate, and then make use of him again; still, it was profoundly depressing. During the grim conference in the Kremlin in January 1948, he learned that the renowned actor Solomon Mikhoels, who in 1944 at a meeting of the Stalin Prize committee had argued eloquently but in vain for that

year's award to go to Shostakovich's Eighth Symphony, was dead, suppos-edly killed in a road accident in Belorussia. In fact, he had been murdered, an early victim of Stalin's anti-Semitic paranoia. Shostakovich joined the mourners visiting the flat of Mikhoels's daughter, Natalya. With his back to the room, he announced, quietly but distinctly, "I envy him."[13] A letter he wrote later the same year reeked of self-contempt; Shostakovich claimed that the mirror showed him a "swollen" face with "purple and puffy" cheeks and "huge bags" under the eyes. "Unfortunately, the ageing of the body seems to be matched by the decay of the mind," he added.[14]

He was barred from teaching, a ban that lasted about a year. Music stu-dents with an eye on self-advancement hastily renounced anything they may have learned from him or any other "formalist." When Shostakovich com-pleted his First Violin Concerto in March 1948, David Oistrakh—who was then comparatively unknown outside the USSR but is now acknowledged worldwide as one of the greatest violinists of the century—looked at the score and pronounced the whole playable without any need for amendments, but no conductor dared perform anything by Shostakovich. Later, he and Ois-trakh performed and recorded the work in private. The first public perfor-mance was held two years after Stalin was dead.

But Shostakovich was too valuable a property to be ignored for long. A Cul-tural and Scientific Congress for World Peace would be held in New York in spring 1949, and Stalin considered it to be in the state's interest to have a re-nowned name among the Soviet delegation. On February 16, it was decided that there would be six delegates, including Shostakovich. Naturally, he was not consulted. A trip to anywhere in the West was bound to be extremely stressful, because he could not avoid being asked questions about the cam-paign the Stalinist authorities had waged against him. Typically, he fretted and prevaricated until March 7, when he wrote to a high-ranking agitprop official pleading that if he must go, Nina should go with him. He forwarded messages Toscanini and others had sent to him offering to organize a con-cert tour while he was in the United States. The decision was, typically, sent up the chain of command to Suslov, who in turn forwarded it to Molotov. Though Molotov was now foreign minister, he was out of favor and could not risk making the wrong decision; he circulated the relevant documents to every member of the Politburo.

On March 16, the composer Yuri Levitin was at the Shostakovich family home when the telephone rang, and Shostakovich was told that Stalin was on the line. Nina ran to the adjoining room to listen on the extension.

Levitin sat in frozen silence on the sofa, hearing only half of the conversation. Yes, Shostakovich said, he was fine, apart from attacks of stomach ache. No, there was nothing he needed. After these opening formalities, there was silence in the apartment as Stalin spoke. Eventually, Shostakovich replied, "Of course I will go, if it's really necessary, but I am in a fairly difficult position. Over there, almost all my symphonies are played, whereas here they are forbidden. How am I to behave in this situation?"

"How do you mean, forbidden? Forbidden by whom?" Stalin asked.

"By the State Commission for Repertoire."[15]

Stalin claimed not to have known about this. He was seventy years old—perhaps he really had forgotten the previous year's order banning the works of Shostakovich and other "formalists." He no longer had his trusted acolyte Zhdanov to remind him; Zhdanov had died in August 1948. Or it is equally possible that Stalin was dissembling to test Shostakovich's reaction.

The next day, Shostakovich wrote to thank Stalin profusely for calling and to promise that he would do what the state required of him.[16] Soon afterward Stalin signed an order that lifted the ban on his work, and Shostakovich's highly publicized visit to New York went unhappily ahead. In his youth, Shostakovich had once named Tchaikovsky and Stravinsky as the two Russian composers he admired most. Igor Stravinsky, living in the States, was invited by the organizers of the World Peace Conference to join more than forty others in signing a telegram welcoming Shostakovich. He refused, and the Soviet press denounced him as a traitor to his homeland. The exiled journalist Nicolas Nabokov, cousin of Vladimir, challenged Shostakovich during a press conference at the Waldorf Astoria in front of a crowd of eight hundred to say whether or not he personally agreed with this condemnation of Stravinsky. Shostakovich replied glumly that he fully agreed with everything the Soviet press was saying. It was a "spectacle of human misery and degradation . . . part of a ritual redemption he had to go through before he could be pardoned again," Nabokov commented.[17]

A happier moment came when Shostakovich's performance of the Scherzo from his Fifth Symphony, in front of eighteen thousand people in Madison Square Garden, was greeted with a deafening ovation.

Though he had done all that the regime asked of him, his troubles at home persisted. He wrote to Stalin on February 16, 1950, asking for a meeting to discuss some "burning issues." He did not say what they were, but there had been some conflict with the authorities over his new oratorio, *Song of the Forests*. After its premiere, in November 1949, Shostakovich fled to his hotel

room, burst into tears, and drowned his sorrows in vodka.[18] There is no record that he and Stalin met, but in July he was allowed to visit Leipzig and was awarded a Stalin Prize later that year. Yet he also was compelled to represent the USSR at peace conferences in Warsaw and Vienna, which he found so irksome that he wore headphones with the sound switched off to spare himself hearing the speeches. In February 1951, he was offered a position as a secretary of the composers' union but wrote to Malenkov, pleading to be allowed to refuse. In May, he nervously performed his *Preludes and Fugues* in front of members of the composers' union, some of whom sat in the front row shaking their heads, scribbling notes, and grimacing disapprovingly. In the discussion that followed, the functionaries in the front row all attacked the work using what one witness described as "mind-bogglingly ghastly bureaucratic clichés." However, Mariya Yudina, a gifted pianist, boldly told these worthies in the front row that Shostakovich's work would live on long after their carping was forgotten. Others in the audience tried to defend Shostakovich but were heckled, and their speeches were omitted from the official record.[19]

Shostakovich was a lover of Jewish folklore, and in October 1948 he completed a new work, *From Jewish Poetry*, that he performed privately for friends but did not even consider offering for public performance. The last of Stalin's manic and paranoid purges was gathering pace. It was set off by Golda Meir, ambassador from the newly created state of Israel, arriving in Moscow and being met by spontaneous celebrations. To Stalin's mind, any spontaneous action was the work of enemies, and he started planning a crime as great as any he had committed before the war. He had thousands of Jews either arrested or fired from their jobs in what is thought to have been a prelude to deporting every Jew in the European states of the USSR east of the Urals. Many of those who were arrested were tortured to extract confessions and then killed. Shostakovich's friend Mikhoels was murdered because of his role in the wartime Jewish Anti-Fascist Committee: Stalin's daughter overheard her father giving the order. When Mikhoels's son-in-law Moisey Vainberg was arrested in February 1953, Shostakovich wrote to Beria attesting to Vainberg's good character. He was not always so brave.

Frightened officials in every industry hunted for Jews to persecute. The film industry had attracted surprisingly few of them, but there was a convenient victim in Leonid Trauberg. Shostakovich had known him since the age of twenty-two. Trauberg and his co-director Grigori Kozintsev had commissioned Shostakovich to provide the score for several films, including *Odna* in

1931, earning Shostakovich his first hit as a songwriter. During the housing shortage that followed the war, Trauberg stayed with the Shostakoviches in Moscow; he and the composer took daily walks to keep fit. In 1948, Trauberg was sacked for being "cosmopolitan" and effectively held under house arrest in Leningrad. One day, he heard that Shostakovich was in the city and rang to ask for a meeting. Shostakovich pleaded that he was too busy but eventually suggested that Trauberg come to his hotel the following day. He arrived to find Shostakovich's room empty: the composer had left Leningrad the previous evening.[20]

It would seem that Shostakovich never recovered from the traumas of 1936 and 1948, and the fear of authority they instilled in him never went away. As an artist, however, he got over it and was able to create as before. Prokofiev never did.

The assault on Prokofiev's reputation hit him all the harder because he had been in debilitatingly poor health for more than two years. Late in 1945, Dmitri Kabalevsky visited Prokofiev in the hospital and found him lying motionless, lapsing in and out of a state of semiconsciousness from a head injury sustained when he had fainted. "With a heavy heart I left him, I thought it was the end," Kabalevsky recalled.[21] After Prokofiev was discharged, he spent weeks under a strict doctors' regime that barred him from working or even playing chess. Illness kept him away from the much-delayed first night of *Betrothal in a Monastery*, a comic opera Mira had persuaded him to write after she had translated the libretto of *The Duenna*, an eighteenth-century English opera by Richard Sheridan. It was a light, escapist work written during the rigors of war.

At the same time, his professional standing in the eyes of Soviet officialdom was higher than it had ever been, with no hint of the blow that was about to fall. He was not blamed for the debacle over *Ivan the Terrible* and even was awarded a Stalin Prize for the score, one of four such prizes conferred on him in 1946 alone. The others were for his Fifth Symphony, Eighth Piano Sonata, and the ballet *Cinderella*, a patchy, war-torn work first performed in November 1945. He won another award in 1947 for his Violin Sonata, played by David Oistrakh in its October 1946 premiere. The prize money and generous subsidies from the composers' union allowed him to live in what counted as opulence in those times, in a dacha on the bank of the river Moscow, outside the city. In June 1945, a truncated version of part one of his monumental opera *War and Peace* opened in Leningrad and ran for fifty performances. The Leningrad premiere of his Sixth Symphony, in October

1947, was so successful that tickets for the first Moscow performance, in December, rapidly sold out. "I had to resort to a ticket profiteer and pay three times the marked price," Alexander Werth recorded.[22] The Moscow audience was ecstatic, but—in a first sign that something was wrong—the following morning's review in *Pravda* was ominously curt.

When Prokofiev received his summons to the conference in the Kremlin, he decided not to go. He was both ill and busy, and, having had so many honors heaped upon him, he may have thought he was invulnerable. Others realized that he was making a dangerous mistake. His son Oleg visited the apartment and overheard Mira's father, Abram Mendelson, berating Prokofiev for his folly. It was said that an official from agitprop was sent to warn him that his absence would not be without consequences. Prokofiev arrived on the second day, inappropriately dressed in a brown suit with baggy trousers tucked into his boots, feeling unwell, and not wanting to be there.[23] His temper could not have improved when he heard Zhdanov utter platitudes such as "Let us not have any smuggling of anti-People formalism under the banner of devotion to our classics" or when the minor composer V.A. Belyi pronounced that Prokofiev "still believes in 'innovation for innovation's sake,' he has an artistic snobbishness, a false fear of being commonplace and ordinary."[24]

Exactly what happened next cannot be verified, because whatever part Prokofiev played in the conference was omitted from the published record. His official biography, published in Moscow in the 1950s, says that he "listened with deep attention to the speeches, especially to the one by A.A. Zhdanov . . . [but] did not participate in the discussions."[25] One of his later biographers, Harlow Robinson, heard rumors that Prokofiev had deliberately created a scene but could not believe that anyone living under Stalin's regime could be so reckless. "Persistent rumours that he behaved truculently have no basis in fact," he concluded.[26] Yet in the 1950s, the Moscow Foreign Languages Publishing House published a bland collection of essays about Prokofiev's life that included a tribute by Shostakovich, who listed five works, all dating from the short period between the war and the meeting in the Kremlin, that had been subject to what Shostakovich, without direct reference to Zhdanov, euphemistically called "sharp criticism." Prokofiev, he noted, "did not change a single note in these works. . . . An artist of strong convictions, he staunchly defended his compositions when he believed them to be unjustly attacked."[27]

There is strong anecdotal evidence that, far from listening to Zhdanov with "deep attention," Prokofiev demonstratively ignored him. One version, told by Ilya Ehrenburg, is that he fell asleep during the lecture, woke with a start,

and loudly asked who this person Zhdanov was. Another version, recounted by two witnesses—the cellist Mstislav Rostropovich and the bureaucrat Tikhon Khrennikov—holds that Prokofiev began a loud conversation with the person sitting next to him. The fearsome Matvei Shkiryatov, who had had such an impact on Mikhail Sholokhov's hometown, was sitting nearby and ordered Prokofiev to pay attention to what Zhdanov was saying. "Who are you?" Prokofiev asked. Shkiryatov retorted that his name was irrelevant but warned Prokofiev to take note of what he said.

"I never pay attention to comments from people who haven't been introduced to me," Prokofiev replied.[28]

Such truculence might have cost Prokofiev his life if he had not had his international reputation to protect him; it was no longer 1940, when an artist of Meyerhold's or Babel's stature could disappear without provoking a reaction abroad, but the authorities could harass him as they harassed Akhmatova by persecuting those close to him. Possibly realizing that he was heading into trouble, he and Mira Mendelson secretly married the same month as the conference in the Kremlin, thus giving her and her family a measure of protection that they would desperately need when the anti-Semitic campaign got under way.

The unintended consequence was that Prokofiev's ex-wife, Lina, still living in Moscow and keeping up the dangerous habit of socializing with diplomats and other Westerners, was left exposed. Her friends included Edmund Stevens, Moscow correspondent for the *Christian Science Monitor*, who noticed sometime during 1948 that he had not seen her for a while. When he rang her home, a frightened voice said that she did not live there anymore.[29] It turned out she had received a telephone call on February 20, 1948, from a friend in Leningrad who told her that another friend was on the train to Moscow that day with a package for her, which she needed to collect from the station. She went reluctantly, because she was feeling unwell, and did not return. Her sons Svyatoslav and Oleg, aged twenty-three and nineteen, were wondering where she was when the police arrived to search the apartment. They went to their father's apartment to break the news of her arrest and appealed to Shostakovich for help, but he pleaded that there was nothing he could do.

Prokofiev had tried to placate the authorities a few days before her arrest by sending a letter to be read aloud at a composers' meeting on February 17 in which he owned up to allowing Western influence to insinuate "formalism" into his early work, writing melodies that were too refined and complicated,

and letting atonality creep into his work. He promised to strive to avoid such mistakes in the future.[30] The humiliation of this act of contrition was made all the worse by its timing, only days after he had learned that Eisenstein was dead. Yet it did not deter speakers at the composers' meeting from virulently attacking his past work.

His doctors allowed him to attend the premiere of his opera *Story of a Real Man* in December 1948 but banned him from staying to hear the discussion that followed. It was left to Mira to listen as the critics ripped the work apart. While posterity generally concurs that the work is inferior to his earlier operas, it was politics rather than musical acumen that fired the critics' virulence—a depressing reminder that the regime was not yet finished with Prokofiev. In the same year, he hoped that his epic two-part opera *War and Peace* might finally be performed, but it was blocked. Prokofiev did not live to see one of his most acclaimed works onstage. It was not until December 19, 1950, almost three years after the attacks on him had begun, that a concert prominently featuring works by Prokofiev was permitted. One of the pieces was a choral work, *On Guard for Peace*; the quality may be inferred from its title. That and the other new piece, *Winter Bonfire*, earned him a 1951 Stalin Prize, a sign that rehabilitation had begun. He also enjoyed a late friendship and musical collaboration with the cellist Mstislav Rostropovich, who was a third his age.

His health was too poor, though, for him to benefit much from this upturn in his fortunes. On the evening of March 5, 1953, he staggered out of his study, nauseated, feverish, and unsteady on his feet, looking for Mira, who helped him to bed. An hour later, he died. His death passed almost unnoticed, with no flowers at his funeral because every flower shop in Moscow had sold out for a much bigger funeral in the same city. Prokofiev had died on the very day that it was announced that Stalin had been found dead, alone, in his Kremlin flat.

15

After Stalin

"I must not perpetually put off giving free expression to my true thoughts."

—BORIS PASTERNAK

Nadezhda Mandelstam had been alone for fifteen years, eking out a living wherever the authorities allowed her to settle, when a shocked and almost hysterical neighbor in Ulyanovsk burst in with the news that Stalin was dead. She feared for the excited woman's safety—to be wrong would have been dangerous—but the radio confirmed the news. As she listened to the broadcast, Nadezhda experienced "a joy such as I had never known before in my whole life." Yet it was to be another lonely day.

Arriving at work, she found a hallway packed with sobbing people; one wailed that it was like losing her father. Such scenes were repeated across the vast Soviet Empire. Children returned from school in tears over the loss of someone they had been told was a kindly ruler who loved children. Adults who were not grief stricken may have thought it expedient to pretend to be. Others had been through so much trouble and violence that any sudden news made them fearful. When there was no one else to overhear, Nadezhda Mandelstam snapped at the local dressmaker, "What are you howling for?" The dressmaker replied that she was used to Stalin—whoever replaced him might be worse.[1]

Actually, there was no danger of things getting worse. Even those in the highest reaches of the communist party knew that they could not continue living in a system of terror so arbitrary that even a Politburo member could disappear overnight without anyone daring to ask questions. The revolting

Lavrenti Beria actually tried to reinvent himself as a reformer until his colleagues overcame their fear and conspired to have him arrested and shot. With his death, the possibility opened up for millions of people to have their freedom or posthumous reputations restored. Prokofiev's widow, Lina, was one of hundreds of thousands released from the camps. Reunited with her sons after eight years of imprisonment, she died in Paris at the age of ninety-two.

In 1955, Nadezhda Mandelstam decided that it was safe to return to Moscow and submit a request for her husband to be added to the list of those rehabilitated. She was staying with Viktor and Vasilya Shklovsky, the remarkable couple who had managed to survive honorably through the whole of the Stalin years, when she received confirmation that Osip was dead. The only person to take the trouble to visit her to offer condolences was, typically, Boris Pasternak.

For Isaac Babel's widow, Antonina Pirozhkova, the wait was longer and more cruel. Beria had never allowed the execution of Yezhov and all who died with him to be made public. Pirozhkova was originally told that her husband had been sentenced to ten years "without the right to correspond." She suspected this was a euphemism for execution but was assured that it was not. Yet the same official advised her, "You need to get your life in order."[2] She continued her work as the only female engineer employed on the construction of the Moscow subway and later as a lecturer in engineering. Papers seized when Babel was arrested were never recovered. His old room in their flat, which had been sealed by his arresting officers, was kept locked for two years, until it was allocated to a drunken, disgraced former NKVD officer, who despised Pirozhkova as the wife of an enemy of the people. She had to share the apartment for seventeen years, an arrangement that ended only when he died of a heart attack. For several years, she availed herself of one of the few rights relatives of the disappeared possessed: she regularly went to an NKVD office to drop a written request for news of Babel into a special mailbox, returning on an appointed day to have a written response handed to her through a grill. Each time, she read that he was alive. In 1947, she read that he would be released in 1948, but when that year came she was given only a short note saying that he was alive. After that, she gave up these annual inquiries. In 1952, she was contacted by a man recently released from a labor camp on the Kolyma River who claimed to have seen Babel in the camp. She later assumed he had been sent by the authorities, presumably to avoid the damage it would do to the USSR's international reputation to admit that they had murdered Babel.

Early in 1954, she appealed for Babel's case to be reopened. After a wait of about five months, she was summoned and told by a sympathetic official that Babel had obviously been falsely accused. This meant so much to her that she almost passed out. Afterward she rushed to share the good news with Ilya Ehrenburg, but when he tried to warn her that Babel might be dead, she burst into tears. He hastily assured her that he was only speculating. About six months later, in December, she was summoned to the office of the Military Collegium, the main military court, to be handed a document informing her that Babel's case had gone to a military tribunal and he had been cleared of all charges. But when she asked to see him, the man behind the desk wrote on a scrap of newspaper that Babel had died of heart failure on March 17, 1941, silently showed her what he had written, and then tore the scrap into small pieces and threw it away. Yet she had been told so many times that he was alive that she refused to abandon hope and appealed to Marshal Voroshilov for help. A message came back from Voroshilov's office telling her that she would have to accept that her husband was dead. In 1984, a notice marking Babel's ninetieth birthday moved his date of death forward one year, to 1940, after Pirozhkova was told this new date had come "from official sources."[3] He had been dead for half a century before she and the world at large learned how and why he was killed. Pirozhkova died in Florida in September 2010, aged 101.

The high point of the thaw, as this short period was known, came on February 25, 1956, when Nikita Khrushchev delivered his Secret Speech to the twentieth party congress, shattering the pretense that all past abuses had been the work of rogue officials. For the first time, the party's first secretary told his hushed audience that Stalin had personally condemned innocent people to imprisonment, torture, and execution. The speech naturally alarmed high-ranking officials who had been complicit in Stalin's crimes. Some hastily reexamined their lives and discovered that they had been struggling against Stalin's "cult of personality" all along, but one culprit who did not take refuge in hypocrisy was Alexander Fadeyev, the old head of the USSR Writers' Union.

Fadeyev was a complex character, equally capable of writing secret letters naming all the Jews in the union to set them up for expulsion and weeping with emotion over the destruction of that wonderful Jewish poet Osip Mandelstam. After hearing the Secret Speech, Fadeyev wrote an appeal to the authorities praising Anna Akhmatova as a poet and a patriot and urging them to release her son from the gulag. She was so grateful that she gave him her

book of translations, inscribed "to a great writer and a good person."[4] In May, he got drunk, wrote a suicide note, and shot himself. Boris Pasternak went to his funeral and was overheard saying, "Alexander Alexandrovich has rehabilitated himself."[5] Pasternak later imagined Fadeyev's last moments: "With that guilty smile which he managed to preserve through all the cunning intricacies of politics, he could bid farewell to himself at the last moment before pulling the trigger with, I should imagine, words like these: 'Well, it's over! Goodbye Sasha!'"[6]

Pasternak had been working for years on what he hoped would be his greatest literary achievement, a novel, which at some point gained the title *Doctor Zhivago*, that he hoped would capture the experience of his generation. He had accepted an advance payment back in 1935, but progress was slow, even without the interruption of war; he grappled helplessly with the problem of what he could write that would be both truthful and printable. He returned to the work after the war, less concerned about what he could get past the censors and more focused on the truth. "This is a very serious work. I am already old, soon, perhaps, I shall die, and I must not perpetually put off giving free expression to my true thoughts," he wrote to his cousin Olga Freidenberg in October 1946.[7] He had made up his mind not to be distracted by critics or agents of the state, even if their attacks threatened his livelihood. "I have taken an enormous step in life, which brings me to a point where trifles, shadings, accents, transitions, half-tones and other secondary considerations no longer can hurt or delight or even exist for me, a point where one must win or lose on a grand scale—all or nothing!" he told Freidenberg.[8] He was investing everything in the masterpiece that would make him immortal.

By the end of 1946, the first two chapters were ready and Pasternak was reading them aloud to select groups of friends, including Anna Akhmatova on one occasion. He had signed a contract with the magazine *Novy mir* for an eighty-thousand-word novel to be completed by the following August. One "changeable October day," he visited the magazine's office and was introduced to the assistant editor responsible for new authors, Olga Ivinskaya, twenty-two years his junior, who gazed awestruck at this man whose poetry had inspired her since childhood. Ivinskaya's reputation is mixed at best and her memoirs are not wholly reliable; Pasternak's biographers generally sympathize with his levelheaded wife, Zinaida, who was with him through the worst of the Stalin years, rather than the starstruck youngster. However, there is no doubt that she adored Pasternak. "What happiness, and horror, and turmoil

he was to bring into my life, this man," she recalled.[9] Their affair lasted for a little less than three years, until Pasternak ended it for Zinaida's sake. "I formed a deep relationship, but since my relationship with Zina is a genuine one, sooner or later I had to sacrifice the other," he wrote to Freidenberg on August 7, 1949. That November, Ivinskaya was arrested. The reason is not wholly clear; while her case was linked to that of a colleague accused of embezzlement, Pasternak was convinced that she was paying for her association with him.

After Stalin's death, Pasternak saw how people had stopped disappearing, and some of those who had disappeared were returning. He was delighted when Marina Tsvetayeva's daughter, Ariadna, reappeared after eighteen years in exile, without having "lost her spirit or sense of humour."[10] Olga Ivinskaya's return in October 1953 was more problematic: she wanted to resume their relationship, which he felt he owed her because of her lost years in the gulag, despite the obvious distress that it caused Zinaida. "This tendency to form an attachment, of which I am only too conscious as the only definite thing about my character, is so powerful in me that it takes the place of work and seems to be my profession," he confessed.[11]

Ten poems from *Doctor Zhivago* were published in 1954, setting off talk in literary circles in the USSR and abroad about the forthcoming novel. Pasternak, typically, was not confident that the finished work was the masterpiece he hoped it would be, but Tsvetayeva heard a rumor that he was in line for a Nobel Prize. So had the Soviet authorities, who were lobbying for the prize to go to Sholokhov instead. Finally, late in 1955, Pasternak handed the completed manuscript of *Doctor Zhivago* to *Novy mir*. In May 1956, in the sunny political atmosphere that followed Khrushchev's Secret Speech, the novel's existence was mentioned in an Italian-language broadcast on Moscow Radio, which ran services in all the main European languages. A few days later an Italian communist named Sergio d'Angelo visited Peredelkino to interview Pasternak. As the journalist was leaving, Pasternak handed him a copy of the manuscript, reportedly commenting, "You have invited me to take part in my own execution."

In September, after months of delay, the editorial board of *Novy mir* reached a decision: Pasternak's description of the civil war lacked a clear ideological perspective and *Doctor Zhivago*'s central character was too individualistic; therefore, they would not publish the novel. The possibility remained that the state publishing house, Goslitizdat, would publish it in a single volume, but the political atmosphere in Moscow suddenly darkened because of the pop-

ular rising in Hungary, which was brutally put down after Red Army tanks rolled into Budapest in November 1956. The crisis set off a desperate power struggle at the top of the communist party between Khrushchev and the hard-line Stalinists, paralyzing decision making in the middle ranks. When Ivin-skaya went to lobby Dmitri Polikarpov, the official at Agitprop in charge of cultural issues, he looked "haggard, rather frightened and prematurely aged."[12] He passed the buck to the head of Goslitizdat, Anatoli Kotov, who seemed keen to publish. A contract was signed with Pasternak in January 1957; a sympathetic editor was appointed to see the novel into print; and a request went out to Giangiacomo Feltrinelli, the rich, young, and communist publisher preparing an Italian translation, asking him to postpone publication until September so that the Russian edition could come out first. He agreed. Then Kotov died suddenly.

Meanwhile, the new head of the USSR Writers' Union, Alexei Surkov, moved into action. He was intent on proving himself worthy of his new job by barring publication of *Doctor Zhivago* anywhere in the world. (This may have been a form of personal revenge: Surkov was a poet by profession but very much inferior to Pasternak.) In what looks like an act of cowardice, instead of sending for Pasternak to explain himself, he had Ivinskaya hauled in front of the union's secretariat to find out what she knew about her lover's motive for sending his manuscript abroad. He also traveled to Italy to try to persuade Feltrinelli to abandon the project. Instead, Feltrinelli resigned from the Communist Party, and *Doctor Zhivago* appeared in Italian translation on November 15, 1957. Feltrinelli also licensed translations into eighteen other languages, creating an international publishing sensation.

Pasternak had been under consideration for a Nobel Prize for several years. The 1957 laureate, Albert Camus, mentioned him in his acceptance speech and nominated him for the 1958 prize, before the *Doctor Zhivago* furor began. On October 23, 1958, Pasternak was declared that year's literature laureate, the first Russian winner other than the émigré Ivan Bunin since the prize was inaugurated. *Doctor Zhivago* was not mentioned in the citation, but directly afterward the U.S. secretary of state, John Foster Dulles, delivered a speech in which he expressed his satisfaction that a novel suppressed in the Soviet Union could receive such high recognition in the free world, thus elevating its author into a reluctant symbol of resistance, a hero of the Cold War.

Pasternak, who was sixty-eight years old and in poor health, was ordered to appear before the secretariat of the USSR Writers' Union on October 27. He had already been warned that he was liable to be expelled from Russia, a

prospect he dreaded. He could not face the meeting but submitted a letter suggesting that the prize should be a source of national pride, offering to donate the prize money to the Peace Fund, and begging them not to reach a decision in haste. It was in vain, of course. He was expelled from the writers' union. The greater threat that he might be deported still hung over him.

Two days later, his son came upon him looking gray, disheveled, and "unrecognizable," with pains shooting down his left arm and shoulder.[13] Pasternak told his son that he had sent a telegram to Sweden that morning turning down the prize. Yet that sacrifice did not stop his tormentors. A general meeting of Moscow writers upheld the decision to expel him and sent a request to the Supreme Soviet to strip him of his citizenship. It was normal for such resolutions to be unanimous, but one woman in her sixties dared to shout out that she was opposing the motion. It was Anna Redens, the older sister of Stalin's late wife, Nadezhda Alliluyeva; Redens had been recently released after nearly a decade in the gulag. She remained grateful for the note that Pasternak had written to Stalin after Nadezhda's suicide.[14]

These events were being followed from afar by Alexander Solzhenitsyn, a gulag survivor who had found work as a teacher and was bitterly disappointed that Pasternak did not continue the fight to the finish. "I measured him against my own intentions, by my own standards, and writhed with shame for him as though for myself," he wrote. "How could he let himself be frightened by mere newspaper abuse, how could he weaken when faced with the threat of exile from the USSR, demean himself by pleading with the government, mumble about his 'mistakes and aberrations' about the novel's 'embodying his own guilt,' repudiate his own thoughts, his innermost self—all just to escape exile?"[15]

Pasternak, it is true, did not demonstrate the kind of courage that Solzhenitsyn threw in the face of Soviet authorities a decade later, but then he had never wanted to be a political celebrity. He wanted people to know him through his work. All his life he had stayed true to himself and loyal to others with the quiet courage of someone whose nature revolted at the idea of behaving dishonorably. By 1958, he was old and unwell. He had completed his life's work. He did not need the kudos or the money that came with a Nobel Prize and could not bear the thought of having to spend what time was left to him as an exile in a strange country. He had also outwitted the authorities, who could not prevent *Doctor Zhivago* from being one of the world's most widely read novels or being turned into a blockbuster film. The strength of the international reaction to his Nobel refusal—including a reproving tele-

phone call to Khrushchev from India's prime minister, Jawaharlal Nehru, whose goodwill was immensely important to Moscow as relations with China deteriorated—warned the Soviet authorities to take no further action against the aging writer. Pasternak was left undisturbed in his Peredelkino dacha, living in a kind of political limbo. He died on May 30, 1960, an end possibly hastened by the stress of the previous seventeen months. In an act of posthumous spite, the authorities then arrested Olga Ivinskaya and sentenced her to another eight years in the camps. She was released in 1964. *Doctor Zhivago* would not be published in Russia until 1988.

In 1961, Khrushchev launched a second phase of de-Stalinization by denouncing Stalin's abuses of power again—this time not in a secret speech but publicly. Stalin's body was removed from the mausoleum in Red Square, where it had lain alongside Lenin's, and cities and streets that had taken his name, such as Stalingrad, were renamed. Shostakovich's Fourth Symphony had its belated premiere in December 1961. The following year, a revised version of *Lady Macbeth of Mtsensk* was performed under the new title *Katerina Izmailova*. Alexander Solzhenitsyn's sensational story about life in the gulag, *One Day in the Life of Ivan Denisovich*, was published in November 1962. Inevitably, neo-Stalinists in the higher echelons fought back. Feeling the pressure, Khrushchev visited an exhibition of modern art in Moscow in December and exploded with anger, describing the works as "shit." One phase in the liberalization of the regime ended there.

It was in this interlude that Osip Mandelstam broke posthumously into print. Four of his poems appeared in an almanac in 1962. With these poems, Nadezhda Mandelstam noticed that he was finding a new audience and wondered who these readers were. The most distinguished of them, the young poet Joseph Brodsky, made a pilgrimage to her flat in Pskov, where she lived in a single room

eight square metres large, the size of an average American bathroom. Most of the space was taken up by a cast-iron twin-sized bed; there were also two wicker chairs, a wardrobe chest with a small mirror, and an all-purpose bedside table, on which sat plates with the leftovers of her supper and, next to the plates, an open paperback copy of *The Hedgehog and The Fox* by Isaiah Berlin . . . a small woman of slim build, and with the passage of years she shrivelled more and more, as though trying to turn herself into something weightless, something pocketed in the moment of flight. Similarly, she had virtually no possessions: no furniture, no art objects, no library.

Later, in her "years of affluence," she indulged herself with one luxury: a cuckoo clock on her kitchen wall.[16]

Brodsky learned something remarkable on his visit: all of Mandelstam's poetry had been preserved. His life's work, including poetry that had never been published, was stored somewhere the police could never find: in this extraordinary woman's memory, along with most of the poetry of Anna Akhmatova. When she was seventy-two years old, Nadezhda Mandelstam warned an American journalist, "Don't get me started, I can recite poetry for three hours without stopping." She then rattled off from memory ten variations of one of her late husband's longer poems.[17]

In her seventies, Nadezhda Mandelstam created a sensation with two volumes of memoirs that circulated by hand in the USSR and were published abroad. A formidable tribe of Soviet widows had emerged since Stalin's death to battle for their husbands' posthumous reputations. Anna Akhmatova half-mockingly called Nadezhda "the luckiest widow" because, in her own extraordinary way, she had beaten the system. She died at the age of eighty-one in December 1980. By then, Osip Mandelstam had been cleared of the charges on which he was sent to his death in the gulag but not of the charge on which he was first arrested in 1934. Eventually that, too, was rescinded, on October 28, 1987. If not the luckiest, Nadezhda Mandelstam was undeniably one of the most formidable of the widows.

Another widow, Yelena Bulgakova, had preserved her husband's manuscripts and lived to see him find a new readership during the last flicker of liberalism that followed the fall of Khrushchev, more than a quarter of a century after Mikhail Bulgakov's death. An abridged and censored version of *The Master and Margarita* first appeared in a literary journal in 1966 and 1967. It was published in full in 1973, along with two other novels, *The White Guard* and *Black Snow*.

By then, the Soviet system had entered into a long period of stagnation. One of the few visible signs of political dissent was the activity of dissidents such as Solzhenitsyn, who risked prison or exile by demanding the right of free expression. Dmitri Shostakovich was an ambiguous figure for the time. His neighbors and close friends the cellist Mstislav Rostropovich and the singer Galina Vishnevskaya—two of the greatest interpreters of his music— sacrificed their careers by siding with the dissidents. Pavel Litvinov, son of Shostakovich's dear friend Flora Litvinova, was sent to the gulag in 1968 for organizing a demonstration against the Soviet occupation of Czechoslovakia. Shostakovich put his head over the parapet after Khrushchev's intemperate

outburst at the Moscow art exhibition: he was one of seventeen eminent artists who signed a collective letter warning against a relapse to "previous methods," a coded attack on the neo-Stalinists who seemed to want to revive the terrors of the past. He also took a calculated risk with his Thirteenth Symphony, which had its premiere a few days after Khrushchev's outburst and was based on five works by the young poet Yevgeni Yevtushenko, including a poem titled "Babi Yar"—the name of a ravine on the outskirts of Kiev where nearly 34,000 Jews were murdered by the Nazis. To remind the Soviet public of the Holocaust when Israel was allied with NATO and members of the USSR's diminished Jewish population were campaigning for the right to emigrate was a provocation. Yevgeni Mravinsky, who had conducted almost all of Shostakovich's works since the premiere of the Fifth Symphony, refused to handle the Thirteenth.

The symphony was an unusual act of public courage for Shostakovich. Generally, he lived a life of outward conformity. After the early death of his strong-willed wife Nina Varzar in 1954, he married a young communist named Margarita Kainova, whom none of his friends seems to have liked. That relationship ended in 1958. His third marriage, to Irina Supinskaya in 1962, was a success. Meanwhile, in 1960, with obvious reluctance, he gave in to pressure to join the Communist Party and in April of the same year was made first secretary of the newly founded Union of Composers for the Russian Republic. His reaction to being drawn into the *nomenklatura* was similar to Pasternak's in 1935: he very nearly had a nervous breakdown. His lifelong friend Isaak Glikman saw him in Leningrad in June 1960, after these concessions, and recalled, "I was struck by the lines of suffering on his face, and by his whole air of distress. He hurried me straight into the little room where he had slept, crumpled down on to the bed and began to weep, with great aching sobs."[18] His therapy was his now-famous Eighth Quartet, which he composed at frantic speed during a visit to Germany in July 1960. He described it to Glikman as an "ideologically flawed quartet" written as his own musical obituary when he was prey to thoughts of dying.

He did not withdraw from public life as Pasternak had done, however, and continued outwardly to do what was required of an eminent Soviet citizen. In August 1973, when the Soviet press was running a virulent campaign against the outspoken nuclear physicist Andrei Sakharov, *Pravda* published a letter with the heading "He Disgraces the Calling of Citizen" bearing the signatures of twelve musicians and composers, including Shostakovich. This act of civic cowardice so shocked his friends Rostropovich and Vishnevskaya

that they refused to say good-bye to Shostakovich when they were driven into exile the same year. When Shostakovich died on August 9, 1975, he was granted a state funeral at which his former tormentor Khrennikov delivered the main address and the entire Politburo, headed by the general secretary, Leonid Brezhnev, signed a tribute to "a loyal son of the Communist Party."[19]

There his reputation might have rested but for a sensational publishing event in 1979. The New York publishing house Harper and Row published what were purported to be Shostakovich's memoirs, dictated to and edited by Solomon Volkov, a journalist who had recently emigrated from the USSR. The Shostakovich portrayed in these memoirs was an inveterate anticommunist with scathing opinions of the system and of its toadies who was so courageous that on one occasion, while in Stalin's presence, he spoke up in defense of an arranger who was being denounced by Alexander Alexandrov, the head of the Red Army ensemble. The book, titled *Testimony*, was instantly and predictably denounced in the USSR as a fabrication and set off a furious academic dispute in the West. Laurel Fay, one of the West's leading specialists in contemporary Russian music, went through it meticulously and suggested that its real author was not Shostakovich but Volkov. This produced a vehement counterreaction in which Volkov's defenders came close to denouncing Fay as a Soviet collaborator. The Volkov camp was reinforced when Shostakovich's son Maxim arrived in the West and, clearly preferring Volkov's portrayal of his father to the official Soviet one, attested to the memoirs' authenticity.

Despite their dubious antecedents, the memoirs performed a public service. As long as Shostakovich was seen as a "loyal son" of the USSR, his reputation as an artist suffered in the West, where he was regarded as the poor fourth member of a quartet of great Russian composers: Stravinsky, Rachmaninoff, Prokofiev, and Shostakovich. *Testimony*—which the critic Wendy Lesser has aptly likened to a badly conducted interview from which the reader struggles to identify "the feeble efforts of the speaker's voice to make itself heard over the static generated by the interviewer's biases"—at least added another dimension to the West's image of what sort of man the enigmatic Shostakovich really was, reviving interest in his music.[20] During his centenary year, in 2006, there were more performances of Shostakovich's work in the UK than anywhere in the world outside of Russia. But to classify Shostakovich as a "dissident," as Volkov attempted to do, almost insults the courageous small band of genuine dissidents who risked prison, exile, or internment in a psychiatric hospital in their struggle with the communist dictatorship. Shostakovich frankly described himself as a "coward," with some justification: when

his second marriage disintegrated, he dispatched his son Maxim to tell Margarita that the relationship was over rather than handle it himself. The trauma of the campaign against *Lady Macbeth of Mtsensk* instilled in him a lifelong habit of concealing what he really thought behind a thick mask of irony, which is perfectly illustrated in one of his letters to Isaak Glikman:

> I arrived in Odessa on the day of our nationwide holiday celebrating the 40th anniversary of the founding of Soviet Ukraine. This morning I went out in the streets; you will understand of course that on such a day as this, one cannot stay at home. . . . Everywhere were portraits of Marx, Engels, Lenin, Stalin, and also Comrades A.I. Belyayev, L.I. Brezhnev, N.A. Bulganin, K.Ye. Vorshilov, N.G. Ignatov, A.I. Kirilenko, F.P. Kozlov, O.V. Kuusinen, A.I. Mikoyan, N.A. Mukhtidinov, M.A. Suslov, Ye.A. Furtseva, N.S. Khrushchev, N.M. Shvernik, A.A. Aristov, F.A. Pospelov, Ya.E. Kaliberzin, A.P. Kirichenko, A.N. Kosygin, K.T. Mazurov, V.P. Mzhavanadze, M.G. Pervukhin, N.T. Kalchenko.
>
> The streets are filled with flags, slogans, banners. All around can be seen beaming smiles on radiantly happy Russian, Ukrainian and Jewish faces. On every side can be heard joyful exclamations hailing the great names of Marx, Engels, Lenin, Stalin, and also Comrades A.I. Belyayev, L.I. Brezhnev, N.A. Bulganin, K.Ye. Vorshilov, N.G. Ignatov, A.I. Kirichenko, F.P. Kozlov, O.V. Kuusinen, A.I. Mikoyan, N.A. Mukhtidinov, M.A. Suslov, Ye.A. Furtseva, N.S. Khrushchev, N.M. Shvernik, A.A. Aristov, F.A. Pospelov, Ya.E. Kaliberzin, A.P. Kirilenko, A.N. Kosygin, K.T. Mazurov, V.P. Mzhavanadze, M.G. Pervukhin, N.T. Kalchenko.[21]

If Shostakovich's letter were seen by the police, they could hardly make a case against him for pedantically copying out the entire membership of the presidium of the Central Committee, as *Pravda* did with dreary frequency— yet he was obviously poking fun. The writer Richard Taruskin drew attention to what was surely a deliberate error: in the second list, Shostakovich transposed the initials of the Ukrainian bureaucrats Kirichenko and Kirilenko as if they were indistinguishable, like Dobchinsky and Bobchinsky in Gogol's *The Inspector General*. What no one appears to have spotted is that Shostakovich also twice misspelled the name of the Latvian party boss Yan Kalnberzin. As Shostakovich wrote it, it can be broken into three parts: Berzin is a Latvian surname, *i* is Russian for "and," and *kal* means "excrement."

A few weeks earlier, he had perpetrated an even more subversive parody, after hearing Dmitri Shepilov, in his capacity as the Communist Party's

leading cultural authority, deliver a speech to the second congress of Soviet musicians in April 1957 in which he mispronounced the name of Rimsky-Korsakov as Kor-SAK-ov. This inspired Shostakovich to write his *Antiformalist Rayok*, a tribute to Modest Petrovich Mussorgsky's *rayok*, a knockabout satire lampooning all of Mussorgsky's enemies. Shostakovich's version featured three Soviet leaders, Edinitsyn, Dvoikin, and Troikin (One, Two, and Three), singing warnings against anti-people composers. The trio were transparently modeled on Stalin, Zhdanov, and Shepilov.

In public, Shostakovich played the part of a loyal son of communism, a member of the Supreme Soviet who read out speeches that had been written for him and allowed his name to be added to proclamations that he may not even have bothered to read. Privately, it appears he thought the communist system was cruel, absurd, and ripe for satire. Alexander Solzhenitsyn caustically observed how "that shackled genius Shostakovich would thrash about like a wounded thing, clasp himself with tightly folded arms so that his fingers could not hold a pen . . . that tragic genius, that pitiful wreck Shostakovich."[22]

If Shostakovich had shared Solzhenitsyn's temperament, hardened by years in the gulag, perhaps he would have ceased compromising, thrown away his privileges, and in a series of magnificent gestures denounced the system he privately despised—but should we wish that he had? A composer's place in society is not like a novelist's or a poet's. A writer can work alone, in secret if necessary, and make private arrangements for his work to be circulated and preserved if the authorities do not approve, but a composer must have musicians, instruments, a venue, and an audience to fill that venue for his work to have any meaning. A film director's situation is similar. Shostakovich, like Eisenstein, had to either arrive at an accommodation with the regime or abandon his vocation. By creating this hypocritical outer crust in the shape of a dumbly loyal Soviet apologist, Shostakovich kept the dictatorship at a distance and allowed himself the space to create a body of work that continues to delight audiences long after the communist system fell apart.

That leaves us with the question of why this appalling regime was host to such an extraordinary range of creative talent. There were stable democratic states that allowed their citizens fully free self-expression but could not produce one artist of the stature of a Shostakovich, a Bulgakov, an Akhmatova, or a Pasternak. A disproportionate amount of the great art of the twentieth century came from a regime where to think freely was to risk death. The question this raises is, Why did they persist? Why would Osip Mandelstam spend his life composing poems he could recite only to trusted friends, with-

out any prospect of getting them published? Why did Shostakovich not simply give up composing after the trauma of the suppression of his first opera?

We do not need to look far for the answer. In our time, we are used to hearing performers pay platitudinous tributes of doubtful sincerity to their audiences, but the underlying truth that it is the audiences who inspire the art remains. In the century before the Bolshevik revolution, educated Russians developed an intense love for great art and accurate taste in distinguishing between what would last and what was rubbish. That public was still present after the revolution, when the hardships of everyday life and the pervasive fear of arrest increased the need for emotional release. We read of audience members at performances of Bulgakov's first play weeping or fainting. "Concerts of Shostakovich's music were distinguished by an atmosphere of incredible festivity," Natalya Vovsi-Mikhoels, daughter of the murdered actor, recalled. "We all had the feeling that we were present at some kind of mystery. At the end, there was a moment of hushed silence, then the hall exploded into ovations."[23] Even the hard-to-please Solzhenitsyn conceded, "Shostakovich steals into our souls."[24] Poetry recitals by Boris Pasternak—a shy, self-critical artist who never wanted to be a celebrity—had a similar impact: after one recital, "Pasternak was surrounded by the crowd, a handkerchief belonging to him was torn to shreds, and the remaining crumbs of tobacco in his cigarette butts were snatched up."[25] And remember the treacherous Fadeyev weeping at the poetry of the doomed Osip Mandelstam.

It was this faith in a reading public that gave the dying Bulgakov the impetus to write the most popular Russian novel of the twentieth century, even though he knew the manuscript would have to remain hidden from the police for the rest of his life. In *The Master and Margarita*, the devil remarks— or Bulgakov boasts, by having his satanic creation say it for him—that "manuscripts don't burn." It was a remarkably self-confident prediction, but it was true.

Notes

Note: where a Russian-language source is cited, the translation is my own unless another translator is named.

Introduction

1. Roberta Reeder, *Anna Akhmatova: Poet and Prophet* (London: Allison and Busby, 1995), 107–8.
2. Israel V. Nestyev, *Prokofiev*, trans. Florence Jonas (Stanford, CA: Stanford University Press, 1960), 135.
3. Alexander Solzhenitsyn, *The First Circle*, trans. Michael Guybon (London: William Collins Sons, 1969), 439–40.
4. Simon Sebag Montefiore, *Young Stalin* (London: Phoenix, 2008), 47.
5. Mikhail Bulgakov, "Moliere," in *Six Plays*, trans. Michael Glenny (London: Methuen, 1991), 251–52.

1. Eisenstein in the Jazz Age

1. Sergei M. Eisenstein, *Selected Works*, vol. 4, *Beyond the Stars: The Memoirs of Sergei Eisenstein*, ed. Richard Taylor and trans. William Powell (London: BFI Publishing, 1995), 434.
2. Interview with Eisenstein in *Cinemonde*, December 1929, quoted in Marie Seton, *Sergei M. Eisenstein* (New York: Grove Press, 1960), 30.
3. Eisenstein, *Beyond the Stars*, 67.
4. Ibid., 72.
5. Nadezhda Mandelstam, *Hope Abandoned*, trans. Max Hayward (London: Collins and Harvill, 1971), 15.

6. Ivor Montagu, *With Eisenstein in Hollywood* (Berlin: Seven Seas Books, 1974), 14.

7. Eisenstein, *Beyond the Stars*, 263.

8. Ibid., 449, 447.

9. Ibid., 447, 106.

10. Norman Swallow, *Eisenstein: A Documentary Portrait* (New York: E.P. Dutton, 1977), 40.

11. Viktor Shklovsky, *On Eisenstein, 1898–1948*, trans. Benjamin Sher (1991), www.websher.net/srl/shk-eis-14point.html.

12. Sergei M. Eisenstein, *Eisenstein's Writings*, vol. 1, trans. Richard Taylor (London: BFI Publishing, 1988).

13. V.I. Lenin, *Collected Works*, trans. David Skvirsky and George Hanna (Moscow: Progress Publishers, 1971), 42:388–39.

14. Richard Taylor and Ian Christie, *The Film Factory: Russian and Soviet Cinema in Documents* (Cambridge, MA: Harvard University Press, 1988), 57.

15. Jay Leyda, *Kino: A History of the Russian and Soviet Film* (London: George Allen and Unwin, 1973), 185.

16. E.H. Carr, *Socialism in One Country, 1924–1926* (London: Macmillan, 1958), 1:423.

17. Eisenstein, *Beyond the Stars*, 150–52.

18. Ibid., 158.

19. Ibid., 168.

20. Swallow, *Eisenstein*, 49–50.

21. Orlando Figes, *A People's Tragedy: The Russian Revolution, 1891–1924* (London: Pimlico, 1997), 767.

22. Richard Hough, *The Potemkin Mutiny* (Geneva: Heron Books, n.d.), 180, 209.

23. Waclaw Solski, "The End of Sergei Eisenstein: Case History of an Artist Under Dictatorship," *Commentary*, March 1949, 253.

24. Quoted in Ronald Bergan, *Eisenstein: A Life in Conflict* (New York: Overlook, 1999), 118.

25. Mandelstam, *Hope Abandoned*, 341–42.

26. Shklovsky, *On Eisenstein*.

27. Leyda, *Kino*, 237.

28. Taylor and Christie, *Film Factory*, 229.

29. Eisenstein, *Beyond the Stars*, 563.

30. Leyda, *Kino*, 238.

31. Simon Sebag Montefiore, *Stalin: The Court of the Red Tsar* (London: Phoenix, 2004), 2.

32. Alexander Barmine, *One Who Survived: The Life Story of a Russian Under the Soviets* (New York: G.P. Putnam's Sons, 1945), 257.

33. Eisenstein, *Beyond the Stars*, 25.

34. Viktor Shklovsky, "Mistakes and Inventions," in Taylor and Christie, *Film Factory*, 183.

35. Shklovsky, *On Eisenstein.*

36. Moshe Lewin, *The Making of the Soviet System: Essays in the Social History of Interwar Russia* (London: Methuen, 1985), 97.

37. Comments by Bukharin in private conversation with Leo Kamenev, reported in Stephen Cohen, *Bukharin and the Bolshevik Revolution* (New York: Vintage, 1975), 291.

38. Eugene Lyons, *Assignment in Utopia* (London: George G. Harrap and Co., n.d.), 383–84.

39. Quoted in Leyda, *Kino*, 268–69.

40. Ronald Bergen, *Eisenstein: A Life in Conflict* (New York: Overlook Press, 1999), 151.

41. Sergei Eisenstein, Vsevolod Pudovkin, and Grigori Alexandrov, "Statement on Sound," in Taylor and Christie, *Film Factory*, 234–35.

2. The Hooligan Poet and the Proletarians

1. Max Eastman, *Artists in Uniform: A Study of Literature and Bureaucratism* (New York: Knopf, 1934), 63.

2. Ivan Bunin, *Cursed Days: A Diary of Revolution*, trans. Thomas Gaiton Marullo (London: Phoenix, 2000), 117.

3. Wiktor Woroszylski, *The Life of Mayakovsky*, trans. Boleslaw Taborski (New York: Orion Press, 1970), 16.

4. Vladimir Mayakovsky, "Lyublyu," in *The Bedbug and Selected Poetry*, ed. Patricia Blake (Bloomington: Indiana University Press, 1960), 154.

5. Woroszylski, *Life of Mayakovsky*, 20.

6. Viktor Shklovsky, *Mayakovsky and His Circle*, trans. and ed. Lily Feiler (London: Pluto, 1972), 10.

7. Vladimir Mayakovsky, "Neskol'ko slovo obo mne samom" [A few words about myself], in *Bedbug and Selected Poetry*, 58.

8. Alexander Pasternak, *A Vanished Present: The Memoirs of Alexander Pasternak*, ed. and trans. Ann Pasternak Slater (Ithaca, NY: Cornell University Press, 1989), 156–58.

9. David Burliuk, "Reminiscences of Mayakovsky," in *Mayakovsky, 1894–1930*, *American Quarterly on the Soviet Union* 3, no. 1 (July 1940).

10. Woroszylski, *Life of Mayakovsky*, 30–31.

11. Ibid., 47–48.

12. Ibid., 293.

13. Ibid., 144–50.

14. Leonid Pasternak, *The Memoirs of Leonid Pasternak*, trans. Jennifer Bradshaw (London: Quartet, 1982), 57.

15. Bunin, *Cursed Days*, 30.

16. From the memoirs of Lev Grinkrug, quoted by Bengt Jangfeldt in Vladimir Mayakovsky, *Love Is the Heart of Everything: Correspondence Between Vladimir*

Mayakovsky and Lili Brik, 1915–1930, ed. Bengt Jangfeldt and trans. Julian Graffy (Edinburgh: Polygon, 1986), 229.

17. Boris Pasternak, *I Remember: Sketch for an Autobiography*, trans. David Magarshak (Cambridge, MA: Harvard University Press, 1983), 92.

18. Boris Pasternak, *Safe Conduct*, trans. Beatrice Scott (New York: New Directions, 1958).

19. Woroszylski, *Life of Mayakovsky*, 210.

20. Shklovsky, *Mayakovsky and His Circle*, 46.

21. Bengt Jangfeldt, "Vladimir Mayakovsky and Lili Brik," in Mayakovsky, *Love Is the Heart of Everything*, 13.

22. Jangfeldt, "Vladimir Mayakovsky and Lili Brik," 12.

23. Vladimir Mayakovsky, "Prikaz 2 Armii Iskusstv," in *Bedbug and Selected Poetry*, 146.

24. Boris Pasternak, *Safe Conduct*, 121.

25. Maxim Gorki, *Days with Lenin* (London: Martin Lawrence, n.d.), 52.

26. N.K. Krupskaya, "Ilych's Favourite Books," in V.I. Lenin, *On Culture and Cultural Revolution* (Moscow: Progress Publishers, 1985), 225.

27. Gorki, *Days with Lenin*, 59.

28. Woroszylski, *Life of Mayakovsky*, 280–81.

29. Ibid., 274–75.

30. V.I. Lenin, *Collected Works*, trans. David Skvirsky and George Hanna (Moscow: Progress Publishers, 1965), 33:218.

31. Victor Serge, *Memoirs of a Revolutionary*, trans. Peter Sedgwick (New York: Readers and Writers, 1984), 164–65.

32. Marc Chagall, *My Life* (New York: Orion Press, 1960), 139.

33. Woroszylski, *Life of Mayakovsky*, 313–36.

34. Ilya Ehrenburg, *Memoirs: 1921–1941*, trans. Tatnia Shebunina (Cleveland, OH: World Publishing Co., 1964), 70.

35. Leon Trotsky, "Class and Art," trans. Brian Pearce, in *Art and Revolution* (New York: Pathfinder, 1970), 68.

36. Aleksandr Konstantinovich Voronsky, *Art as the Cognition of Life: Selected Writings 1911–1936*, trans. and ed. Frederick S. Choate (Oak Park, MI: Mehring Books, 1998), 134.

37. Woroszylski, *Life of Mayakovsky*, 325.

38. Vladimir Mayakovksy, "Sergeiyu Yeseninu," in *Stikhotvoreniya i poemyi* (Moscow: Eksmo, 2005), 302, 306.

39. Serge, *Memoirs of a Revolutionary*, 264.

40. Vladimir Mayakovsky, "Domoi," in *Bedbug and Selected Poetry*, 186–88.

41. Woroszylski, *Life of Mayakovsky*, 435.

42. L. Averbakh, "O tselostnykh masshtabakh I chastnykh Makarakh," *Na literaturnom postu*, nos. 21–22 (1929): 164, quoted in Jan Plamper, "Abolishing Ambiguity: Soviet Censorship Practices in the 1930s," in *The Russian Review* 60, no 4 (Hoboken, N.J.: Wiley 2001), 526.

43. "Litso nashikh protivnikov, A. Voronsky," *Na literaturnom postu*, nos. 21–22 (1930), quoted in Robert A. Maguire, *Red Virgin Soil: Soviet Literature in the 1920s* (Ithaca: Cornell University Press, 1987), 428.

44. Woroszylski, *Life of Mayakovsky*, 583.

45. Shklovsky, *Mayakovsky and His Circle*, 197.

46. Mayakovsky, *Love Is the Heart of Everything*, 187.

47. Woroszylski, *Life of Mayakovsky*, 484.

48. Solomon Voikov, *Testimony: The Memoirs of Dmitri Shostakovich*, trans. Antonina W. Bouis (London: Hamish Hamilton, 1979), 192.

49. Bunin, *Cursed Days*, 118.

50. RGASPI, fond 57, opis 1, d 64, list 58–51. This document is accessible in the original Russian in Leonid Maximenkov and Christopher Barnes, "Boris Pasternak in August 1936—An NKVD Memorandum," *Toronto Slavic Quarterly*, no. 6 (Fall 2003), www.utoronto.ca/tsq/06/pasternak06.shtml.

51. Evgeny Pasternak, *Boris Pasternak: The Tragic Years, 1930–60*, trans. Michael Duncan (London: Collins Harvill, 1990), 21–22.

52. Mayakovsky, *Love Is the Heart of Everything*, 216.

53. Woroszylski, *Life of Mayakovsky*, 526–27.

54. Boris Pasternak, *Safe Conduct*, 129–30.

55. Emma Gerstein, *Moscow Memoirs: Memories of Anna Akmatova, Osip Mandelstam and Literary Russia Under Stalin*, trans. and ed. John Crowfoot (Woodstock, NY: Overlook Press, 2004), 15.

56. Shklovsky, *Mayakovsky and His Circle*, 202.

57. *Literaturnaya gazeta*, April 21, 1930, quoted in Patricia Blake, "The Two Deaths of Vladimir Mayakovsky," in Mayakovsky, *Bedbug and Selected Poetry*, 48.

58. Katerina Clark and Evgeny Dobrenko with Andrei Artizov and Oleg Naumov, *Soviet Culture and Power: A History in Documents, 1917–1953*, trans. Marian Schwartz (New Haven, CT: Yale University Press, 2007), 286–88.

59. Boris Pasternak, *I Remember*, 101.

60. *Moscow News*, July 22, 2013.

3. The Master

1. The full text of Bulgakov's letter is in J.A.E. Curtis, *Manuscripts Don't Burn: Mikhail Bulgakov, a Life in Letters and Diaries* (London: Bloomsbury, 1991), 92–94.

2. There is a vast amount of information about Bulgakov, including the full text of the conversation with Stalin, in Russian, at www.bulgakov.ru.

3. Quoted in the introduction to *The Early Plays of Mikhail Bulgakov*, ed. Ellendea Proffer (Bloomington: Indiana University Press, 1972), xiii.

4. Eugene Lyons, *Assignment in Utopia* (London: George Harrap, n.d.).

5. Constantin Stanislavky, *My Life in Art*, trans. J.J. Robbins (London: Geoffrey Bles, 1948), 554–55.

6. Mikhail Bulgakov, *Black Snow: A Theatrical Novel*, trans. Michael Glenny (London: Penguin, 1971), 13, 32.

7. Vitali Shentalinsky, *The KGB's Literary Archive*, trans. John Crowfoot (London: Harvill, 1995), 73.

8. Curtis, *Manuscripts Don't Burn*, 17.

9. The full text of Vershilov's note is in ibid., 62.

10. Anatoly Smeliansky, *Is Comrade Bulgakov Dead? Mikhail Bulgakov and the Moscow Art Theatre*, trans. Arch Tait (London: Methuen, 1993), 49.

11. Curtis, *Manuscripts Don't Burn*, 75.

12. Mikhail Bulgakov, *The Heart of a Dog*, trans. Michael Glenny (London: Collins and Harvill, 1968), 38.

13. Nadezhda Mandelstam, *Hope Against Hope*, trans. Max Hayward (London: Collins and Harvill, 1971), 241–43.

14. Curtis, *Manuscripts Don't Burn*, 17.

15. Mikhail Bulgakov, *The White Guard*, trans. Michael Glenny (London: Harvill, 1971), 41, 256–57.

16. Shentalinsky, *KGB's Literary Archive*, 77–79.

17. Curtis, *Manuscripts Don't Burn*, 83.

18. Mikhail Bulgakov, *The Life of Monsieur de Molière*, trans. Mirra Ginsburg (New York: New Directions, 1986), 160.

19. Ibid., 115.

20. Nikolai A. Gorchakov, *The Theater in Soviet Russia*, trans. Edgar Lerman (New York: Columbia University Press, 1957), 187.

21. Smeliansky, *Is Comrade Bulgakov Dead?*, 90.

22. Curtis, *Manuscripts Don't Burn*, 85.

23. Juri Jelagin (Yuri Yelagin), *Taming of the Arts*, trans. Nicholas Wreden (New York: E.P. Dutton, 1951), 108.

24. Smeliansky, *Is Comrade Bulgakov Dead?*, 110.

25. Curtis, *Manuscripts Don't Burn*, 90–91.

26. The full text of the letter is in Katerina Clark and Evgeny Dobrenko, *Soviet Culture and Power: A History in Documents, 1917–1953*, trans. Marian Schwartz (New Haven, CT: Yale University Press, 2007), 54–55. On Bill-Belotserkovsky, see *Bol'shaya sovietskaya entsiklopediya*, vol. 5 (Moscow: Kommunisticheskoi Akademii TsIK SSSR, 1927), col. 238.

27. Smeliansky, *Is Comrade Bulgakov Dead?*, 160–61.

28. The full text of this letter, which came to light after the collapse of the Soviet Union, was first published in *Moskovskie novosti*, no. 17, April 25, 1993. It then appeared in English in Anatoly Smeliansky, "The Destroyers: Lunacharsky's Letter to Stalin on Censorship at the Moscow Art Theatre," *Comparative Criticism* 16 (1994): 33–37.

29. I.V. Stalin, "Reply to Bill-Belotserkovsky," February 2, 1929, in *Works* (Moscow: Foreign Languages Publishing House, 1954), 11:343.

30. George Orwell, "Freedom and Happiness," *Tribune*, January 4, 1946, reprinted in *Orwell in Tribune: "As I Please" and Other Writings 1943–7*, ed. Paul Anderson (London: Politico's, 2006).

31. Yevgeny Zamyatin, *The Dragon and Other Stories*, trans. and ed. Mirra Ginsburg (New York: Random House, 1966).

32. Yevgeny Zamyatin, "On Literature, Revolution, Entropy and Other Matters," in *A Soviet Heretic*, trans. and ed. Mirra Ginsburg (London: Quartet, 1991), 107.

33. The first account of the Pilnyak/Zamyatin affair appeared in Max Eastman, *Artists in Uniform: A Study of Literature and Bureaucratism* (New York: Knopf, 1934), which includes the text of Zamyatin's resignation letter. That and his letter to Stalin can also be found in translation in Zamyatin, *A Soviet Heretic*. For Pilnyak, see Chapter 7, below.

34. Shentalinsky, *KGB's Literary Archive*, 80–81.

35. Curtis, *Manuscripts Don't Burn*, 99.

36. Shentalinsky, *KGB's Literary Archive*, 93.

4. Corrupting Gorky

1. Quoted in David Remnick, "Seasons in Hell: How the Gulag Grew," *New Yorker*, April 14, 2003. The author interviewed Likhachev shortly before his death.

2. Alexander Solzhenitsyn, *The Gulag Archipelago, 1918–1956: An Experiment in Literary Investigation*, trans. Thomas P. Whitney (London: Collins/Fontana, 1976), 2:57.

3. Gorky's account of his visit is not available in full in English translation. The original is Maksim Gorky, "Solovki," in "Po Soiuzu Sovetov" [Around the Union of the Soviets], in *Sobranie sochinenii v tridtsati tomakh* [Collected works in thirty volumes], vol. 17 (Moscow: Khudozhestvennaia Literatura, 1952).

4. Maxim Gorky, *Mother*, trans. Margaret Wettlin (Moscow: Foreign Languages Publishing House, 1950), 403–4.

5. Introductory note, dated September 20, 1901, to Maxim Gorky, *The Man Who Was Afraid*, trans. Herman Bernstein (Adelaide, Australia: University of Adelaide, 2014), https://ebooks.adelaide.edu.au/g/gorky/maksim/g66ma/introduction.html.

6. Rosamund Bartlett, *Tolstoy: A Russian Life* (New York: Profile, 2010), 404.

7. Leon Trotsky, *Art and Revolution: Writings on Literature, Politics and Culture* trans. Brian Pearce (New York: Pathfinder, 1992), 217.

8. Maxim Gorky, "On Polemics," *Novaya zhizn*, April 22 (May 5), 1917.

9. Constantin Stanislavsky, *My Life in Art*, trans. J.J. Robbins (London: Geoffrey Bles, 1948), 398.

10. Arkady Vaksberg, *The Murder of Maxim Gorky: A Secret Execution*, trans. Todd Bludeau (New York: Enigma, 2007), 8.

11. Maxim Gorky, *My Apprenticeship*, trans. Margaret Wettlin (Moscow: Foreign Languages Publishing House, 1952), 185, 192.

12. Ibid., 590, 434.

13. *Lenin and Gorky: Letters, Reminiscences, Articles* (Moscow: Progress Publishers, 1973), 15.

14. Lubov Krassin, *Leonid Krassin: His Life and Work* (London: Skeffington, 1929). Mrs. Krassin spelled her husband's name with a double *s*, though in Russian it has only one *s*.

15. Alexander Kaun, *Maxim Gorky and His Russia* (London: Jonathan Cape, 1931), 592.

16. Maxim Gorki, *Days with Lenin* (London: Martin Lawrence, n.d.), 5.

17. *Lenin and Gorky*, 251.

18. V.I. Lenin, *Collected Works*, trans. David Skvirsky and George Hanna (Moscow: Progress Publishers, 1965), 34:385–86.

19. Victor Serge, *Memoirs of a Revolutionary*, trans. Peter Sedgwick (New York: Readers and Writers, 1984), 72–73.

20. *Novaya zhizn*, July 14 (17), 1917, and October 18 (31), 1917, reproduced in Maxim Gorky, *Untimely Thoughts: Essays on Revolution, Culture and the Bolsheviks, 1917–1918*, trans. Herman Ermolaev (New York: Paul S. Riksson, 1968), 72, 83.

21. Serge, *Memoirs of a Revolutionary*, 73.

22. Nadezhda Mandelstam, *Hope Abandoned*, trans. Max Hayward (New York: Collins and Harvill, 1971), 64.

23. Yevgeny Zamyatin, *A Soviet Heretic*, trans. and ed. Mirra Ginsburg (London: Quartet, 1991), 254. The quotation is from an obituary by Zamyatin written in 1936.

24. Gorky, *Days with Lenin*, 45.

25. Serge, *Memoirs of a Revolutionary*, 82.

26. The full text of the letter, retained in the KGB archives, is available in Russian in Vitaly Shentalinsky, *The KGB's Literary Archive*, trans. John Crowfoot (London: Harvill, 1995), 231.

27. Gorky, *Days with Lenin*, 52.

28. Lenin, *Collected Works*, 35:233; Gorky, *Days with Lenin*, 57.

29. Chris Bowers, *Nick Clegg: The Biography* (London: Biteback, 2001), 13.

30. Maxim Gorky, letter to the writer Vsevolod Ivanov, early 1928, quoted in Shentalinsky, *KGB's Literary Archive*, 244.

31. *Lenin and Gorky*, 64.

32. Boris Pasternak, letter to O.M. Freidenberg, May 10, 1928, in Boris Pasternak, *Sobranie sochineni v pyati tomakh*, vol V (Moscow: Khudozhestvennayay Literatura, 1992), 247.

33. Gorky, *Days with Lenin*, 34.

34. These descriptions of Genrikh Yagoda are taken from William Reswick, *I Dreamt Revolution* (Chicago: H. Regney, 1925), the memoirs of an American journalist who was allowed to join the prime minister, Alexei Rykov, and Yagoda on a tour of the Volga in 1924; and from Vladimir Ipatieff, *The Life of a Chemist* (Stanford, CA: Stanford University Press, 1946), the memoirs of a scientist who met Yagoda in 1918 and 1927 and noted the changes in his appearance.

35. Simon Sebag Montefiore, *Stalin: The Court of the Red Tsar* (London: Phoenix, 2004), 191.

36. Vaksberg, *Murder of Maxim Gorky*.

37. Quoted in Katerina Clark and Evgeny Dobrenko, *Soviet Culture and Power: A History in Documents, 1917–1953*, trans. Marian Schwartz (New Haven, CT: Yale University Press, 2007), 87.

38. Maxim Gorky, letter to Vyacheslav Ivanov, in Shentalinsky, *KGB's Literary Archive*, 242–43.

39. I.V. Stalin, letter to A.M. Gorky, December 1930, in Clark and Dobrenko, *Soviet Culture and Power*, 83.

40. A.M. Gorky, letter to I.V. Stalin, November 1930, in Clark and Dobrenko, *Soviet Culture and Power*, 81.

41. Shentalinsky, *KGB's Literary Archive*, 236.

42. Vaksberg, *Murder of Maxim Gorky*, 231.

43. Robert A. Maguire, *Red Virgin Soil: Soviet Literature in the 1920s* (Ithaca: Cornell University Press, 1987), 172–73, 184–85.

44. Aleksandr Konstantinovich Voronsky, *Art as the Cognition of Life: Selected Writings, 1911–1936*, trans. Frederick S. Choate (Oak Park, MI: Mehring Books, 1998), 432.

45. Serge, *Memoirs of a Revolutionary*, 268.

46. Letter from Stalin to Molotov, July 29, 1929, in *Stalin's Letters to Molotov, 1925–1936*, ed. Lars T. Lih, Oleg V. Naumov, and Oleg V. Khlevniuk (New Haven, CT: Yale University Press, 1995), 162.

47. W.G. Krivitisky, *I Was Stalin's Agent* (London: Right Book Club, 1940), 170. Krivitsky was an intelligence officer who defected to the West in 1937 and whose memoirs are generally credible.

48. Nadezhda Mandelstam, *Hope Against Hope*, trans. Max Hayward (London: Collins and Harvill, 1971), 233.

49. Clark and Dobrenko, *Soviet Culture and Power*, 87.

50. Sebag Montefiore, *Stalin*, 97.

51. Shentalinsky, *KGB's Literary Archive*, 258.

52. Ibid., 253.

53. A.N. Pirozhkova, *At His Side: The Last Years of Isaac Babel*, trans. Anne Frydman and Robert L. Busch (South Royalton, VT: Steerforth Press, 1996), 61.

54. Maxim Gorky, L. Auerbach, and S.G. Firin, eds., *The White Sea Canal* (London: John Lane, 1935), 249.

55. Anne Applebaum, *Gulag: A History of the Soviet Camps* (London: Penguin, 2004), 79.

56. *Report of Court Proceedings in the Case of the Anti-Soviet "Bloc of Rights and Trotskyites"* (Moscow: People's Commissariat for Justice of the USSR, 1938), 530, 624.

5. The Stalin Epigram

1. Viktor Shklovsky, *Sentimental Journey: Memoirs, 1917–1922*, trans. Richard Sheldon (Ithaca, NY: Cornell University Press, 1970), 237.

2. Joseph Brodsky, "The Child of Civilization," in *Less Than One: Selected Essays* (New York: Viking, 1986), 143–44. Though this essay is dated 1977, the words quoted do not appear in the original version, which was published as the introduction to Osip Mandelstam, *50 Poems*, trans. Bernard Meares (New York: Persea, 1977).

3. Osip Mandelstam, *Moskovskoe stikhi, sochineniya*, vol. 1 (Moscow: Khudozhestvennaya literaturna, 1990), 175. This poem and most others cited can be found in English translation in Osip Mandelstam, *The Moscow and Voronezh Notebooks: Poems 1930–1937*, trans. Richard and Elizabeth McKane (Northumberland: Bloodaxe Books, 2003), 43.

4. Clarence Brown, *Mandelstam* (New York: Cambridge University Press, 1978), 128–29.

5. Alexander Solzhenitsyn, *The Gulag Archipelago, 1918–1956: An Experiment in Literary Investigation*, trans. Thomas P. Witney (London: Collins/Fontana, 1976), 412.

6. Osip Mandelstam, "Fourth Prose," in *The Noise of Time: Selected Prose*, trans. Clarence Brown (Evanston, IL: Northwestern University Press, 2002), 184.

7. Nadezhda Mandelstam, *Hope Against Hope*, trans. Max Hawyard (London: Collins and Harvill, 1971), 11; for the story about the trousers, 117.

8. "Impressions of Boris Pasternak," *New Reasoner* 4 (1958): 88.

9. Nadezhda Mandelstam, *Hope Against Hope*, 145.

10. Osip Mandelstam, *Sochineniya*, 1:197.

11. Olga Ivinskaya, *A Captive of Time: My Years with Pasternak*, trans. Max Hayward (London: Fontana, 1979), 65.

12. Joseph Brodsky, introduction to Osip Mandelstam, *50 Poems*, 14.

13. Osip Mandelstam, "Sem'ya Sinani" [The Sinani family], in *Sochineniya*, vol. 2 (Moscow: Khudozhestvennaya literaturna, 1990). There is an English translation of this essay in Osip Mandelstam, *Noise of Time*.

14. Nadezhda Krupskaya, *Memories of Lenin* (London: Panther, 1970), 97; Boris Nicolaievsky, *Aseff: the Russian Judas*, trans. George Reavey (London: Hurst and Blackett, 1934), 53.

15. Victor Serge, *Memoirs of a Revolutionary*, trans. Peter Sedgwick (New York: Readers and Writers, 1984), 255.

16. "Blyumkin, Yakov Grigorievich," in *Bolshaya sovietskaya entsiklopediya*, vol. 6 (Moscow, 1927), col. 537.

17. Roberta Reeder, *Anna Akhmatova: Poet and Prophet* (London: Allison and Busby, 1995), 137.

18. *Rossiya*, no. 2, 1922, quoted in Wiktor Woroszylski, *The Life of Mayakovsky*, trans. Boleslaw Taborski (New York: Orion Press, 1970), 287.

19. Nadezhda Mandelstam, *Hope Against Hope*, 172, 178.

20. Osip Mandelstam, *Noise of Time*, 184.

21. Nadezhda Mandelstam, *Hope Against Hope*, 178.

22. Osip Mandelstam, *Sochinenya*, 1:178.

23. Osip Mandelstam, "Chetvertaya proza" [Fourth prose], in *Sochineniya*, 2:96.

24. Osip Mandelstam, *Sochineniya*, 1:167.

25. Osip Mandelstam, "Otryvki unichtozhennykh stikhov" [Extracts from destroyed poems], in *Sochineniya*, 1:180.

26. Nadezhda Mandelstam, *Hope Against Hope*, 112–13.

27. John Scott, *Behind the Urals: An American Worker in Russia's City of Steel*, ed. Stephen Kotkin (Bloomington: Indiana University Press, 1989), 82.

28. Isaac Deutscher, *The Prophet Outcast: Trotsky, 1929–1940* (New York: Oxford University Press, 1963), 84–89.

29. Nadezhda Mandelstam, *Hope Against Hope*, 102.

30. Robert Conquest, *The Harvest of Sorrow: Soviet Collectivisation and the Terror-Famine* (London: Arrow, 1988), 118.

31. Ibid., 156–57.

32. *Pravda*, December 2, 1930, quoted in Robert Conquest, *The Great Terror: Stalin's Purge of the Thirties* (London: Pelican, 1971), 51.

33. Osip Mandelstam, "Leningrad," in *Moskovskoe stikhi*, *Sochineniya*, 1:168.

34. Osip Mandelstam, "Leningrad."

35. Osip Mandelstam, *Sochinenya*, 1:173.

36. Ibid., 1:171.

37. Ibid., 1:196–97.

38. Osip Mandelstam, "Ariosto" in *Sochineniya*, 1:194; Osip Mandelstam, "Chetvertaya proza," in *Sochineniya*, 2:92.

39. Vitaly Shentalinsky, *The KGB's Literary Archive*, trans. John Crowfoot (London: Harvill, 1995), 177–78.

40. Nadezhda Mandelstam, *Hope Against Hope*, 30, 79.

41. Osip Mandelstam, "Volk," in *Sochineniya*, 1:171–72.

42. Nadezhda Mandelstam, *Hope Against Hope*, 150.

43. Osip Mandelstam, *Sochineniya*, 1:199.

44. Shentalinsky, *KGB's Literary Archive*, 176.

45. Nadezhda Mandelstam, *Hope Against Hope*, 85.

46. A facsimile of this poem, written in Khristofovich's handwriting, and of the epigram to Stalin, in Osip Mandelstam's handwriting and signed by him, are both reproduced in Shentalinsky, *KGB's Literary Archive*, on pp. 179 and 174, respectively.

47. Nadezhda Mandelstam, *Hope Against Hope*, 93.

48. Max Eastman, *Artists in Uniform: A Study of Literature and Bureaucratism* (New York: Knopf, 1934), 74.

49. Osip Mandelstam, "Kama," in *Sochineniya*, 1:215.

50. Osip Mandelstam, "Stansyi," in *Sochineniya*, 1:217.

51. Shentalinsky, *KGB's Literary Archive*, 183.

52. This version of the conversation was included in the anonymous essay "Impressions of Boris Pasternak," *New Reasoner* 4 (1958): 88–89. The author's identity was known to Clarence Brown, who believed that he was a reliable source who had heard the story firsthand from Pasternak. See his introduction to *The Prose of Osip Mandelstam* (Princeton, NJ: Princeton University Press, 1965).

53. Nadezhda Mandelstam, *Hope Against Hope*, 146.

54. Ibid., 147.

55. Osip Mandelstam, "Esli b menya nashi vragi vzyali," [If our enemies captured me], in *Sochineniya*, 1:416–17. When Mandelstam wrote this poem down to send it to a critic, his wife suggested that he replace the word *budit*, meaning "destroy," with *gubit*, meaning "rouse," reversing the meaning of the line.

56. Anna Akhmatova, "Voronezh," in *The Complete Poems of Anna Akhmatova*, trans. Judith Hemschemeyer (Boston: Zephyr Press, 1997), 381.

57. Nadezhda Mandelstam, *Hope Against Hope*, 159, 170.

6. Babel's Silence

1. Ilya Ehrenburg, *Men, Years, Life*, vol. 4, *Eve of War, 1933–41*, trans. Tatiana Shebunina and Yvonne Kapp (London: MacGibbon and Kee, 1963), 40.

2. Ehrenburg, *Eve of War*, 42.

3. Ibid.

4. A.I. Stetsky, "Under the Flag of the Soviets, Under the Flag of Socialism," in *Soviet Writers' Congress 1934: The Debate on Socialist Realism and Modernism*, ed. H.G. Scott (London: Lawrence and Wishart, 1977), 263.

5. Karl Radek, "Contemporary World Literature and the Tasks of Proletarian Art," in Scott, *Soviet Writers' Congress 1934*, 152–54.

6. A.A. Zhdanov, "Soviet Literature: The Richest in Ideas, the Most Advanced Literature," in Scott, *Soviet Writers' Congress 1934*, 21.

7. Kaganovich's letters to Stalin about this controversy, dated August 12 and 14, 1934, are in *The Stalin-Kaganovich Correspondence 1931–36*, ed. R.W. Davies, Oleg V. Khlevniuk, E.A. Rees, Liudmila P. Kosheleva, and Larisa A. Rogovaya (New Haven, CT: Yale University Press, 2003), 249–50, 253.

8. Maxim Gorky, "Soviet Literature," in Scott, *Soviet Writers' Congress 1934*, 45.

9. Konstantin Paustovsky, *Years of Hope*, trans. Manya Harari (London: Harvill, 1968).

10. Charles King, *Odessa: Genius and Death in a City of Dreams* (New York: W.W. Norton, 2011), 129–30.

11. Isaac Babel, "Odessa," in *The Complete Works of Isaac Babel*, ed. Nathalie Babel and trans. Peter Constantine (New York: W.W. Norton, 2002), 75–77.

12. Isaac Babel, "1920 Diary," in *Complete Works*, 434.

13. Isaac Babel, "My First Goose," in *Complete Works*, 231.

14. Isaac Babel, "Dolgushov's Death," in *Complete Works*, 244–45.

15. Babel, "1920 Diary," 447.

16. Ibid., 403.

17. Isaac Babel, "A Letter," in *Complete Works*, 210.

18. Babel, "1920 Diary," 380.

19. Ibid., 431.

20. Isaac Babel, "Murderers Who Have Yet to Be Clubbed to Death," in *Complete Works*, 372.

21. Babel, "1920 Diary," 457.

22. Paustovsky, *Years of Hope*, 120.

23. G. Gorbachev, "Babel," in *Bolshaya sovetskaya entsiklopediya*, vol. 4 (Moscow: Kommunisticheskoi Akademii TsIK SSSR, 1926), col. 257.

24. Budenny's open letter, first published in *Krasnaya gazeta*, October 26, 1928, is reproduced in translation, along with Gorky's reply, which was published in *Pravda* on November 7, 1925, in *Isaac Babel: The Lonely Years, 1925–1939: Unpublished Stories and Private Correspondence*, ed. Nathalie Babel and trans. Andrew R. Mac-Andrew and Max Hayward (Boston: David R. Godine, 1995), 384–89.

25. *Isaac Babel: The Lonely Years*, 255.

26. Ibid., 155.

27. *Stalin-Kaganovich Correspondence*, 143, 124, 149.

28. Quoted in Vitaly Shentalinsky, *The KGB's Literary Archive*, trans. John Crowfoot (London: Harvill, 1995), 28.

29. *Isaac Babel: The Lonely Years*, 264.

30. Shentalinsky, *KGB's Literary Archive*, 32–33.

31. *Isaac Babel: The Lonely Years*, 245.

32. The whole speech is available in translation in ibid., 396–400.

7. Pasternak's Sickness of the Soul

1. Boris Pasternak to his parents, March 6, 1936, in *Family Correspondence 1921–1960*, trans. Nicolas Pasternak Slater and ed. Maya Slater (Stanford, CA: Hoover Institution Press, 2010), 263.

2. Louis Fischer, *Men and Politics: An Autobiography* (New York: Duell, Sloan and Pearce, 1941), 231.

3. Alexander Barmine, *One Who Survived: The Life Story of a Russian Under the Soviets* (New York: G.P. Putnam's Sons, 1945). Barmine, a Soviet diplomat who defected in the 1930s, knew Poskrebyshev for fifteen years.

4. Victor Serge, *Memoirs of a Revolutionary*, trans. Peter Sedgwick (New York: Readers and Writers, 1984), 318.

5. Christopher Barnes, *Boris Pasternak: A Literary Biography* (New York: Cambridge University Press, 2004), 2:108.

6. Boris Pasternak to his parents, March 19, 1936, in *Family Correspondence*, 295.

7. Alexander Solzhenitsyn, *The Gulag Archipelago, 1918–1956: An Experiment in Literary Investigation*, trans. Thomas P. Witney (New York: Harper and Row, 1973), 231.

8. Boris Pasternak to his parents, late September 1934, in *Family Correspondence*, 289.

9. Boris Pasternak to Titsian Tabidze, September 6, 1935, in Boris Pasternak, *Letters to Georgian Friends*, trans. David Magarshack (London: Martin Secker and Warburg, 1968), 62.

10. Evgeny Pasternak, *Boris Pasternak: The Tragic Years, 1930–60*, trans. Michael Duncan (London: Collins Harvill, 1991), 62.

11. Boris Pasternak, letter to Josephine Pasternak, February 11, 1936, in *Family Correspondence*, 210.

12. Rosamund Bartlett, *Tolstoy: A Russian Life* (London: Profile, 2010), 412.

13. Boris Pasternak, letter to Asya Freidenberg, May 20, 1928, in *The Correspondence of Boris Pasternak and Olga Freidenberg, 1910–1954*, comp. and ed. Elliott Mossman and trans. Elliott Mossman and Margaret Wettlin (New York: Harcourt Brace Jovanovich, 1981), 110.

14. Boris Pasternak, *Doctor Zhivago*, trans. Richard Pevear and Larissa Volokhonsky (London: Harvill Secker, 2010), 45; Alexander Pasternak, *A Vanished Present*, ed. and trans. Ann Pasternak Slater (Ithaca, NY: Cornell University Press, 1984), 119–20.

15. Boris Pasternak, *Safe Conduct*, trans. Beatrice Scott (New York: New Directions, 1958), 98; Boris Pasternak, *The Last Summer*, trans. George Reavey (London: Penguin, 1960), 31.

16. Boris Pasternak, *Doctor Zhivago*, 8.

17. Boris Pasternak, *I Remember: Sketch for an Autobiography*, trans. David Magarshak (Cambridge, MA: Harvard University Press, 1983), 92.

18. Boris Pasternak, "Pro eti stikhi" [About these poems], in *Sestra moya-zhizn'* [My sister-life] (Moscow: Tranisitkniga, 2005), 47.

19. Boris Pasternak, letter to V.Ya. Bryusov, August 15, 1922, in *Sobranie sochineni v pyati tomakh*, vol. 5, *Pis'ma* (Moscow: Khudozhstvennaya Literatura, 1992), 134.

20. Leon Trotsky, *Art and Revolution: Writings on Literature, Politics and Culture* (New York: Pathfinder, 1982), 70.

21. Zhenya Pasternak, letter to Olga Freidenberg, November 30, 1924, in *Correspondence of Boris Pasternak and Olga Freidenberg*, 82; Boris Pasternak, letter to his parents and sisters, December 19, 1927, in *Family Correspondence*, 101.

22. Robert A. Maguire, *Red Virgin Soil: Soviet Literature in the 1920s* (Ithaca, NY: Cornell University Press, 1987), 10.

23. Evgeny Pasternak, *Boris Pasternak*, 7.

24. Nadezhda Mandelstam, *Hope Against Hope: A Memoir*, trans. Max Hayward (London: Collins and Harvill, 1971), 151.

25. Boris Pasternak, letter to O.M. Freidenberg, May 10, 1928, in *Pis'ma*, 248.

26. Evgeny Pasternak, *Boris Pasternak*, 24.

27. Boris Pasternak, letter to Lydia Pasternak, January 9, 1930, in *Family Correspondence*, 160.

28. Boris Pasternak, letter to O.M. Freidenberg, June 11, 1930, in *Pis'ma*, 305.

29. Evgeny Pasternak, *Boris Pasternak*, 41.

30. Boris Pasternak, *Safe Conduct*, 88–89.

31. Quoted in the introduction by David Magarshak to Boris Pasternak, *Letters to Georgian Friends*, 21.

32. Boris Pasternak to Titsian and Nina Tabidze, November 6, 1933, in *Letters to Georgian Friends*, 49.

33. Barnes, *Boris Pasternak*, 75.

34. On Alliluyeva's suicide, see the prologue to Simon Sebag Montefiore, *Stalin: The Court of the Red Tsar* (London: Phoenix, 2004).

35. Emma Gerstein, *Moscow Memoirs: Memories of Anna Akhmatova, Osip Mandelstam and Literary Russia Under Stalin*, trans. John Crowfoot (New York: Overlook, 2004), 349–50.

36. Roy A. Medvedev, *Nikolai Bukharin: The Last Years* trans. A.D.P. Briggs (New York: W.W. Norton, 1980), 71.

37. Lazar Fleishman, "Pasternak and Bukharin in the 1930s," in *Pasternak and His Times: Selected Papers from the Second International Symposium on Pasternak*, ed. Lazar Fleishman (Berkeley, CA: Slavic Specialties, 1989).

38. Lazar Fleishman, *Boris Pasternak: The Poet and His Politics* (Cambridge, MA: Harvard University Press, 1990), 178.

39. Alexander Gladkov, *Meetings with Pasternak*, trans. Max Hayward (London: Collins and Harvill, 1977), 73.

40. Boris Pasternak, letter to Frederick Pasternak, August 1926, in *Family Correspondence*, 70.

41. Boris Pasternak, letter to Asya Freidenberg, October 18, 1933, in *Pis'ma*, 345.

42. Mandelstam, *Hope Against Hope*, 161.

43. Roy A. Medvedev, *Nikolai Bukharin*, 110.

44. Boris Pasternak, letter to his parents and sisters, June 23, 1934, in *Family Correspondence*, 206.

45. Gerstein, *Moscow Memoirs*, 184.

46. Ante Ciliga, *The Russian Enigma*, trans. Fernand G. Fernie and Anne Cliff (London: Ink Links, 1979), 120, 74.

47. Mandelstam, *Hope Against Hope*, 98.

48. Extract from the diary of Olga Freidenberg, in *Correspondence of Boris Pasternak and Olga Freidenberg*, 153–54.

49. Boris Pasternak, letter to his parents and sisters, December 25, 1934, in *Family Correspondence*, 277.

50. Boris Pasternak, letter to Olga Freidenberg, April 3, 1935, in *Pis'ma*, 356.

51. Boris Pasternak, *I Remember*, 101.

52. Boris Pasternak, letter to his parents, end of September 1935, in *Family Correspondence*, 289.

53. Full text in Gerstein, *Moscow Memoirs*, 427–28

54. Boris Pasternak, "Byit znamenityim nekracivo," in *Sobranie sochineni v pyati tomakh*, vol. 2, *Stikhotvoreniya* [Poems] *1931–1959* (Moscow: Khudozhestvennaya Literatura, 1989), 74.

8. Stalin and the Silver Screen

1. Ivor Montagu, *With Eisenstein in Hollywood* (Berlin: Seven Seas Books, 1974), 30–31.

2. Sergei Eisenstein, *Selected Works*, vol. 4, *Beyond the Stars: The Memoirs of Sergei Eisenstein*, ed. Richard Taylor and trans. William Powell (London: BFI Publishing, 1995), 328.

3. Marie Seton, *Sergei M. Eisenstein* (New York: Grove Press, 1960), 167.

4. Hunter Kimbrough, letter to Upton Sinclair, December 22, 1930, in *Sergei Eisenstein and Upton Sinclair: The Making and Unmaking of Que Viva Mexico!*, ed. Harry M. Geduld and Ronald Gottesman (Bloomington: Indiana University Press, 1970), 36.

5. Eisenstein, *Beyond the Stars*, 414.

6. Upton Sinclair, letter to S. Estrada, April 15, 1931, in *Sergei Eisenstein and Upton Sinclair*, 67.

7. Seton, *Sergei M. Eisenstein*, 515.

8. Hunter Kimbrough, letters to Upton Sinclair, August 31, 1931, and October 9, 1931, in Geduld and Gottesman, *Sergei Eisenstein and Upton Sinclair*, 124–26, 170–73.

9. Sergei Eisenstein, letter to Upton Sinclair, November 13, 1931, in Geduld and Gottesman, *Sergei Eisenstein and Upton Sinclair*, 200–204.

10. I.V. Stalin, letter to L.M. Kaganovich, September 12, 1931, in *The Stalin-Kaganovich Correspondence, 1931–36*, ed. R.W. Davies, Oleg V. Khlevniuk, and E.A. Rees (New Haven, CT: Yale University Press, 2003), 82.

11. Stalin, telegram to Upton Sinclair, November 21, 1931, in Geduld and Gottesman, *Sergei Eisenstein and Upton Sinclair*, 212. The original is in block capitals with "STOP" in place of punctuation.

12. Upton Sinclair, letter to V.F. Smirnov, March 19, 1932, Geduld and Gottesman, *Sergei Eisenstein and Upton Sinclair*, 310.

13. Upton Sinclair, letter to Marie Seton, April 5, 1950, in Seton, *Sergei M. Eisenstein*, 515.

14. Upton Sinclair, letter to V.F. Smirnov, March 19, 1932, and Sinclair, telegram to Stalin, August 15, 1932, in Geduld and Gottesman, *Sergei Eisenstein and Upton Sinclair*, 310, 347–49.

15. Peter Kenez, *Cinema and Soviet Society, 1917–1953* (New York: Cambridge University Press, 1992), 131–32.

16. Alexander Barmine, *One Who Survived: The Life Story of a Russian Under the Soviets* (New York: G.P. Putnam's Sons, 1945), 139.

17. Jay Leyda, *Kino: A History of the Russian and Soviet Film* (London: George Allen and Unwin, 1960), 340.

18. Kenez, *Cinema and Soviet Society*, 131.

19. Richard Taylor and Ian Christie, *Inside the Film Factory: New Approaches to Russian and Soviet Cinema* (London: Routledge, 1994), 216.

20. Milovan Djilas, *Conversations with Stalin*, trans. Michael B. Petrovich (London: Penguin, 1963), 82.

21. Theodore Van Houten, *Leonid Trauberg and His Films—Always the Unexpected* ('s Hertogenbosch, Netherlands: Art and Research Graduate Press, 1989), 162.

22. I.V. Stalin, note to B.Z. Shumyatsky concerning the screenplay for *The Great Citizen*, January 27, 1937, in Katerina Clarke and Evgeny Dobrenko, *Soviet Culture and Power: A History in Documents, 1917–1953* (New Haven, CT: Yale University Press, 2007), 296–97.

23. Dmitri Shostakovich, *Testimony: The Memoirs of Dmitri Shostakovich*, as related to and ed. Solomon Volkov and trans. Antonina W. Bouis (London: Hamish Hamilton, 1979), 195.

24. Leyda, *Kino*, 275.

25. Dovzhenko's account of his meetings with Stalin, "Teacher and Friend of the Artist," first appeared in *Izvestya*, November 5, 1936; then in *Iskusstvo kino*, October 1937; and in translation in Taylor and Christie, *The Film Factory: Russian and Soviet Cinema in Documents 1896–1939* (Cambridge, MA: Harvard University Press, 1988), 383–85.

26. A.P. Dovzhenko, letter to I.V. Stalin, November 26, 1936; I.V. Stalin, note to B.Z. Shumyatsky, December 9, 1936, in Clark and Dobrenko, *Soviet Culture and Power*, 289–90, 295.

27. Davies et al., *Stalin-Kaganovich Correspondence*, 117.

28. Leon Trotsky, *Literature and Revolution*, trans. Rose Strunsky (1925), chap. 2, p. 3. The full text can be accessed at the Leon Trotsky Internet Archive, www.marxists.org/archive/trotsky/1924/lit_revo/ch02.htm.

29. Vitaly Shentalinsky, *The KGB's Literary Archive*, trans. John Crowfoot (London: Harvill, 1995), 198–99.

30. Waclaw Solski, "The End of Sergei Eisenstein: Case History of an Artist Under Dictatorship," *Commentary*, March 1949, 252–53.

31. Eisenstein, *Beyond the Stars*, 737.

32. Boris Shumyatsky, "A Cinema for the Million (Extracts)," in Taylor and Christie, *The Film Factory*, 367.

33. "The Whole Country Is Watching *Chapayev*," *Pravda*, November 21, 1934, in Christie and Taylor, *The Film Factory*, 334–35.

34. The quote is from the stenographic report of the Orgburo session of May 7, 1933, which is Document 140 in the online companion to *Stalinism as a Way of Life:*

A Narrative in Documents, ed. Lewis Siegelbaum and Andrei Sokolov (New Haven, CT: Yale University Press, 2000), Annals of Communism, Yale University Press, www.yale.edu/annals/siegelbaum/English_docs/Siegelbaum_doc_140.htm.

35. Taylor and Christie, *The Film Factory*, 355, 353.

36. Catriona Kelly, *Comrade Pavlik: The Rise and Fall of a Boy Hero* (London: Granta, 2005).

37. Leyda, *Kino*, 328–29.

38. Boris Shumyatsky, "The Film Bezhin Meadow," *Pravda*, March 19, 1937, in Taylor and Christie, *The Film Factory*, 379.

39. A.N. Pirozhkova, *At His Side: The Last Years of Isaac Babel*, trans. Anne Frydman and Robert L. Busch (South Royalton, VT: Steerforth Press, 1996), 76–79.

40. The full text of Shumyatsky's report to Stalin, dated February 5, 1937, is in Clark and Dobrenko, *Soviet Culture and Power*, 243–44.

41. Kelly, *Comrade Pavlik*, 8, 146–47.

42. The text of the Politburo resolution is in Clark and Dobrenko, *Soviet Culture and Power*, 245.

43. Quoted in Kenez, *Cinema and Soviet Society*, 152.

44. Taylor and Christie, *The Film Factory*, 379.

45. B.Z. Shumyatsky, memorandum to V.M. Molotov, March 28, 1937, in Clark and Dobrenko, *Soviet Culture and Power*, 246–47.

46. Peter Kenez, "A History of Bezhin Meadow," in *Eisenstein at 100*, ed. Al La-Valley and Barry P. Scherr (New Brunswick, NJ: Rutgers University Press, 2001), 194–95.

47. G. Yermolayev, "What Is Holding Up the Development of Soviet Cinema," *Pravda*, January 9, 1938, in Taylor and Christie, *The Film Factory*, 386–87.

48. Jamie Miller, "The Purges of Soviet Cinema, 1929–38," *Studies in Russian and Soviet Cinema* 1, no. 1 (2006): 5–26, doi:10.1386/srsc.1.1.5_1.

9. Stalin's Nights at the Opera

1. L.M. Kaganovich, letter to G.K. Ordzhonikidze, September 4, 1935, cited in *The Stalin-Kaganovich Correspondence, 1931–36*, ed. R.W. Davies, Oleg V. Khlevniuk, and E.A. Rees (New Haven, CT: Yale University Press, 2003), 19.

2. Svetlana Alliluyeva, *20 Letters to a Friend*, trans. Priscilla Johnson (Harmondsworth: Penguin, 1968), 122.

3. "The Architect of a Socialist Society" was published in English as a pamphlet in 1935 and is the introductory essay in Karl Radek, *Portraits and Pamphlets*, introduction by A.J. Cummings and notes by Alec Brown (New York: R.M. McBride, 1935). The text is also online at www.archive.org/stream/TheArchitectOfSocialistSocietyT heNinthOfACourseOfLecturesOnthe/ASS_djvu.txt.

4. N. De Basily, *Russia Under Soviet Rule: Twenty Years of Bolshevik Experiment* (London: Allen and Unwin, 1938), 210.

5. J.V. Stalin, "Speech at the First All-Union Conference of Stakhanovites," November 17, 1935, full text at the Marxist Internet Archive, www.marxists.org /reference/archive/stalin/works/1935/11/17.htm.

6. Quoted in Laurel E. Fay, *Shostakovich: A Life* (New York: Oxford University Press, 2005), 83.

7. Rosa Sadykhova, "Shostakovich: Letters to His Mother, 1923–1927," trans. Rolanda Norton, in *Shostakovich and His World*, ed. Laurel E. Fay (Princeton, NJ: Princeton University Press, 2004), 16, 21. The letters are dated February 8, 1926, and January 10, 1927.

8. Ian MacDonald, *The New Shostakovich* (Oxford: Oxford University Press, 1991), 3.

9. Elizabeth Wilson, *Shostakovich: A Life Remembered* (Princeton, NJ: Princeton University Press, 1994), 335.

10. Quoted in Anatoly Smeliansky, *Is Comrade Bulgakov Dead? Mikhail Bulgakov and the Moscow Arts Theatre*, trans. Arch Tait (London: Methuen, 1993), 256.

11. Quoted in Solomon Volkov, *Shostakovich and Stalin*, trans. Antonina W. Bouis (London: Little, Brown, 2004), 118.

12. Sergei Eisenstein, *Selected Works*, vol. 4, *Beyond the Stars: The Memoirs of Sergei Eisenstein*, ed. Richard Taylor and trans. William Powell (London: BFI Publishing, 1995), 345.

13. Fay, *Shostakovich*, 77.

14. Quoted in Volkov, *Shostakovich and Stalin*, 116.

15. Fay, *Shostakovich*, 76.

16. Jay Leyda, *Kino: A History of the Russian and Soviet Film* (London: George Allen and Unwin, 1960), 290; Peter Kenez, *Cinema and Soviet Society, 1917–1953* (New York: Cambridge University Press, 1992), 167.

17. Leonid Maximenkov, "Stalin and Shostakovich: Letters to a 'Friend,'" in Fay, *Shostakovich and His World*, 46.

18. Fay, *Shostakovich*, 84–85.

19. Isaak Glikman, *Story of a Friendship: The Letters of Dmitry Shostakovich to Isaak Glikman 1941-1975*, trans. Anthony Phillips with a commentary by Isaak Glikman (London: Faber and Faber, 2001), xviii.

20. Volkov, *Shostakovich and Stalin*, 134.

21. P.M. Kerzhensetsev, memorandum to I.V. Stalin and V.M. Molotov, February 7, 1936, in Katrina Clark and Evgeny Dobrenko, *Soviet Culture and Power: A History in Documents, 1917–1953* (New Haven, CT: Yale University Press), 230–32.

22. Juri Jelagin, *Taming of the Arts*, trans. Nicholas Wreden (New York: E.P. Dutton, 1951), 152.

23. Clark and Dobrenko, *Soviet Culture and Power*, 237.

24. Ibid., 230–37.

25. Vitaly Shentalinsky, *The KGB's Literary Archive*, trans. John Crowfoot (London: Harvill, 1995), 36, 48.

26. Dmitri and Lumilla Sollertinsky, *Pages from the Life of Dmitri Shostakovich*, trans. Graham Hobbs and Charles Midgley (New York: Harcourt Brace Jovanovich, 1980), 78.

27. Clark and Dobrenko, *Soviet Culture and Power*, 231.

28. "Diary of Lyubov Vasilievna Shaporina," in *Intimacy and Terror: Soviet Diaries of the 1930s*, ed. Veronique Garros, Natalia Korenevskaya, and Thomas Lahusen, trans. Carol A. Flath (New York: The New Press, 1995), 346.

29. Mikhail Bulgakov, *Molière*, trans. Michael Glenny, in *Six Plays* (London: Methuen, 1991), act 4, scene 1, 277.

30. Clark and Dobrenko, *Soviet Culture and Power*, 270.

31. Glikman, *Story of a Friendship*, xix.

32. Ibid., xxiii.

33. Wilson, *Shostakovich*, 124–25; Allan B. Ho and Dmitry Feofanov, *Shostakovich Reconsidered* (London: Toccata Press, 1998), 182.

34. Sollertinsky, *Pages from the Life of Dmitri Shostakovich*, 81.

35. Dmitri Shostakovich, *Testimony: The Memoirs of Dmitri Shostakovich*, as related to and ed. Solomon Volkov and trans. Antonina W. Bouis (London: Hamish Hamilton, 1979), 206.

36. "Diary of Lyubov Vasilievna Shaporina," 356.

37. Shostakovich, *Testimony*, 140.

38. Volkov, *Shostakovich and Stalin*, 181; Wilson, *Shostakovich*, 134.

39. Excerpt from the memoirs of the composer Mikhail Chulaki, cited in Wilson, *Shostakovich*, 134–35.

40. Quoted in Sollertinsky, *Pages from the Life of Dmitri Shostakovich*, 82.

41. Shostakovich, *Testimony*, 172–73; on Tolstoy's drunkenness, see Jelagin, *Taming of the Arts*, 126–28.

42. Fay, *Shostakovich*, 102.

10. Pasternak in the Great Terror

1. Boris Pasternak, *Doctor Zhivago*, trans. Richard Pevear and Larissa Volokhonsky (London: Harvill Secker, 2010), 247.

2. Sergei Eisenstein, *Selected Works*, vol. 4, *Beyond the Stars: The Memoirs of Sergei Eisenstein*, ed. Richard Taylor and trans. William Powell (London: BFI Publishing, 1995), 686–87.

3. Leonid Maximenkov and Christopher Barnes, "Boris Pasternak in August 1936—An NKVD Memorandum," *Toronto Slavic Quarterly* 49 (Summer 2014).

4. Alexander Gladkov, *Meetings with Pasternak: A Memoir*, trans. Max Hayward (London: Collins Harvill, 1977), 34–35.

5. André Gide, *Journals: 1889–1949*, trans. and ed. Justin O'Brien (London: Penguin, 1967), 600.

6. Christopher Barnes, *Boris Pasternak: A Literary Biography*, vol. 2, *1928–1960* (Cambridge: Cambridge University Press, 1998), 140.

7. Roy A. Medvedev, *Nikolai Bukharin: The Last Years*, trans. A.D.P. Briggs (New York: W.W. Norton, 1980), 138. Anna Larina mentions "two short missives from Boris Pasternak" but does not say when the second one arrived (ibid., 311).

8. Christopher Barnes, *Boris Pasternak*, 148.

9. Olga Ivinskaya, *A Captive of Time: My Years with Pasternak*, trans. Max Hayward (London: Collins Harvill, 1978), 141–42.

10. Boris Pasternak, letter to Samara Yashvili, August 28, 1937, in *Sobranie sochneni v pyati tomakh*, vol. 5, *Pis'ma* (Moscow: Khudozhstvennaya Literatura, 1992), 372.

11. Boris Pasternak, *I Remember: Sketch for an Autobiography*, trans. David Magarshak (Cambridge, MA: Harvard University Press, 1983), 90.

12. Boris Pasternak, letter to N.A. Tabidze, 1938, in *Pis'ma*, 375.

13. Victor Serge, *Memoirs of a Revolutionary*, trans. Peter Sedgwick (New York: Readers and Writers, 1984), 269.

14. Vitaly Shentalinsky, *The KGB's Literary Archive*, trans. John Crowfoot (London: Harvill Press, 1995), 142.

15. Mandelstam, *Hope Against Hope*, 199–200.

16. Osip Mandelstam, *Sochinenya* (Moscow: Khudozhestvennaya literaturna, 1990), 1:224; in English as "The Idol," in Second Voronezh Notebook, *The Moscow and Voronezh Notebooks*, trans. Richard and Elizabeth McKane (Tarset, Northumberland, UK: Bloodaxe, 2003), 145–46.

17. Nadezhda Mandelstam, *Hope Against Hope*, 352–53.

18. Gladkov, *Meetings with Pasternak*, 75.

19. Nadezhda Mandelstam, *Hope Against Hope*, 299.

20. Ibid., 367.

21. Stavsky's letter and Pavlenko's attached note are reproduced in full in Shentalinsky, *KGB's Literary Archive*, 186–87.

22. Nadezhda Mandelstam, *Hope Against Hope*, 460.

23. Boris Pasternak, Marina Tsvetayeva, and Rainer Maria Rilke, *Letters: Summer 1926*, trans. Margaret Wittlin and Walter Arnolt (London: Jonathan Cape, 1983).

24. Pavel Sudoplatov and Anatoli Sudoplatov with Jerrold L. Schecter and Leona P. Schecter, *Special Tasks: The Memoirs of an Unwanted Witness—A Soviet Spymaster* (Boston: Little, Brown, 1994), 47.

25. On Tsvetayeva's life at Bolshevo, see Irma Kudrova, *The Death of a Poet: The Last Days of Marina Tsvetaeva*, trans. Mary Ann Szporluk (Woodstock, NY: Overlook Duckworth, 2004).

26. Evgeny Pasternak, *Boris Pasternak: The Tragic Years, 1930–60*, trans. Michael Duncan (London: Collins Harvill, 1990), 117. Irma Kudrova, whose account is based on recollections by others who lived at Bolshevo, queries whether this visit took place.

27. Boris Pasternak, letter to his sisters, December 1945, in *Family Correspondence, 1921–1960*, trans. Nicolas Pasternak Slater and ed. Maya Slater (Stanford, CA: Hoover Institution Press, 2010), 368.

11. Sholokhov, Babel, and the Policeman's Wife

1. Mikhail Sholokhov, *The Don Flows Home to the Sea*, trans. Stephen Garry (London: Penguin, 1970), 93.

2. Roy Medvedev, *Problems in the Literary Biography of Mikhail Sholokhov*, trans. A.D.P. Briggs (Cambridge: Cambridge University Press, 1977), 16.

3. Geir Kjetsa, "The Battle of *The Quiet Don*: Another Pilot Study," *Computers and the Humanities* 11, no. 6 (November–December 1977): 345.

4. J.V. Stalin, *Works*, vol. 12, April 1929–June 1930 (Moscow: Foreign Languages Publishing House, 1954), 118–21. The letter can be accessed at the Marxists Internet Archive, www.marxists.org/reference/archive/stalin/works/1929/07/09 .htm.

5. M.A. Sholokhov, letter to I.V. Stalin, April 20, 1932 in *Pisatel' i vozhd': Perepiska M.A. Sholokhova s I.V. Stalinym: 1931–1950 gody. Sbornik dokumentov iz lichmnogo arkhiva I.V. Stalina* [Writer and leader: correspondence between M.A. Sholokhov and I.V. Stalin: 1931–1950. Selected documents from the personal archive of I.V. Stalin], ed. Yuri Murin (Moscow: Raritet, 1997), 82; Mikhail Sholokhov, *Virgin Soil Upturned*, trans. R.Daglish (Moscow: Foreign Languages Publishing House, n.d.), 30.

6. Mikhail Sholokhov, *And Quiet Flows the Don*, trans. Stephen Garry (London: Penguin, 1967), 515–16.

7. Ibid., 66.

8. Josif Stalin, letter to Kaganovich, June 9, 1932, in *The Stalin-Kaganovich Correspondence*, ed. R.W. Davies, Oleg V. Khlevniuk, E.A. Rees, Liudmila P. Kosheleva, and Larisa A. Rogovaya (New Haven, CT: Yale University Press, 2003), 124.

9. M.A. Sholokhov, letter to I.V. Stalin, January 16, 1931, in Murin, *Pisatel' i vozhd'*, 64.

10. Murin, *Pisatel' i vozhd'*, 28–29, 57–58.

11. Lars T. Lih, Oleg V. Naumov, and Oleg V. Khlevniuk, eds., *Stalin's Letters to Molotov* (New Haven, CT: Yale University Press, 1995), 232.

12. Leon Trotsky, *Stalin: An Appraisal of the Man and His Influence*, trans. and ed. Charles Malamuth (London: Panther, 1969), 2:247.

13. Murin, *Pisatel' i vozhd'*, 133.

14. On Yevdokimov, see A. Avtorkhanov, *Stalin and the Soviet Communist Party: A Study in the Technology of Power* (New York: Frederick A. Praeger); and A. Uralov, *The Reign of Stalin*, trans. L.J. Smith (London: Bodley Head, 1953). These two books are by the same author, who worked in the North Caucasus in the 1930s. "Uralov" is a pseudonym.

15. V.P. Stavsky, letter to I.V. Stalin, September 16, 1937, in Katerina Clark and Evgeny Dobrenko, *Soviet Culture and Power, 1917–1953*, trans. Marian Schwartz (New Haven, CT: Yale University Press, 2007), 336–39.

16. Marc Jansen and Nikita Petrov, *Stalin's Loyal Executioner: People's Commissar Nikolai Ezhov, 1895–1940* (Stanford, CA: Hoover Institution Press, 2002).

17. M.A. Sholokhov, letter to I.V. Stalin, February 16, 1938, in Clark and Dobrenko, *Soviet Culture and Power*, 340–43.

18. Jansen and Petrov, *Stalin's Loyal Executioner*, 103, 84–85.

19. Alexander Orlov, *A Secret History of Stalin's Crimes* (London: Random House, 1954), 161.

20. Nadezhda Mandelstam, *Hope Against Hope: A Memoir*, trans. Max Hayward (London: Collins and Harvill, 1971), 322–23.

21. Ilya Ehrenburg, *Men, Years, Life*, vol. 4, *Eve of War, 1933–1941*, trans. Tatiana Shebunina and Yvonne Kapp (London: MacGibbon and Kee, 1963), 197.

22. A.N. Pirozhkova, *At His Side: The Last Years of Isaac Babel*, trans. Anne Frydman and Robert L. Busch (South Royalton, VT: Steerforth Press, 1996), 104.

23. Clark and Dobrenko, *Soviet Culture and Power*, 310.

24. Isaac Deutscher, *The Prophet Armed: Trotsky, 1879–1921* (Oxford: Oxford University Press, 1954), 207.

25. Vitaly Shentalinsky, *The KGB's Literary Archive*, trans. John Crowfoot (London: Harvill, 1995), 57–58.

26. Simon Sebag Montefiore, *Stalin: The Court of the Red Tsar* (London: Phoenix, 2004), 273.

27. This is from the account given by Glikina under interrogation, quoted in Jansen and Petrov, *Stalin's Loyal Executioner*, 166–67.

28. Jansen and Petrov, *Stalin's Loyal Executioner*, 160.

29. V. Petrov and E. Petrov, *The Empire of Fear* (New York: Frederick A. Praeger, 1956).

30. The full text of Yevgenia Yezhov's letter to Stalin is in Jansen and Petrov, *Stalin's Loyal Executioner*, 169–70.

31. Pirozhkova, *At His Side*, 105.

32. Claud Cockburn, *In Time of Trouble* (London: Rupert Hart-Davis, 1957), 245.

33. Shentalinsky, *KGB's Literary Archive*, 58–59.

34. Pirozhkova, *At His Side*, 115.

35. Nikita S. Khrushchev, *Khrushchev Remembers*, trans. and ed. Strobe Talbott (Boston: Little, Brown, 1971), 530.

36. Pavel Sudoplatov and Anatoli Sudoplatov with Jerrold L. and Leona P. Schecter, *Special Tasks: The Memoirs of an Unwanted Witness—A Soviet Spymaster* (Boston: Little, Brown, 1994), 234.

37. Shentalinsky, *KGB's Literary Archive*, 27.

38. Pirozhkova, *At His Side*, 63.

39. Shentalinsky, *KGB's Literary Archive*, 66–67.

40. Ibid., 69.

12. Altering History

1. Quoted in Roman Szporluk, introduction to M.N. Pokrovskii, *Russia in World History: Selected Essays*, trans. Roman Szporluk and Mary Ann Szporluk (Ann Arbor: Michigan University Press, 1970), 13.

2. Quoted in Konstantin F. Shteppa, *Russian Historians and the Soviet State* (New Brunswick, NJ: Rutgers University Press, 1962), 103.

3. Pokrovskii, *Russia in World History*, 22, 65.

4. Simon Sebag Montefiore, *Stalin: The Court of the Red Tsar* (London: Phoenix, 2004), 137.

5. D. Bedny, letter to I.V. Stalin, December 8, 1930, and I.V. Stalin, letter to D. Bedny, December 12, 1930, in Katerina Clark and Evgeny Dobrenko, *Soviet Culture and Power: A History in Documents, 1917–1953* (New Haven, CT: Yale University Press, 2007), 69–75.

6. Josif Stalin, letter to Lazar Kaganovich, June 7, 1932, and Kaganovich, letter to Stalin, June 12, 1932, in *The Stalin-Kaganovich Correspondence*, ed. R.W. Davies, Oleg V. Khlevniuk, E.A. Rees, Liudmila P. Kosheleva, and Larisa A. Rogovaya (New Haven, CT: Yale University Press, 2003), 124, 131.

7. Nadezhda Mandelstam, *Hope Against Hope*, trans. Max Hayward (London: Collins and Harvill, 1971), 26.

8. Resolution on the banning of D. Bedny's play *The Bogatyrs*, November 14, 1936; report from the NKVD Secret Political Department, "On the Responses of Writers and Arts Workers to the Removal of D. Bedny's *The Bogatyrs* from the Repertoire," November 16, 1936, in Clark and Dobrenko, *Soviet Culture and Power*, 250–58.

9. Nikolai Gorchakov, *The Theater in Soviet Russia*, trans. Edgar Lehrman (New York: Columbia University Press, 1957), 315.

10. Jay Leyda, *Kino: A History of the Russian and Soviet Film* (London: George Allen and Unwin, 1973), 350.

11. S.M. Eisenstein, "Director of *Alexander Nevsky* Describes How the Film Was Made," *Moscow News*, December 5, 1938, quoted in Marie Seton, *Sergei M. Eisenstein* (New York: Grove Press, 1960), 384.

12. S.M. Eisenstein, "My Subject Is Patriotism," *International Literature*, no. 2 (1939): 90–93 (original in English), reproduced in *The Film Factory: Russian and Soviet Cinema in Documents*, ed. Richard Taylor and Ian Christie (Cambridge, MA: Harvard University Press, 1988), 398–401.

13. S.M. Eisenstein, *Selected Works*, vol. 4, *Beyond the Stars: The Memoirs of Sergei Eisenstein*, ed. Richard Taylor and trans. William Powell (London: BFI Publishing, 1995), 545.

14. Quoted in Victor Seroff, *Sergei Prokofiev: A Soviet Tragedy* (New York: Taplinger, 1969), 217.

15. Quoted in Simon Morrison, *The People's Artist: Prokofiev's Soviet Years* (New York: Oxford University Press, 2009), 27.

16. Quoted in Daniel Jaffe, *Sergey Prokofiev* (London: Phaidon, 1998), 145.

17. Morrison, *People's Artist*, 41.

18. Leyda, *Kino*, 307.

19. Harlow Robinson, *Sergei Prokofiev: A Biography* (London: Robert Hale, 1987), 318.

20. Z.N. Raikh, letter to I.V. Stalin, April 29, 1937, in Clark and Dobrenko, *Soviet Culture and Power*, 328–30.

21. Clark and Dobrenko, *Soviet Culture and Power*, 248.

22. Gorchakov, *Theater in Soviet Russia*, 364.

23. Vitaly Shentalinsky, *The KGB's Literary Archive*, trans. John Crowfoot (London: Harvill, 1995), 25–26.

24. Meyerhold's last photograph is reproduced in David King, *Ordinary Citizens: The Victims of Stalin* (London: Francis Boutle, 2003), 160.

25. Boris Pasternak, letter to O.M. Freidenberg, February 4, 1941, in *Sobranie sochineni b pyati tomakh* [Collected works in 5 volumes] (Moscow: Khudozhestvennaia Literatura, 1952), 5:392.

26. Quoted in Maureen Perrie, *The Cult of Ivan the Terrible in Stalin's Russia* (New York: Palgrave, 2001), 30.

27. Pokrovskii, "Bourgeoisie in Russia," in *Russia in World History*, 71.

28. This story comes from the memoirs of the composer Tikhon Khrennikov, quoted in Perrie, *Cult of Ivan the Terrible*, 86.

29. Isaak Glikman, *Story of a Friendship: The Letters of Dmitry Shostakovich to Isaak Glikman 1941–1975*, trans. Anthony Phillips with a commentary by Isaak Glikman (London: Faber and Faber, 2001), xxxiv.

30. For a detailed study of the background and impact of the Seventh Symphony, see Brian Moynahan, *Leningrad: Siege and Symphony: Martyred by Stalin, Starved by Hitler, Immortalised by Shostakovich* (London: Quercus, 2013).

31. A.S. Shcherbakov, letter to I.V. Stalin, April 28, 1942, in Clark and Dobrenko, *Soviet Culture and Power*, 433.

32. Quoted in Seton, *Sergei M. Eisenstein*, 367.

33. I.V. Stalin, letter to I.G. Bolshakov, September 13, 1943, in Clark and Dobrenko, *Soviet Culture and Power*, 436.

34. James Agee, "Ivan the Terrible," *The Nation*, April 26, 1947.

35. On the mass deportations of small nationalities, see Robert Conquest, *The Nation Killers* (London: Macmillan, 1970).

36. There is a detailed account of the Stalin Prize committee discussion in Joan Neuberger, "The Politics of Bewilderment: Eisenstein's *Ivan the Terrible* in 1945," in *Eisenstein at 100*, ed. Al LaValley and Barry P. Scherr (New Brunswick, NJ: Rutgers University Press, 2001), 239–44.

37. G.V. Alexandrov, letter to I.V. Stalin, March 6, 1946, in Clark and Dobrenko, *Soviet Culture and Power*, 436–38.

38. The transcript of Stalin's speech and the published resolution are in Clark and Dobrenko, *Soviet Culture and Power*, 447–53.

39. The transcript of this talk has appeared in various sources. For convenience, I have followed the translation in Clark and Dobrenko, *Soviet Culture and Power*, 440–45. There is also a full translation in Ronald Bergan, *Sergei Eisenstein: A Life in Conflict* (New York: Overlook, 1999), 340–44.

40. Alexander Solzhenitsyn, *One Day in the Life of Ivan Denisovich*, trans. Ralph Parker (London: Gollancz, 1963), 70–71.

13. Anna of All the Russias

1. György Dalos, *The Guest from the Future: Anna Akhmatova and Isaiah Berlin*, trans. Antony Wood (London: John Murray, 1998), 18.

2. The standard English-language history of the siege is Harrison E. Salisbury, *The 900 Days: The Siege of Leningrad* (London: Martin Secker and Warburg, 1969).

3. Isaiah Berlin, "Anna Akhmatova: A Memoir," in *The Complete Poems of Anna Akhmatova*, trans. Judith Hemschemeyer and ed. Roberta Reeder (Boston: Zephyr Press, 1997), 36.

4. Victor Serge, *Memoirs of a Revolutionary*, trans. Peter Sedgwick (New York: Readers and Writers, 1984), 59.

5. Akhmatova, *Complete Poems*, 84.

6. Berlin, "Anna Akhmatova," 39.

7. Anna Akhmatova, "Pages from a Diary," in *My Half-Century: Selected Prose*, ed. Ronald Meyer (Evanston, IL: Northwestern University Press, 1997), 26.

8. Roberta Reeder, *Anna Akhmatova: Poet and Prophet* (London: Allison and Busby, 1995), 137.

9. Akhmatova, *Complete Poems*, 282.

10. Reeder, *Anna Akhmatova*, 168–69.

11. Leon Trotsky, *Literature and Revolution*, chap. 1, available at the Marxists Internet Archive, www.marxists.org/archive/trotsky/1924/lit_revo/ch01.htm.

12. Reeder, *Anna Akhmatova*, 172.

13. Elaine Feinstein, *Anna of All the Russias: The Life of Anna Akhmatova* (London: Phoenix, 2006), 90, 42.

14. Boris Pasternak, *Family Correspondence, 1921–1960*, trans. Nicolas Pasternak Slater and ed. Maya Slater (Stanford, CA: Hoover Institution Press, 2010), 238.

15. Feinstein, *Anna of All the Russias*, 150–51.

16. Reeder, *Anna Akhmatova*, 202–3.

17. Emma Gerstein, *Moscow Memoirs: Memories of Anna Akmatova, Osip Mandelstam, and Literary Russia Under Stalin*, trans. and ed. John Crowfoot (Woodstock, NY: Overlook Press, 2004), 238.

18. Anna Akhmatova, "Requiem," in *Complete Poems*, 384, 385.

19. Reeder, *Anna Akhmatova*, 229–30; Svetlana Alliluyeva, *Twenty Letters to a Friend*, trans. Priscilla Johnson (Harmondsworth: Penguin, 1968), 154.

20. Katerina Clark and Evgeny Dobrenko, *Soviet Culture and Power: A History in Documents, 1917–1953* (New Haven, CT: Yale University Press, 2007), 365.

21. Akhmatova, *Complete Poems*, 426.

22. Anna Akmatova, "An Address Broadcast on the Program This Is Radio Leningrad," in *My Half-Century*, 259.

23. "Extract from Margarita Aliger's 1940–46 Memoirs," in Sophie Kazimirovna Ostrovskaya, *Memoirs of Anna Akhmatova's Years 1944–1950*, trans. Jessie Davies (Liverpool: Lincoln Davies, 1988), 75.

24. Anna Akhmatova, "Briefly About Myself," in *My Half-Century*, 27–28.

25. Akhmatova, *Complete Poems*, 690.

26. Ostrovskaya, *Memoirs of Anna Akhmatova's Years*, 1, 3.

27. Berlin, "Anna Akhmatova," 39–40.

28. Ibid., 45.

29. Anna Akhmatova, "Poem Without a Hero," in *Complete Poems*, 547.

30. Berlin, "Anna Akhmatova," 47.

31. Ibid., 47–48.

32. *The Bathhouse* is one of six stories by Zoshchenko available in *Russian Short Stories from Pushkin to Buida*, ed. and trans. Robert Chandler (London: Penguin, 2005).

33. Mikhail Zoshchenko, "The Adventures of an Ape," in *Scenes from the Bathhouse and Other Stories of Communist Russia*, ed. Marc Slonim and trans. S. Monas (Ann Arbor: University of Michigan Press, 1961), 177–83.

34. Reeder, *Anna Akhmatova*, 290; Dalos, *Guest from the Future*, 76.

35. Ostrovskaya, *Memoirs of Anna Akhmatova's Years*, 48.

36. Nadezhda Mandelstam, *Hope Abandoned*, trans. Max Hayward (New York: Atheneum, 1974), 375.

37. Milovan Djilas, *Conversations with Stalin*, trans. Michael B. Petrovich (London: Penguin, 1963), 27.

38. Dalos, *Guest from the Future*, 63.

39. Ibid., 69–70.

40. Reeder, *Anna Akhmatova*, 293.

41. Dalos, *Guest from the Future*, 56–57.

42. Gerstein, *Moscow Memoirs*, 175.

43. Evgeny Pasternak, *Boris Pasternak: The Tragic Years, 1930–60*, trans. Michael Duncan (London: Collins Harvill, 1990), 166–67.

44. Simon Sebag Montefiore, *Stalin: The Court of the Red Tsar* (London: Phoenix, 2004), 623.

14. When Stalin Returned to the Opera

1. Svetlana Alliluyeva, *Twenty Letters to a Friend*, trans. Priscilla Johnson (Harmondsworth: Penguin, 1968), 169–70.

2. Alexander Werth, *Musical Uproar in Moscow* (London: Turnstile Press, 1949), 26.

3. D. Shostakovich, letter to I.V. Stalin, May 27, 1946, and January 31, 1947. Both letters are reproduced in full in Leonid Maximenkov, "Stalin and Shostakovich: Letters to a 'Friend,'" in *Shostakovich and His World*, ed. Laurel E. Fay (Princeton, NJ: Princeton University Press, 2004), 43–44.

4. Flora Litvinova quoted in Elizabeth Wilson, *Shostakovich: A Life Remembered* (Princeton, NJ: Princeton University Press, 1994), 203.

5. Alexandrov's memorandum and Shepilov's accompanying note are in Katerina Clark and Evgeny Dobrenko, *Soviet Culture and Power: A History in Documents, 1917–1953* (New Haven, CT: Yale University Press, 2007), 459–62.

6. Maximenkov, "Stalin and Shostakovich," 52.

7. Werth, *Musical Uproar in Moscow*, 49.

8. Clark and Dobrenko, *Soviet Culture*, 235.

9. Juri Jelagin, *The Taming of the Arts*, trans. Nicholas Wreden (New York: E.P. Dutton, 1951), 93, 96.

10. Dmitri Shostakovich, *Testimony: The Memoirs of Dmitri Shostakovich*, related to and ed. Solomon Volkov and trans. Antonina W. Bouis (London: Hamish Hamilton, 1979), 105.

11. Martin Sixsmith, *Russia: A 1,000 Year Chronicle of the Wild East* (London: BBC Books, 2011), 298.

12. Werth, *Musical Uproar in Moscow*, 27.

13. Natalya Vovsi-Mikhoels quoted in Wilson, *Shostakovich*, 228.

14. Dmitri Shostakovich, letter to Isaak Glikman, December 12, 1948, in Issak Glikman, *Story of a Friendship: The Letters of Dmitry Shostakovich to Isaak Glikman, 1941–1975* (London: Faber and Faber, 2001), 34.

15. Wilson, *Shostakovich*, 212–13. A similar version of this conversation is in Shostakovich, *Testimony*, 112.

16. D. Shostakovich, letter to I.V. Stalin, March 17, 1949, in Maximenkov, "Stalin and Shostakovich," 55.

17. Wilson, *Shostakovich*, 241.

18. Fay, *Shostakovich and His World*, 175.

19. Recollections by the writer Lyubov Rudneva, quoted in Wilson, *Shostakovich*, 248–55.

20. Theodore van Houten, *Leonid Trauberg and His Films: Always the Unexpected* ('s Hertogenbosch, Netherlands: Art and Research Graduate Press, 1989), 156.

21. S. Shlifstein, ed., *Sergei Prokofiev: Autobiography, Articles, Reminiscences* (Moscow: Foreign Languages Publishing House, n.d.), 216.

22. Werth, *Musical Uproar in Moscow*, 24.

23. Simon Morrison, *The People's Artist: Prokofiev's Soviet Years* (New York: Oxford University Press, 2009), 461.

24. Werth, *Musical Uproar in Moscow*, 49.

25. Israel V. Nestyev, *Prokofiev*, trans. Florence Jonas (Stanford, CA: Stanford University Press, 1960), 404.

26. Harlow Robinson, *Sergei Prokofiev* (London: Robert Hale, 1987), 474.

27. Shlifstein, *Sergei Prokofiev*, 192–93.

28. Morrison, *People's Artist*, 299.

29. Edmund Stevens, *This Is Russia, Uncensored* (New York: Didier, 1950), quoted in Victor Seroff, *Prokofiev: A Soviet Tragedy* (New York: Taplinger, 1969), 292.

30. Nestyev, *Prokofiev*, 405.

15. After Stalin

1. Nadezhda Mandelstam, *Hope Abandoned*, trans. Max Hayward (New York: Atheneum, 1974), 384–85.

2. A.N. Pirozhkova, *At His Side: The Last Years of Isaac Babel*, trans. Anne Frydman and Robert L. Busch (South Royalton, VT: Steerforth Press, 1996), 120.

3. Ibid., 150.

4. Roberta Reeder, *Anna Akhmatova: Poet and Prophet* (London: Allison and Busby, 1995), 323.

5. Olga Ivinskaya, *A Captive of Time: My Years with Pasternak*, trans. Max Hayward (London: Collins/Harvill, 1978), 151.

6. Boris Pasternak, *I Remember: Sketch for an Autobiography*, trans. David Magarshack (Cambridge, MA: Harvard University Press, 1983), 90.

7. Boris Pasternak, letter to O.M. Freidenberg, October 5, 1946, in *Sobranie sochineni v pyati tomakh* [Collected works in five volumes] (Moscow: Khudozhestvennaia Literatura, 1992), 5:452.

8. Elliott Mossman, comp. and ed., *The Correspondence of Boris Pasternak and Olga Freidenberg, 1910–1954*, trans. Elliott Mossman and Margaret Wettlin (New York: Harcourt Brace Jovanovich, 1981), 264.

9. Ivinskaya, *Captive of Time*, 9.

10. Mossman, *Correspondence of Boris Pasternak and Olga Freidenberg*, 334.

11. Boris Pasternak, *Letters to Georgian Friends*, trans. David Magarshack (London: Martin Secker and Warburg, 1968), 51.

12. Ivinskaya, *Captive of Time*, 218.

13. Evgeny Pasternak, *Boris Pasternak: The Tragic Years, 1930–60*, trans. Michael Duncan (London: Collins Harvill, 1991), 237.

14. Christopher Barnes, *Boris Pasternak: A Literary Biography*, vol. 2, *1928–1960* (Cambridge: Cambridge University Press, 1998), 348.

15. Alexander Solzhenitsyn, *The Oak and the Calf: A Memoir*, trans. Harry Willetts (London: Collins and Harvill, 1980), 262.

16. Joseph Brodsky, *Less Than One* (London: Viking, 1986), 146–47.

17. Hedrick Smith, *The Russians* (London: Sphere, 1976), 489–90.

18. Isaak Glikman, commentary in *Story of a Friendship: The Letters of Dmitri Shostakovich to Isaak Glikman*, trans. Anthony Phillips (London: Faber and Faber, 2001), 91.

19. Laurel E. Fay, *Shostakovich: A Life* (New York: Oxford University Press, 2005), 219, 285.

20. Wendy Lesser, *Music for Silenced Voices: Shostakovich and His Fifteen Quartets* (New Haven, CT: Yale University Press, 2011), 6–7.

21. D. Shostakovich, letter to I. Glikman, December 29, 1957, in *Story of a Friendship*.

22. Solzhenitsyn, *Oak and the Calf*, 221, 405.

23. Elizabeth Wilson, *Shostakovich: A Life Remembered* (Princeton, NJ: Princeton University Press, 1994), 230.

24. Solzhenitsyn, *Oak and the Calf*, 405.

25. Ivinskaya, *Captive of Time*, 7.

Index

About the Author

Andy McSmith is a senior reporter at *The Independent*. He is the author of *No Such Thing as Society*, *Faces of Labour*, *Kenneth Clarke*, *John Smith*, and the novel *Innocent in the House*. Self-taught in Russian, he has visited Russia numerous times and was present when Margaret Thatcher met Mikhail Gorbachev and when Tony Blair met Vladimir Putin. He was educated at Oxford University and lives in London.

Publishing in the Public Interest

Thank you for reading this book published by The New Press. The New Press is a nonprofit, public interest publisher. New Press books and authors play a crucial role in sparking conversations about the key political and social issues of our day.

We hope you enjoyed this book and that you will stay in touch with The New Press. Here are a few ways to stay up to date with our books, events, and the issues we cover:

- Sign up at www.thenewpress.com/subscribe to receive updates on New Press authors and issues and to be notified about local events
- Like us on Facebook: www.facebook.com/newpressbooks
- Follow us on Twitter: www.twitter.com/thenewpress

Please consider buying New Press books for yourself; for friends and family; or to donate to schools, libraries, community centers, prison libraries, and other organizations involved with the issues our authors write about.

The New Press is a 501(c)(3) nonprofit organization. You can also support our work with a tax-deductible gift by visiting www.thenewpress.com/donate.

GLEN COVE PUBLIC LIBRARY

3 1571 00334 8789

700.9224 McSmith, Andy.
M
 Fear and the muse
 kept watch.

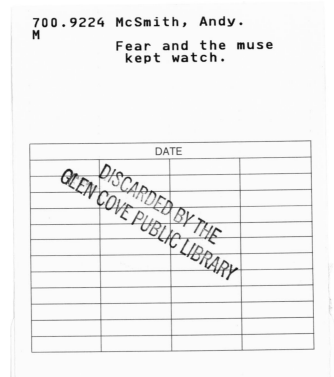

DATE

DISCARDED BY THE
GLEN COVE PUBLIC LIBRARY

GLEN COVE PUBLIC LIBRARY
GLEN COVE, NEW YORK 11542
PHONE: 676-2130
DO NOT REMOVE CARD FROM POCKET

BAKER & TAYLOR